PHOTOGRAPHY

THE DEFINITIVE VISUAL HISTORY

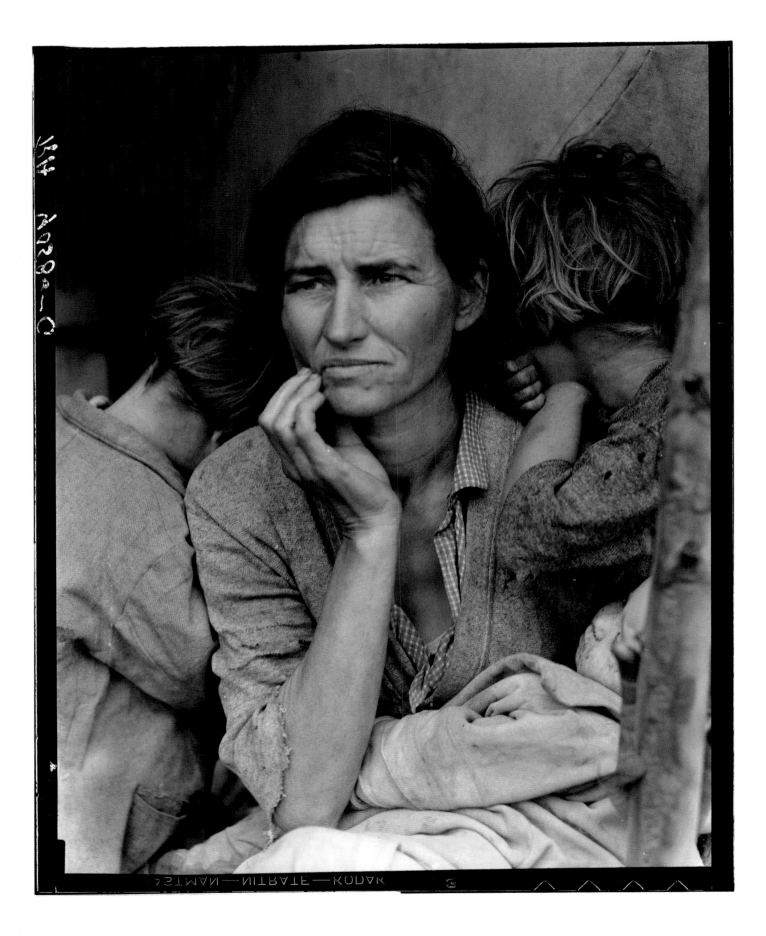

PHOTOGRAPHY

THE DEFINITIVE VISUAL HISTORY

TOM ANG

Dedicated to Nicky Munro

Senior Editor Angela Wilkes
Project Art Editor Joanne Clark
Designer Saffron Stocker
Editors Anna Fischel, Satu Fox,
Andy Szudek
Editorial Assistant Stuart Neilson
Picture Research Jenny Faithfull,
Luped Media Research
Jacket Designer Mark Cavanagh
Jacket Editor Maud Whatley
Jacket Design Manager Sophia MTT
Producer, Pre-Production Lucy Sims
Senior Producer Mandy Inness
Senior Managing Art Editor Lee Griffiths
Managing Editor Stephanie Farrow
Publisher Andrew Macintyre
Art Director Phil Ormerod
Associate Publishing Director Liz Wheeler
Publishing Director Jonathan Metcalf

First published in Great Britain
in 2014 by
Dorling Kindersley Limited
80 Strand, London WC2R 0RL

A Penguin Random House Company

2 4 6 8 10 9 7 5 3 1
001–193221–October/2014

A CIP catalogue record for this book is
available from the British Library
ISBN 978-1-4093-4645-6

Printed and bound by LEO Paper Products, China

Discover more at **www.dk.com**

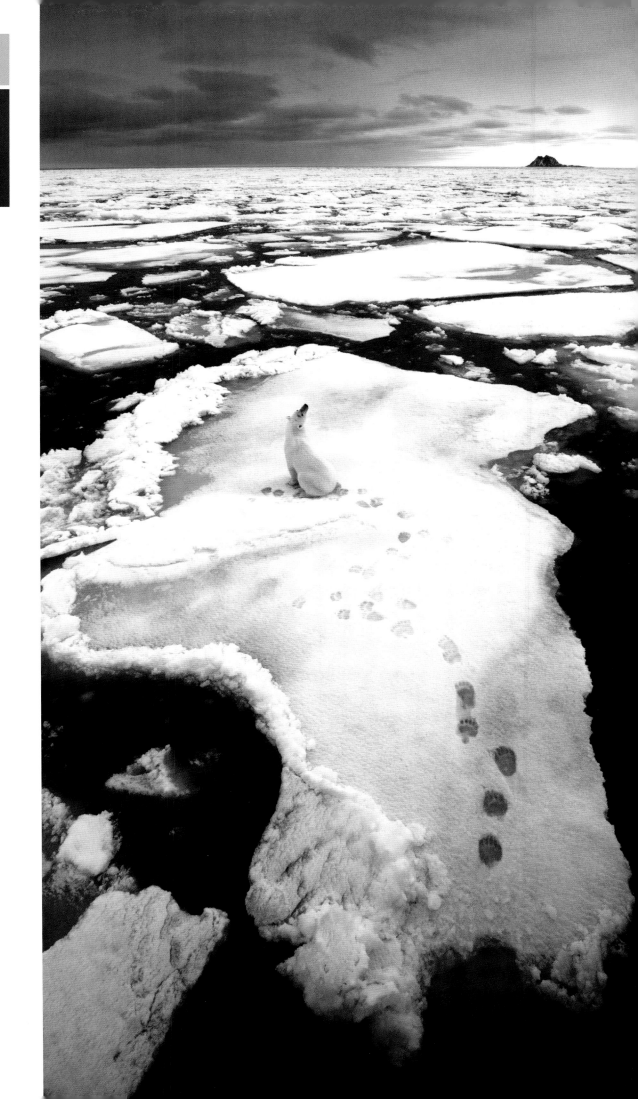

2000–PRESENT
THE DIGITAL AGE

▷ *LIVING ON THIN ICE*, OLE JØRGEN LIODDEN, 2012

The camera is **a sketch book,** an instrument of **intuition** and **spontaneity.**

We close our eyes and can recall little, but a camera glances for a fraction of a second yet retains every detail. This capacity, hard-wired into every photograph ever made, gives substance to our vision, making it permanent. It enables photography to hold a mirror to all activity on our planet and beyond. Life's pageant flows from photographs – cloud-capped mountains, gorgeous palaces, personal intimacies, even the universe as it was billions of years ago – all are laid bare by the camera.

Compared to other arts developed over thousands of years, photography is still in its infancy. Music expanded from fireside chants to opera cycles and symphonies, painting developed from scratches on cave walls, and troubadour recitals evolved into epic novels. Clearly, the best of photography is yet to come. In less than two centuries, photography has ceased to be the hobby of the wealthy and become the most widely available art form. Without any training, more than one and a half billion people worldwide can take a photograph, and most do.

Remarkably, the rapid proliferation of photographs – from a few million images to a billion – has nearly all taken place in the first decade of this century, and more than a trillion new photographs are now created every year.

In the blink of an eye, historically speaking, photography has become part of the very fabric of our existence. Modern life cannot be explained without understanding photography's role in communication – helping, distorting, clarifying, obscuring issues at every level, from the personal to the international. Now is the best possible time to review the story of photography, from its first stumbling steps in the dark to its current state of sleek, technical virtuosity.

We could concentrate on photography as an art, but it owes its existence to technology – optics, chemistry, and electronics. Photography is invaluable to industry, science, commerce, and the military, but for many it is also indispensable as a means of communication. Throughout the world, images are used to

disseminate new ideas and pass on the latest trends – indeed, without pictures, it is hard for an idea to make any progress at all through a social network.

The story of photography is a magnificent roll call of photographers who have invited us to look afresh and have changed how we see the world. These innovators, inventors, and visionaries have woven an intricate story that is by turns entertaining, breathtaking, and inspiring. Understanding what has happened in the past stokes creative energy, giving photographers today the stimulus for the art of tomorrow. In looking back over photography's past, our eyes are firmly on the expanding horizons of photography's future.

Tom Ang, Auckland, 2014

THE DAWN OF PHOTOGRAPHY

The invention of photography was a triumph of the Industrial Revolution mission to bend nature to the human will. By the 20th century, fire, wind, steam, gas, and electricity had all been harnessed for industry, construction, and transport. It was no accident, therefore, that all three key photographic discoveries came about in France and Britain as people tried to replace a task or skill with technology. Niépce wanted to avoid the labour of hand-engraving, Daguerre was tired of painting large panels for his light shows, and Fox Talbot was so horrified by his inability to draw a lakeside scene that he turned to science.

The rapid spread of photography around the world – by 1850, there were studios in India and Hong Kong, and in 1853, two New Zealand girls had their portrait made – was largely due to the vision of the French government. It was fortuitous that Daguerre's process did not depend on precise chemical formulations, so those gripped by "daguerreotypomania" could achieve good results even when inexperienced.

Given photography's short history, it is hardly surprising that the fine-art establishment took an instant dislike to it. Whereas other mechanical art processes demanded certain levels of skill and craftsmanship, it was only too clear that even people with no artistic skill at all, could, if moderately practical, produce photographs of scenes and portraits that were better than the finest drawings.

So began photography's hundred years' war with painting, during which it battled to be recognized as an art in its own right on the one hand, and to be as different as possible from painting on the other. That such a debate took place at all reveals a fact that is often overlooked. To be a photographer in the early days, you needed ready access to pure silver, hand-ground lenses, and cabinet-quality cameras, as well as studio and darkroom space. Commissioning a daguerreotype portrait was therefore expensive. Photography was the exclusive preserve of the wealthy.

In the beginning

The camera obscura dates from the very first time someone observed an image on a wall projected by a small hole in a door or curtain. By the Middle Ages, the basic properties of light were understood, but it took over a century more to make a permanent image.

The camera obscura was well known by the time of Chinese philosopher Mozi (470–390 BCE). He charmingly called it the "locked treasure room", presumably because the door had to be kept closed or the image would disappear. Around the same time, Greek philosopher Aristotle also described the phenomenon.

By 1000 CE, Basra-born scientist Ibn al-Haythem (also known as Alhazen) showed through systematic experiment – a procedure 500 years ahead of his time – the basic properties of light, such as the fact that it travels in straight lines. The work of al-Haythem provided the first methodical analysis of the camera obscura. It laid the foundations for theories of vision and optics taken up by German Johannes Kepler six centuries later. Meanwhile, Giovanni Battista della Porta's science book *Magia Naturalis* (1558) spread knowledge about the camera obscura throughout Europe. Isaac Newton's

living-room experiments of the 1670s further refined the understanding of light, particularly of colour. In this era, artists in Europe such as Canaletto, Vermeer, and Velasquez were using various optical devices to provide a basis for their compositions.

Unlocking the treasure room

What remained was photography's central problem – how to keep the image once the door to the camera obscura was opened. Anyone who experienced a camera obscura knew how frustrating it was to watch the image dissolve into a pool of pale forms as soon as the light was let in.

One vital step was to understand that light was independent of heat. In 1602, Italian alchemist Vincenzo Cascariolo created a powder, barium sulphide, which glowed in the dark after being exposed to light. With it came the idea of insolation – exposure to light to obtain an effect.

Experimenting on these lines, German anatomy professor Johann Heinrich Schulze discovered in 1724 that silver nitrate darkened when exposed to light. But try as he might,

he could not make the change permanent. The race was on, thanks in part to French author Charles-François Tiphaigne de la Roche, whose novel *Giphantie à Babylon* (1760) described a mirror that perfectly preserved a scene reflected in it. Notably, de la Roche placed this instrument in a virtuous paradise. Early histories of photography in the 1860s would acknowledge his anticipation of the daguerreotype.

Back in the real world, one of the first to use light-sensitive compounds such as silver nitrate to fix patterns was the chemist Elizabeth Fulharne. Her understanding of metal salts (published in 1794) laid a foundation

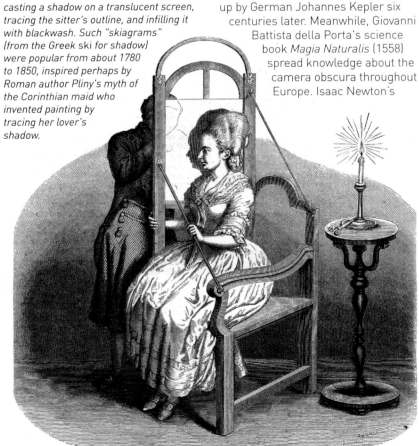

▽ **SILHOUETTE MACHINE**

LATE 18TH CENTURY

An accurate silhouette could be created by casting a shadow on a translucent screen, tracing the sitter's outline, and infilling it with blackwash. Such "skiagrams" (from the Greek ski *for shadow) were popular from about 1780 to 1850, inspired perhaps by Roman author Pliny's myth of the Corinthian maid who invented painting by tracing her lover's shadow.*

▷ **CAMERA OBSCURA**

ENGRAVING, 1685

The use of periscopic mirrors installed in rooms improved the quality of the camera obscura as well as allowing several people to gather round the image. Johann Zahn, a monk from Würzburg, applied lenses of longer and shorter focal lengths in 1685, the first time any camera offered different fields of view.

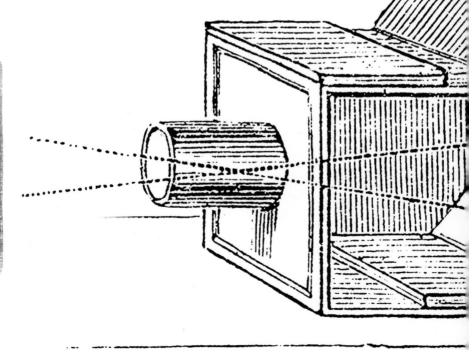

VITELLONIS THV

RINGOPOLONI OPTI-

CAE LIBRI DECEM.

Inftaurati, figuris nouis illuftrati atque auſti:infinitiſqz erroribus,
quibus antea ſcatebant, expurgati,

A'

FEDERICO RISNERO.

BASILEAE,

◁ **BOOK OF OPTICS**

IBN AL-HAYTHEM, 1572 EDITION

Persian father of modern optics Ibn al-Haythem spent most of his life researching mathematics, medicine, and physics. Optics, written 1011–21, includes the first accurate description of the parts of the eye and the first scientific explanation of vision, and the first account of atmospheric refraction and reflection from curved surfaces.

(Switzerland). The calibre of these scientists, coupled with their continued failure, showed that the mission to fix the image of a camera obscura was no easy task. English artist William Gilpin speculated that there had to be a way to preserve the image seen in a Claude glass (see below right). Hércules Florence, in Brazil, also engaged in the research. In 1833, he proposed silver nitrate as the actinic (light-sensitive) compound, and he named the process "photographia". Florence was arguably the first to use the term, four years before John Herschel (see p.20), but this fact emerged only in 2004.

In the meantime, it was a matter of looking but not touching. The best way to capture a likeness was to cast a shadow, using the light of the sun or a candle, on a screen of instruments such as the "physionotrace" and trace the person's silhouette. Other aids to help artists create accurately representational drawings were the camera lucida (which helped the eye to superimpose the scene on the paper) and instruments for enlarging drawings. All these devices showed that both the public and artists were increasingly ready to use mechanical aids to achieve their ends. What was needed was a fusion of physics, chemistry, and art. And that was to be found in the quiet genius of French inventor Nicéphore Niépce.

stone for photographic chemistry. Other distinguished investigators included master-potter Thomas Wedgwood, who collaborated with the scientists Humphry Davy, Thomas Young (England), Jacques Charles (France), and Andreas Gerber

... so **small a space** contains the **image** of the **universe**...

LEONARDO DA VINCI ON THE CAMERA OBSCURA / 1500

IN CONTEXT
Claude glass

On a walk in a park in the late 18th to early 19th centuries, you might have been intrigued to notice that some people had turned their backs to the scene and seemed to be intently examining themselves in a mirror. In fact, they were using a Claude glass, named after the 17th-century French painter Claude Lorrain. Claude invented a blackened mirror, gently convex in section, which had the effect of reducing a scene to its bare essentials, compressing tones, and suppressing bright colours. The attractive but idealized rendering suited the limp romanticism of the time. It paved the way for early photography's dim blurriness to be accepted as a representation of reality.

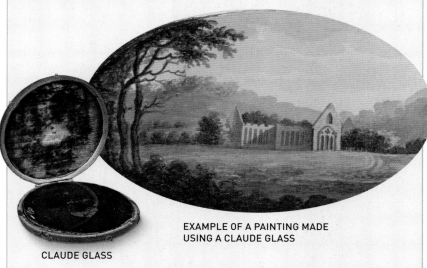

EXAMPLE OF A PAINTING MADE USING A CLAUDE GLASS

CLAUDE GLASS

Capturing an image

One of the crucial steps in the invention of photography was to fix the image. The first attempts established that photography works negatively – where light strikes, the resulting image is dark, while shadows are pale.

ON TECHNIQUE
Cyanotype process

Cheap and robust, the cyanotype (blueprint) process has been in use since its discovery by Sir John Herschel in 1842. He applied a mixture of potassium ferricyanide and ammonium ferric citrate, which is weakly sensitive to light, to paper and allowed it to dry in the dark. On exposure to ultraviolet light, usually from the sun, the salts reacted to produce ferric ferrocyanide (Prussian blue), a bright blue dye. Washing the image in water removed the unexposed and soluble iron salts, leaving the insoluble Prussian blue.

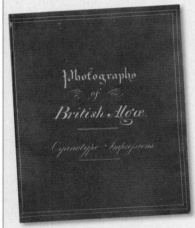

CYANOTYPE COVER OF ATKINS'S BOOK

Among the many distinguished names who struggled to fix the image of a camera obscura, Nicéphore Niépce was a well-to-do amateur who bested the finest scientific minds of the time. A soldier turned civil servant turned inventor, Niépce settled back in the family seat in France in 1801 to pursue his researches.

Sun exposure
In trying to overcome his self-confessed lack of skill with engravings, Niépce sought a mechanical method. His best results came from coating a polished metal plate with asphalt bitumen of Judea, a varnish used by lithographers at that time. Exposure to light hardened the bitumen, leaving the unexposed areas soft enough to be dissolved by oils of lavender and petroleum. The bitumen represented the lights and the metal the darks, so creating a direct positive. Niépce called his process "heliography", from the Greek *helios* for sun, because he used the light of the sun to expose the plate. Success came in 1822 with the reproduction of an engraving of Pope Pius VII, but the print was destroyed in

a later experiment. In 1827, Niépce travelled to England and told Francis Bauer, a botanical illustrator at the prestigious Kew Gardens near London, about his findings. Bauer immediately recognized their usefulness to botanical illustration and urged Niépce to present his invention to the Royal Society, but the paper that Niépce gave was full of fluff and guardedly vague about the details of his process. It was rejected.

Blueprints of nature
Such lensless photography was essential to early investigations. Photography pioneer Henry Fox Talbot paved the way in Britain, making what he called "photogenic drawing" (photograms) – placing objects on paper and leaving them in the sun for hours (see p.26).

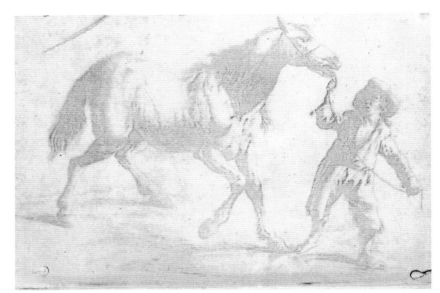

△ **BOY LEADING HIS HORSE**

NICÉPHORE NIÉPCE, 1825

The earliest heliograph reproduces a 17th-century Dutch engraving of a man leading a horse. Deemed a "national treasure" by the French government as the first surviving photograph, it was bought for €450,000 in 2002 for the Bibliothèque Nationale de France in Paris.

Herschel's discovery of the cyanotype (see top left) seemed to be yet another half-baked process, but Anna Atkins spotted an opportunity. Brought up by a distinguished scientist-father, John Children, she assisted his researches and was a botanist in her own right. Atkins took up Herschel's invention for her plant collection. Just over a year later, in 1843, she published the first volume of her *Photographs of British Algae: Cyanotype Impressions*, featuring hand-made cyanotype prints.

Nominally compiled for plant identification as each specimen was named, every page was exquisitely beautiful, arranged with the Victorian talent for finery as well as clarity of illustration. Not only was Atkins's work the first book of photographs, it was also an unequalled masterpiece.

◁ **PHOTOGRAMS**

c.1839

The masking caused by solid objects and the simple set-up of photograms – object on paper in sun – aided research into lensless photography. Speculation about the new process was rife and many people made copies of lace and leaves.

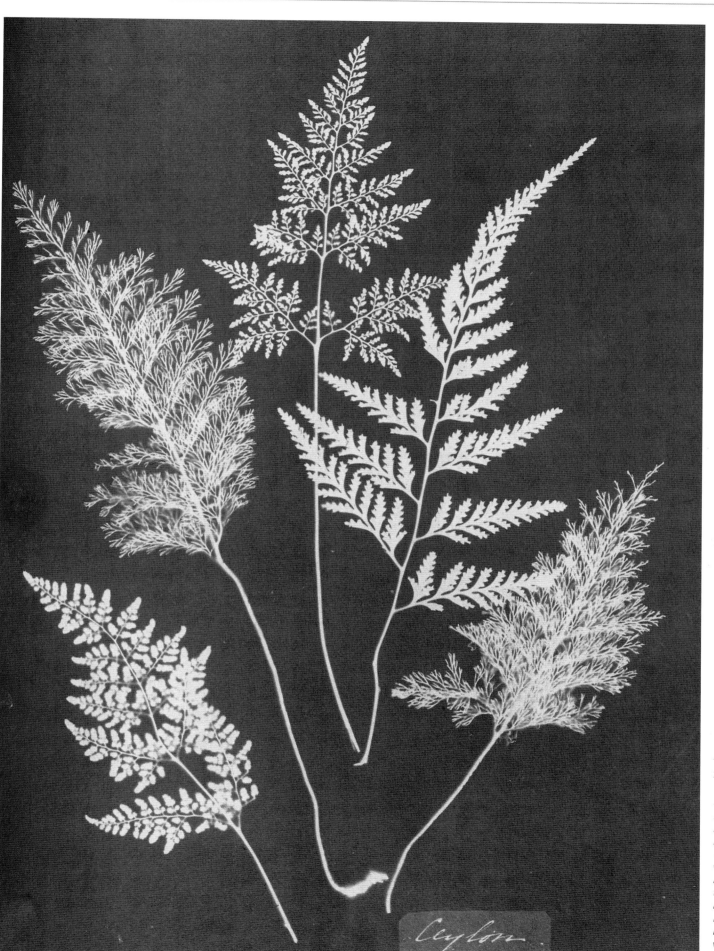

◁ **CEYLONESE FERNS**

ANNA ATKINS, 1853

Exposures for cyanotypes could stretch into hours. If the sun provided the illumination, its movement blurred shadows for all but the flattest objects. Atkins would have had to take measures to account for the sun's movement when making her prints. Fortunately, the cyanotype is bi-value - only blue or white, with no gradation – so all outlines appear sharp.

The first photographs

The discovery of photography is well documented. Unlike other arts, whose origins are buried under the dust of ages, the first photographs emerged in full light. Still, claims and counterclaims have obscured true achievements.

Sir John Herschel
1792–1871

An outstanding polymath in an era that was not short on remarkable brains, Herschel was the powerhouse behind the early days of photography. Mentor to Talbot, he guided the younger man's researches. He replaced the awkward phrase "photogenic drawing" with "photography", came up with the term "negative", and proposed the use of sodium thiosulphate solution to "fix" – another of his words – silver-based sensitive materials. He was mentor to Julia Margaret Cameron (see pp.66–67), too, who said of him "... you were my first teacher and to you I owe all the first experiences and insights". Herschel also pioneered research into colour and how to record it. He wrote on mathematics, astronomy, and chemistry, and was a fine illustrator.

Photography resulted from three related but separate inventions – photo-resist, the daguerreotype, and the negative/positive method – each representing a different side of its nature. All three inventions occurred within a few years of each other.

To Nicéphore Niépce goes the first honour for photo-resist. He used light to harden selective areas of a surface. He then washed off unhardened parts to make a printing plate. Using this process, Niépce created the first true photograph: recording a permanent image projected by a lens. This image – a direct positive – was hard to view even when first created but it is still possible to make it out today.

Aware of his limitations, Niépce teamed up in 1829 with Louis-Jacques-Mandé Daguerre, a scene painter. Together, Daguerre and Niépce researched new materials, experimenting with silver-plated copper sensitized by iodine fumes by the early 1830s. Niépce died in 1833, but Daguerre invented another direct positive method in 1837, which he modestly named after himself.

Invisible but present

As often in those early days, Daguerre made another discovery, the latent image. Although the instinct was to expose until a result was visible, the coating on the silver plate looked the same before and after full exposure. The image only developed by holding the plate over heated mercury.

Daguerre was a canny businessman and was not about to give away his secret. He showed his invention to François Arago, director of the Paris Observatory and a towering figure in scientific and government circles. So impressed was Arago with Daguerre's invention, he petitioned that it was, "... indispensable that the Government should compensate M. Daguerre direct, and that France should then nobly give to the whole world this discovery which could contribute

> ### ... this discovery which could contribute so much to the progress of art and science.
>
> **FRANÇOIS ARAGO / 1837**

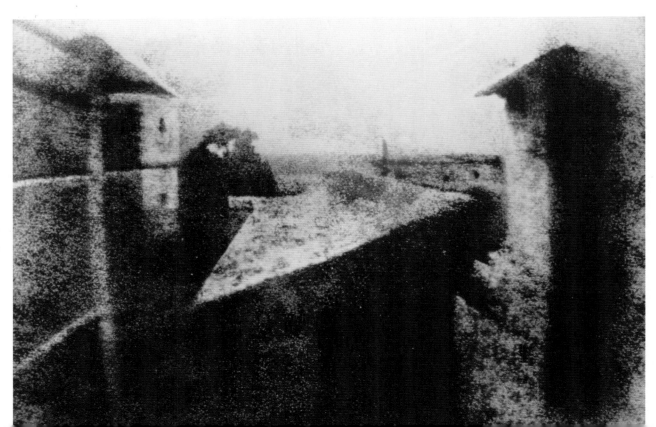

▷ **VIEW FROM THE WINDOW AT LE GRAS**

NICÉPHORE NIÉPCE, 1826

Exposed over a period of about eight hours, Niépce's image could not be precisely reconciled with the view from any window of his family home, so some doubt surrounded its authenticity. Then it was discovered that a window had been moved during past renovation. When adjusted for the original position, the image fitted perfectly. This first photograph is on show at The University of Texas at Austin, US.

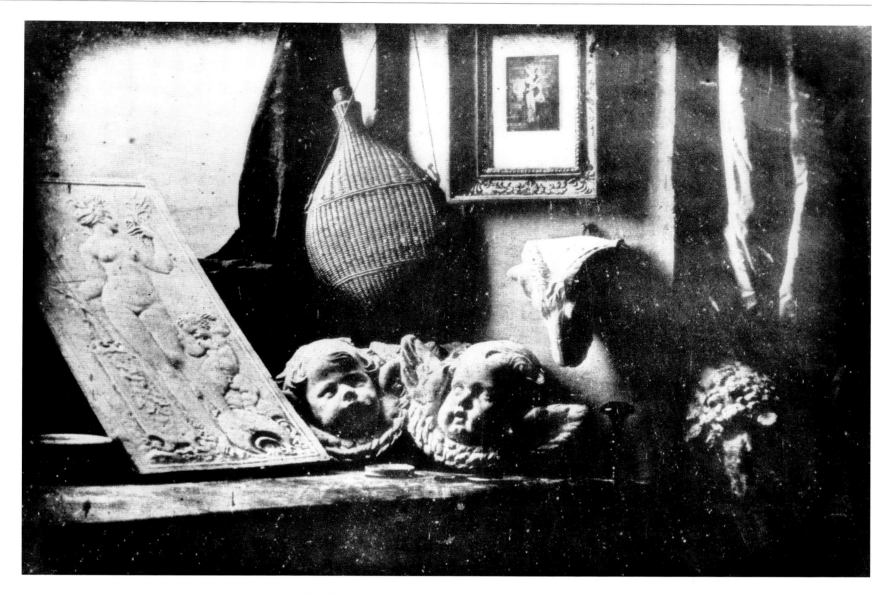

so much to the progress of art and science". Daguerre received a princely 6,000 francs a year and Niépce's estate 4,000 francs. Little more is heard of Daguerre after this award.

Thanks to French generosity, daguerreotype studios sprang up all over the world within years. By chance, Daguerre had hit on a method that produced continuous tone yet was capable of high-contrast results thanks to its use of reflected light.

Many were inspired by Daguerre. Hippolyte Bayard discovered another direct positive process, but he was hustled out when he too demanded a pension in return for revealing it. In the meantime, across the English Channel, Henry Fox Talbot (see pp.26–27) rushed to catch up.

Unknown rivals

A skilled chemist, Talbot had taken a different route to Daguerre – he worked with silver nitrate. His experiments were timely in that

Antoine Lavoisier had pioneered quantitative chemistry, so relatively pure chemicals of consistent quality and composition were available to researchers. Without such ready supplies, photography could never have taken off.

By August 1835, Talbot had his first negative image – shadows appeared pale and the fall of light created darks. He realized that he could print the negative back to create a positive, leading to the negative/positive method that was to dominate photography for over 150 years.

Talbot dallied with publishing his work, only to discover that Daguerre and Arago were marching months ahead. He then had the nerve to complain to Arago that he had made the discovery first – revealing a litigious streak that was to prove his downfall in court when he lost a case over unlicensed use of his patented calotype process in 1854.

△ **WINDOW AT LACOCK ABBEY**

HENRY FOX TALBOT, 1835

By the side of this earliest existing camera negative, Talbot wrote, "Latticed window (with the Camera Obscura) August 1835". Lacock Abbey, the Talbot home in Wiltshire, now houses a photography museum.

△ **DAGUERREOTYPE OF INTERIOR**

LOUIS DAGUERRE, 1837

Some 15 of Daguerre's original images survive. Even now, their exquisite tonality and detail are surprising. But the physical delicacy of the images, while appealing at first, became tiresomely impractical.

Daguerreotype camera

Daguerre invented not only photography but also the camera. All aspects of succeeding cameras, even the format sizes of modern photography, are essentially elaborations on his basic design.

The very first camera was a portable camera obscura on which light-sensitive paper was placed instead of the tracing paper normally used by artists. However, the first camera to be manufactured in any quantity was the Giroux Daguerreotype. Alphonse Giroux was an art restorer and cabinet-maker, and was related to Daguerre by marriage. In 1839, he obtained a licence from Louis Daguerre and Isidore Niépce (son of the deceased Nicéphore) to manufacture daguerreotype cameras.

High quality but heavy

Giroux's camera was a great improvement on Daguerre's original home-made version. It carried a 380-mm focal length lens of between *f*/14 and *f*/15 aperture specially created by Charles Chevalier, a renowned designer of microscopes and telescopes. The front flap of the lens opened to make the exposure.

The camera itself consisted of two boxes – a smaller rear one inside the larger front box – which slid apart or together for focusing, with a brass screw provided to lock it into position. The boxes were sturdy but simply constructed and so easy to mass-produce.

At the back, a mirror could be dropped so that the photographer could see the image more conveniently, and the right way up (although reversed left to right), just as the final daguerrotype would look. Daguerre and Giroux lined the inside of the camera with black velvet to reduce reflections that would degrade the image, even though most users would neither see nor appreciate it. A branding plaque was attached to every camera to assure the buyer that the camera was made under the direction of its designer. The camera is about the size of an office document-archive box and massively heavy. Together with all its accessories, a photographer would have 50kg (110lbs) to carry around. Portability was not high on the list of priorities.

High price, high demand

After the announcement in August 1839 of the daguerreotype going on sale, orders for cameras flooded in and both Giroux and Chevalier struggled to meet demand. Cleverly, Daguerre sold the entire photographic package – customers bought not only the camera but also an iodine box for sensitizing, a mercury box for development, and other accessories such as a burner for heating the mercury, and plate holders. The plate holder established the format from which smaller sizes – half-plates and quarter-plates – were produced. Obtaining the whole kit was some recompense for the extremely high price – 400 francs, which was by some accounts equivalent to an average annual income.

The partnership, which split the profits three ways, with 50 per cent going to Giroux and 25 per cent each to Daguerre and Niépce, made a handsome return. A pristine example of their ground-breaking camera sold for €732,000 in 2010.

The box measures 30.5 x 38 x 51cm (12 x 15 x 20in) overall

The 380mm *f*/15 lens by Charles Chevalier has two elements cemented together

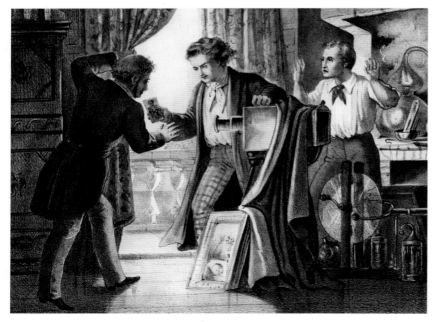

◁ **MOMENT OF DISCOVERY**

CHROMOLITHOGRAPH, c.1851

An artist's impression of the invention of the daguerreotype – Daguerre and one of the Niépce family research the technology that caused an international sensation.

I have **seized the** light. I have **arrested** its flight.

LOUIS-JACQUES-MANDÉ DAGUERRE / 1839

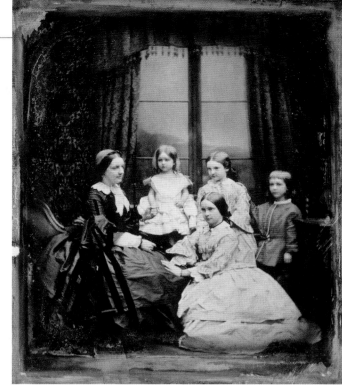

▷ **STUDIO PORTRAIT**

ANTOINE CLAUDET, c.1845

Family portraits soon became popular as daguerreotype studios sprang up. In 1845, exposure times were still around five minutes, so this group would have had to sit very still. The portrait has been hand-coloured, as was fashionable among wealthier clients.

The plate holder at the back holds a 6½ x 8½in whole plate

A flip-down mirror angled at 45 degrees shows the image right way up

IN CONTEXT
Camera developments

The drawbacks of the Giroux design soon became clear to photographers. In particular, the sliding box mechanism used for focusing was impossible to slide smoothly, tended to wear, and was prone to let in light.

As early as 1845, cameras such as the Bourquin of Paris had the lens in a metal tube using a rack-and-pinion mechanism for focusing – the first of its kind (it also had a "birdy" to distract sitters during the long exposures). By 1851, manufacturers such as Lewis of New York inserted pleated bellows to improve lightfastness. As the market diversified, fancy models such as pistol-shaped cameras were introduced. This is perhaps from where the notion of "shooting" a photo comes.

The rear box is lightproof and slides in and out to focus

△ **DAGUERREOTYPE CAMERA**

MADE BY ALPHONSE GIROUX, 1839

The camera consists of two boxes made of different woods. The aperture of the lens is removed for focusing and replaced for photography, using the swivelling lens cap as a shutter.

A branding plaque guarantees quality control

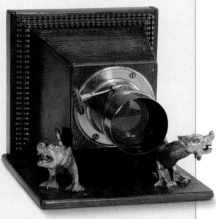

BOURQUIN CAMERA, c.1845

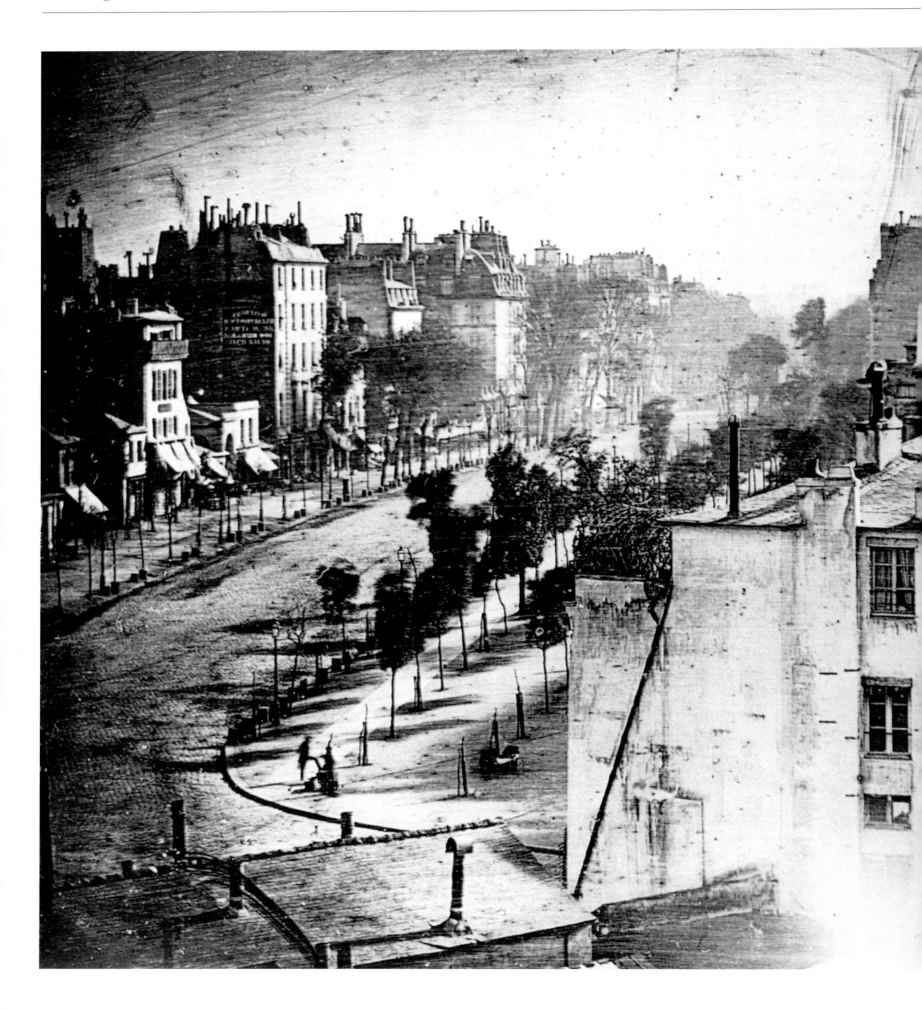

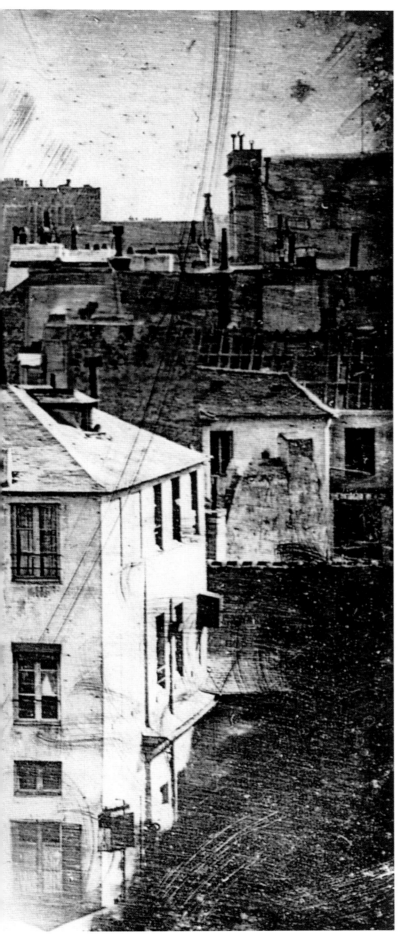

Boulevard du Temple, Paris

LOUIS-JACQUES-MANDÉ DAGUERRE / 1838

This is a modern copy, made by the historian Beaumont Newhall, of one of the earliest daguerreotypes. It would have been one of the earliest surviving daguerreotypes but for the incompetent attentions of a museum restorer, who tried to clean the original but destroyed it. It is the first known image featuring people, but it is also a marvellous image by any standard. Its sweeping lines, contrasts of scale, and rhythmic forms demonstrate Daguerre's artistic background. Unfortunately, he became so relaxed after gaining a government annuity of 6000 francs that he seems to have done nothing else in life.

The image was perhaps set up, as the man having his shoes shined seems all too perfectly positioned and improbably near the street when the pedestrian area is as wide as the road. By good luck, the inherent contrast of the daguerreotype technique suited the rudimentary lenses of the time, combining to deliver sharp, detailed images.

NAVIGATOR

1 REVERSED CURVE
In real life, the boulevard sweeps upwards to the left but the reversed view of a daguerreotype creates a movement that is visually more pleasing for those accustomed to reading left to right. Daguerre was sufficiently skilled as an artist to have consciously exploited this reversal of reality.

2 CORNER FIGURES
The man and shoe-shine appear impressively steady during the exposure of anything between five and 10 minutes. There are also signs of people in the shadowed area a few metres away. In fact, the street was probably full of people, but the very long exposure shows that no one else stopped for any significant time.

3 DEFECTIVE PLATE
The scratches and marks on the plate are perhaps what the "restorer" was trying to clean up. They may indicate an early production, as later daguerreotypes show surfaces polished to mirror quality. This would date the daguerreotype to 1838, rather than the alternative of 1839.

4 VERTICALS CORRECT
The nearest building – the most critical – shows parallel verticals, proving Daguerre aimed the camera level, to avoid projection distortion. It is astonishing that so early in photography's history, he avoided errors which still plague today's practitioners.

William Henry Fox Talbot

ENGLISH / 1800–77

Like many of the early pioneers in photography, H.F. Talbot, as he liked to be known, came from a privileged background. Thanks to his brilliant, polyglot mother – who turned her late husband's estate round from debt-ridden to prospering – Talbot enjoyed education at Harrow and Trinity College, Cambridge, with an income that allowed him to research and travel Europe. Today, he would be described as a nerd: painfully shy with interests ranging from mathematics to Greek verse, astronomy, and chemistry.

His life-changing moment revealed his competitive streak. While other members of the family produced pleasing sketches of Lake Como in Italy, where they holidayed in 1833, his attempts were derisory. He jotted down notes as to experiments he might try to translate the material world on to paper by the action of light. Back home, with the help of John Herschel (see p.20), he embarked energetically on his project. Within two years, while also discharging his duties as a Member of Parliament for a year, he had fixed an image on to paper. By 1840, he had made considerable improvements to the process, reducing exposure times to around eight seconds. He patented it under the name "calotype". The differences between the calotype, with its fibrous texture and blurred detail, and the daguerreotype, with its clarity and precision, set the scene for an enduring tension between objective lucidity and painterly granularity. The debate is more alive now than ever.

After the debacle of a court case in 1854 over his patent, Talbot turned to investigations into photomechanical printing. In part, this was a response to the rapid fading of his images. The work occupied the last 25 years of his life, leading to early experiments with half-tone and the photogravure process.

> How charming it would be if it were possible to cause these **natural images** to **imprint themselves** durably and remain fixed upon the paper.
>
> **H.F. TALBOT / 1833**

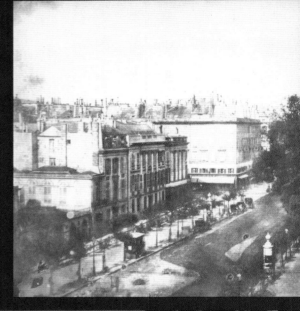

▷ **VIEW OF THE BOULEVARDS AT PARIS**

1843

The second plate in The Pencil of Nature, *this could well have been intended to counter Daguerre's* Boulevard du Temple *(see pp.24–25), which Talbot was likely to have seen. Talbot described the contents of his image in detail, at pains to show that his process, too, could retain sharp details.*

△ **LEAF OF A PLANT**

1843

Talbot used this image to explain the negative/positive process with admirable clarity. It is also an example of lensless photography – the image is a positive, printed from a negative photogram in which the leaf would be pale and the background dark.

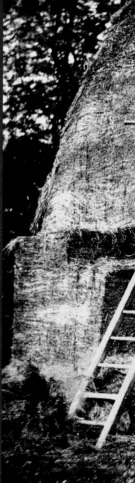

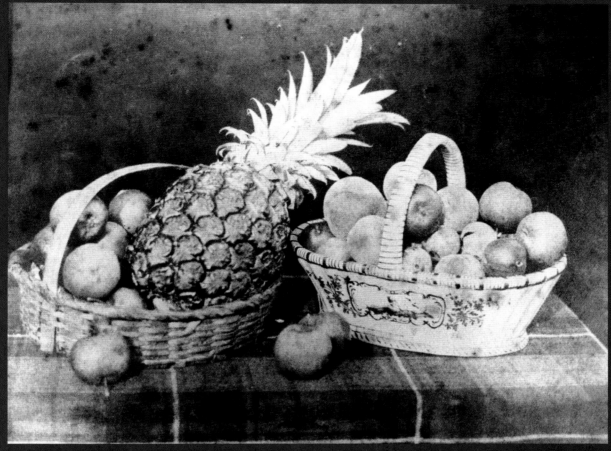

◁ **A FRUIT PIECE**

1844

The final plate in The Pencil of Nature, *this image is significant as one of the earliest still-life photographs. Talbot did not refer to the image in his comments, but discussed at length the number of copies that could be made – a direct snub to the daguerreotype's key limitation.*

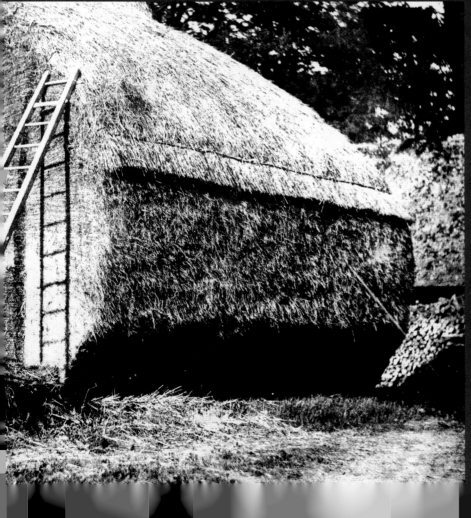

◁ **THE HAYSTACK**

1844

Pleased, perhaps, with the mathematical precision of the ladder and its shadow, Talbot introduced the notion that photographs contained a wealth of detail which ˝no artist would take the trouble to copy faithfully from nature˝. This is plate 10 from The Pencil of Nature.

IN CONTEXT
Publicity, discovery, and technique

In 1844, Talbot published the first part of *The Pencil of Nature* illustrated with prints ˝tipped˝ (stuck) on to separate sheets inserted into the book sections. Intended as a promotion piece for his process, it tells the story of its discovery and demonstrates its various uses. Although the images were on loose pages rather than integrated, it is the first book fully illustrated by photographs and also the first book *on* photography.

COVER OF
THE PENCIL OF NATURE

Facing the camera

The rising middle classes fuelled a boom in portraiture as their numbers grew during the 1800s. A full-blown oil painting was expensive, while cheaper, quicker options lacked distinction. Photography came to the rescue at just the right time.

ON TECHNIQUE
The Petzval lens

Josef Petzval was a Hungarian mathematician who applied himself to lens design, such was the clamour for an objective that would be faster than the f/16 commonly available. He first computed a theoretical lens, using a rule that bears his name. It was of unprecedented complication – two sets of achromat pairs (negative and positive in groups), one formed into a cemented pair. It worked brilliantly. His "Portrait lens" of 1840 offered an angle of view of about 25–30 degrees (equivalent to 105–80mm) with maximum aperture of f/3.6– f/3.7. This reduced exposure times at a stroke from up to 20 minutes to one.

PETZVAL LENS

▷ **NEW YORK TRIBUNE**

MATTHEW BRADY, 1844

Brady opened his studio in New York in 1844 and set about taking daguerreotypes of prominent men such as the editorial staff of the New York Tribune*. In 1850, he published* The Gallery of Illustrious Americans *and went on to take pictures of Abraham Lincoln and the Civil War.*

The miniature, the cut-out, the silhouette, and the skiagram or physionotrace (see pp.16–17) were all low-cost alternatives to a canvas painting. They also marked the owner as someone who could not quite afford the full treatment. Photography, meanwhile, delivered a striking resemblance, a good deal better than a sketch or engraving, and it certainly left cut-outs and silhouettes in the shade. Above all, it was fashionably technical, a triumph of science.

Holding a pose

The beginnings were shaky. The extremely long exposure times of the daguerreotype led to frustratingly fuzzy images as no one could hold still enough for five or 10 minutes at a time. Even the perceptive Paris Observatory director François Arago despaired of using daguerreotypes for portraiture.

These difficulties led to the development of contraptions that kept people's heads and bodies steady without appearing in the picture and instructions that the best expression to hold was one of "absolute indifference". The lengthy exposure times needed had another consequence: if you wanted a picture

of a baby, it had to hold still. Early methods included etherizing the infant to subdue its movements. Some surviving images are post mortem, the photograph a sad reminder of a young life taken early.

Photographers tackled the problem of exposure time with energy and ingenuity. Hippolyte Bayard set up operations in the open, transforming a courtyard with props to simulate a studio so he made maximum use of daylight yet still conformed to the convention that portraits were made indoors. The chemists among them tried different halide salts to improve the sensitivity of plates. And the lens had to be larger and faster to let in more light, leading to innovations by Josef Petzval (see left). Before these developments, daguerreotype portrait

◁ **MR HOGG AND MR JOHNSON**

RICHARD BEARD'S STUDIO, 1843

Mr Hogg times the exposure of his portrait with a watch. The daguerreotype was probably taken to illustrate his book A Practical Manual of Photography *(1843).*

studios appeared within a year of Arago's announcement of the free availability of the technique. Alexander Wolcott opened a studio in New York in 1840; Richard Beard started up in London in 1841, while numerous studios were set up all over continental Europe.

Suitable expressions

Even with the greatly shortened exposure times made possible by using wet-collodion plates, the smile was not yet part of the convention of portraiture. It could not be. No one could hold a natural-looking smile for more than a few seconds without it turning into a grimace.

Photographers such as Antoine Claudet in London and Gustav Oehne in Berlin developed ways of grouping multiple sitters and posing them to suit different subjects. Family groups were informal, while important persons were posed in full dress and given props such as part of a "Roman" column or a grand chair.

Despite all its deficiencies, the new upstart medium troubled portrait artists. There were art-critical objections – could something be considered a portrait when it was "made in a single, mechanical action?". Some questioned whether a photograph of someone could capture their soul as a painting did. But these were last-ditch hurdles. The public loved the clarity and perfect likeness. Author Edgar Allan Poe summed up the general enthusiasm, exclaiming, "the daguerreotype plate is infinitely more accurate than...any painting by human hands".

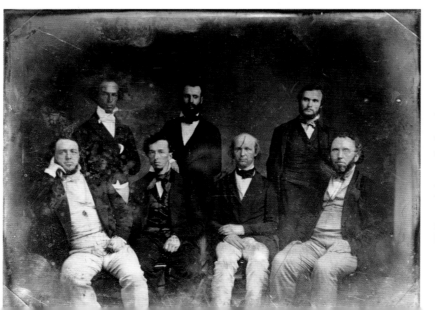

◁ **DOROTHY CATHERINE DRAPER**

JOHN DRAPER, 1839–40

John Draper is credited with producing the first female portrait. The sitter, his sister, reputedly powdered her face with flour in an attempt to lighten her skin tones. Aside from portraits, Draper also created the first detailed photograph of the moon.

Hill and Adamson

SCOTTISH / ACTIVE 1843–48

In a demonstration of what could be achieved when artistic and technical forces combined, David Octavius Hill and Robert Adamson produced 3,000 prints of consistently high quality in just four years. Working entirely in Scotland, their work was the first substantial document of a country. The younger man was Adamson, a brilliant engineer who had set up a photography studio in Edinburgh in 1843. Adamson had mastered the production of calotypes, helped by Sir David Brewster, who was a close friend of Talbot (see pp.26–27). Hill was a well-known painter, accepted into Scottish society and at ease with people – no incidental detail, as someone had to persuade strangers to hold their positions still for up to 10 minutes at a time.

When Hill contemplated creating a vast portrait of some 190 Scottish ministers and elders, Brewster urged him to use photographs as an aid, suggesting Adamson as the man for the job. Initially sceptical, Hill took to photography with enthusiasm. He soon tired of ministers and, with Adamson, planned the publication of a series of books on Scottish life. With a new camera commissioned from the instrument-maker Thomas Davidson, they were able to make 16 x 13in (40.5 x 33cm) negatives, substantially larger than most work of the time. Their interests were consciously generalist, covering landscapes, architectural and street scenes, as well as portraits of workers and fishermen.

The division of labour was clear – artist Hill was in charge of setting up and posing, and technician Adamson handled the camera and processing. But Hill's inability to produce any work of significance after Adamson's death argues a collaboration that was much deeper. Sadly, the partnership came to an untimely end with Adamson's early death at the age of 26.

IN CONTEXT
Disruption Assembly

David Hill was present at the Disruption Assembly of 1843, which saw 194 ministers and elders leave the Church of Scotland over disagreements about the spiritual independence of the Church. Hill resolved to paint the scene but it doubled in size as more ministers joined the demission. He used Adamson's photographs to help plan the painting, which took Hill 23 years to finish. Their first project together produced scores of portraits of Scottish clergy, many striking sittings in their own right. On the right, Dr Chalmers signs the Act of Separation.

PHOTOGRAPH USED FOR THE PAINTING

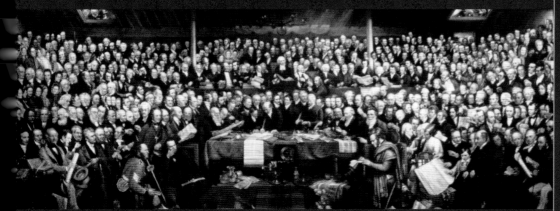

THE SIGNING OF THE DEED OF DEMISSION, OIL PAINTING BY DAVID OCTAVIUS HILL (COMPLETED 1866)

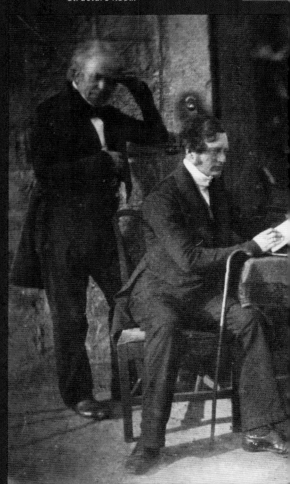

▷ **SCOTT MONUMENT**
EDINBURGH, SCOTLAND, c.1845

This is one of several pictures Hill and Adamson took of the Victorian Gothic monument to the author Sir Walter Scott. Its landscape (wide) format gave context, while versions in portrait (tall) format emphasized the height of the structure itself.

△ **FAIRBURN READING TO THE FISHWIVES**
NEWHAVEN, SCOTLAND, c.1843

Their paper-negative process could not record fishermen at sea, so Hill and Adamson turned the lens on fishwives in the town of Newhaven, near Edinburgh. Wearing traditional striped aprons and woollen petticoats, the women baited lines, unloaded and cleaned the catch – in between listening to the Reverend Fairburn – and hauled the laden willow baskets up the hill to Edinburgh to sell their fish.

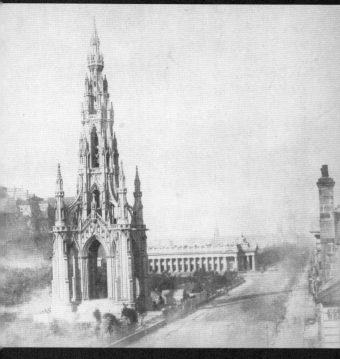

◁ **MISS GLYNN, THE GOWN AND CASKET**

EDINBURGH, SCOTLAND, c.1845

*The props allude to the subject's profession –
"Glynn, Actress & Reader" is inscribed in pencil on
the mount. The RSA stamp indicates that this was
one of the prints selected by Hill as their finest and
presented to the Royal Scottish Academy in 1852.*

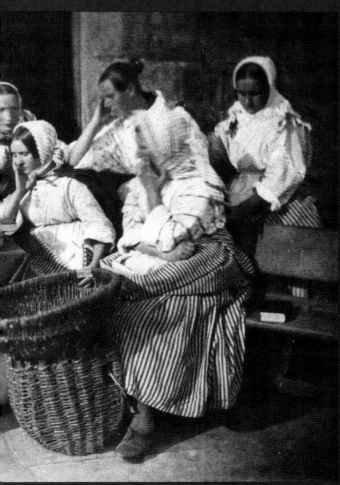

▷ **JAMES LINTON WITH SONS
AND BOAT**

NEWHAVEN, SCOTLAND, c.1844

*Hill and Adamson presented Newhaven as a
model community united by tradition, hard
work, and mutual support. Careful posing of
the figures, combined with the graphic
strength and grittiness of the calotype,
emphasized such positive qualities.*

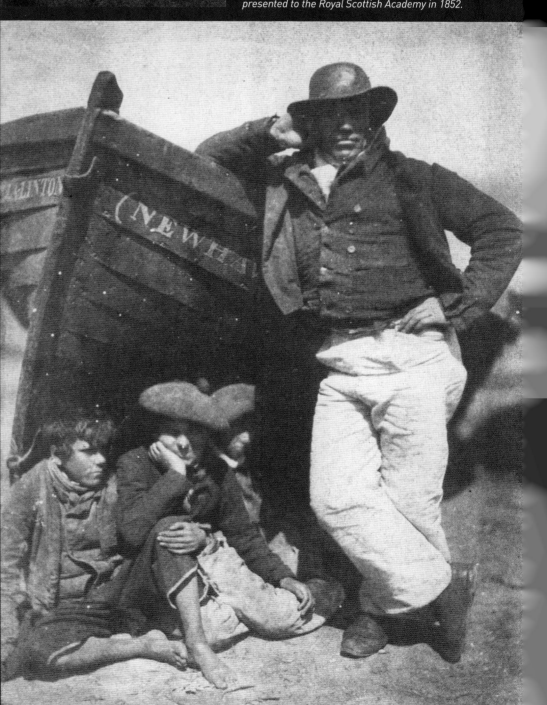

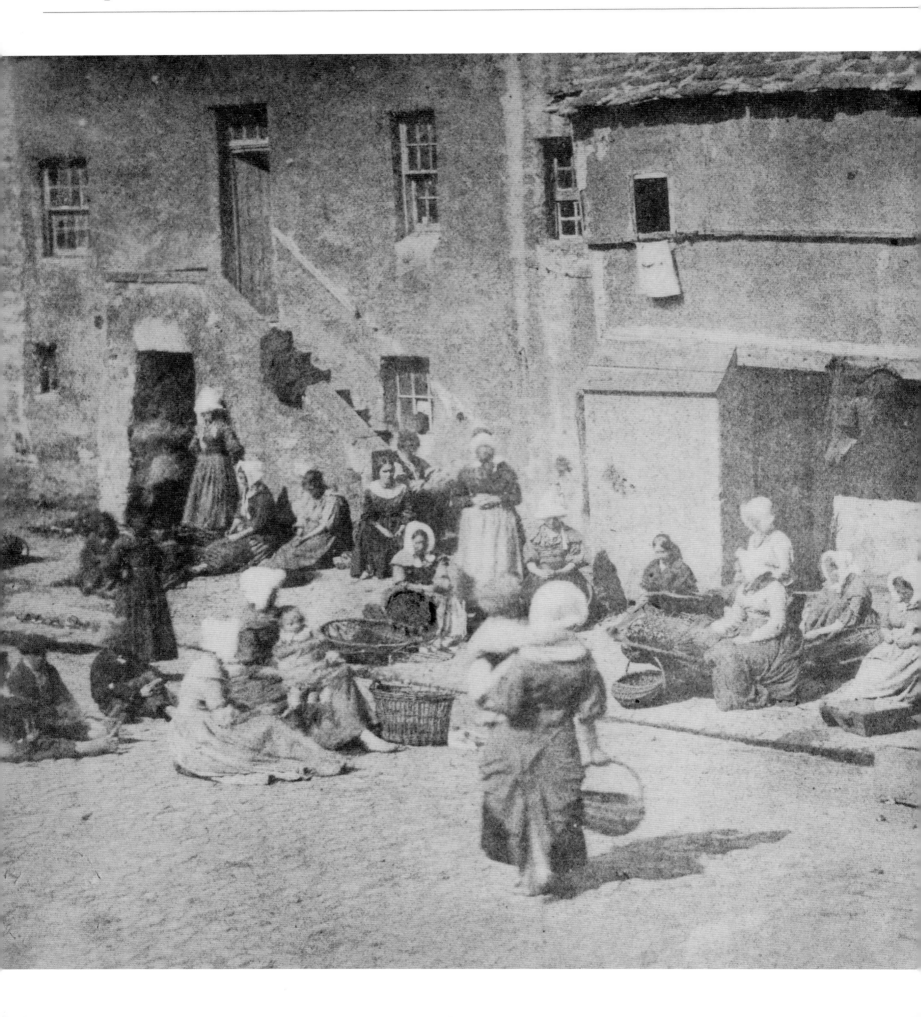

Fishergate, St Andrews

DAVID OCTAVIUS HILL AND ROBERT ADAMSON / c.1845–46

This image of St Andrews, on the east coast of Scotland not far from Edinburgh, is breathtaking in quality and in ambition of undertaking, particularly considering the photographic process used. Adamson (and some experts attribute this image solely to him) was a master of the calotype process. High-quality writing paper was coated first with silver nitrate, then potassium iodide. The salts reacted to form light-sensitive silver iodide. This was the negative when dried. After an exposure of at least a minute – probably more even in the bright sunshine of this scene – the negative could be developed using acids and a little silver nitrate. A wash in sodium thiosulphate solution fixed the image. A print could then be made by placing the negative in contact with a fresh piece of sensitized paper and the process repeated.

The key to this image is Hill's adroit placement of players, choice of camera position, and ability to cajole a cast of over 20 into position, then hold steady for a time. There are even children in view, including one toddler who is surprisingly sharp. What looks like a documentary shot of street life was in fact carefully rehearsed and meticulously set up – no one knows exactly how. From the white bonnets to the towel drying out of the window and the raised heel and bare ankle of the central figure, it is brilliantly executed.

NAVIGATOR

1 WHITE BONNETS
The highlights of the white bonnets, bright in the sun, dot the central portion of the image. By intention, not one overlaps or is even close to another. The bonnets separate the heads of the women from dark backgrounds. Not all the figures wear bonnets, and they sink into the mire of shadows.

2 WHITE TOWEL
An artfully placed towel – or perhaps it was well spotted – brings light and liveliness to the upper part of the picture, like a reflection of the bright bonnet of the central backview figure.

3 CENTRAL FIGURE
The woman carrying a baby holds the whole image together. From her shadow, which defines the lower margin, to her pose – about to put her whole weight on her right foot while she balances the baby on her hip with her laden basket – she animates the scene.

4 STRUCTURAL DIAGONALS
Hill and Adamson used a sophisticated framing device: the strong diagonal of the balustrade and steps on the right mirrored by another set on the left. Its line points at the central figure, while her shadow points to the stairs on the right, setting up a visual flow.

5079

GATHERING MOMENTUM

Within a few years of its invention, photography had not only spread around the globe, but had also leapt forward in terms of technical development. Inventive photographers, chemists, and instrument-makers came up with myriad ways to improve the speed, quality, and clarity of images, approaching the challenge from every possible angle. Cameras benefited from a steady stream of innovations, all aimed at making them more portable and quicker to use, yet sufficiently durable to use outside the studio. There was also a flurry of improvements to lenses. Then, as now, people wanted them to be smaller, lighter, faster, cheaper, and better. And scientists improved the sensitivity of photographic materials, introducing innovations such as pieces of curved glass to make panoramas.

Although there were clear objectives on the technical front and progress was steady, with barely a false step, there were problems on the artistic and creative front. Photography struggled to get into its stride because photographers bickered

among themselves and were harried by the fine-art establishment, which was itself reeling from the impact of the Impressionists. As a result, some photographers urged a union with the art establishment, and others argued for severance.

While wealthy amateurs continued this debate, professional photographers were enjoying the spoils of an industry that had not yet been invaded by amateurs. Some packed capacious bags and left the debates far behind, heading for distant lands that promised them exotic new subjects to photograph. They created a new type of being – the travel photographer, the worth of whose expeditions was judged by the quality of the pictures he or she brought home. Others carved out a new role for photography, launching the enduring project to document everything – life, the planet, and even the universe. Others still went their own sweet way, deaf to criticism and heeding only their own creative instincts as they explored the endless fascinating possibilities of their craft.

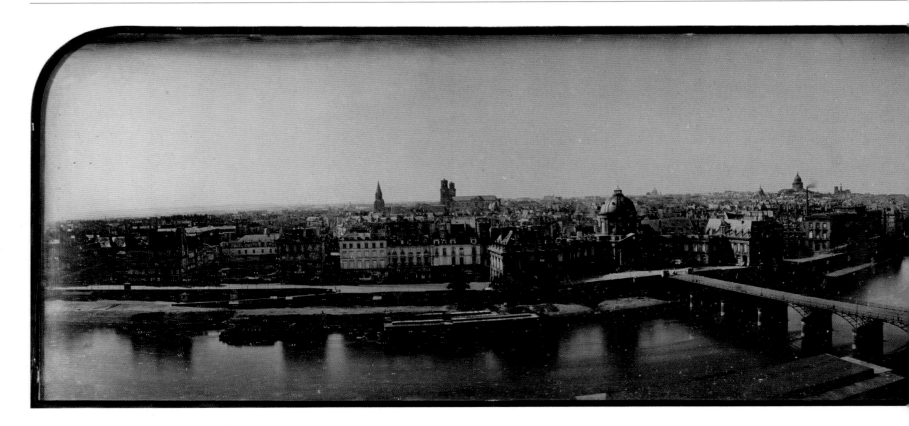

Stretching photography

The first photograph had barely been exhibited when inventors launched projects to see how far they could stretch the medium, to test the daguerreotype's ability to capture anything that could be seen.

▽ **THE MOON**

JOHN ADAMS WHIPPLE, 1851

American John Whipple made a daguerreotype of the moon through a telescope at the Harvard College Observatory in Cambridge, US. His pictures, among the first lunar images, opened the eyes of the world to the potential of astronomical photography.

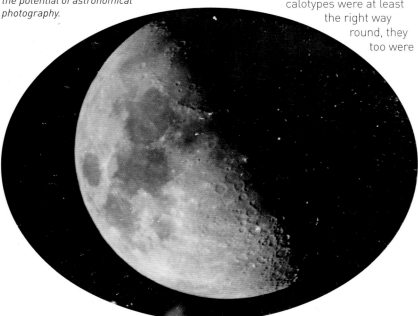

Early photography had its deficiencies. Daguerreotypes were tiny, flipped side to side, and lacked colour. While calotypes were at least the right way round, they too were judged colourless and tonally rather dull, as well as thin on details (in the 1970s, the same criticisms were made of the first digital images). Unlike a painting, which could be imprecise, a photograph had to have a clear subject and sufficent light, and had to be processed according to strict methods. All were necessary for a picture to emerge.

A swing of the head
These limitations did not inhibit early photographers from trying to push the boundaries. One of the earliest developments that showed photographers could extend human vision was the panorama. From the late 18th to the mid-19th centuries in Europe, painted views of cities and landscapes presented on the inside of a cylinder or curved wall were a popular attraction in museums. These displays showed more than the eye could see in a single view. You had to turn your head or walk around the painting to take in a panorama. Consisting of multiple images stitched together – a technique still used today – the paintings created coverages all the way up to 360 degrees. The 1792 specialist exhibition *Panorama* of Robert Barker showed such paintings in London, and it coined the name.

Naturally, once photography was invented, the race was on to produce panoramic photographs. As early as 1844, Friedrich von Martens made panoramic views of Paris on his Megaskop. This camera carried a daguerreotype plate curved so that its light-sensitive surface faced inwards. The plate was relatively large at 4¾ × 15in (12cm × 38cm) – and expensive. It faced a lens that swivelled on a gear-cranked mount, which viewed an angle of 150 degrees.

The design was surprisingly elaborate. After reviewing the results of early experiments, von Martens masked the back of the lens with a wedge-shaped slit that was wider at

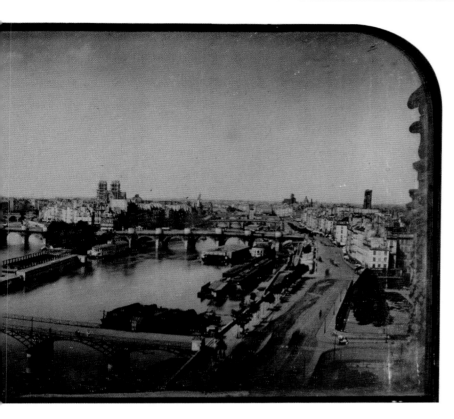

> # The photograph takes the law into its own hands. Psychological insight is not reserved for painters alone and they know it.
>
> **NADAR / 1856**

the top than bottom. This reduced the exposure at the top of the image and increased the exposure at the bottom – where the foreground was. It was the first graduated exposure device.

The Megaskop design of a swinging lens exposing curved film was the template for all other true panorama cameras, superseded only in the late 20th century by digital scanning techniques.

Compact versatility

The small size of the daguerreotype and its ability to hold fine detail anticipated the versatility of the miniature negative. It was easy to attach a camera to instruments such as microscopes or telescopes, which produced a small image circle (calotypes were of limited value because the fibres of the paper negative obscured detail).

However, early photographers had to learn that the image seen in an optical instrument was virtual – it could not be projected onto a surface – so it was not in a form that could be captured on a photograph. For the image to be photographed, it had to have converging rays that could be seen on a surface. Once that technical obstacle was overcome, daguerreotype cameras were attached to all sorts of optical instruments. Astronomers made daguerreotypes of the night skies. Many photographers have

△ PANORAMA OF PARIS

FRIEDRICH VON MARTENS, c.1845

Published as La Seine, la Rive Gauche [*Left Bank*] et l'Île de la Cité, *this image shows a small error in alignment that exaggerates the curvature of the horizon. Von Martens's design enabled him to capture some clouds in the sky while exposing the foreground correctly – a remarkable achievement.*

expected the moon to be a dark object requiring long exposure, but astronomers knew better. The bright face of the moon was as well lit as an overcast day, so exposure times were relatively short and avoided blur from the Earth's rotation. Daguerreotype images of the moon were successful and delivered beautiful results – the first images of space to be seen by the public.

The next challenge was to take photographs from the air – from hot-air balloons – but this was considerably trickier given the instability of the platform. The daguerreotype plates had to be more sensitive than those Daguerre used, to allow for shorter exposures. The use of halides other than silver in the sensitization of the plates improved speeds to the point that Nadar (see right) could make passable images on a calm day.

IN CONTEXT
Images from the air

Using a tethered balloon, Nadar (see pp.60–61) made the first daguerreotype from the air in the late 1850s. By then, exposure time had been reduced to seconds, but it would still have been hard to obtain a sharp image. The first attempt has not survived, which suggests it was not valued. Sam King had better luck in 1860 when he photographed Boston, US, using wet plates. It is hard to believe he prepared eight wet plates while in a balloon. Nadar apparently had another try in 1866 and again in 1868, capturing this fascinating aerial image of Paris.

CARTOON OF NADAR, HONORÉ DAUMIER, 1863

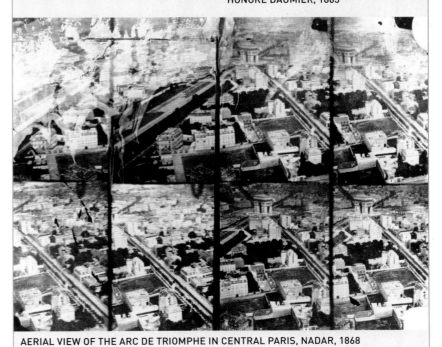

AERIAL VIEW OF THE ARC DE TRIOMPHE IN CENTRAL PARIS, NADAR, 1868

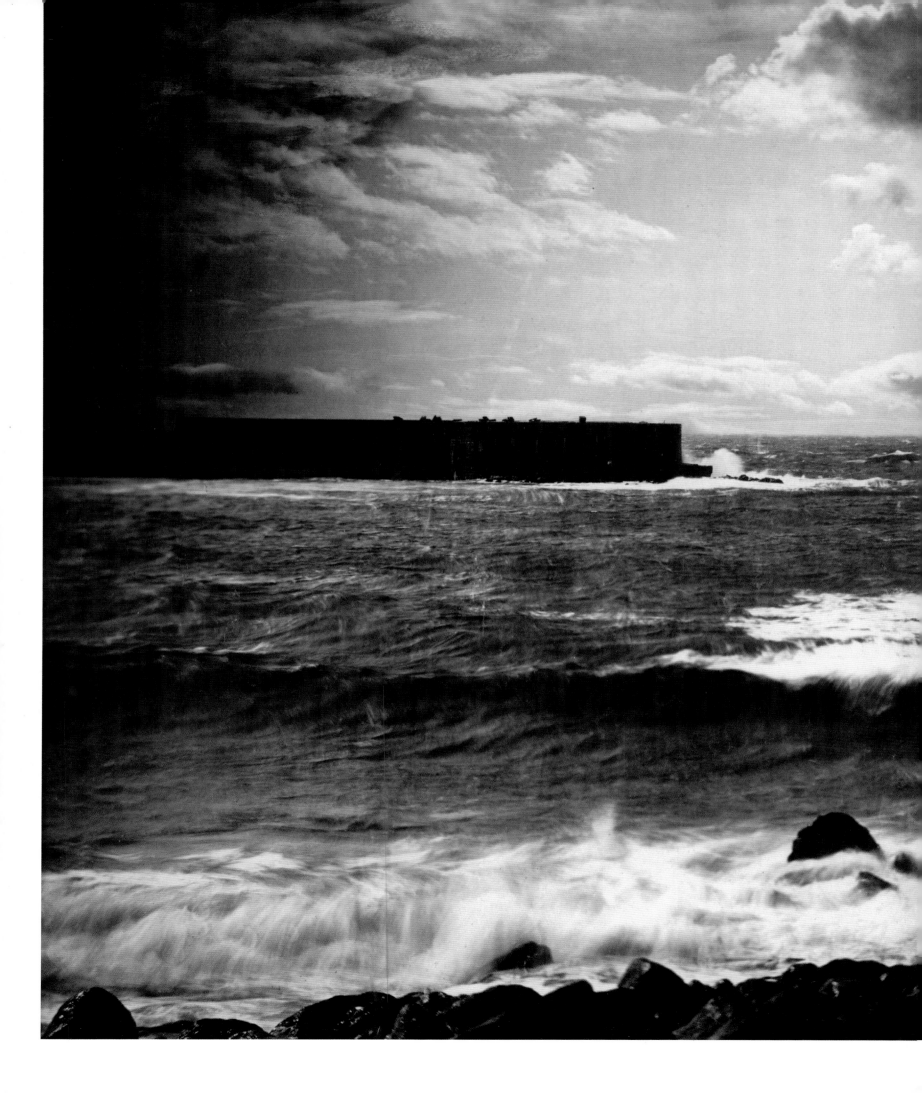

The Great Wave

GUSTAVE LE GRAY / 1856–60

The only son of a haberdasher, Le Gray rose to the first ranks of photography while still in his 20s. Brilliant at portraits, he raised a large loan to set up a lavish studio in 1855, attracting plenty of wealthy clients. He was also a distinguished teacher, writing four works on photography, and he significantly improved on Talbot's calotype process by waxing the paper to gain more transparency.

It is Le Gray's mastery of the seascape that is his greatest legacy. He was the first to solve the technical problem of wet-collodion plates being too sensitive to blue to record both foreground and sky naturalistically on one negative. Le Gray made two negatives and exposed the sea for longer than the sky. He printed both negatives onto the same piece of paper coated with albumen (egg white). Albumen prints have a smooth, glossy surface, and warm, rich tones.

The two negatives for this print, in which light breaks through the clouds and turns the surface of the sea silver, were made at Sète in the South of France. Between 1856 and 1860, Le Gray made a series of seascape prints from combined negatives, sometimes taken at different times and locations, but mostly featuring the Mediterranean at Sète. The resulting swirling mood pieces of heavy skies and agitated seas remain unequalled for their sense of elemental energies. They also occupy the top reaches of auction values, fetching six-figure sums.

NAVIGATOR

1 LEFT-HAND FRAME
Le Gray strongly burnt in (exposed to light) the left-hand side of the image to darken and so enclose the image. This frame leads the viewer's attention towards the central, main part of the image.

2 MIDDLE-GROUND INTEREST
The harbour wall blocks part of the horizon, underlining how the sea stretches into the distance. With good timing, Le Gray caught a wave crashing, adding interest to an otherwise blank section.

3 CLOUD EXPOSURE
Le Gray's negatives were much more sensitive to blue light – as from the sky – than to other colours. He exposed one negative specifically for the clouds.

4 BALANCING THE IMAGE
The shoreline and crashing waves animate and energize the scene in symmetry with the angry skies. A gentle diagonal frames the picture's foreground.

Architectural archives

Official archivists seized on photography. Even though no one yet knew whether or not the images would be permanent, the far-sighted saw its potential for documenting national heritage. France led the way.

Édouard-Denis Baldus
1813–89

Of all the Mission photographers, Baldus was perhaps the most at home with architectural photography. Using large-scale paper negatives with refinements that he had patented, he adopted multiple printing methods to extend tonal range for dramatic views. The areas he covered were the choice ones of Burgundy, the Dauphiné, and the south.

Photographers were recording not only old buildings, but also new ones, including the railways that were being constructed at the time. In 1855, Baldus won a major commission from Baron James de Rothschild to chart the building of the Paris-Boulogne railway. The prints were presented in a red leather album to Queen Victoria of Great Britain.

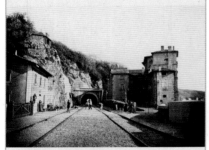

VIENNE, TUNNEL, 1861

If buildings in Europe, many of them centuries old, were to be recorded and preserved, it was now or never. Industry was developing at an unprecedented rate, and alongside it the population was growing. Both were altering the face of the countryside, expanding urban centres, and excising the very hearts of cities. The newly wealthy made their mark by having inconveniently sited ancient buildings torn down, and constructing grandiose new edifices such as the Louvre extensions in Paris.

French initiative
In 1837, France's Commission des Monuments Historiques started cataloguing significant old buildings. Baron Isidore-Séverin-Justin Taylor was the editor of a celebrated series of lithographs of the French countryside. He open-mindedly suggested to Prosper Mérimée, head of the Commission, that daguerreotypes would be a grand way to document its work. But Mérimée disliked daguerreotype images and rejected the idea.

By 1850, a photographic archival project was underway in Belgium, and a year later the calotype made its way to France. Mérimée agreed to integrate photography into the Commission's work. He selected the finest photographers in France for the task – Édouard-Denis Baldus, Hippolyte Bayard, Gustave Le Gray (see pp.40–41), Henri Le Secq, and Auguste Mestral.

Mission to photograph
The project was called Mission Héliographique (literally, sun-writing) after the Société Héliographique the men had founded. Each of them was given a list of buildings to document and sent to all corners of France.

Bayard's patch was west of Paris – Brittany and Normandy. Baldus went south (see top left) and Le Gray and Mestral headed south-west, while Le Secq went north and east. All worked with paper negatives except for Bayard, ever the outlier, who used glass negatives.

On its own terms, the photographic part of the Commission was not a great success, turning in a mere 300 negatives, although some were of outstanding quality. The images were never published in the photographers' lifetimes, although some of the prints were shown at the first annual exhibition put on by the Société Française de Photographie in 1855.

There were positive outcomes. The work set a benchmark for architectural photography well into the 20th century, and some of their images were to prove invaluable aids to restoration work.

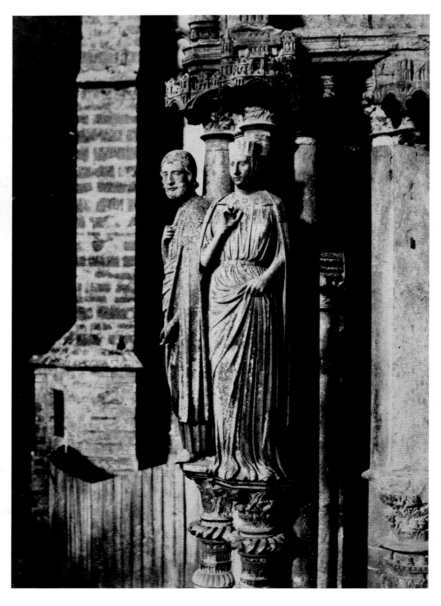

▷ **NORTHERN PORTAL, CHARTRES**

CHARLES MARVILLE, 1853–55

Architectural photographers recorded details, such as these Gothic statues on the medieval Chartres Cathedral, as well as buildings in their entirety. Marville became the official photographer of Paris in 1862.

Amateur contribution

The British, while predisposed to photograph their architectural heritage, were slower to start. Talbot (see pp.26–27) had set the scene by his choice and presentation of architectural images in the *Pencil of Nature* in 1844. But it was not until 1887 – perhaps inspired by Queen Victoria's Golden Jubilee – that Sir Benjamin Stone, a great advocate of systematic photography to create historic records, initiated the Survey movement. This culminated in the National Photographic Record Association (NPRA) of 1897, which encouraged photographers to take pictures of just about anything with a foundation, as well as folk customs.

The NPRA deposited 5,883 photographs at the British Museum between 1897 and 1910; of these 1,532 were by Stone. In the early 2000s, all were transferred to London's Victoria & Albert Museum. The project was one of the first nationwide schemes largely made up of amateur contributions. Instructions called for fidelity, with no artistic interventions or pictorial styles welcome – the sub-text being to discourage professionals.

In common with later projects, such as Mass Observation in England, the Photo League in the US, and the Archaeological Survey of India, the underlying ideology was to create a permanent record of the rapidly disappearing architectural heritage. In Stone's own words, the purpose was "to portray for the benefit of future generations the manners and customs, the festivals and pageants, the historic buildings and places of our time".

IN CONTEXT
Alinari Fratelli

The oldest photography firm in existence was founded in Florence, Italy, in 1852 by Leopoldo Alinari, with his brothers Giuseppe and Romualdo. Specializing in portraiture, views of works of art, and historical monuments, the business continues to thrive today, having survived both world wars and revolutions in photography itself.

Alinari set up a digital archive as early as 2001, with some 330,000 images available online. Its collection numbers more than five million images in total, featuring almost every photographic process known, collected from sources all around the world.

THE UFFIZI, FLORENCE, c.1860

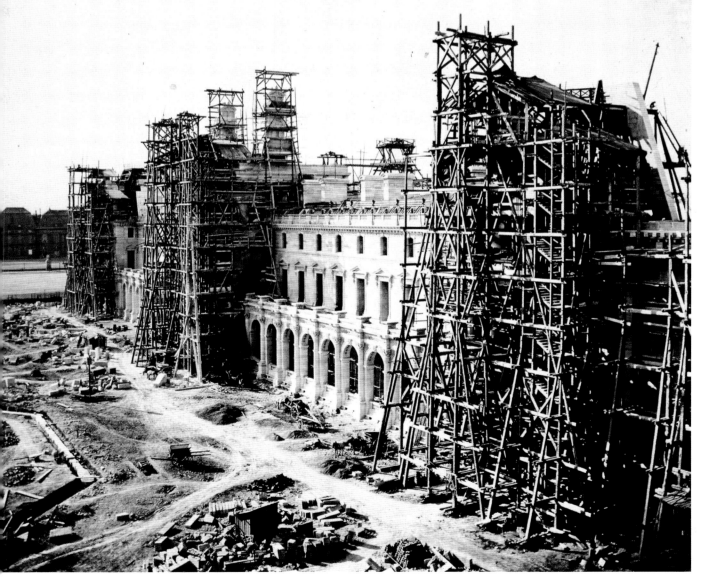

◁ **THE LOUVRE UNDER CONSTRUCTION**

ÉDOUARD-DENIS BALDUS, 1854

After his success with the Mission Héliographique, Baldus was commissioned by the Interior Ministry to photograph large building projects such as the Louvre in Paris. The museum was extended many times on the site of the existing palace, which was first built as a fortress in the late 12th century.

Exploring the world

Published more or less simultaneously in 20 countries across the world, Daguerre's instruction manual of 1839 created great enthusiasm for photography and inspired people to set off on voyages across the oceans.

Francis Frith
1822–98

The work of English photographer Francis Frith added fuel to the popular passion for foreign travel. He went on three trips to Egypt and the Holy Land. Before the first, he bought a steam boat and thousands of pounds' worth of apparatus to keep him going in the desert, out of reach of any supplies. Most of the equipment was either fragile or dangerous – glass plates, chemicals, and lenses. He had to prepare and develop all his photographs on site in sweltering heat, keeping everything free of sand. On his return, he opened a printing studio in Surrey to meet the huge demand for his images of the Near East, still very exotic for the majority.

The landmarks and vistas in Frith's work fired the public imagination. This enthusiasm paved the way for the first tour groups, pioneered by Thomas Cook, who arranged trips to Germany (1855), Switzerland (1863), and Egypt (1869). The wealthy could now see the sights for themselves with relative ease.

Daguerreotype production swept through Europe and the US, and then on to other parts of the world. Photographers reached China shortly after 1839, although the earliest identified daguerreotypes there, by Jules Itier, only date from 1844. Captain Lucas of Sydney took the first picture of Australia as early as 1841, and Helgi Sigurdsson took the technique of daguerreotype production to Iceland in 1846, having learnt photography when he was supposed to be studying medicine in Copenhagen. Press advertisements for daguerreotype equipment were on view in India in 1840, soon after its invention in Europe, and in March that year, Irish physician Dr William Brooke O'Shaughnessy put on the first photography exhibition in India, of views of Calcutta.

In 1842, a wagon pulled by six horses left the Russian Foreign Ministry in Moscow and journeyed to Tehran, Iran, to deliver a daguerreotype outfit – complete with photographer – to Muhammad Shah Qajar, King of Persia, who had requested it. Photography took a little longer to reach Japan. In 1843, Ueno Toshinojo, Nagasaki's official clock-maker, tried to import the necessary equipment, but according to contemporary records it did not arrive until 1848. Peru pipped Japan, welcoming its first photographers in 1847.

Voyagers returned home from distant lands with photographs of cloud-topped mountains and gorgeous palaces, which suggested that untold riches might be gained by funding trading ships to the Orient. Tales of the unknown were a similar lure. They started with the best-selling 13th-century accounts of Marco Polo, in which it was hard to separate fact from wild fiction. Travellers were eager to see the fabulous palaces, temples, and strange peoples and beasts mentioned in these tales for themselves and better still, to capture them on camera.

Egypt beckons
Ever since Napoleon's campaigns in Egypt in 1798, the French had been intrigued by Egypt, the Holy Land, and the Orient. The French writer Maxime Du Camp took the most celebrated early travel photographs. With fellow author Gustave Flaubert, he journeyed through Egypt to Turkey via Palestine and Syria from 1849 to 1851. Using the calotype (paper-negative) process that Du Camp had learnt from Gustave Le Gray (see pp.40–41), the pair surveyed major monuments.

Du Camp had obtained official sponsorship for the work, which represents the first attempt to create a coherent, illustrated survey of a subject. The publication, in 1852, of *Égypte, Nubie, Palestine et Syrie*, an album of 125 salted-paper prints

▷ **INTERIOR HALL OF COLUMNS, KARNAC**

FRANCIS FRITH, c.1857

Pictures of the exotica of Ancient Egypt thrilled the British public. Frith published his work in book form and in stereo cards or prints, which made them look more three-dimensional.

◁ **ABUTTING CORRIDOR AT KHERKHAI SHERIF**

ABDULLAH BROTHERS, c.1869

Architectural views to sell to tourists supplemented the brothers' income from portraits at the Abdullah Studio. The intricate patterns decorating Islamic buildings provided popular subject matter.

▽ **MAIN FACADE OF THE NUNNERY OF CHICHEN ITZA**

DÉSIRÉ CHARNAY, c.1860

Charnay found that the ancient Mayan palaces, decorated with motifs completely different from European ornament, were overgrown with grass and centuries of undergrowth. The French archaeologist was the first to photograph the remains of this lost civilization.

made from Du Camp's 220 negatives, sold out immediately. The album won Du Camp a Légion d'Honneur medal (France's highest honour), arguably more for services to French interests in the Middle East than for his aesthetic contribution to the arts.

Five years later, the archaeologist Auguste Salzmann used photographs to back up Félicien de Saulcy's drawings of ruins, which had been dismissed as too fanciful. Salzmann's photographs concentrated on details, in contrast to the general views favoured at time. The positive reception of Du Camp's and Salzmann's work marked a key moment in visual culture, as it was the first time that the West's view of the Orient had been shaped by photographs.

While the Middle East was geographically near Europe, religion and politics were greater barriers to cross than land and sea. Nonetheless, the Abdullah brothers in Egypt overcame local reservations enough to set up studios in Constantinople,

Cairo, and Alexandria and became court photographers to the Ottoman sultanate in 1862.

The lure of the unknown

A search began for objects of curiosity. The exotic, the eastern, and above all the different – in the form of people, buildings, and artefacts – were to be found in lands far from the salons of Europe. In 1857, for example, the French government commissioned archaeologist Claude-Joseph-Désiré Charnay to go to Mexico. He spent four years there, and was the first to photograph the archaeological sites of the once mighty Mayan civilization. He managed to create wet-plate negatives of ruins in the steamy jungles of the Yucatán, Mexico.

Another Frenchman, Émile Gsell, photographed Indo-China extensively, taking the first pictures of the magnificent temple of Angkor Wat in what is now Cambodia. Travelling photographers spread the art to the locals, and they too began to take

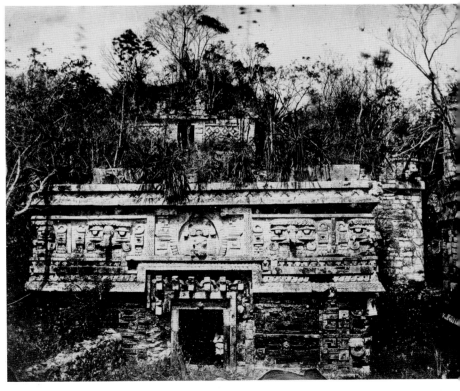

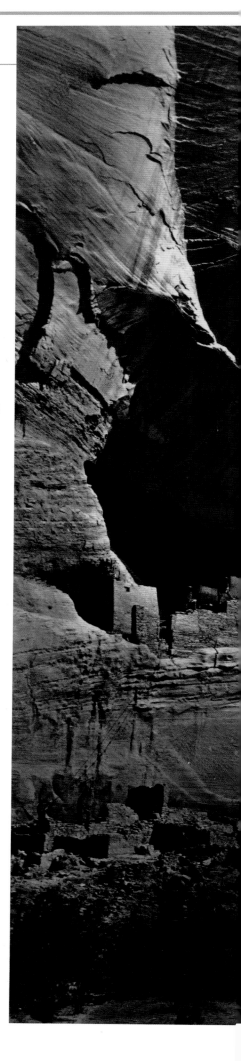

pictures of their national heritage. Not everyone travelled to the four corners of the Earth – landscapes closer to home were also unknown. The Bisson brothers contended with frozen equipment to take photographs of Mont Blanc. The spectacular snowy heights of the mountain staggered the French public.

Wild expansionism in the US

Tales of wonderful sculptural landscapes to be found in the Wild West of America were quick to reach the salons of the East Coast. Descriptions of grandeur in the untamed wilderness conjured up a heady mix of freedom and danger and excited the interest of photographers.

First off the mark were John Charles Frémont and Solomon Carvalho, who came back in 1854 from what are now the states of Kansas, Colorado, and Utah with hundreds of daguerreotypes. The Civil War put a halt to all exploration from 1861 to 1865, but afterwards the United States Geological and Geographic Survey sent teams of photographers and geologists west. Painters also accompanied the surveys, but they had already been demoted. They were not paid, and had to cover their own expenses.

Each summer, William Bell, John K. Hillers (see p.51), William Henry Jackson, Timothy H. O'Sullivan (see p.71), and Carleton E. Watkins, among others, sent back bulk shipments of glass photographic plates, some of which were enormous, to the photography department of the Treasury in Washington.

Many more images never made it back because the difficulties facing these men were huge. The only means of transport through the wilderness were wagons and small boats. O'Sullivan himself almost drowned when he fell out of a boat in the rapids and was washed downriver.

The photographs that did survive were so impressive that they led to the formation of the first national parks in 1864 and 1872. Senator John Conness of California, who put forward the Yosemite Bill of 1864 to protect the area, owned a set of Watkins's prints. These pioneering photographers also provided impetus for the expansion of the railways, pushing the American frontier ever westwards.

The extraordinary beauty and scale of the landscapes depicted in these photographs, never seen in the US before, created a sense of national identity and pride. There is no doubt that the work of Watkins, O'Sullivan, and other adventurous photographers shaped the American consciousness and the nation's landscape photography for a century or more.

▽ **CATHEDRAL ROCKS, YOSEMITE**

CARLETON E. WATKINS, c.1865

In this view – one of many photographs Watkins took of Yosemite Valley – the background rocks dwarf the lakeside trees. Watkins was working for the California Geological Survey, and his equipment, including enough glass for over a hundred negatives, required six mules to carry it.

As specimens of the **photographic art** they are **unequaled.** The views are... indescribably **unique and beautiful.**

THE NEW YORK TIMES, REVIEW OF WATKINS'S YOSEMITE VALLEY PHOTOGRAPHS / 1862

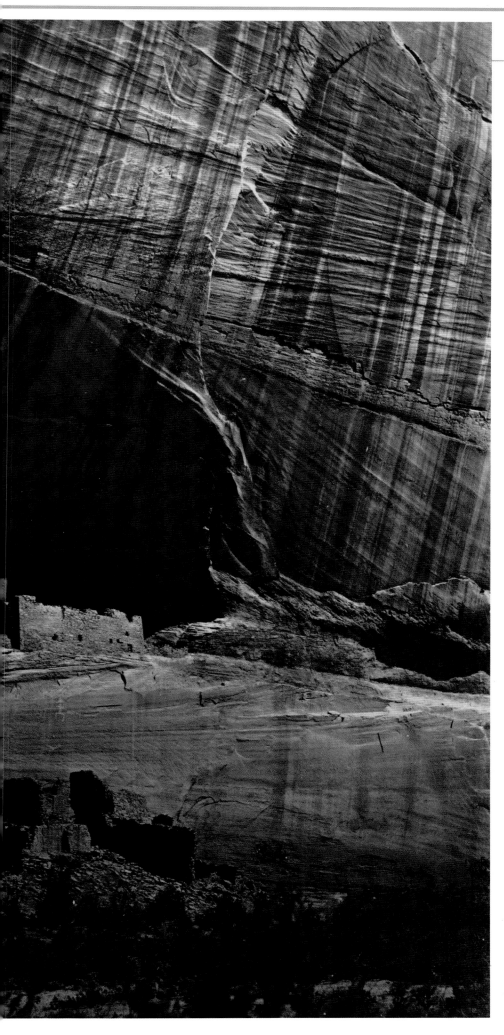

◁ **CANYON DE CHELLY, NEW MEXICO**

TIMOTHY H. O'SULLIVAN, 1873

The surrounding landscape is so dramatic that it is easy to overlook the ruins of an Anasazi Indian pueblo, squatting at the dark, gaping entrance to a cave. The black and white contrast emphasizes the striations in the rock. Its towering height, accentuated by the vertical format, blocks out the sky. The canyon became a national monument in 1931.

ON TECHNIQUE
Mammoth cameras

Daguerreotypes of the Wild West were too small to do justice to the vast views. At this time, prints had to be the same size as negatives. So in 1861, Carleton E. Watkins commissioned a cabinet-maker to create a camera that could take 18 × 22in (46 × 56cm) glass negatives. The skill needed to coat one of those plates evenly with wet collodion was considerable. Watkins's prints of Yosemite amazed the public, and other photographers, including Henry Jackson (right), vied to compete. In 1900, a Mammoth camera was built that could take a vast picture 8 × 4½ft (1.4 × 2.5m) in size.

MAMMOTH PLATE CAMERA

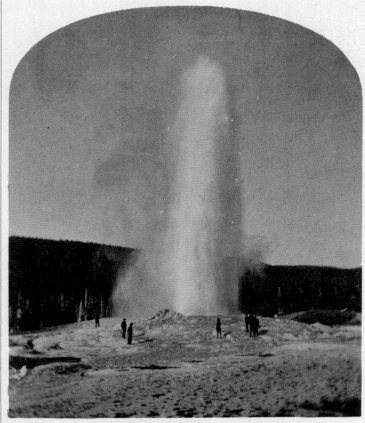

OLD FAITHFUL, WILLIAM HENRY JACKSON, 1870

▷ **AIGUILLES DE CHARMOZ**

AUGUSTE-ROSALIE
BISSON, 1862

*Travel over any distance was
hard in the 19th century, and
the Alps were remote and
extraordinary to most people.
The Bisson brothers needed
25 porters to carry their
equipment, which included a
portable darkroom, over the
mountains. Third time lucky,
they reached the summit of
Mont Blanc. Auguste dared
make only three exposures on
the windswept peak before
starting the dangerous descent,
which involved crossing
crevasses and glaciers.*

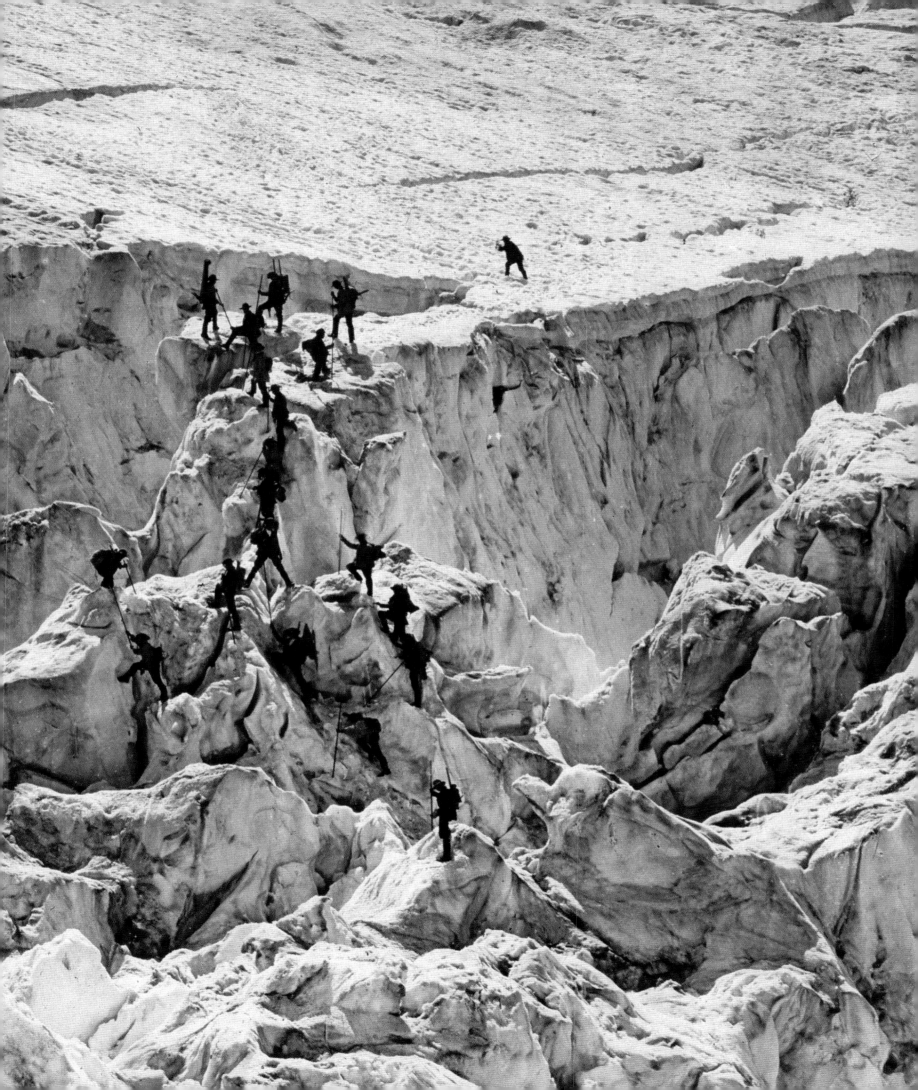

Framing the unknown

It was not just wondrously strange landscapes that were eagerly photographed. People from other lands also came into the frame, regarding the camera with expressions that ranged from suspicious to resigned to defiant.

Kusakabe Kimbei
1841–1943

Probably an assistant to Felice Beato (see pp.52–53), working as a colourist, Kimbei opened his own studio in Yokohama, Japan, in 1881. His clientele were largely expatriates but he also photographed his fellow Japanese (including the Royal Family), using viewpoints and arranging groups in a manner that revealed Beato's influence. In this sense, Kimbei was recording his own people and culture through foreign eyes. His prints were technically skilled and hand-coloured with a great range and delicacy.

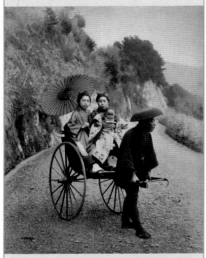

HAND-COLOURED PRINT OF RICKSHAW IN NEGISHI, YOKOHAMA

▷ **ALBANIAN WOMAN: BRIDE FROM SHKODRA**

JOSEF SZÉKELY, 1863

Struggling through remote Albania with his great "photographic machine" and a wagon of plates, this Austrian photographer took the first pictures of the area. Among his photographs of the landscape, settlements, and people, he captured this woman from Scutari in northern Albania dressed in wedding finery.

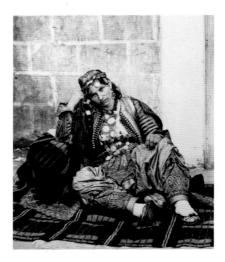

Photography offered the chance to record cultures before they were destroyed, unable to compete in the face of railways, religious conversion, and modernization. Sensitive observers in the 19th century were painfully aware that encroachments through colonizing and the zeal of missionaries, as well as European diseases, were destroying whole civilizations before they could be documented and studied. So photographers and scientists in tandem, tried to make a record of unknown societies – their dress, appearance, and customs – before they vanished.

However, the notion that photography helped to preserve what it documented was at best wishful thinking, certainly when applied to people's ways of life. Some critics today argue that the semblance of preservation is all the more likely to result in destruction. Photographs of the exotic did tend to speed up its disappearance – an issue with which future travel photographers had to come to terms.

On a mission

If missionary work was a spearhead of colonizing influences, photography was vital backup. Used to raise funds and campaign for support, photographs of "primitive peoples" by missionary groups helped to reinforce stereotypes of the noble savage. Photography was also used to impress the natives. William Ellis of the London Missionary Society, for example, learnt wet-plate photography, in order "to gratify those people who will be useful to me". Those who feared that photography might steal their souls may have had a point.

By the late 19th century, Britain alone had sent over 10,000 missionaries worldwide, many of whom used photography. Early photographs of native peoples looked stiffly posed and unnatural. Such awkwardness was imposed not only by the limitations of taking photographs at the time, in particular the low sensitivity of wet-plate negatives and slow lenses, but also by ignorance. Photographers

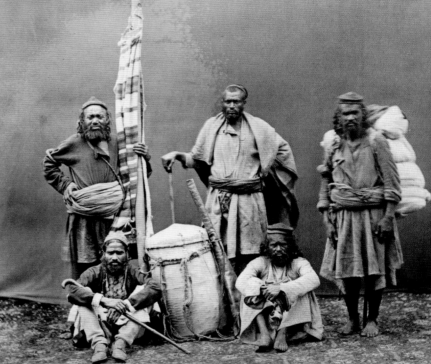

△ **HILL PORTERS**

SAMUEL BOURNE, 1863

A keen British amateur photographer, Bourne gave up his banking career to go professional, and set sail for Calcutta. He spent six years in India, returning to England in 1871 with over 2,000 images of people and places. This portrait was posed in the studio but captures the forbearance of these porters, employed to carry bags and equipment in the Himalayan foothills.

encountering people from different civilizations did not know how to pose their subjects other than as if they had popped into a studio off a Parisian boulevard or London thoroughfare. Significantly, photographers who were more familiar with local people, such as John Thomson in China, and Felice Beato (see pp.52–53) in Japan, posed their subjects in a more natural way. In other instances, subjects were

positioned rigidly in front of grids in order to aid measurement (an idea proposed by John Lamprey in 1868) and to give the impression of scientific objectivity. Some, such as Jean Louis Rodolphe Agazziz, a brilliant Swiss zoologist, used photography to support his creationist theory, which proposed that different types of humans were created by God in distinct provinces, with particular characteristics. This was an attempt to explain the differences between, for example, the Brazilian Indians he had studied and the Caucasian type.

Not all European photographers went so far afield. Austrian Josef Székely accompanied German scholar Johann Georg von Hahn to Albania, Kosova, and Macedonia in 1863 and was the first to document the southern Balkans in pictures.

Indigenous Americans

While the official surveys of the American West minimized coverage of the indigenous peoples who were being displaced by East Coast migrants, photographers such as John Karl Hillers were fascinated by them. He returned to the subject repeatedly for over 20 years.

Born in Hanover, Germany, Hillers moved to the US as a child and was a policeman, then a soldier. He joined John Wesley Powell, a scientist of the Geological Survey, as boatman on the expedition down the Colorado River in 1871. Within a year, he was appointed chief expedition photographer.

Hillers's portraits – posed sympathetically, even heroically – and landscapes totalled an impressive 23,000 photographs. His work was to prove an inspiration to Edward Sheriff Curtis, who photographed indigenous Americans from 1901.

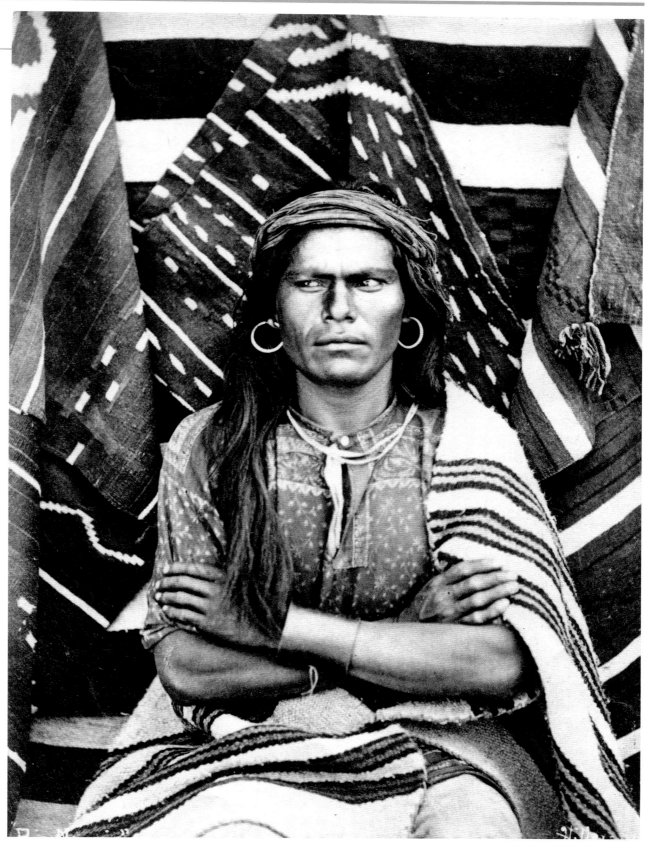

△ **TRIBAL ELDER, ARIZONA**

JOHN K. HILLERS, 1879

With this seated three-quarter-length pose, Hillers conveyed the chieftain's dignity – and his reluctance to look at the camera. Hillers also referenced the importance of woven cloth to the Navajo tribe. Hunter-gatherers turned farmers, the Navajo traded sheep as a form of currency and a status symbol, and they spun and wove the wool into patterned blankets and clothing.

We will never have true civilization until we have learned to **recognize others.**

WILL ROGERS / 1924

Felice Beato

ITALIAN-BRITISH / 1832–1909

One of the greatest ever travel photographers, Felice (or Felix) Beato was such a fast-moving target that historians have had problems keeping up with him. The places of his birth and death were only discovered in 2009, and much of his life is speculation based on the work he left behind.

Born in Venice, Beato gained British citizenship when his family lived in Corfu, at that time a British protectorate. He became a photographer as a young man and opened a studio in Constantinople (now Istanbul). After taking over from Roger Fenton (see p.63) in the Crimea, he went on to India in the 1850s, where he covered the Indian Mutiny of 1857 and joined an Anglo-French army marching to China, becoming one of the first photographers ever to work there. He told the story of China's Second Opium War in photographs (another world first).

A brief interlude in England in 1861 enabled him to raise funds by selling some 400 photographs. He soon set sail and arrived in Yokohama, Japan, in 1863. His coverage of Japan during the isolationist Edo Period is remarkable for its intimate access to Japanese society, which was little known to Westerners at the time. After further journeys to Sudan and Burma, he returned to Europe, ending his days in Florence, Italy.

> There was Signor Beato, who became perhaps **the best known figure in Burma**... He was a man quite **unlike any other**, and Mandalay is different now he is gone.
>
> **HAROLD HALL / 1906**

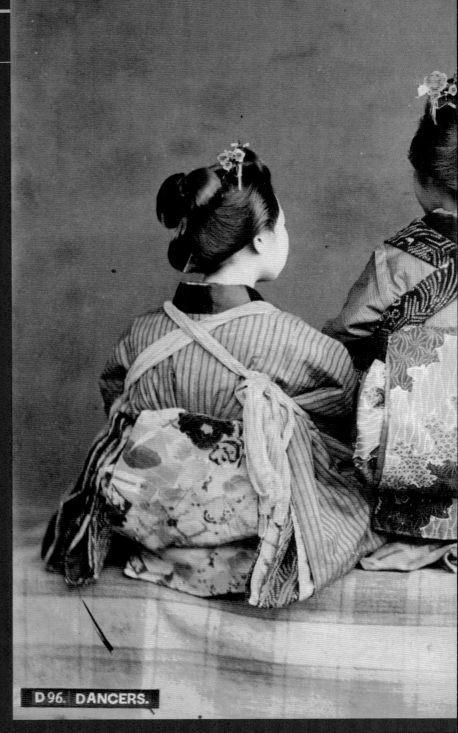

D 96. DANCERS.

▷ **SAMURAI IN ARMOUR**
JAPAN, 1860s

The Samurai were Japan's elite warrior class, although by the 1860s their role had become more administrative, as bureaucrats and courtiers. This man demonstrates his traditional fighting skills with a raised sword.

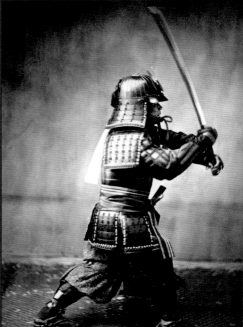

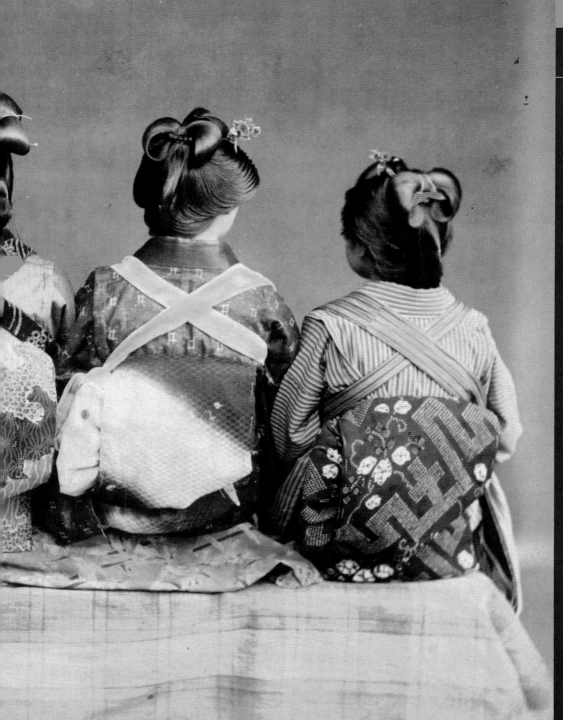

◁ **JAPANESE DANCERS**

JAPAN, c.1875

While the girls' hairstyles are similar, hand-colouring brings out the many different and rich patterns and textures of the textiles.

▽ **AMOY**

CHINA, c.1877

Now called Xiamen, Amoy was the main port for the export of tea in the 19th century. This ancient monument frames an inland view while the shape of the print echoes its symmetry and tiered structure.

◁ **VEGETABLE PEDLAR**

JAPAN, 1882

Beato hand-coloured this photograph, published in Japan by the US Consul-General in Yokohama. The scope of Beato's photography in Japan was vast, providing a unique insight into the lives of ordinary people as well as the elite.

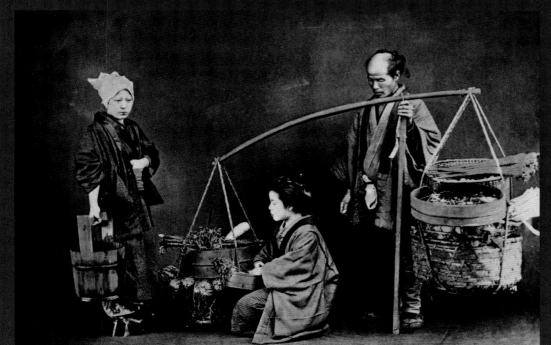

Sumo Training

FELICE BEATO / 1863

Little is known about the character of Felice Beato (see pp.52–53) except for a story about him dancing in glee over the "beautiful" arrangement of bodies on a battlefield. From his work in Japan in the 1860s, however, it is clear that he had excellent interpersonal and persuasive skills, and held his subjects in high regard. Above all, he created his records of "Native Types", as he called an album of photographs of Japanese people, with understanding and knowledge.

Beato's perception is amply shown in his study of sumo wrestlers. The photograph may appear to be awkwardly posed, but is in fact the result of careful planning and probably some protracted negotiations with the people in the picture. For the key figures are not just any wrestlers, but *sumotori* or *sekitori* – wrestlers of the top rank – identifiable by their hair style and coloured silken belts. Proud and exclusive, these men would not have agreed easily to being posed.

Not only did Beato organize these fighters for the session, he also persuaded the referee to pose with his *gunbai*, the wooden paddle used to indicate the winner of each bout. Seated close to the others, for the purposes of the picture, are the *oyakata* (judges), the formal kimono of the man with the fan indicating that he is the head of his own stable of wrestlers.

NAVIGATOR

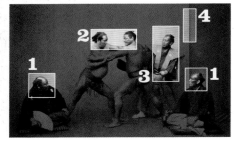

1 AXIS OF GAZE
Beato has created a classic triangular composition with a broad base. The gazes of the men seated on either side of the wrestlers define the sides of the triangle, which leads to the central figures.

2 APEX OF ACTION
The top-rank wrestlers, in fringed aprons, are holding a training pose. This would have had to be approved by the senior master before Beato was allowed to make the exposure.

3 A CLEAR VIEW
The referee, in a fine kimono, is leaning back as if judging some technical detail, which means the view of him is not blocked by the wrestlers. His judging paddle has been positioned so that it can be seen.

4 CLEVER FRAMING
In order to avoid a completely plain background, Beato posed the group near the corner of a room. The change in texture and colour on the right of the image helps to define the profile of the man on the ground.

Cartes de visite

The roots of social media reach back to 1859, when the craze for collecting portraits first gripped fashionable Europe. Ownership of a celebrity likeness granted acquaintance by proxy, while exchanging portrait cards with friends reinforced status and social ties.

△ **NAPOLÉON III**

ANDRÉ-ADOLPHE-EUGÈNE DISDÉRI, 1859

Disdéri put about the tale – probably apocryphal – that Napoléon III, Emperor of France, halted his troops to pop into the studio before leading them out on his Austrian campaign. True or not, Napoléon's victorious return from battles at Magenta and Solferino no doubt fuelled demand for his portrait.

When André-Adolphe-Eugène Disdéri patented a system of making 10 small prints at a time in 1854, he was not the first to think of the idea but the fastest to put it into production. Fellow-Frenchman Louis Dodero had proposed pictures the size of visiting cards in 1851, and an article by Édouard Delessert and Count Olympe Aguado relating their work on card-sized portraits had been published in the weeks before Disdéri's application. Still, the marketing for the idea lacked a spark.

It was only in 1859, when French Emperor Napoléon III posed for a carte de visite (calling card), that the small portraits became a craze in the salons of Paris. Soon anyone who was anyone was distributing cartes de visite; failure to have several on one's person to transact exchanges became a serious faux pas.

In Britain, not to be outdone by Napoléon III, Queen Victoria endorsed the carte de visite. She allowed her royal portrait by Jabez Edwin Mayall to be sold, and commissioned official portraits for distribution. After the Prince Consort died on 14 December 1861, some 70,000 of his portraits were sold in a week. Between 1861 and 1867, over 300 million cartes de visite were sold in England.

Small and collectable

Initially scorned by portrait photographers, the diminutive card consisted of a thin paper print measuring about 9 × 6cm (3½ × 2½in) stuck onto slightly larger thick card. Typically, sitters posed in their finest clothes and with regal demeanour, regardless of their rank in society, with props such as a scholarly desk or book to add gravitas.

The resulting "cartomania" reached high and low. In the US, the first photo albums were produced to hold card collections. People put cards of their nearest and dearest – often soldiers going to war – next to generals and politicians, reinforcing national

[Disdéri] created a veritable fad which... **infatuated the entire world**... by giving **infinitely more for infinitely less.**

NADAR / 1900

sentiment. In Europe, Empress Elizabeth of Austria instructed her diplomats to search out pictures of celebrities and beauties. She collected hundreds of such portraits for her albums. Photographers such as Abraham Bogardus who had laughed at the "little thing" had to ruefully admit to making them "at the rate of thousands a day" to keep up with demand. Nadar, not one to admit defeat lightly, said, "Either you had to succumb... or resign". Like all fads, the craze had its day – by 1867, cartes de visite were "so yesterday" in Paris, giving ground to larger-format cabinet cards, although little cards were still produced into the 1870s.

▷ AFRICAN PRINCESS

CAMILLE SILVY, 1862

Sarah Forbes Bonetta was a West African of royal blood, orphaned in tribal warfare. Captain Forbes of the British Royal Navy rescued and renamed her. Sarah was "given" to Queen Victoria, who raised her as a goddaughter and commissioned royal photographer Camille Silvy to take her portrait. Like all cartes de visite, this one is tiny – just 8.3 × 5.6cm (3¼ × 2¼in).

◁ UNCUT CARTE DE VISITE SHEET

ADOLPHE-EUGÈNE DISDÉRI, c.1860

Measuring a mere 20.1 × 23.7cm (8 × 9¼in), Disdéri's multiple exposure sheets could be of one pose or several. Portrait mania swept all Europe, and Disdéri's clients included, here, the Duc de Coimbre, brother of the king of Portugal.

ON TECHNIQUE
Four eyes

Disdéri's camera, probably made to his design, used four Petzval portrait lenses with a sliding back. He could use a wet-collodion plate to take eight exposures, in two steps. Cartes de visite were feasible because the technical improvements in materials and lenses led to better-quality images, so even small prints retained acceptable levels of detail.

Equally important, smaller sizes allowed multiple prints to be made on a single sheet of paper, and blemishes reduced in size to the point of vanishing, saving retouching costs. Studios set up production lines to produce the albumen paper, dry it, and pass it on to the darkroom workers. They then passed on prints for drying, trimming, and mounting on cards.

DISDÉRI CARTE DE VISITE CAMERA WITH PETZVAL LENSES, c.1860

Seeing double

While few ever complained about the flatness of a painting, photography was so closely linked with seeing that its lack of spatial depth was more obvious. Stereo photography was born in response.

The idea of creating artificial stereo views was first known through English scientist-inventor Charles Wheatstone's work in 1833. Back in the Italian Renaissance, Leonardo da Vinci had understood that the two human eyes see slightly differing views. But it was Wheatsone who first made an invention out of the principle of stereoscopy – seeing in three dimensions.

He realized that two images of a scene can be made from two separate viewpoints which are as far apart as, or a little further apart than, the space between a typical person's eyes. When these images are viewed together so that they overlap, a typical human brain fuses them to create the impression of looking at a scene with depth. Wheatstone took five years to develop his "reflecting mirror

**SLIDING BOX
BINOCULAR STEREOSCOPIC CAMERA**

stereoscope", first demonstrated in 1838. At the ends of horn-like holders, it bore translucent pictures which the spectator viewed via mirrors in the centre, through the two eye holes. It was cumbersome and did not catch on. It was not until Scottish scientist David Brewster (who went on

to invent the kaleidoscope) came up with his Stereoscope in 1849 that stereo photographs could be easily viewed. At first, stereo pairs were made simply by shifting the camera to one side after the first exposure was made. While interest was strong, the big stimulus came when, at the Great Exhibition of 1851 in London, Queen Victoria exclaimed over a variation of Brewster's concept made by French inventor Louis Duboscq.

Improving stereo cameras
In 1853, British engineer Latimer Clark was the first to overcome the awkward sideways movement of the camera by placing the film in a shifting holder. Unfortunately, the camera also had to be shifted. John Spencer suggested using a sliding lens in 1854, but the first

twin-lens design did not appear until Benjamin Dancer showed his 1856 "binocular" camera. This became the template for all future stereo cameras, evident even today in compact digital cameras and accessories for video cameras.

Popular illusions

Although the stereoscopic novelty captured both landscapes and ordinary domestic scenes, many users were quick to see other possibilities. Stereo views of nude women, disingenuously offered as studies for artists, were hugely popular. Had she known, Queen Victoria was likely to have been displeased that her enthusiasm for the technique had led to a thriving industry producing thousands of images of risqué nudity. Many of the pictures were hand-painted to enhance the illusion of real flesh in three dimensions.

The hunger for stereoscopic views extended to every kind of subject matter, from household objects to comic tableaux, and even to dead soldiers, especially during the American Civil War. But the stunning landscapes of the American West and of exotic foreign places were favourite topics. Landscapes were made with the two exposures much further apart than a person's eyes, to enhance the 3D effect.

Three-dimensional legacy

Through the 20th century, interest in 3D photography waxed and waned as new techniques caught the interest of amateurs, then failed to sustain themselves. For example, American photographer William Gruber's Viewmaster of 1938 held seven stereo pairs of small Kodachrome slides in a circular holder, which could be rotated in the viewer. In the 1940s and '50s, before television dominated visual entertainment, Viewmasters could be found in homes throughout the world.

While no photographer appears to have created an oeuvre founded on stereo photography, many were masters of the technique, such as Eadweard Muybridge (see p.78) and American Civil War photographer Timothy H. O'Sullivan. Jacques-Henri Lartigue (see pp.96–97) also used stereo cameras extensively. Some of these photographers' best-known works were originally stereographs.

IN CONTEXT
Depth with a single image

While some worked on improving stereo cameras and viewers, German Wilhelm Rollmann wanted to avoid having two separate images, which often failed to match in contrast or density, spoiling the effect. In 1852, he invented the anaglyph, in which stereo images were coloured and superimposed into a single image. Viewed with filters that separated the correct image for each eye, with one red and one green side, a darkened 3D image could be seen. Rollmann's invention continues in today's 3D cinema, with images separated by polarization instead of colour. A later innovation was the lenticular print, which used two or more lenses. When the eye viewed the image from different angles, it gave a 3D effect.

SET OF ANAGLYPH PICTURES, WITH VIEWING SPECTACLES, c.1900

ANAGLYPH IMAGE

The **mind perceives an object** of three dimensions by means of the **two dissimilar pictures** projected by it on the **two retinae.**

CHARLES WHEATSTONE / 1833

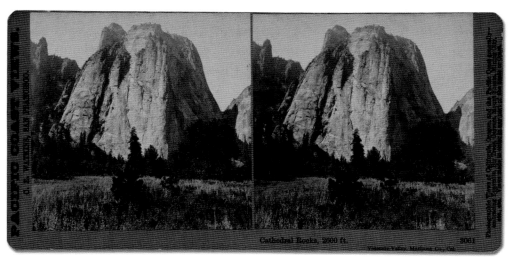

◁ **CATHEDRAL ROCKS**

CARLETON E. WATKINS, c.1870

Watkins often used a stereo camera to make his dramatic Wild West views. Composing the images with fore- and background interest – here a nearby tree and a huge rock in the distance – with a relatively clear middle ground helped increase the sense of depth.

Nadar

FRENCH / 1820–1910

He built a giant balloon that inspired a novel, lampooned the entire French Assembly in an infamous cartoon, wrote plays, and created some of his finest photography while mired in a bitter lawsuit against his brother.

Born Gaspard-Félix Tournachon, Nadar acquired his *nom de guerre* from his reputation as a barbed caricaturist, expressed in French as *tourne à dard* (turn a dart), itself a pun on his name. He was diverted from his cartoons by rescuing his brother's foundering photography studio. Nadar's exuberance, talent for portraiture, and prominent friends quickly established the studio as a most fashionable venue in Paris.

Nadar's photographic style was as spare as his life was full of bohemian bustle. He set his subjects against plain backgrounds with barely any props and used soft available light, exposed on collodion plates printed on salted paper. He favoured sidelit three-quarter poses.

His best-known work centres on a handful of years of miraculous productivity, between 1855 and 1860. This was also the period in which he sued his brother over ownership of the Nadar nickname. In court papers, Nadar explained his approach to portraiture: "the moral intelligence of your subject... puts you in communion with the model, and allows you to render...the intimate resemblance". In 1860, Nadar moved his studio to lavish premises in a more fashionable part of the city, and changed his working practices. He became highly selective and, except for clientele from the top drawer, such as Sarah Bernhardt, portrait sessions were taken by his assistants, or his son Paul.

A **bygone maker of caricatures,** a draftsman... and finally refugee in the **Botany Bay** of photography.

NADAR ON HIMSELF / 1899

▽ **GEORGE SAND**

1860s

The rich textures of the novelist's dress and hair more than compensate for the dearth of props or coquettish charms. Her centre parting forms the top of a pleasing triangle made by her face and her pose as a whole.

△ **SARAH BERNHARDT**

1864

The extraordinary actress was only about 20 when Nadar photographed her – several times – swathed in baroque swirls of fabric that revealed one slender shoulder and focused attention on the compelling but delicate features of her face.

ON TECHNIQUE
Supplementary lighting

Never one to accept the status quo, Nadar railed against the inadequate methods of artificial lighting available. He must have tried miners' lamps, and perhaps also gaslights, which had been invented in 1735. It was not known that silver halide suspensions were sensitive only to blue and ultraviolet light until 1873. This accounts for the purity of skin tones of Nadar's early portraits – photographs did not record blemishes well because these are mostly flesh-coloured.

Nadar's use of supplementary lights to photograph the catacombs underground in Paris, as well as in some portraiture, was pioneering. It was not until the late 1870s that electric lights were first used in the studio, probably by the Russian photographer Count Sergei Levitsky.

CATACOMBS, PARIS, 1862

◁ **CHARLES BAUDELAIRE**

1855

For his friend the poet Charles Baudelaire, Nadar personified "the most astonishing expression of vitality". Nadar made his name with such early portraits, which homed in on the sitter's intense and brooding gaze, devoid of artifice.

△ **PANTHÉON**

LITHOGRAPH, 1850s

Nadar became well known for his Panthéon, a panoramic caricature of contemporary French cultural figures, published twice in the 1850s. For some of the nearly 300 celebrities of the Parisian scene, such as the novelists Honoré de Balzac and Victor Hugo, Nadar used portrait photographs he had already taken.

Reality or painterly?

Photography was a disruptive technology – it challenged people's concepts of art. Early photographers were used to paintings, so it was natural to turn to them for inspiration.

Henry Peach Robinson
1830–1901

A bookseller by trade, and one of Britain's talented painters, by 1857 Robinson was working as a photographer in England. He based his composite prints on tableaux centred around the death of lovely maidens (*Juliet with the Poison Bottle*, *Lady of Shalott*), which soon brought him fame. In 1869, he published the influential *Pictorial Effect in Photography*, which was roundly attacked by Peter Henry Emerson (see p.99). By then, Robinson had been forced to give up darkroom work, having poisoned himself with processing chemicals. He helped found the Brotherhood of the Linked Ring (see p.100) in 1891.

When the French painter Paul Delaroche saw a daguerreotype in 1839 he is said to have let out the pithy wail of despair: "From today painting is dead". But he also wrote to Paris Observatory director François Arago extolling the potential of the new medium.

Such a muddle was not unusual. It was caused in part by photography's sudden eruption onto the arts scene. There was hardly time to adapt, let alone analyse the impact. By the 1850s, however, battle lines were drawn up. The simplistic view (echoed over a century later in photographers' initial reaction to the arrival of digital techniques) was that photography was somehow inferior to art because it was the product of mechanical and chemical processes.

Pecking order

The view that photography could not be counted as art was common among painters. The great French neoclassicist Jean-Auguste-Dominique Ingres and others were happy to use photography as reference for their paintings, but they denied its value as an art. The critic Ernest Lacan's acerbic analogy was that for these artists: "photography is like a mistress... about whom one speaks with joy, but does not want others to mention".

An intermediate view, which satisfied no one, was that photography had its uses but was not the equal of fine art in either craftsmanship or creativity. This view gave grist to the mill of photographers such as Robert Demachy (see pp.102–03), who set out to prove that their work was just as demanding as any other art form. Naturally, there were also advocates for photography's unique qualities, recognizing that it could – and would – contribute to advancing art.

The pro-photography line was best seen in the work of the pictorialists (see pp.98–100). And none other than the influential French Romantic painter Eugène Delacroix enthused that, with the aid of daguerreotypes, an artist might "raise himself to heights that we do not yet know".

Increasing complexity

Britain's Henry Peach Robinson was typical of early photographers, bent on following the model of painting. Instead of simply photographing what was there, he staged his best-known work, *Fading Away*, creating it from several negatives. Robinson's technical control – the image was probably at first a carbon print that was then rephotographed – is impressive, especially as photography was then in its infancy. He had learnt how to make combination prints from Oscar Rejlander (see pp.64–65).

Still lifes

Roger Fenton, who trained in law while dabbling in painting and photography, was nothing if not pragmatic. Working as a photographer for the British Museum from 1854 to 1859, Fenton had honed his skills to a fine pitch. After his stint at the museum, he started on a series of some 40 photographic studies.

His approach to fine-art photography was through still lifes. He produced a composite image – after a fashion – but one created in front of the camera and with rather

△ **FADING AWAY**

HENRY PEACH ROBINSON, 1858

Deathbed scenes were common in art as in life, but this photograph was posed. Robinson combined five negatives to make the final image. The separate exposures kept all the details sharp, and the women are lit from several directions at once, as in a Pre-Raphaelite painting. The man at the window is just as clear as the figures in the foreground.

less trouble than Henry Peach Robinson went to. Intending to prove photography's artistic credentials by joining its realism with his fruit-arranging skills, Fenton cheekily chose the very same fruits as painters, and set up similar designs. Nonetheless, his series of fruit, drapes, and tableware props are remarkable for their succulent luxury. They seem to radiate a timeless opulence.

> Photography would have been **settled a fine art** long ago if we had not... **gone so much into detail.**

HENRY PEACH ROBINSON / 1896

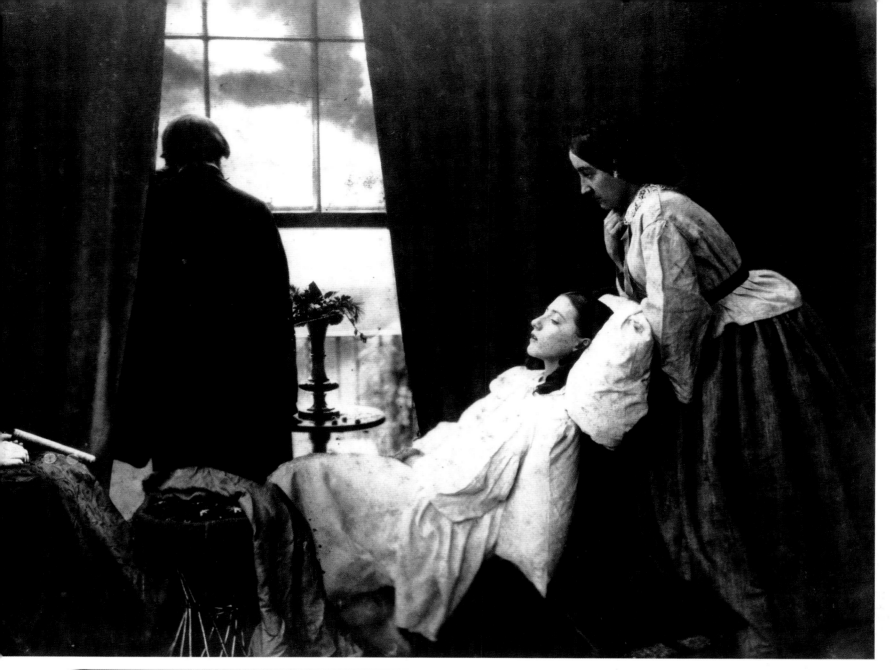

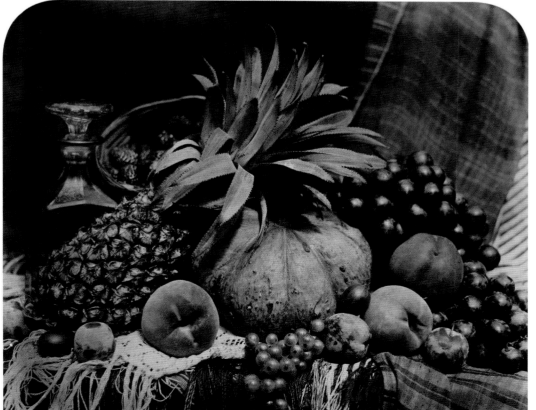

◁ **STILL LIFE OF FRUIT**

ROGER FENTON, 1860

Fenton's still lifes were clearly modelled on contemporary paintings such as those of William Henry Hunt (above). Hunt himself was harking back to the realistic and sharply detailed still lifes in vogue in the Netherlands in the 17th century. The darkness of some fruit, such as the pineapple and peach, is due to the silver salts in Fenton's negatives not being able to register red or yellow light.

Two Ways of Life

OSCAR GUSTAV REJLANDER / 1857

This picture is an allegory of the choice between virtue and vice, with a bearded sage leading two young men onto the stage of life. Meticulously planned, Rejlander – a Swede based in London – photographed each model and background separately. The final combination print measured an impressive 31 × 16in (79 × 41cm) at a time when few were larger than 10 × 8in (25 × 20cm). It was probably based on Thomas Couture's conventionally noble painting *Romans in the Decadence of the Empire* (1847), which it closely resembles. There are also references to William Hogarth's *Rake's Progress* (1733).

By using these direct references, and showing nudes in photographs for the first time, Rejlander was openly courting controversy. The photographic presentation of a moral tale with fine-art pedigree threw a challenge to those who rejected photography's claim to parity with painting.

Just about every aspect of the image – from its use of nudes (most viewers knew they were looking at prostitutes) to its composite techniques and its moralistic subject matter – was a point of hot debate. It was first shown in 1857 at the Manchester Art Treasures Exhibition. One visitor was Queen Victoria, who liked it so much she bought a print for the Prince Consort. Astutely, the Queen bought a cheap copy – only 10 guineas – instead of the original, which must have disappointed Rejlander. But clashes of contrast evident in the original were evened out in copies.

Rejlander had made a carbon print, which was a transfer process: parts of images from 32 negatives were separately applied to the main print. Technically then, *Two Ways of Life* was a collage. Although much easier than other printing methods, it still took Rejlander six weeks to produce, not counting the time taken to plan and shoot the initial 32 negatives.

NAVIGATOR

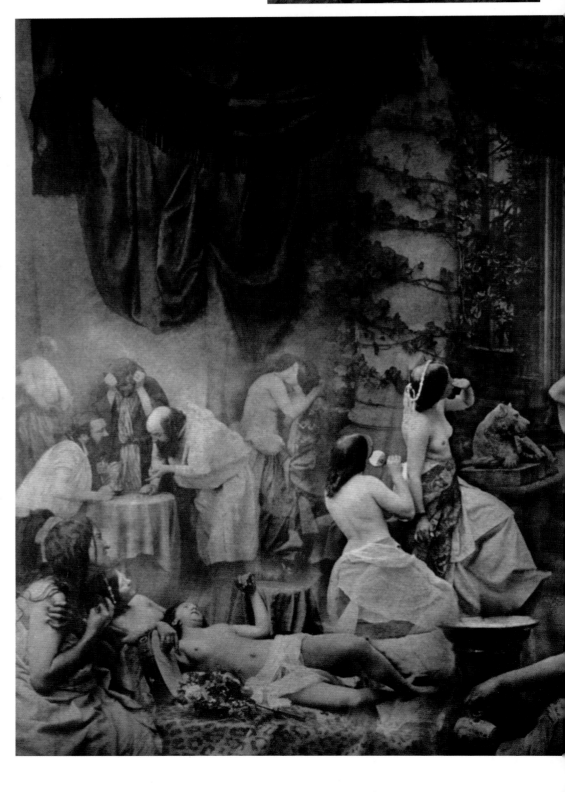

1 THREE CENTRAL FIGURES

A father figure or sage leads two young men from the Eden behind to show them the two ways of life they can choose between. To the left – their right – is the route of sin with all its allure. To their left is the pious road of service and prayer. The right-hand path is usually the virtuous one; the reversal here can only be deliberate.

2 VINE-COVERED PILLAR

The covered pillar marks the region of sin with a liberal scattering of nude females, probably including Mary Bull, one of Rejlander's regular models who became his wife. Rejlander carefully reduced the contrast of the more distant figures to be consistent with their smaller scale.

3 MIRROR IMAGE

Rejlander freely reversed images to suit his purpose – in one of the negatives the figure under a veil turns to the left. He also changed his mind about a prop in the original and appears to have retouched it out when he made the carbon transfer print.

4 THEATRICAL CURTAINS

Heavy drapes were used in part to signify the theatrical and allegorical nature of the work. They also help to fill out the print and give it height. Added without the same care taken with the rest of the image, the two central curtains are identical and the overall effect is unnecessarily dark and heavy.

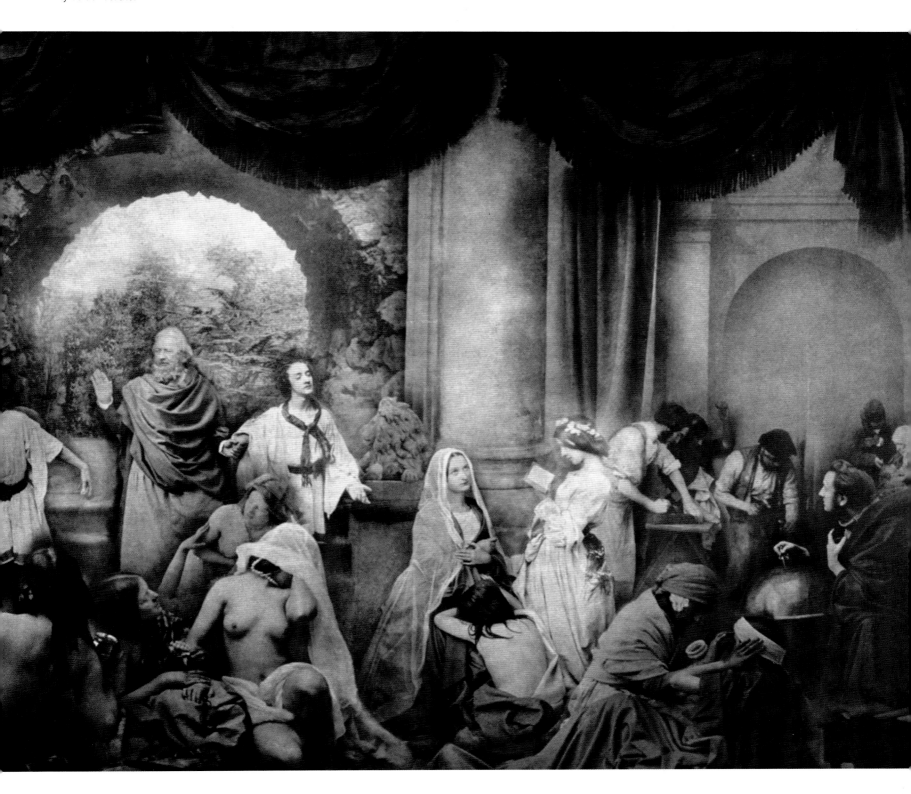

Julia Margaret Cameron

ENGLISH / 1815–79

Proof, if any were needed, that it is never too late to start, Julia Margaret Cameron received a camera for her 48th birthday. Her recently married daughter thought "it may amuse" her. Far from a mere toy, it was, as Cameron recalled, "tender ardour" at first sight, and sparked a frenzy of sublime portraiture that has never been equalled.

"I began with no knowledge of the art", she admitted, but not only was she indefatigable in acquiring expertise, her neighbours were also magnificent subjects. Numbering luminaries such as Charles Darwin and Thomas Carlyle, as well as the literary giants Alfred Tennyson and Robert Browning, her circle of portrait subjects was charmed. Nonetheless, her strong individuality is the most remarkable feature of her work as a photographer. She knew what she wanted, visualizing her results exactly: gently lit soft focus with limited depth of field, with long-held poses to imbue a spiritual intensity of expression. One sitter complained about breaking down after holding a pose for five minutes.

Cameron used wet-collodion glass negatives, up to 15 × 12in (38 × 30.5cm) in size. She did not hold back from manipulating the negative when printing to albumen paper. Largely self-taught, she was distraught when she found some of her negatives peeling apart because of improper processing.

Her work was dismissed with condescension by other professionals (all now forgotten). She had modest success, gaining an agent with London print dealers Colnaghi, selling prints to the Victoria & Albert Museum, and landing a publication contract.

What is **focus** and who has the right to say what focus is **the legitimate focus?**

JULIA MARGARET CAMERON / 1864

▽ **THE ROSEBUD GARDEN OF GIRLS**

1860s

Recognizable for her soft focus, Cameron came upon her technique by fluke. She wrote: "When focusing and coming to something which, to my eye, was very beautiful, I stopped there instead of screwing on the lens to the more definite focus which all other photographers insist upon".

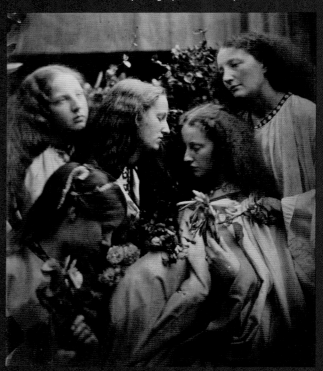

▷ **ALFRED, LORD TENNYSON**

1865

Cameron persuaded the Poet Laureate Alfred Tennyson to pose as a "Dirty Monk", as she captioned the print. She was fortunate in having neighbours who were both illustrious and compliant.

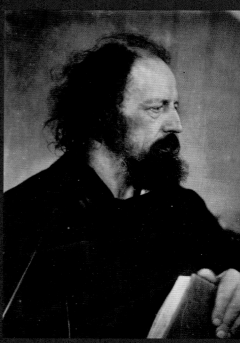

◁ PAUL AND VIRGINIA

1864

Cameron based this allegorical portrait on a French novel, Paul et Virginie, which was popular at the time. In it, the young pair live in Mauritius in equality and harmony, two qualities in short supply when it was written on the eve of the French Revolution.

▽ MY NIECE JULIA

1867

Cameron described this as "my favourite picture". Her niece Julia Jackson was to become the mother of writer Virginia Woolf and artist Vanessa Bell.

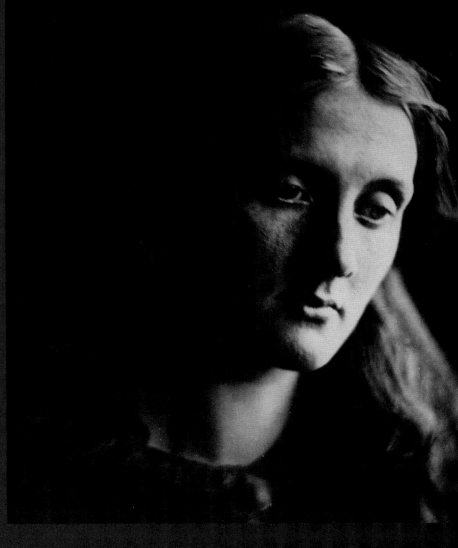

◁ MY GRANDCHILD

1865

Young Archie, aged two, was the son of Cameron's eldest son. Cameron often used him as a model for the infant Jesus in biblical tableaux.

Photographing children

While older children would often oblige by posing for photographs, babies and toddlers were a different matter. Photographers resorted to some curious, even dangerous, methods of keeping them still.

In the very first years of photography, even adults were barely able to sit still long enough for a satisfactory image – which took about five minutes on a cloudy day. There was no hope that children could be photographed successfully. Any images of children before the 1860s are likely to be postmortem (see below).

For studio portraitists, not being able to photograph children cut out a substantial slice of potential business. They wanted faster portrait lenses, such as the Petzval design (see p.28), not just to meet technical needs but also to increase sales.

Women photographers

It was recognized that the tact, diplomacy, and patience required in portraiture were often best offered by women photographers. Women also made excellent stylists. They were far better able to advise their clients on hair styles and accessories than their male colleagues – and women could arrange clothing, a task forbidden to men for reasons of propriety.

Few professions of mid-19th century Europe welcomed women, but prejudice against female photographers had not had time to develop. Indeed, a male commentator magnanimously allowed that the profession of photography, "is one in which there is no sexual hostility to their employment". According to British census returns, the number of female photographers rose from one woman for every 14 men in 1861 to one woman for every six men 10 years later. By 1901, one in three photographers was female in the UK.

Soothing the baby

Even women photographers needed help to constrain babies. The head restraints and tasteful columns that helped grown-ups to hold themselves still for several minutes were of no use with babies. Drugs of various potencies were favourite alternatives. Methods ranged from gassing with

chloroform to administering a tincture of laudanum – an alcoholic extract of about 10 per cent opium by weight. Little wonder that the subjects so treated were reported to "become most delightfully tractable".

Some photographers preferred safer strategies. One trick was to cover the infant's fingers in treacle then dip them in feathers. Picking off the feathers occupied the baby and kept it still for the exposure. A photographer called Davis may have invented the "watch the birdy" antic. He trained a canary to start singing just when he removed the lens cap to make the

exposure. Another photographer trained a monkey to make an exposure. Both tactics were designed to make the sitter forget all about the process of photography, which for many – adults as well as children – was an ordeal to be endured for as short a time as possible.

The best advice – even now – for photographing children was published in a pamphlet by the Rockwood studio of New York in 1874. It advised, "With your child bring plenty of patience, and we will endeavour to exercise a becoming degree of that grace".

▷ **ISABELLA AND CLEMENTINA HAWARDEN**
LADY HAWARDEN, 1863

A pioneering amateur photographer, Lady Hawarden used her daughters as models for a series of costumed tableaux staged in their home in London. She left more than 800 photographs, most featuring her family and servants.

▽ **HIDDEN MOTHER**
UNKNOWN

When a baby or toddler was the main or sole subject of a photograph, it was necessary to conceal the mother yet allow her to hold and reassure the child. The solution – with somewhat bizarre results – was to drape the mother in dark cloth, as if part of the backdrop, or cunningly disguise her as an armchair.

IN CONTEXT
Preserving memories

With the advent of photography, grieving parents could readily obtain keepsakes of children who did not survive infancy or childhood. In the second half of the 19th century, as many as one in five infants failed to reach their first birthday. In the US in particular, postmortem daguerreotypes were common. The approach was often deceptive – the baby was posed with its mother as if fast asleep – or, as here, the child was placed in a coffin and nestled among flowers and finery.

PORTRAIT, c.1860

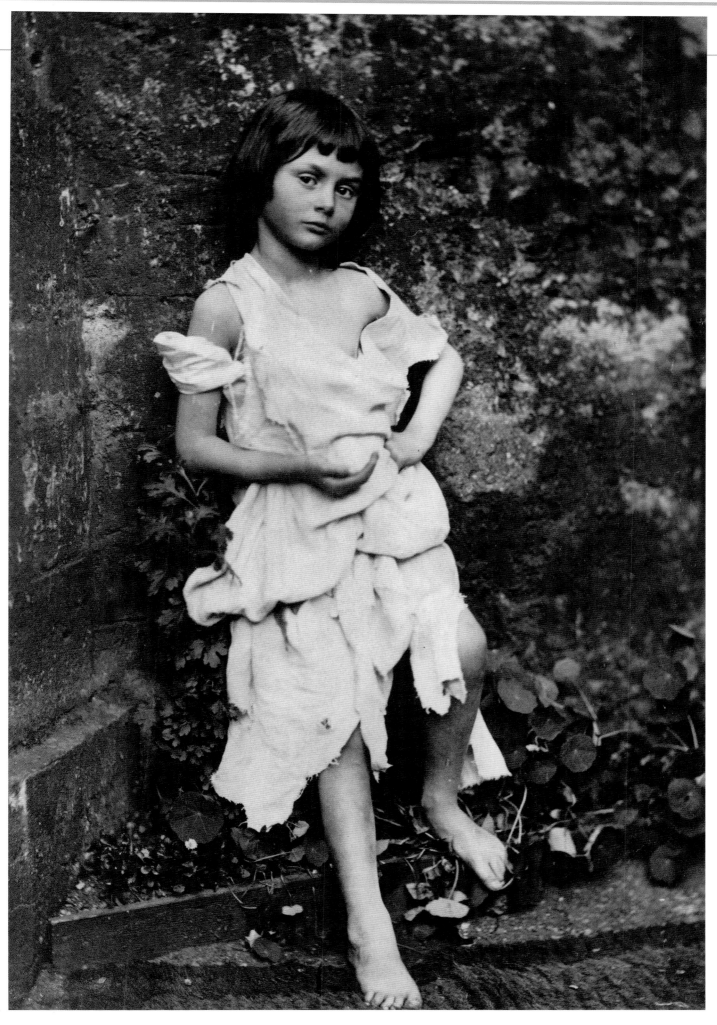

◁ **THE BEGGAR MAID**

LEWIS CARROLL, 1858

Author Lewis Carroll had enough of a rapport with children to cajole them into staying still long enough for him to photograph them. The six-year-old model is Alice Liddell, for whom he wrote Alice's Adventures in Wonderland.

War souvenirs

When a war proved unpopular, the decision to dispatch a photographer was reached more readily than resolutions to send nurses. Photographers could be selective in what they shot and frame out unpalatable truths.

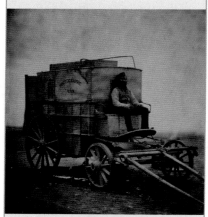

FENTON'S PORTABLE DARKROOM WAGON

The Crimean War (1853–56) was a baptism of fire for photographers. Despite the physical limitations of technique, early photographers encountered the same key issues that have subsequently dogged all conflict reportage. By the time British photographer Roger Fenton was sent to Crimea, the war was unpopular because of reports of the terrible suffering of the soldiers and incompetence of the officers.

No one knows how Prince Albert and Henry Pelham-Clinton, the British Secretary of State for War, briefed Fenton. But when he returned from a short trip to Crimea – from March to June 1855 – he delivered reams of pictures of soldiers posed so casually that they might all have been at training camp.

Crimean casualties

The physical difficulties of photography at that time cannot be underestimated. Working with the wet-collodion process, Fenton had to coat his plates with collodion (helped by his assistant Marcus Sparling), then use them within 15 minutes, while they were damp and sticky – and the plates dried quickly in the heat.

The absence of dead or even wounded soldiers and few images of destruction make Fenton's coverage unashamedly one-sided. By no means a documentation of the war, Fenton bequeathed instead the first lesson in war propaganda by a photographer. That he exercised self-censorship is evident from the work of James

Robertson and Felice Beato (see pp.52–55). They arrived just weeks after Fenton had left and showed everything he had failed to: death, the wounded, destruction, and hardship.

Fenton also made landscape views, which led to the best known image of the Crimea series. Entitled *Valley of the Shadow of Death* for his London exhibition, it referred to the valley in which the Charge of the Light Brigade – a frontal assault by British cavalry against overwhelming Russian forces – took place. It was not in fact the location of the charge, which occurred in a wide valley some miles away.

Versatile tool of war

The American Civil War (1861–65) was the next major conflict to come under the camera's scrutiny. Sprung from the frivolity of portraits and landscapes, photography was put to many uses during the war. Besides

> **I had to go.** A spirit in my feet said **"Go"** and I went.
>
> MATTHEW BRADY / 1891

being used as propaganda by both sides, photographs were taken to promote the abolition of slavery, to look for spies, for military reconnaissance, and to create the public persona of Abraham Lincoln. But photography was most famous for bringing the grim and unglamorous realities of the battlefield into the living room.

Matthew Brady, who ran a portrait studio in Washington, was quick to spot business opportunities offered by the war. Noticing a brisk trade in cartes de visite (see pp.56–57) of young soldiers about to leave home, he encouraged the trend with a press advertisement that had the unconscionable tag line: "You cannot tell how soon it may be too late".

Brady also saw more – a market for full coverage of the Civil War. With permission from President Lincoln himself (but no patronage), Brady gathered a team of 23 photographers, including Alexander Gardner and Timothy H. O'Sullivan (see pp.46–47). He paid them and equipped them with portable darkrooms to cover every major battle and aspect of the war.

The photographers undertook great risks for their pictures. Fortunately, they were regarded as neutral observers and even when captured by Confederate troops, they were released unharmed. By the end of the war, they had delivered thousands of images.

Brady, sadly, became the victim of his own success. Tired of an agonizing war, the last thing people wanted were more reminders. All his attempts to sell books or prints of the war failed and he died destitute. By then, he had gifted to the world a personally funded documentation of the war that, despite its faults, is justly celebrated as the birth of photojournalism.

IN CONTEXT
Death's deception

In October 1862, Matthew Brady held an exhibition in his New York gallery called *The Dead of Antietam*. It was the first public showing of photographs of the dead, taken after the Battle of Antietam, and it was shocking. Some of the images had been created by moving dead soldiers around to intensify the emotional impact and adding props such as rifles (these were the first items to be stolen by battlefield scavengers).

Alexander Gardner's Gettysburg picture (right) was an example of this controversial staging. Gardner shifted the corpse so that its head faced the camera and added the rifle himself.

HOME OF A REBEL SHARPSHOOTER,
ALEXANDER GARDNER, 1863

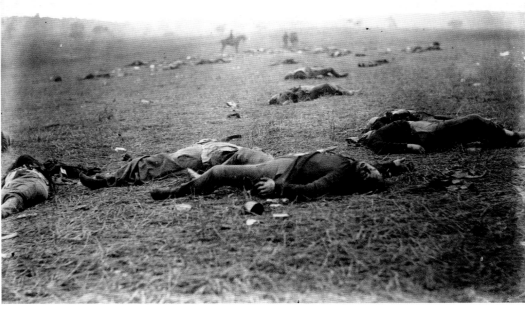

◁ **VALLEY OF THE SHADOW OF DEATH**

ROGER FENTON, 1855

The supposed scene of the Charge of the Light Brigade exists in two versions. This one shows the ground littered with cannonballs. The other is relatively clear of balls. The precise duplication of viewpoint suggests they were made on the same occasion, one after another. But it is not clear which came first – whether Fenton cleared or added the cannonballs.

△ **HARVEST OF THE DEAD**

TIMOTHY H. O'SULLIVAN, 1863

The dead awaiting burial after the Battle of Gettysburg is a famous Civil War scene. O'Sullivan served as a field operator for Alexander Gardner, who published and captioned the photograph: "It was, indeed, a 'harvest of death'... Such a picture conveys a useful moral: It shows the blank horror and reality of war, in opposition to its pageantry. Here are the dreadful details! Let them aid in preventing such another calamity falling upon the nation".

Dry plate

A busy doctor, Maddox bought his first lens in 1846, but his medical duties prevented him from using it until 1852. He was an early practitioner of photomicrography, and used wet collodion to produce high-quality 7 × 5in lantern slides direct from his microscope, some enlarged 838 times. Maddox also created stereoscopic views of diatoms (single-celled algae) – an astonishing achievement for the time – which he published in a book on microscopy in 1865. Being a doctor, he recognised the need for a safer alternative to the wet-collodion process, and in 1871, he suggested replacing harmful chemicals with a gelatine emulsion - a proposal that changed photography forever.

That a process as inconvenient as wet collodion was widely accepted from the 1850s to the 1880s is a tribute to the tenacity and dedication of early photographers. Dry plates were a big step forward in convenience.

The wet-collodion process, invented with working chemicals by Frederick Scott Archer in 1851, delivered exquisite, tonally rich results, but it had its drawbacks. It was sensitive only to blue light, and it had to be exposed within 10 minutes of being made. Although inventors tried to improve the process, they made little progress for 20 years. The invention of the dry plate changed the whole process by bringing together two ideas. Firstly, the light-sensitive silver salts could be carried directly on the photographic plate – previous methods made the plate sensitive only after the initial coating. The second idea was to use gelatin – a protein made from boiling animal bones and connective tissue – to carry the silver salts. Richard Leach Maddox (see left) was the first to propose its use, in 1871, and gelatin was ideally suited to the job. It absorbs water, allowing solutions to saturate it, and traps halogen ions released during exposure to help improve sensitivity. It was later discovered that trace amounts of chemicals in the gelatin improve the responsiveness of silver salts to light. Just as vital for its wide adoption, dry plates could also be mass-produced. By 1873, ready-made emulsion was available in London, and by 1878, dry plates could be ordered. Although they were more convenient and sensitive to light than wet-collodion plates, the tone was inferior. Many photographers used

GEORGE EASTMAN'S DRY PLATES, c.1888

▷ **TROPICAL DRY-PLATE KIT**

HEINRICH HOFFMAN, c.1940s

This plate camera, crafted from tropical hardwood and brass, originally belonged to the German photographer Heinrich Hoffmann (see pp.190–91), and later became a gift to his protégé, Eva Braun.

Large-format lens by Meyer Goerlitz Trioplan

Sliding back

both methods according to the subject or task in hand, but by the mid-1880s, dry plates had replaced wet collodion.

For the next 120 years, therefore, the principal material used in photography was boiled animal parts – rabbits' ears were said to produce particularly superior gelatin. Glass was the next to be replaced, when the Reverend Hannibal Godwin invented cellulose nitrate film in 1887. George Eastman took the idea further to produce his roll films from 1888.

◁ **BOY POLISHING BOOTS**

GEORGE DAVISON, c.1885

Dry plates coated with gelatin were widespread by the mid-1880s, and Davison experimented with them to create the painterly effects he wanted. While details of the wicker basket, gate, and background wall are clear, the boy's face is gently blurred in soft focus. Highlights on the boots attest to his thorough work.

IN CONTEXT
Faster film

Once chemists grasped the advantages of gelatin, they experimented to make it more consistent and durable, and to improve the sensitivity of the silver salts. They also added dyes to extend the sensitivity to all visible wavelengths. By the 1930s, manufacturers could make multiple coatings, which further improved sensitivity and reduced grain sizes to produce high-definition films. Films were made in a wide range – over 70 formats for stills photography are known, some imperial and some metric, ranging in size from 11 × 14in to 8 × 11mm. For a century from the 1890s, roll film was the most widely used form of film.

ILFORD PRINTING PAPER IN DIFFERENT FORMATS

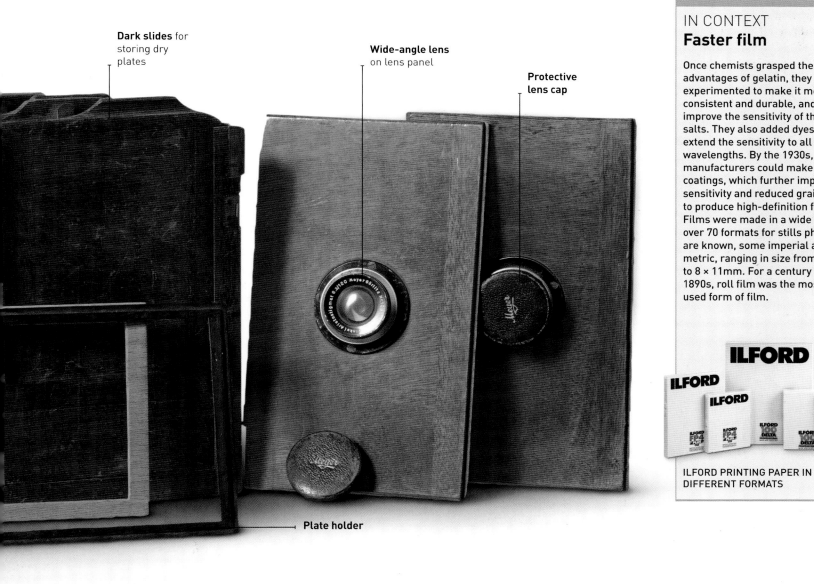

Dark slides for storing dry plates

Wide-angle lens on lens panel

Protective lens cap

Plate holder

30%

ART OR
SCIENCE?

As photographic materials improved and techniques became easier thanks to developments in technology, scientists were quick to exploit photography's potential for creating reliable visual records instantly. A photograph was perfect for recording the results of experiments or capturing people's transient expressions – anything, in fact, that had previously required lengthy written description could be recorded in a second. Photographers also extended their range to reveal things that had not been seen before, such as rays invisible to the human eye, and to capture images of rapid movement – facial tics, the wingbeats of birds, the sequence of a horse's gait – that had previously been impossible to depict with any reliability.

While enjoying a new-found confidence in their usefulness, however, photographers still had to establish their own cultural identity. This was the age of the amateur. Wealthy, leisured photographers who could pursue their dreams were the force behind creative evolution. It was they who could afford to

experiment and push the artistic boundaries. Amateurs set a torch to established practices to promote pictorialism – photography that resembled paintings. By forcing a marriage between photography and art, they sought to redefine art, although it was not until the 1970s that the idea that art is not defined by its medium finally gained currency. Professional photographers, meanwhile had settled into an uneasy stand-off with art and had drawn up canons of practice that defined their spheres of influence.

No sooner had photographers won some battles with classicism and the fine-art establishment, however, than roll film and cheap, mass-produced small cameras were invented in the late 19th century. Almost overnight, photography became demotic, creating a population explosion of a new kind of amateur who did not need a darkroom in order to make photographs. These amateurs were responsible for creating the new *bête noire* of photography – the snapshot.

Picturing motion

Of its many sleights of hand, photography's depiction of movement is the most obviously contradictory. Moving action has to be stopped dead in its tracks before it can be examined in a print – it is visual vivisection.

Eadweard Muybridge
1830–1904

Born near London, Muybridge emigrated to the US in the 1850s. He produced photographs of the American West for the US Geological Survey (see pp.46–47), including panoramas of the Yosemite valley and pictures showing the rapid growth of the nation, especially the city of San Francisco. Styling himself in many ways, including "Helios" (the Sun), Muybridge was a showman and larger-than-life character. In 1874, he murdered his young wife's lover but successfully claimed the lesser charge of justifiable homicide.

The murder trial interrupted his photographic studies of horses but, after an interlude in Central America, he resumed work in the US for Leland Stanford in 1877. To the end, he was tireless in publicizing his work on locomotion.

There are three ways to capture movement in photographs. Early photographers were all too familiar with the first – action was implied by a blur caused by either the subject or the camera, or both, moving during exposure. At the time, this record of motion was not seen as a virtue but as a grave defect. Photography's early technical development was almost entirely devoted to inventing ways – devices to help sitters hold their poses, faster emulsions, faster lenses – to *avoid* motion blur.

Only much later did photographers, such as Italian brothers Anton Giulio and Arturo Bragaglia in 1911 and Ernst Haas (see pp.290–91) in the 1950s, appreciate that motion blur was one of photography's truly innovative contributions to art. The second approach is to "stop" or "freeze" the movement by using an extremely short exposure, so any movement made during exposure does not show up as a blur or lose sharpness. The best-known early proponent of this approach was Eadweard Muybridge, who showed how to dissect a smoothly flowing action into distinctly separated steps, reversing the modern technique of "stop motion".

The original commission from Leland Stanford (ex-Governor of California) in 1872 was to settle a debate about whether all four hooves of a trotting or galloping horse were ever off the ground at once. Muybridge succeeded in making photographs that proved "unsupported transit", but Stanford had bigger ideas. His true motive was to improve performance of his stable by understanding how a horse moved. Muybridge went on to devise a series of cameras with tripwires, which were set off one by one by the horse's movement.

Locomotion at work
The resulting image, *The Horse in Motion* (1878), was a triumph – both for those who had placed bets on all four hooves being in the air at the same time and for Muybridge, who lost no opportunity to present the work to incredulous audiences.

▷ **GALLOPING HORSE**

EADWEARD MUYBRIDGE, 1887

Muybridge photographed a horse and rider using cameras with shutters set to a speed of 1/500 sec, which were released by tripwires triggered by the horse or by clockwork. He showed the moment in the four-time gait when all four hooves are in the air at the same time (top row).

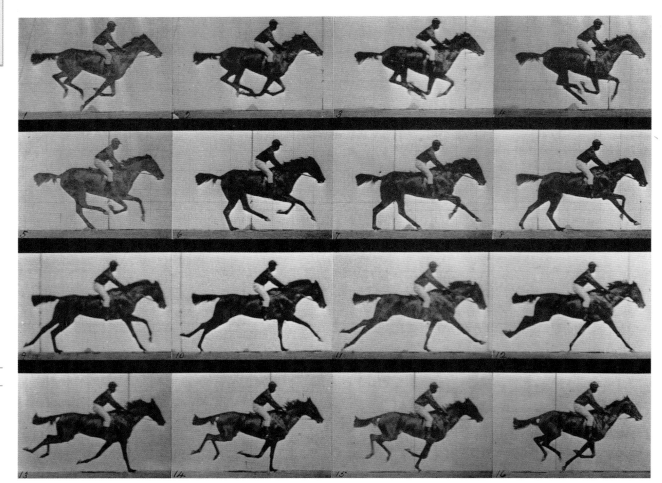

He devised the zoopraxiscope (see right) to simulate the movement, setting the stage for the invention of cinematography.

In 1881, he embarked on a project for the University of Pennsylvania that was to output nearly 100,000 images on human and animal movement, some 20,000 of which were published in 11 volumes in 1887. Human figures (including Muybridge himself) were shown nude. While men pursued virile activities such as jumping, running, and boxing, women were pictured putting on shawls, sweeping, and scrubbing floors. Many plates were assemblies of odd moments rather than composed of strictly sequential images. Nonetheless, the work has been incalculably influential and an invaluable artists' resource.

Third approach

Muybridge's laxity of method would not have passed muster with Étienne-Jules Marey (see pp.80–81). He was a renowned French physiologist whose main interest was in movement and flight. In 1881, Marey met Muybridge, who convinced him of the value of photography for his research.

Marey was the first to explore the third approach – recording a series of exposures on to a single image, capturing stages of a movement on one negative. His process ensured that the snatched moments were truly sequential and not merely the result of conjecture. Among modern exponents of this technique are Harold Edgerton (see pp.202–03) and Stephen Dalton (see pp.286–87).

△ **GRAND PRIX OF THE AUTOMOBILE CLUB OF FRANCE, JUNE 1912**

JACQUES-HENRI LARTIGUE, 1912

The distortions come from two simultaneous actions during exposure. Lartigue panned the car, pulling the wheels in one direction. At the same time, the open slit of the shutter made its relatively leisurely way across the film, dragging the static parts of the images at angles across the film in the opposite direction.

IN CONTEXT
Zoopraxiscope

Muybridge was familiar with the zoetrope and phenakistoscope, which showed an animated image by presenting a rapid sequence of single pictures to the viewer. But only one person could use these instruments at a time and he had bigger ambitions – to project his images to large audiences. He adapted the zoetrope concept to a projector but found that the images from a disc were distorted. Ingeniously exploiting cylindrical or anamorphic distortion for perhaps the first time, Muybridge made distorted copies of his horse images which, on projection, appeared natural in proportion.

MUYBRIDGE'S PROJECTOR, 1880 ZOOPRAXISCOPE DISK, c.1893

Étienne-Jules Marey

FRENCH / 1830–1904

Taken at the same time as his fellow photographers were struggling to keep the subjects of their portraits sitting still, Marey's records of pigeons in flight and athletes in action are astonishing. Yet the beauty and technical virtuosity of his photography were secondary to his scientific aims. While there is no evidence that he was immune to the charms of his images, it is true that for Marey photography was purely a means of studying locomotion.

By the time Marey started experiments in photography in the late 1860s, he was a renowned physiologist, and his inventions laid the foundations for modern life-monitoring systems. When his interests took him to locomotion, he again invented what he needed. Using a number of different "chronophotographic" cameras, Marey captured a sequence of movements in a single image (rather than taking sequences of shots, as Muybridge did, see pp.78–79). By 1890, he had enough material to publish a large volume called *Le Vol des Oiseaux* (The Flight of Birds), illustrated with photographs as well as drawings.

Late in life, Marey's attention turned to the motion of liquids and air. He suspended silver balls in water to study its flow, at 42 frames per second. He also used a smoke machine with dark-field lighting to investigate the movement of air.

ON TECHNIQUE
Rifle camera

Marey's major contribution to photographic technology was his *Fusil Photographique* (photographic rifle). Using a disc of 12 separate negatives, it could make sequential exposures of birds in flight in the wild. With exposure times of about 1/720 sec, it could rattle off all 12 exposures in around a second.

Marey's camera also demonstrated that it was not necessary to use Muybridge's large, cumbersome, and extremely costly methods. It opened the door to the cine camera as it was the first camera that could follow the movement of a subject, rather than capture it by shifting viewpoints. After 1886, when Marey started using gelatin film, he could increase the series speed of exposures to, it was claimed, some 60 frames per second.

PHOTOGRAPHIC RIFLE, 1882

DISSOCIATION DES MOUVEMENTS D'UN OISEAU

26 IMAGES D'UN PIGEON, OBTENUES EN 1/2 SECONDE; — POSE $\frac{1''}{8000}$

Phototypie Balagny

△ PIGEON IN FLIGHT

LE VOL DES OISEAUX, 1890

Marey made his chronophotographic (time photography) studies of moving subjects against a black background for added precision and clarity. He recorded pelicans, herons, and ducks flying, as well as pigeons.

▽ SWORD THRUST

1895

Marey's studies included humans taking part in athletic pursuits such as fencing, as well as running, jumping, and walking. The locomotion of dogs, horses, cats, and lizards also came under his scrutiny, as did the trajectories of stones, sticks, and balls.

> [My method measures] the relation of **space to time** that is the **essence of motion.**

ÉTIENNE-JULES MAREY / 1878

◁ SMOKE MACHINE

1899–1902

In the final years of his life, Marey experimented with a wind tunnel filled with smoke to photograph the movement of air. His images of a 57-tube smoke machine are weirdly beautiful, unique studies of air flow.

▽ HIGH JUMP

1892

Images such as these, capturing the trajectory made by a pole-vaulter, are among the first scientific pictures that can stand alone as great photography.

Retina of science

Reliability, accuracy, capacity for detail, and apparent objectivity made photography the ideal recording medium for science. Photographs could even show aspects of the world that had never before been visible to the naked eye.

BOOK PLATE, ADRIEN TOURNACHON, c.1862

When French astronomer Jules Janssen declared in 1888, "The sensitive photographic film is the true retina of the scientist", he was making a case for science itself. They both seemed objective, but were limited in what they could achieve and were open to interpretation. The camera was the perfect artificial eye for the scientist, whose job was both to observe and to record.

Changing faces
In the early 19th century, mental illness was diagnosed by visible signs. It was thought that external symptoms reflected disturbances within the mind because of the face's connection to the soul. There were manuals, such as that of French psychiatrist Jean-Étienne Esquirol, but they were generally illustrated with engravings.

Photography was considered perfect for the research of mental illness, but the long exposure times of early photography were no good for catching fleeting expressions. The first photographs of the mentally ill, made by the neurologist Jules Baillarger, date from around 1848.

Psychiatrist Hugh Welch Diamond went a step further, suggesting that photography could actively help in diagnosis and treatment, although it was unclear how and seems to have produced limited results. Jean-Martin Charcot, France's most eminent neurologist, regarded photography and indeed art in general as important tools for treatment – a forerunner of art therapy.

Medical records
In other hospital departments, doctors began to appreciate the value of photographic records of disease. One of the pioneers was Frederick T.D. Glendening, a staff photographer at St Bartholomew's Hospital, London. His work in the outpatient department demonstrated the value of visual records not only for treatment and follow-up, but also for teaching.

DAVID GILL, 1882

Scottish astronomer Gill mapped the skies from his base in South Africa, methodically recording the stars and their positions. He captured an unusually bright comet as it passed near the earth.

Looking up and within

It was a natural next step for scientists to attach a camera to any tool that created an image, in order to make a permanent picture. As early as 1839, Henry Fox Talbot made photographs through a microscope. The earliest surviving daguerreotype of the moon was made via a telescope by John Adams Whipple in 1851 (see p.38). The advantages over drawing were immediately obvious to astronomers, who relied on absolute precision for star positions. They could now map the heavens and measure brightness.

Meanwhile, German physicist Wilhelm Röntgen was looking inward rather than outward. In 1895, he was experimenting with vacuum tube equipment when he noticed that it caused a shimmer on a nearby fluorescent screen, even though the screen was covered with black card. He called the effect "X-rays".

After further tests, he X-rayed his wife's hand and created a print. The skin and flesh were transparent to X-rays, while bones and metal were opaque. The process allowed doctors to see inside the living body for the first time, and Röntgen was awarded the Nobel Prize in 1901 for his discovery.

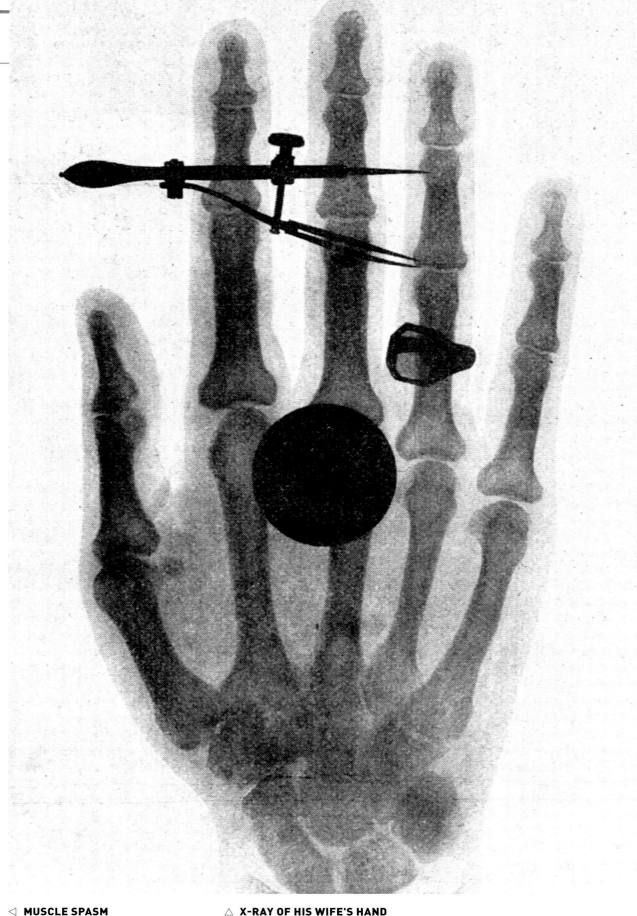

◁ **MUSCLE SPASM**

JEAN-MARTIN CHARCOT, 1889

A blepharospasm is a strong, involuntary closing of the eyelids – more than just blinking. Photography helped to capture evidence of spasms, which could be too quick for the naked eye to detect.

△ **X-RAY OF HIS WIFE'S HAND**

WILHELM RÖNTGEN, 1896

Metals and bones show up in X-rays, so the ring on Mrs Röntgen's finger is visible, as is the pair of compasses giving her hand a sense of scale. When she saw her bones, Mrs Röntgen reacted badly – "I have seen my death!" she exclaimed.

Criminal evidence

Usually thought of as a creative medium, photography has had just as great an impact on society as a practical tool. The police soon made the most of photographs as visual evidence.

The earliest example of photography as a tool in crime-fighting was in Belgian prisons, where portraits of inmates were taken, somewhat haphazardly, from 1843. Nearly four decades later, in 1879, Alphonse Bertillon – an obsessively tidy clerk – started working at the Prefecture of Police in Paris, and found that their records were a chaotic mass of five million files and 80,000 mug shots. He observed that physical descriptions were vague and that criminals were intentionally grimacing when photographed in order to confuse identification so he set about thinking how to improve the system.

Bertillon system

By 1883, Bertillon had perfected a complex card-index system for organizing information on arrestees. It was based on cranial and body measurements, the shapes of features such as ears, lips, and nose, and other details collected at the time of arrest. To support his system of measurement, known as *bertillonage*, he pioneered the use of full-face and profile portraits consistently lit and at

a standard size for final identification. He used a cross-referencing system to whittle a choice of thousands of suspects down to a handful. It was the precursor of the punch-card system and of the computer relational database with algorithmic search. In the first six months of its operation, Bertillon spotted 50 repeat offenders from 7,336 arrests. In one famous case, detectives were able to identify a badly decomposed body using his system, which provided their only lead.

By the late 1880s, the practice of routinely photographing arrested suspects had been widely adopted and had reached as far as New Zealand.

◁ **MARGARET LLOYD, CONVICT**

UNKNOWN, 1887

This woman was convicted of felony (serious crime) and larceny (theft). In New Zealand, commercial or amateur photographers took mug shots of criminals, often showing hands to aid identification; finger-printing was still two decades away.

Taking mug shots was an integral part of setting up their police force in 1886, although they did not yet have the benefit of Bertillon's system.

Forensic photography

Bertillon also pioneered systematic photography of crime scenes. He specified that the camera, mounted on a tall tripod, should look vertically down over the scene to take an overview before removal of the body or any evidence. At the University of Lausanne in Switzerland, Professor of forensic science Rodolphe A. Reiss followed suit, publishing an influential book on forensic photography in 1903.

Metric photography, using grids to locate objects and enable measurement to be made at leisure, was another of Bertillon's ideas. He explained, "Every measurement slowly reveals the workings of the criminal. Careful observation and patience will reveal the truth".

▽ **THE SCENE OF THE CRIME**

RODOLPHE A. REISS, 1913

Reiss was interested in the scientific uses of photography for criminal investigation. He published two books on forensic photography and science, illustrated with his pictures of crime scenes and fatalities, such as this car crash.

One can only see **what one observes,** and one observes only things which **are already in the mind.**

ALPHONSE BERTILLON

Planche 41.

Forme générale de la tête vue de profil.

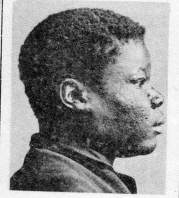
1. Nègre à prognathisme moyen.

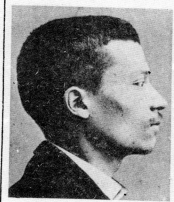
2. Type d'Européen prognathe.

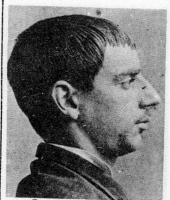
3. Prognathisme limité aux os de la base du nez. (prognathisme nasal).

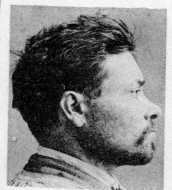
4. Prognathisme accentué avec proéminence du menton.

5. Type d'orthognathe.

6. Profil fronto-nasal rectiligne.

7. Tête en bonnet à poils (acrocéphale).

8. Tête en carène (scaphocéphale).

9. Tête en besace (cymbocéphale).

IN CONTEXT
Mug-shot art

As images of people in stressful situations – just arrested for violence, drunkenness, or other misdemeanours – mug shots are unique photographic portraits. The setting, with identification, gives a semblance of machine-like objectivity, but the faces reveal a real, living person. As a result, they have become an unlikely source of art – used directly, reproduced in books, or appropriated for derivative works such as large posters. Mug shots are, in many legislations, public record, so it appears that these images can be used freely. The woman below was a dancer arrested for false pretences and the photographs were reproduced in a book of American mug shots.

MUG SHOT OF 1968, MARK MICHAELSON, 2006

◁ **FACIAL TYPES**

ALPHONSE BERTILLON, 1893

Bertillon's interest in photography went beyond identification of criminal suspects. His profiles and full-face shots were also part of a project to support the then-widespread view that personality types were revealed by cranial and facial features.

Artistic licence

The invention of photography was bound to rankle with some painters, who feared it signalled the death of art. Others recognized the potential value of photographs instead of regarding them as a threat.

NUDE MODEL, EUGÈNE DURIEU, c.1857

ODALISQUE, EUGÈNE DELACROIX, 1857

Whether or not an artist welcomed photography depended more on individual concerns rather than on the new art itself. On viewing Hill and Adamson's calotypes in 1843, the watercolourist John Harden enthused, "The pictures produced are as Rembrandt's but improved... doubtless a great progress in portrait painting... must be the consequence". The painter J.M.W. Turner, however, is said to have lamented, "This is the end of Art. I am glad I had my day".

Even without the unexpected arrival of photography, younger painters were already struggling against the conservative shackles of institutions such as the Académie des Beaux-Arts in France. This was to lead in 1863 to the Académie's spectacular own goal, when the Salon des Refusés displayed all the works rejected for the official show. The Salon des Refusés was far more popular, and provided a showcase for new directions in art.

Photography as memory vault

Painters were not the only fine artists to take a dim view of photography. Later in the century, French sculptor Auguste Rodin found himself depending on photographs for reference despite his disdain of the medium. "Mere exactitude, of which photography and life-casting are the lowest forms, does not inspire feelings", he stated. "If the artist only reproduces superficial features as photography does... he deserves no admiration". In 1891, Rodin was commissioned to create a memorial

to the writer Honoré Balzac, but he was unable to locate a photograph. (Balzac had a dread of being photographed; only a single daguerreotype survives.) Rodin had to rely on photographs of men from Balzac's region as physiognomic types. Making a virtue out of necessity, Rodin said of the sculpture that it aimed to portray the writer's persona rather than a physical likeness.

Capturing movement

The keenest photographer among great painters was Parisian Edgar Degas. His career as an artist developed alongside photographic technology. For this all-devouring visual genius, photography was simply another means of experimentation.

Degas was fascinated by capturing action and, probably influenced by the work of Muybridge and Marey

(see pp.78–81), he made drawings of nudes and moving horses, and sculptural maquettes of dancers.

Degas and his camera

In 1895, after many years of first dismissing, then referring to the photographs of others, Degas acquired his own camera. It instantly captivated him and, for one brief year, he experimented with portraits of his artist and poet friends, female nudes, and some landscapes. He preferred to take photographs indoors, in the evening, as his days were busy.

His camera, thought to have been a Kodak, was intended for amateurs and required uncomfortably long exposure times. His friends posed for him, subjected, according to the writer Paul Valéry, to a "fearful quarter hour of immobility". Degas controlled light conditions in his night photographs

▷ **DANCERS ADJUSTING SHOULDER STRAPS**

EDGAR DEGAS, 1895

Degas combined several studies to make this pastel of dancers offstage stretching and adjusting their costumes. Compositions like this – carefully cropped and yet casual – were considered shocking at the time, but now look thoroughly modern.

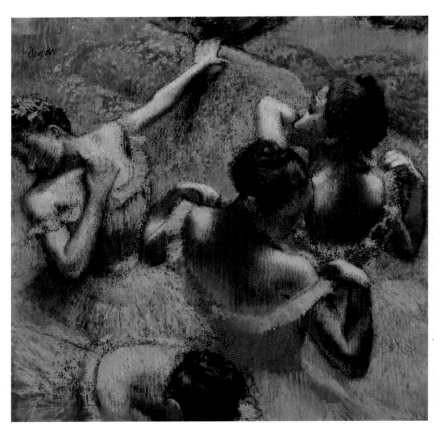

with lamps and reflectors. "What I want is difficult – the atmosphere of lamps and of moonlight", he said.

As well as posed portraits, Degas photographed the subject of many of his best-loved paintings – ballerinas. Dancers were already heavily photographed, for cartes de visite (see pp.56–57) and publicity stills. They were especially used to cameras in Paris, a city obsessed with ballet and photography. Degas shot dancers in balletic poses on stage and behind the scenes, in the wings. He used his photographs as a starting point for pastels and oil paintings but also had an exhibition of his prints in 1896. Sadly, by then his eyesight had deteriorated so much that he had to stop taking photographs.

He moved lamps... reflectors... [put] a lamp on the floor...

DANIEL HALÉVY, ON SITTING FOR EDGAR DEGAS / 1895

ON TECHNIQUE
Cropping

Édouard Manet responded to criticisms levelled at photographs – incorrect poses, gauche gestures, and clumsy compositions – by incorporating camera mannerisms into his paintings. Below, he boldly chops a sign and places a ladder so it almost cuts off a passer-by who is in the "wrong" position. Although the painting is based on sketches made on location, Manet's handling of space and his sense of the instantaneous are strikingly photographic.

RUE MOSNIER WITH FLAGS, ÉDOUARD MANET, 1878

◁ **PHOTOGRAPHIC REFERENCE**

EDGAR DEGAS, 1895

Degas was interested in capturing the fluid movements of ballet in the static art forms of photography and sketching. Offguard, personal moments such as adjusting a shoulder strap intrigued him as much as the ballet steps themselves.

Camera of conscience

The social changes of the late 19th century were largely at the expense of the working class and the poor. Reformers called on photographers for support, dragging them away from the studio and into crime-ridden slums. But not all was as it appeared.

Lewis Wickes Hine
1874–1940

Apart from Jacob Riis, the great campaigning photographer was Lewis Hine. While Riis's work in New York slums shocked through the subject matter itself, Hine used his skill as a photographer to bring out the pathos. A sociologist by training, his photographs of immigrants arriving at Ellis Island, New York, led to a commission from the reforming National Child Labour Committee. Often working under cover or with a false identity, Hine undertook a photographic survey of child labour from 1908 to 1918, which produced a monumentally damning body of 5,000 images that owed much to Riis. Hine supported every image with full details of the child, his or her working conditions, and even wages.

By 1919, he was receiving recognition as a photographer as well as a reformer, but continued working for government agencies. Sadly, by the late 1930s his contribution to society was no longer valued and he spent his last days homeless and on welfare. Even his prints were not wanted, turned down by MoMA, New York; but nearby George Eastman House, the world's oldest photography museum, took them in.

▷ **MOTHER AND BABY**

JACOB RIIS, c.1890

Dubbed "Madonna of the Slums", photographs such as this, taken in a tenement on New York's Lower East Side, stirred people's consciences.

Photography was expensive, and most early photographers wanted to make a living from the camera, so they took few pictures of subjects that did not bring a return. There was no money in photographing the poor, the slums, and disreputable districts. Brutal economics kept photographers away.

Reforming zeal
As the numbers of the poor grew, together with sprawling slums and tenements, reformers called on every means available to help change government policies and raise funds. Photographers' apparently neutral pictures, full of unpleasant details, were perfect for supporting verbal accounts. A crucial element in the use of photography for reform campaigns was the invention in 1881 of half-tone printing presses. These made it possible to reproduce photographs in journals and pamphlets. There was no longer a need for engravings, which were in any case far less convincing at portraying the reality of poverty.

Jacob Riis, a Dane who emigrated to New York in 1870, was not the first to photograph the poor. Oscar Rejlander (see pp.64–65) photographed orphans in London, and Heinrich Zille's work in Berlin was extensive, although never published or exhibited in his lifetime. Eugène Atget's work in Paris (see pp.126–29), contemporary with Riis

and Lewis Wickes Hine (see left), also concentrated on poor areas. But none of these photographers used their pictures with the reforming zeal of Riis and Hine.

Back to his roots
Riis, like Zille, knew what it was to be completely penniless. Like many immigrants to New York, he laboured in casual jobs, survived being cheated several times, and found his feet after a few years. But unlike other immigrants, his new job as crime reporter took him back to the lawless, impoverished, densely populated tenements he had left.

For example, Riis wrote about a tenement housing over 1,000 people in 132 rooms. 20 people slept in one room, with just two beds to serve them all. He resolved to make a difference to the conditions of the poor, and he developed campaigning journalism to serve this purpose.

Technology brings light
Riis turned to photography to improve the impact of his journalism, finding sketches and other artwork inadequate, but the technology was not up to the task of working in near-total darkness.

The invention of magnesium flash powder (see pp.176–77) was crucial for Riis's work. German chemists Adolf Miethe and Johannes Gaedicke mixed magnesium with potassium chlorate and antimony sulphide in powder. The mixture was ignited in a pistol-like device that fired cartridges (hence the term "flash gun"). This design was soon replaced with a more innocuous-looking flash pan.

As he was no photographer himself, Riis enlisted the help of amateurs Richard Hoe Lawrence and Henry G. Pifford. They may have taken up to a third of the images now attributed to Riis, but they soon tired of trudging around the roughest parts of New York at night with what looked like a gun. Riis then had to buy his own

photographic equipment, spending a princely US$25 on a 5 x 4in camera, and he set about teaching himself.

Changing reputation

The birth of photographic conscience is widely attributed to Riis. The images in his book *How the Other Half Lives* (1890) both shocked and intrigued, marking the beginning of reforming, conscience-driven, documentary photojournalism.

But views have changed. Riis has since then been criticized for his stereotyping, his intrusive methods, and his thinly concealed racism. His work has also been turned into art objects, initially weakening its advocacy of the disadvantaged. Once a photograph becomes public, its fate is no longer under the photographer's control or direction.

IN CONTEXT
Thomas Annan

In 1866, Glasgow's city fathers ordered the demolition of its slums. Thomas Annan, the most prominent photographer of the time, was the obvious person to document the slums before the clean-up. Working with wet-plate collodion in the dark, dank closes, Annan produced about 35 sublime studies of the filthy hovels between 1868 and 1871. When the houses were cleared, many of the dwellers were made homeless.

Despite the pathos of his photographs, Annan's approach was not reformist in the slightest. Although he was cited as a documentary photographer, his work was essentially a response to a commercial commission.

TENEMENTS, GLASGOW, THOMAS ANNAN, 1868

△ **CIGAR-MAKERS**

LEWIS HINE, c.1910

A witness reported that these three boys making cigars in a factory in Tampa, Florida, looked under 14. She was told that work was slack, but in busy times many small boys and girls were employed. They all smoked.

▷ **LITTLE SPINNER GIRL IN GLOBE COTTON MILL, AUGUSTA, GEORGIA**

LEWIS HINE, 1909

Travelling up and down the US, Hine documented the social conditions of children, many of them working in coal mines or in factories like this girl. The Child Welfare League used his photographs to back their campaign against child labour.

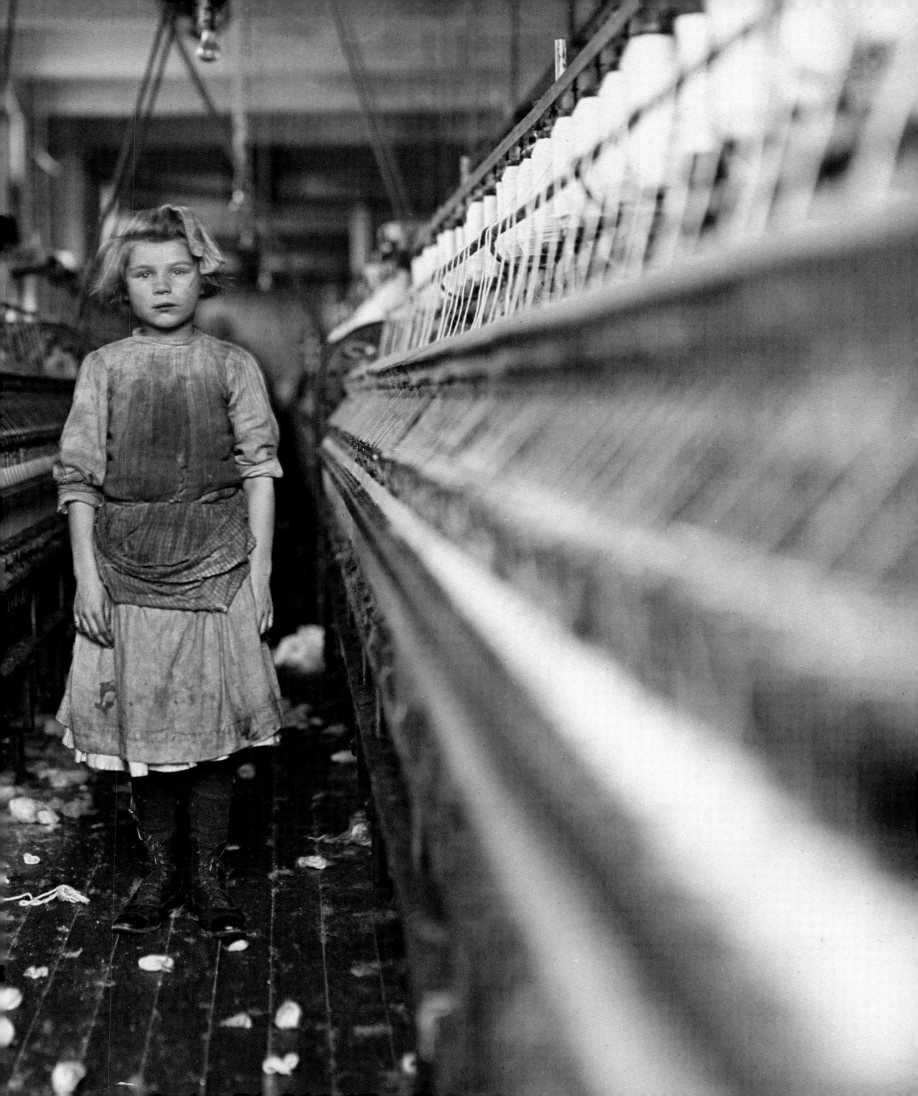

The Box Brownie

A superb example of the triumph of packaging over engineering, the Brownie was the cheapest camera possible. Yet its success – founded on a dozen years of aggressive commercial development – changed amateur photography forever.

Portability in photography meant that both cameras and materials were easier to carry around. It was simple enough to reduce the size of the camera by making a smaller box, but miniaturizing glass negatives was impractical. As early as 1854, Joseph Spencer and Arthur Melhuish had patented the use of rolls or bands of sensitized paper. Variations on this theme had little success until, in 1884, US entrepreneur George Eastman, with William H. Walker, introduced a roll-holder for a strip of paper carrying a layer of sensitized gelatin.

Eastman's first successful camera – and the precursor of the Brownie – was patented in 1888. He gave it the nonsense name of "Kodak", a word he devised with his mother. The Kodak's lens of 57mm focal length gave a wide 60-degree field of view (equivalent to about 32mm in standard 35mm format), while a small, fixed aperture of f/9 offered extensive depth of field. The film was preloaded into the camera, and contained enough for around 100 circular negatives 64mm in diameter. Thanks to the thick, tolerant emulsion, images could be captured in a wide range of conditions. While the portability for what was then a month's worth of photography was stunningly attractive in itself, the greatest appeal of the Kodak lay outside the camera itself.

Develop and print
Once you had used up the roll of film, you would fill out a little memo book that came with it, then post the camera to the Eastman factory. Five to 10 days later, your prints arrived back (depending on the weather, as they were made in the sun on printing-out paper) with the camera reloaded. The system was astute, the quality more than acceptable, and the Kodak sold in the thousands, despite costing more than an average week's salary.

By providing developing and printing services, Eastman had severed the link between photography and darkroom skills for the first and most decisive time. He invented a whole new industry at a stroke.

But this was not enough. Eastman sought to improve the film itself. In 1889 he introduced flexible celluloid (cellulose nitrate) film, which simplified processing. Although he claimed it was developed by his chemist Heinrich Reichenbach, Eastman knew that inventor Hannibal Goodwin had a patent pending, dating from two years earlier. Nevertheless, Eastman steamed ahead and for years fought off infringement actions.

He settled in 1914 only when faced with the certainty of losing. The sum subsequently disclosed was US$5 million – a fraction of what he would have had to pay legitimately on licence fees. Eastman also relied on another invention, Samuel Turner's roll-film cartridge (so-called because of its similarity to a shotgun cartridge) of 1892. Turner's simple invention – a roll of black backing paper protected the film from light – enabled cameras to be reloaded in daylight, another notable liberation from the darkroom. This time, Eastman paid for a licence to use the roll-film cartridge and he eventually bought the technology from Turner outright.

Brownie magic
By the time he settled the Goodwin patent claim, Eastman had sold hundreds of thousands of Brownie cameras. Designed and built to the unbeatable price of US$1 by Frank Brownlee, it may well have been made to appeal to children – named after cartoon characters and constructed from the cheapest wood – but it was a masterpiece of industrial design. The Brownie was, and is, instantly recognizable, adaptable to elaborations and up-market variants, and surprisingly sturdy.

The first model was introduced in 1900, taking 12 exposures of 57mm square images. It had a pop-up periscopic viewfinder, and no controls. That did not inhibit sales, which topped 100,000 in the first year. The impact of the Kodak cannot be overestimated – it opened photography to the masses and launched the photographic industry.

△ **KODAK BROWNIE ADVERT**

1903

George Eastman marketed the Brownie as an inexpensive camera for the mass market, a perfect gift for children, although not a toy. When first introduced in 1900, the price of the camera was just US$1 (5 shillings in the UK).

△ **THE BROWNIE IN USE**

c.1910

The Brownie had no viewfinder in its basic form. Taking a picture was simply a matter of holding it at waist height and pressing a lever. The process was easy enough for children to take family "snapshots" while out and about.

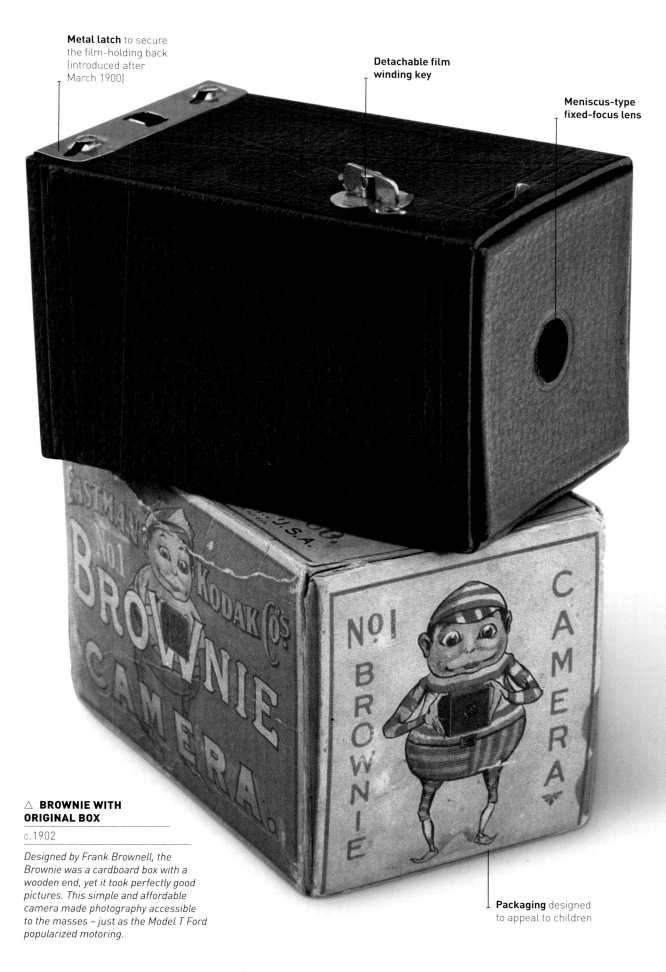

Metal latch to secure the film-holding back (introduced after March 1900)

Detachable film winding key

Meniscus-type fixed-focus lens

△ **BROWNIE WITH ORIGINAL BOX**

c.1902

Designed by Frank Brownell, the Brownie was a cardboard box with a wooden end, yet it took perfectly good pictures. This simple and affordable camera made photography accessible to the masses – just as the Model T Ford popularized motoring.

Packaging designed to appeal to children

IN CONTEXT
Brownie movement

A long string of variants followed the first Brownie, with improvements to the shutter and additional viewfinders of various types. A range of negative formats varying from 41mm × 64mm to 74mm × 124mm were offered at different times. The No.2 Brownie of 1901 introduced the No.120 film – even today the standard medium-format film size. Brownies also turned up with up-market designer finishes and as toy models of numerous shapes. The Brownie Hawkeye (1950) and Brownie 127 (1952) vie for the title of the most successful Brownie ever. But this discussion is academic – both sold in their millions.

NO.2A BEAU BROWNIE, 1930

BROWNIE SPECIAL, 1938

BROWNIE FLASH 20, 1957

People's photography

The turn of the century was a watershed for photographers. New cameras cut the chains to the darkroom, dispensed with the need for a tripod, and proved that all you needed to create magic was a cheap little wooden box.

Photography underwent a dramatic change around 1900. George Eastman's first camera, launched in 1888, had sold for US$25, equivalent to about US$600 (£360) now – it was a luxury item. But when Eastman slashed the price of photography by selling the Kodak Brownie (see pp.92–93) for a mere US$1, his competitors were not the only people dismayed. Professional photographers were horrified that the trade that they had been assiduously developing for decades would plummet in value. They were all, however, wrong. Eastman actually achieved the opposite – he opened up the market. By lowering the barrier to entry into photography, millions more people could take photographs, and there was more business for everyone.

Democratization

The key to Eastman's revolution was in the processing – enjoying photography no longer demanded knowing how to develop film. The public were not interested in working in the dark, but they did love prints. With Eastman's shortcut process, people could spend more time taking photographs, and no time at all in the alien environment of a darkroom.

The "snapshot", as it soon became called, was sneered at by those who prided themselves on being real photographers. They feared their craftsmanship was being sidelined by casual photography, and their art usurped by pictures of family holidays and cute babies. Alfred Stieglitz thundered, "Don't believe you became an artist the instant you received a gift Kodak on Christmas morning". Typical Brownie owners did not, of course, have the slightest care for art, and cheerfully ignored all suggestions for improving their photography.

In fact, the users of the Brownie camera (and its many imitators) were creating an aesthetic of their own. If they had been asked to explain their photography they would have said that it was purely functional and met very simple needs – to capture moments with their friends and family. The snapshot was a genre delightfully devoid of artifice.

The family album

As more photographs were taken, the family album also had to evolve. The binding of the new volumes had to match that of earlier ones to form a set, and expandable albums became popular for housing the ever-growing collections. Ways of mounting prints – such as photo corners – were sold, so that photos could be moved around easily. Standardizing the size of prints made this more straightforward.

A set of unspoken rules developed for the family album. Nudity, distress, anger, or embarrassing moments were tacitly forbidden, and sunny smiles and laughter – redolent of good times – encouraged. Gentle humour was often a feature of candid shots of families enjoying holidays (a new experience for many at the time), or attending events such as weddings and anniversary celebrations.

This family censorship of the darker side of life arose from the album's function as a form of entertainment for family and guests. The album represented the family as it wished to be seen – a kind of private propaganda – and this in turn shaped the aesthetic of the snapshot, which reflected changes in social mores. To see how this continues today, compare what is considered acceptable in the virtual family albums of Facebook with their leather-bound predecessors.

▽ **WEDDING GROUP IN THE GARDEN**

F.J. MORTIMER, c.1900

Weddings were a rite of passage in family life and many amateurs therefore used the new affordable cameras for wedding portraits. The pictures took full advantage of natural light and did not require a special journey to a portrait studio.

▽ PARTY ASCENDING THE GREAT PYRAMID OF GIZEH

UNKNOWN, 1882

Just like tourists today, people in the late 19th century wanted visual proof of their adventures in exotic places, confirming their social standing as members of the leisured classes.

△ THREE TEENAGE GIRLS WALKING DOWN A BEACH

UNKNOWN, c.1890s

With impeccable timing, the amateur photographer has captured the girls acting naturally as they make their way along the beach. The pale, airy spaces of the sky and wet sand form an appealing visual frame for the trio.

IN CONTEXT
A moment in history

As amateurs became used to their cameras, they started to record events. When RMS *Carpathia* suddenly diverted course in the middle of the night during 1912, to go to the aid of RMS *Titanic*, none of its passengers would have guessed the reason. Remarkably, although their first sight of the stricken liner was not until 4am, some of them had the presence of mind to photograph the rescue of 705 survivors. In the subsequent three-day passage to New York, many pictures were taken of shocked people who had escaped the disaster. Some – such as these newlyweds with a widow – simply look like holiday snaps.

TITANIC SURVIVORS, BERNICE PALMER, 1912

Charmed lives

**Amateur photographers drove the early development of photography.
The landed and the wealthy were in the best position to develop innovations
– both artistic and technical – that required costly materials like silver.**

△ **LA CASTIGLIONE**

PIERRE-LOUIS PIERSON, 1893

Italian aristocrat Virginia, Countess of Castiglione, conceived, produced, and directed tableaux and portraits of herself dressed in various guises. She relegated the menial task of making the exposure to photographer Pierre-Louis Pierson, whose studio she used.

In the 19th century, the term "amateur photographer" was something to be proud of. Photographers hauled their heavy cameras around and spent interminable hours in the darkroom for the love of it. Meanwhile, studio-based portrait businesses sprang up in every city. These hard-working professionals had pretensions neither to invent nor to create fine art.

Instead, history belongs to the lawyers, doctors, scientists, and housewives whose independent means freed them from having to make a living from camera work. People such as Peter Henry Emerson and Julia Margaret Cameron (see pp.66–67), who wanted to make a living from photography, were in the minority. Roger Fenton (see pp.62–63) was more typical – even with royal patronage for his photography, he returned to his law practice.

In the first decades of photography, clubs were important for discussion and sharing know-how and were active in displaying members' work to the public. Then, as now, amateurs dominated the membership.

Female freedom

As photography emerged so quickly, it came with no social strings and few notions of what should or should not be done. It was open to women to take up, when many other activities were controlled by men or deemed to be exclusively male. Women as photographers were not a source of scandal, even in one of the oldest of noble Italian houses, the Borghese.

Princess Anna Maria Borghese, born in the castle of Montallegro in 1874, married Prince Scipione Borghese, an explorer, diplomat, and adventurer, in 1895. Accompanying him on travels throughout Europe and as far as Japan and to what is now known as Uzbekistan, the princess recorded their travels, the parties, and their elegant friends. The coverage is wide-ranging, executed with skill and invention, and amounts

to some 8,000 prints. At the outbreak of the war, she went to the Italian front, working for the Red Cross, and photographed near the fighting. Her work remains to be fully revealed.

Better known because she has been more widely published was Virginia, Countess de Castiglione. Between 1856 and 1898, she created a unique body of work. Bringing a stream of new costumes and props to dress

herself up for the camera, she could claim with some justification to be the first fashion photographer. She produced some 400 images, and reputedly spent the family fortune on her infatuation with herself.

Born in Africa into a family that seemed to be perpetually having fun – running, racing, flying – Jacques-Henri Lartigue started young. With his wealthy background, he had access to

the best equipment and a wide variety of cameras. He made stereographs as well as photographs.

Although sensationally "discovered" in the 1963 exhibition of his work in New York, Lartigue was already widely published in France, with magazine credits going back as far as 1912. It was only in the 1960s, however, that his enormous record of photographs of his family, wives, mistress, sports events, aeroplanes, and French life – the epitome of the family album – came to light with the publication of *Diary of a Century*. This led to a stream of commissions that continued to the end of his long life. It was only in his 70s that Lartigue found the success that had hitherto eluded him.

◁ **NORA BALZANI, ISOLA DEL GARDA**

ANNA MARIA BORGHESE, 1907

The Borghese family property was a splendid villa on the largest island on Italy's Lake Garda. When not travelling, Anna Maria liked to photograph her friends striking poses in the grounds.

Jacques-Henri Lartigue
1894–1986

The young Lartigue was a self-taught savant. He rarely made a single poor exposure from the moment he received a camera he could barely hold up at the age of seven. Taught by his father – an engineer and financier – the young Lartigue captured life in a deceptively simple yet penetrating way.

Lartigue soon overtook his father's skills, and forged his own way. From around 1910, when he was 16, he concentrated on reportage, but he was also a gifted painter, and from 1915 he applied himself to art. Painting brought him into a circle that included Picasso, Cocteau, Truffaut, and Fellini, who all sat for him. Lartigue's work is a visual autobiography, one that fills 120 large albums with charm, humour, and summer light.

THE YOUNG LARTIGUE WITH HIS CAMERA, 1903

◁ **ARLETTE PREVOST, AVENUE DES ACACIAS, BOIS DE BOULOGNE, PARIS**

JACQUES-HENRI LARTIGUE, 1911

The dark fox furs of the woman, carrying herself with an hauteur that smacks unmistakably of privilege, stand out against the pale tones of the street and even whiter coats of her dogs. Lartigue captured the lives of the wealthy with wit and affection.

Linked ideas

Real or not real, painterly or not, straight photography or manipulated prints – such topics provoked heated debate in camera circles all over Europe, often leading to furious resignations and splinter groups.

▽ **WHITBY**

FRANK MEADOW SUTCLIFFE, 1880

The British photographer recorded the people, places, and way of life in the North Yorkshire town of Whitby. Like many of his photographs, this is printed on brown carbon, which mellows the sharp tonal contrast created by the sunlight. The rigging of the foreground boat shows up in detail, while the background fades into an atmospheric haze.

More than a hundred years later, it can be difficult to see what the fuss was about. To modern eyes – used to the crisp detail, clarity, and colourfulness of digital images – all 19th-century photographs look rather like art. They are neither detailed nor sharp, and many are textured from the watercolour papers used. Any distinction between straight and manipulated images seems more accidental than deliberate. Whatever our view today, at the time the differences were debated with an almost religious fervour – the future of photography itself appeared to be at stake.

In the 1870s, photography entered a rebellious phase. With 30 years' experience in camera and darkroom skills, it needed to break away from art and science and establish itself as an art in its own right, with its own language and its own processes. This found expression in the pictorialist movement. Art photographers were horrified at the rapid assimilation of photography into science and industry, the increasing mechanization of photographic processes, and the growing numbers of weekend snapshooters. They wanted photography to be a fine art, not a

technique or commercial activity that anyone could do. To this end, they used photogravure and other intricate and time-consuming darkroom processes involving substances such as carbon, gum, bichromate, platinum, and bromoil, most of which resulted in prints that looked attractively smudged and velvety, like lithographs or charcoal drawings.

Naturalistic or not

In Britain, the first to publish his thoughts was Henry Peach Robinson, in his essay *Pictorial Effect in Photography* of 1868. Far more than the "hints on composition and chiaroscuro" of its subtitle, it described how to make complicated composite images, of which he was the acknowledged master (see pp.62–63). This manual became enormously influential, was reprinted many times, and translated into several languages.

In 1886, Peter Henry Emerson, who barely four years earlier had picked up his first camera, gave a lecture called – with some mischievous intention to confuse – *Photography as a Pictorial Art*. The lecture, which was subsequently published, articulated the first clear theoretical programme for photography, elaborated in *Naturalistic Photography for Students of Art* (1889).

Emerson started from the premise that the finest art was the most naturalistic. He wrote, "... we must first see the picture in nature and be struck by its beauty so that we cannot rest until we have secured it on our plate...". For photography to be an art form, he declared, it must be true to nature using purely photographic means, without recourse to other art. In particular, the camera should see like the eye.

Depth of field and focus

An erstwhile medical student, Emerson was the first to blend theories of vision with photographic method. He promoted differential focus, in which depth of field is limited to the main subject, and recognized that extensive depth of field – in which everything is in sharp detail – led to spatially dreary results.

The "rule" that true photography could be done only on large-format cameras on tripods using normal focal-length lenses, making a single exposure, with no subsequent

△ **KELMSCOTT ATTICS**
FREDERICK HENRY EVANS, 1896

Evans used natural daylight to bathe the area near the stairs in soft light and shade the left foreground, emphasizing the geometric structure of the beams. He kept his photography pure and simple and used only the platinum print process, which mutes the tones and here makes the light look even more diffused.

◁ **GATHERING WATER LILIES**
PETER HENRY EMERSON, 1887

Emerson strove to represent nature – mainly life on the Norfolk Broads of England's East Anglia – as the human eye sees it, in selective focus. Details of the men and boat, such as the hand reaching out for a water lily, are clear, while the reeds and background are blurred.

Nothing in **nature** has a **hard outline,** but everything is seen against something else, and its **outlines fade gently** into something else.

PETER HENRY EMERSON / 1889

▷ **LEICESTER SQUARE**

PAUL MARTIN, 1896

Martin used 15-minute exposures to capture his atmospheric shots of London by night. The lights of the city illuminated his photographs and were also an integral part of them.

Paul Martin
1864–1944

French by descent, Martin lived and worked in England. He took up photography in the 1880s and was something of an outsider. An early street photographer, between 1892 and 1898 he used a Fallowfield Facile "detective" camera. Designed to look like a wooden box, the camera came with straps and a handle to disguise it as a case. Martin used it to make candid portraits that were precursors of work by Paul Strand and Walker Evans. He was also a pioneer of night photography. His series of London by gaslight so impressed his peers that he was awarded a Royal Photographic Society gold medal in 1896. Alfred Stieglitz paid Martin the compliment of imitating his work for his own views of New York at night.

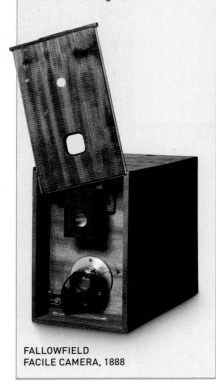

**FALLOWFIELD
FACILE CAMERA, 1888**

enlarging, no cropping, and no retouching stemmed from Emerson. He proposed a view that was diametrically opposed to that of Robinson, even though both men agreed that photography should express artistic creativity.

Brotherhood of man
In May 1892, dissatisfied with the Royal Photographic Society and tired of debates which only seemed to deepen differences between them, Henry Robinson, together with George Davison and Henry Van der Weyde, formed the Brotherhood of the Linked

Ring in Britain. United by a naturalistic vision of beauty and a conviction that photography had aesthetic value, the men met monthly for photographic outings and dinners.

The Linked Ring was one of a string of similar groups in Paris, New York, Berlin, Brussels, Hamburg, Toronto, Turin, and Sydney. True to its Masonic roots, membership was by invitation only, to "those who are interested in the development of the highest form of Art of which Photography is capable". All the initial invitees were men, including many of the leading photographers of the day, such as

Frank Meadow Sutcliffe and James Craig Annan. No woman was invited until Gertude Käsebier received the honour in 1900, the same year that the group recognized Frederick Evan's fastidious purism. By holding an annual Photographic Salon from 1893, and publishing a journal from 1896 to 1909, the Linked Ring had a long-lasting influence on photography.

Beauty, picturesqueness, and all **loveliness** are the food of art.

HENRY PEACH ROBINSON / 1868

△ **MOUNTAIN ROAD IN SPAIN**

JAMES CRAIG ANNAN, 1913

Annan used the photogravure process to create rich tones. Although this image looks spontaneous, he posed the figures so that they jut out from the dark foreground wedge into the light sky, linking the two parts. The figures are almost silhouettes – the fall of light and shadow interests the photographer rather than detail.

▷ **VILLAGE UNDER THE SOUTH DOWNS**

GEORGE DAVISON, 1901

Inspired by Peter Henry Emerson's advocacy of selective focus, Davison went further. Nothing is in sharp focus in this romantic and impressionistic vision of rural England, and the blurry quality is enhanced by printing on rough-textured paper.

Désespoir

ROBERT DEMACHY / 1905

At the beginning of the 20th century, Demachy was the leading French pictorialist. He wanted his photographs to appear soft focus, like some paintings of the time, stating that, "No straight print... with its false values, its lack of accents, its equal delineation of things important and useless could really be called art". To achieve the artistic blur he was after, Demachy used a soft-focus lens or deliberately made the image slightly out of focus. He then used processing techniques that also added painterly effects.

Demachy gave this image of a nude woman the symbolic title *Désespoir* (Despair). The gauzy drapery that shrouds her lower half is made more hazy from the processing method of a bromoil transfer print. The photograph is developed normally on silver bromide paper then put in bleach to harden the gelatin coating that holds the silver in place. The print is immersed in warm water, which makes the gelatin swell. The gelatin is hardest in the shadows and swells little, and softest in the highlights, which swell a lot. Greasy ink is brushed onto the moist surface. The shadows absorb the ink but the highlights repel it because they are swollen with water. The inked-up print is then transferred through a press onto paper.

In this print, Demachy applied the ink with loose brushstrokes to resemble a painting, and transferred the print onto textured paper to give it its grainy appearance. The diagonal shape of the woman's torso emerges from the surrounding shadow as the lightest area.

Robert Demachy
1853–1937

Originally a banker, Demachy was the grandfather of post-processing. He favoured complicated printing processes, proud of methods that revealed the hand of the master. Famously declaring that "the end justifies the means", he would bleach, dye, wash, transfer, brush over, print, and substitute dyes and ink for silver in order to create painterly effects, aiming to get as far from a straight print as possible.

In 1888, he founded the Photo-Club de Paris and rose to a position of great influence in the photography world by the 1890s, thanks partly to writing extensively. The first of many shows took place in 1895 and he was elected to the Brotherhood of the Linked Ring (see pp.100–101) that year, leading to a flourishing international career. In 1914, for reasons that are still a mystery, he suddenly stopped photographing for good. His prints are highly prized today.

UNTITLED NUDE, c.1906

NAVIGATOR

1 LOST DETAILS
Demachy removes virtually all details of the setting and lower body by brushing plenty of ink into the shadowed areas. The textured paper also absorbs ink and its grain obscures detail.

2 CLOSED HAND
Without sight of the face, the hand takes on an important function, giving a glimpse into the mental state of the figure. But it is neither relaxed nor tense, which leaves the message ambiguous.

3 HIDDEN HEAD
By concealing the model's head, Demachy turns her into an object – anonymous, unknowable – better to serve as symbol. Her hair is the darkest tone in the image, contrasting with her pale body.

4 INCLINATION
Transfer processes reverse the image, so on the original print the model was leaning to the right. By convention, a leftward inclination is less active or energetic than one to the right.

AACHY

Auto Graflex

Graflex cameras were neither sleek, fast, nor beautiful, but for many years they were considered second-to-none by the world's top photographers. They could be used for anything, from domestic scenes to landscapes, weddings, and war.

Valentin Linhof
1854–1929

The Linhof Company, established by mechanic Valentin Linhof in 1887, produced the first all-metal camera in 1889. The Linhof differed from the Graflex in that it had an inter-lens shutter (a shutter located in its lens rather than at the rear of the camera body), and offered more elaborate lens movements, which suited its industrial and commercial clientele.

By 1950, Linhof cameras offered refined designs, extensive technical movements, and a coupled rangefinder. Diversifying into specialist medium-format cameras and studio cameras, Linhof is the oldest camera manufacturer in the industry.

America's most distinguished and long-lived line of cameras came from a business (the Folmer and Schwing Manufacturing Company) that switched from making gaslights to manufacturing bicycles and then to selling cameras as market conditions changed from 1887 to 1896. Then, in 1897, the company's director, William Folmer, created the Graflex camera. Its distinguishing feature was a focal plane shutter – a curtain with an adjustable slit so that photographers could regulate the amount of time the film was exposed to light. The initial design proved awkward and unreliable, but it was succeeded by the Auto Graflex of 1904, which used a simpler system of pre-set slit widths. This was surprisingly robust and stayed in production with minor improvements for over 60 years.

Graflex cameras available in three sizes were favoured for press and sports work because the shutter offered exposure times as brief as 1/1000 second. However, the shutter took at least 1/30 second to traverse the film, which caused distortions in speeding subjects such as cars (see p.79). The cameras themselves were neither quick nor easy to use, but they did offer single-lens reflex viewing (see p.240) at waist level.

The design also made it possible to dispense with a tripod, although holding it in the hand called for some brawn and dedication. The usual practice was to first set the shutter. A key at the top set the slit width – wide for a long exposure and narrow for a short exposure. Next, it had to be tensioned. The photographer then lowered the mirror with a lever and peered into the hood to frame and focus. When ready, the mirror was raised and the shutter tripped. Photographers had to be methodical and make sure they had uncapped the film before tripping the shutter, as blank exposures were common. Nevertheless, Graflex cameras, particularly the Speed Graphic models, were so extensively used by the press that they were virtually the badge of the professional.

Design evolution
In 1914, Graflex cameras cost between US$74 and US$114 (the equivalent of US$3,340 and US$5,150 – or £2,021 and £3,116 – today), and at these prices it is no surprise the company scraped through the Depression with fewer than 100 employees and limited production. But by 1957, the company had over 760 employees, and a steady line of models with variations in film format and features flowed out of

△ **CHRYSLER BUILDING**

MARGARET BOURKE-WHITE, 1931

In 1930, Bourke-White was commissioned to document the construction of the Chrysler Building in New York. On the strength of these and other images she was voted one of the five most notable women in the US.

the factory through to the 1970s. The evolution of Graflex cameras and their accessories (see pp.176–77) influenced European manufacturers such as Linhof (see left) and Sinar, and form a potted history of large-format camera design.

◁ **MARGARET BOURKE-WHITE**

OSCAR GRAUBNER, 1935

American photojournalist Margaret Bourke-White perches on one of the gargoyles at the top of the Chrysler Building in 1935 using an Auto Graflex to photograph the skyline.

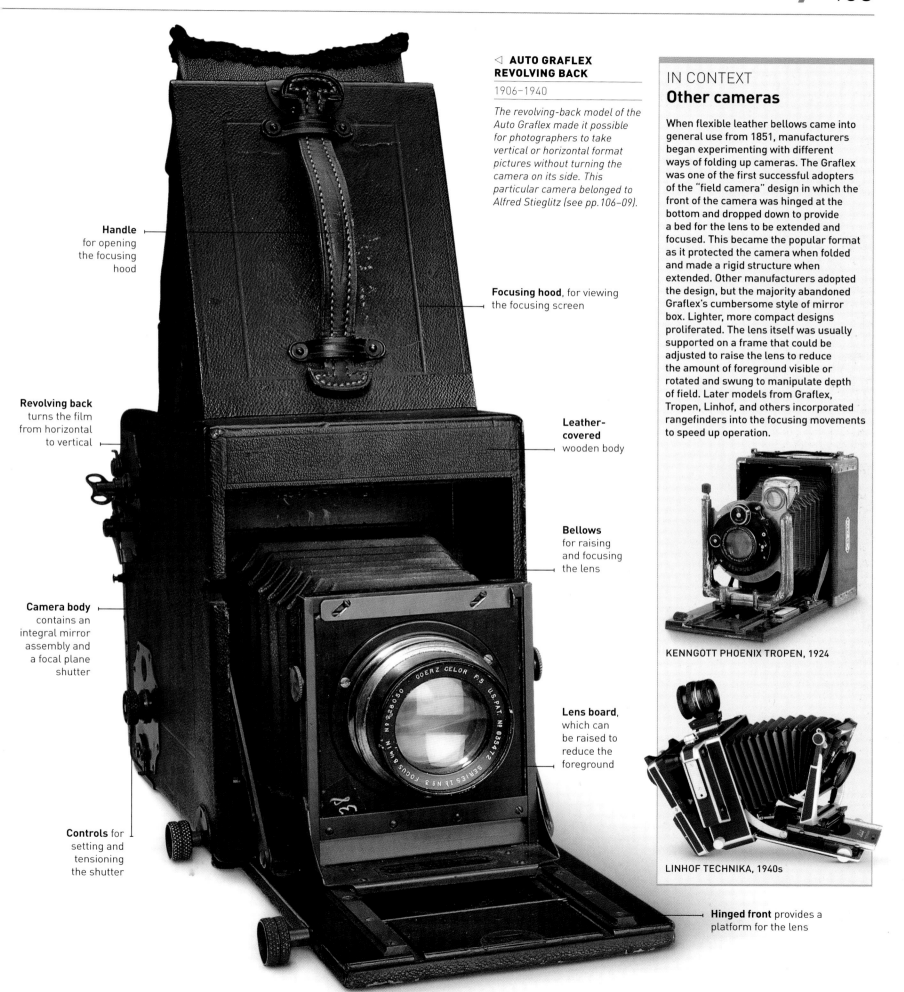

◁ AUTO GRAFLEX REVOLVING BACK

1906–1940

The revolving-back model of the Auto Graflex made it possible for photographers to take vertical or horizontal format pictures without turning the camera on its side. This particular camera belonged to Alfred Stieglitz (see pp.106–09).

Handle for opening the focusing hood

Focusing hood, for viewing the focusing screen

Revolving back turns the film from horizontal to vertical

Leather-covered wooden body

Bellows for raising and focusing the lens

Camera body contains an integral mirror assembly and a focal plane shutter

Lens board, which can be raised to reduce the foreground

Controls for setting and tensioning the shutter

GOERZ CELOR F:5 U.S PAT N° 835472 SERIES Ib N°3 FOCUS 8 ½ IN. N° 228050

IN CONTEXT
Other cameras

When flexible leather bellows came into general use from 1851, manufacturers began experimenting with different ways of folding up cameras. The Graflex was one of the first successful adopters of the "field camera" design in which the front of the camera was hinged at the bottom and dropped down to provide a bed for the lens to be extended and focused. This became the popular format as it protected the camera when folded and made a rigid structure when extended. Other manufacturers adopted the design, but the majority abandoned Graflex's cumbersome style of mirror box. Lighter, more compact designs proliferated. The lens itself was usually supported on a frame that could be adjusted to raise the lens to reduce the amount of foreground visible or rotated and swung to manipulate depth of field. Later models from Graflex, Tropen, Linhof, and others incorporated rangefinders into the focusing movements to speed up operation.

KENNGOTT PHOENIX TROPEN, 1924

LINHOF TECHNIKA, 1940s

Hinged front provides a platform for the lens

Alfred Stieglitz

AMERICAN / 1864–1946

Stieglitz was the most influential amateur photographer of his era, possibly of all time. Thanks to a private income, he could indulge his passion for art and photography, pursue his perfectionist ideals, and criticize others for trying to make a living by the camera. His early work was softly focused and, in the pictorial style, resembled painting. By 1917, he had changed his mind in line with modernism and made the most of photography's strengths rather than shrouding them in painterly effects. His work became harder-edged and played up geometric forms. Stieglitz's output was surprisingly small – it was his roles as a photography journalist and gallerist that put him at the hub of art and photography.

Born in New Jersey, US, Stieglitz spent his youth in Germany. In around 1884, he took a course on photography given by the chemist Hermann Vogel, sparking an enduring passion. On his return to the US in 1890, Stieglitz's influence grew with writing and editing for *The American Amateur Photographer* magazine, then *Camera Notes* of the prestigious Camera Club of New York. After falling out with the Club, he curated a group exhibition that launched the Photo-Secession (see pp.110–111). Its success led to his publishing the exquisitely produced *Camera Work* magazine. In 1905, he founded the first of two galleries that showed photography alongside – and equal to – other fine arts.

IN CONTEXT
Georgia O'Keeffe

In 1918, Stieglitz was so impressed by the portfolio of an artist that he exhibited the work in his gallery without consultation. So began a tumultuous relationship between him and Georgia O'Keeffe, who was the muse that he had long sought. Stieglitz photographed O'Keeffe incessantly from 1918 to 1925. His many pictures of her chimed with the modernist thought that personality constantly changes, given the pace of modern life, and so could not be captured in a single image. The photographs also expressed Stieglitz's view of O'Keeffe as much as O'Keeffe herself. Stieglitz made 350 studies of her aquiline beauty, which are unmatched for their passion, acute observation, and exuberance.

GEORGIA O'KEEFFE, STIEGLITZ, 1918

▷ **TWO TOWERS, NEW YORK**

c.1911

Stieglitz published this photogravure in Camera Work in a greenish-black ink, which softened the image and made it more wintry. The snow unifies the different components of the image, creating a painterly effect.

△ **REFLECTIONS, NIGHT, NEW YORK**

1898

Stieglitz used natural elements such as rain to bring his compositions together. Light reflecting on the wet pavement makes a glimmering backdrop to the silhouetted trees. His stated aim was to create a vision of New York that would be as beautiful to its citizens as Paris was to Parisians.

▷ **A PORTRAIT, HANDS WITH THIMBLE**

1920

The dark folds of cloth set off Georgia O'Keeffe's long, dexterous fingers as she pins the rich fabric. The photograph is one of many images that Stieglitz made of O'Keeffe's expressive hands.

The Steerage

ALFRED STIEGLITZ / 1907

Towards the end of his life, Stieglitz wrote, "If all my photographs were lost, and I were to be remembered only for *The Steerage*, I would be satisfied". Taken on a voyage to Europe in 1907 on the SS *Kaiser Wilhelm II*, one of the most luxurious liners of the time, Stieglitz and family were travelling first class. Stieglitz recounted that when he explored the ship, he saw people from the steerage class enjoying the fresh air. He rushed back to his cabin, loaded his RB Auto Graflex with the one unexposed glass negative he had, returned to the scene, and made the exposure. Although he claimed he "immediately" recognized the importance of the picture, Stieglitz did not develop the plate for a week after arriving in Europe, and did not publish *The Steerage* until four years later. It took another two years for him to exhibit it.

The Steerage was a turning point in Stieglitz's thinking about the medium of photography. Instead of aiming to recreate fine-art ideals of the past, he switched to modernist values, looking forward to the machine age, construction, and science. Captured within a modernist framework of walkways and chimney, the visual contrast between the upper and lower decks literally divides the social classes. The photograph is both of its time and well ahead, anticipating the spatially articulated documentary photographs of Henri Cartier-Bresson (see pp.204–05) and Sebastião Salgado (see pp.372–75).

> ## Wherever there is **light,** one can **photograph.**
>
> **ALFRED STIEGLITZ / 1935**

(see pp.204–05) ... (see pp.372–75).

IN CONTEXT
Modernism and art

Tired of infighting at *Camera Notes*, Stieglitz decided to launch his own magazine, "the best and most sumptuous of photographic publications". True to his word, in December 1902, he mailed out the beautifully designed *Camera Work*, filled with exquisite photogravure plates printed by his own company. He supervised every step of production, and Edward Steichen designed the Art Deco typeface and the typographic cover. Even Kodak advertisements on the back cover had to use the same typeface. For the next 14 years, *Camera Work* came out about once a quarter, featuring work by Stieglitz's friends, and from 1910 also his own paintings. Commercially it was a failure, garnering only 68 subscriptions for launch, and 302 after 10 years. Yet Stieglitz printed 1,000 copies a time. Artistically it was a treasure, but few copies survive – overstock was pulped after the final issue in 1917.

FIRST COVER OF
***CAMERA WORK*, 1903**

NAVIGATOR

1 WALKWAY
Cutting the image decisively in half, the diagonal walkway is empty and appears to go nowhere. Functionally and visually uninviting, it dominates the image and works as the axis around which all the other elements revolve.

2 STRAW BOATER
The boater symbolizes the upper classes on the upper deck. Its graceful tilt catching the light provides a point of focus for the busy scene and encourages the eye to look for more details. In contrast, the boom of the ship frames the top of the image with an industrial-scale marker line.

3 RISING STAIRS
Straight lines set at odd angles were unusual in images of the period. The stairway's upwards movement links the throng of people in the lower deck visually to those in the upper deck. These structural elements were probably what led Picasso, as Stieglitz reports, to admire the image.

4 SLICE OF LIFE
While those on the upper deck look as if they might be posing for a group photo, those on the lower deck are in delightfully casual disarray, each separately delineated. Even the clothing hanging up seems to be perfectly placed for the composition.

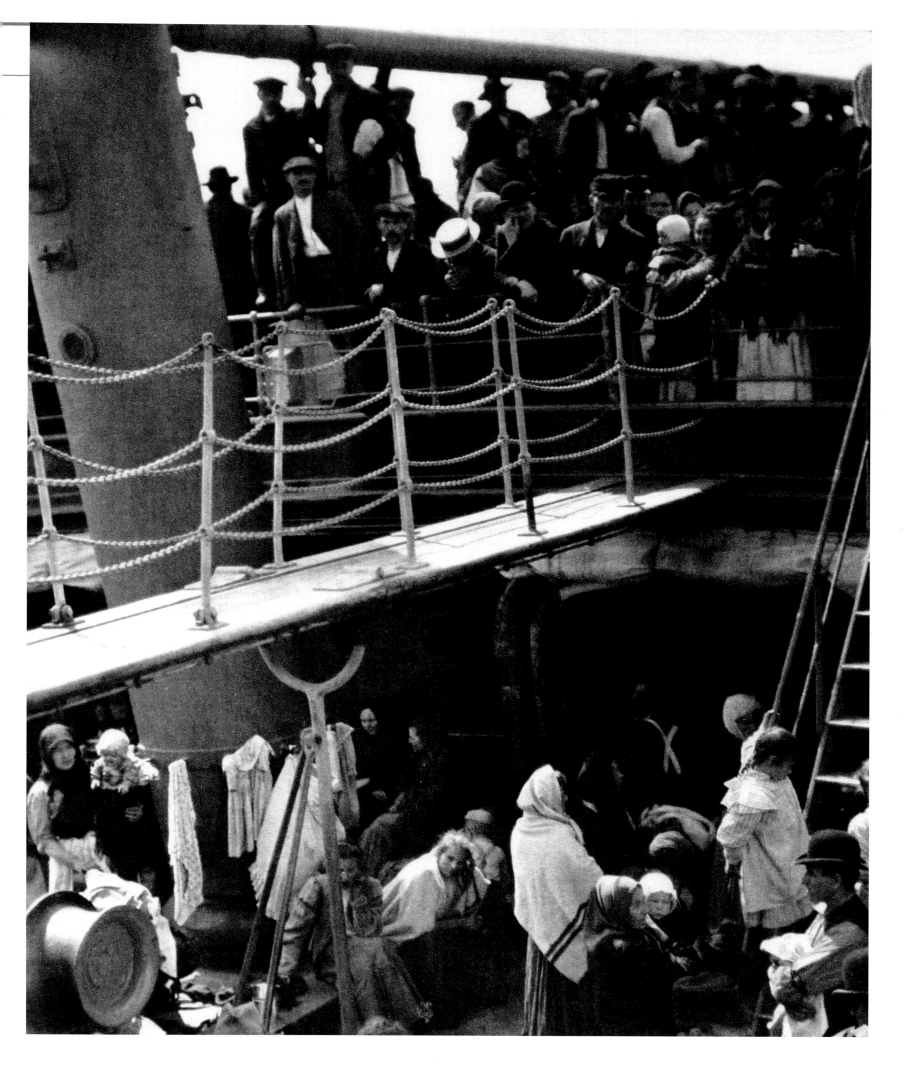

Withdrawing from reality

The same desire for recognition and status that had led British photographers to form the Linked Ring prompted Alfred Stieglitz to set up the Photo-Secession, breaking away from the Camera Club of New York.

▽ **KAHLIL GIBRAN**

FREDERICK HOLLAND DAY, 1897

Day often took only one print from a negative, like an artist whose painting is unique. He always made platinum prints, and the rich mid-tones and subdued highlights of the process are evident in this portrait. The sitter was a Lebanese immigrant to Boston, who became a well-known author. Here, he is posing with a copy of his famous book The Prophet.

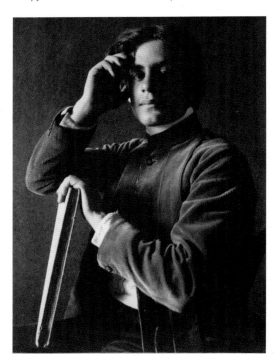

Alfred Stieglitz was anxious to the point of obsession about the status of the photographer and took advantage of every editorial and curatorial opportunity to promote photography as an art in its own right. In 1902, the National Arts Club, a leading private club dedicated to "educating the American people in the fine arts", asked Stieglitz to put together an exhibition of the best contemporary American photography. This might have been expected to please Stieglitz, but instead, he used disagreements about whose work should be included to engineer a show of artists he had hastily bundled together.

New direction

Just two weeks before the exhibition was to open, he called the group the Photo-Secession, distancing them from amateur clubs, and in particular from the Camera Club of New York. Well aware that the word "secession" had strong political overtones for many Americans, Stieglitz took as his model the anti-establishment movements in London and Munich, which he had watched with admiration.

When talking about the Secession of the Association of Visual Artists in Munich, he stated: "The most advanced and gifted men of their times" (implying that others were neither as advanced nor as gifted) "have admitted the claims of the pictorial photograph to be judged on its merits as a work of art independently, and without considering the fact that it has been produced through

... the camera". The core of the Photo-Secession comprised Stieglitz, Alvin Langdon Coburn, Frederick Holland Day, Frank Eugene, Gertrude Käsebier, Edward Steichen, and Clarence H. White. Others came and went according to Stieglitz's shifting tastes and whims.

Artistic creation

As a group, the Photo-Secession favoured techniques that would produce soft, painterly or obviously manipulated effects. Soft-focus lenses and gauze or scrim (an open-weave fabric) were used to blur images and the photographers chose materials such as platinum and carbon to enrich their prints, and toning to add colour.

However, a split was developing within the group as it tried to establish its collective ideals. Some of the more perceptive photographers struggled with the contradiction inherent in pictorialism. Using effects such as visible brushstrokes and textured papers to emulate painting meant that photographers were kowtowing to fine-art techniques. Surely, these photographers argued, exploiting the strengths and limitations of the pure photographic process would be a better way to assert photography's standing as an art in its own right. This tendency was most evident in the work of Edward Steichen (see pp.116–17) and Alvin Langdon Coburn, and in some of Frederick Holland Day's portraits. The same tension could be found even in Stieglitz's work (see *The Steerage*, pp.108–09).

Gallery promotion

The influence of the Photo-Secession spread far and wide, thanks in part to Stieglitz's inspired creation of galleries dedicated to promoting his ideas. In 1905, with Edwards Steichen

he set up the Little Galleries of the Photo-Secession, which showed until 1908. The same year, he opened Gallery 291, where he showed sculpture and paintings, as well as photographs, from 1910 until 1917. He also showed the work of photographers such as Paul Strand, whose increasingly modernist work was stylistically far removed from the first Photo-Secession show.

Stieglitz's changing ideas about photography eventually prompted others to secede from him. In 1916,

▽ **AMÉLIE RIVES**

PIERRE TROUBETZKOY (PRINTED BY
ALVIN LANGDON COBURN), 1904

*Coburn transformed Troubetzkoy's image in the
darkroom with gum bichromate over platinum
to resemble pure pictorialist work, with muted,
warm tones and suffused light. He deliberately
increased the foreground shadow and used the
soft focus to create a sense of atmosphere.*

Clarence H. White formed the Pictorial
Photographers of America with Karl
Struss, Edward Dickinson, Gertude
Käsebier, and others. This was to be
a national organization promoting the
use of artistic expression to counter
commercialized and mechanized
photography. In short, it was formed
to continue promoting pictorialism.

A year later, the Photo-Secession
was quietly dissolved, but pictorialism
continued to influence photography
for at least another 40 years, and its
impact can still be felt today.

△ **THE RUDDER, LIVERPOOL**

ALVIN LANGDON COBURN, 1906

*Photographed and platinum-printed by
Coburn, the smudged outlines and
addition of colour are typical of the
Photo-Secession's painterly effects.*

ON TECHNIQUE
Platinum paper

The doyen of printing processes, the
platinotype or platinum print was invented
by William Willis in 1873. Its extended
mid-tone range, suppressed highlights,
and rich shadows, coupled with a matte
surface, made it a great favourite with
pictorialists. The process used paper
coated with a potassium-platinum
chloride salt. The tones of the print could
be varied depending on the processing
temperature or be changed by salt-toning
to different colours. As there was no
gelatin coat, the image lay deep within the
paper's fibres, with some fine variation
in surface quality depending on the
quantity of metal present.

When platinum became widely used in
car exhausts, its cost rose, and palladium
was substituted until that also became too
expensive. Platinum prints are still made
by photographers for archival art prints.

THE ODOR OF POMEGRANATES, PLATINUM
PRINT, ZAIDA BEN-YUSUF, c.1900

 MINUET

FRANK EUGENE, 1900

American Frank Eugene was one of the first members of the Photo-Secession (see pp.110–11), a group of photographers who favoured painterly effects. He used an etching needle to scratch textural lines into the background of this picture of a woman curtseying before dancing a minuet, creating an image that is part photograph and part etching.

Women pioneers

Photography developed so quickly that there was no time for prejudice to form against female photographers. Even though women were still denied the vote, those with ability found professional photography a refreshingly level playing field.

Gertrude Käsebier
1852–1934

After bringing up a family, Gertude Käsebier studied painting at the Pratt Institute in New York. In 1896, she took up photography professionally and in 1899, Alfred Stieglitz published five of her photographs in *Camera Notes,* and described her as the leading artistic portrait photographer of the day. A print of one of her photographs, *The Manger,* sold for US$100, a record for any photograph at the time. In 1902, Stieglitz included Käsebier in the Photo-Secession.

There was, however, a difference of opinion, as Käsebier had to support her family financially and Stieglitz was against commercial photography. Käsebier therefore subsequently resigned from the Photo-Secession and joined the Professional Photographers of New York. In 1916, she joined Clarence H. White to form the rival Pictorial Photographers of America group.

Käsebier's artistry and independence inspired generations of future photographers, such as Imogen Cunningham (see pp.158–59).

KÄSEBIER WITH HER CAMERA, 1905

Although some female photographers such as Anna Atkins (see pp.18–19) and Julia Margaret Cameron (see pp.66–67), are still well known, many who were celebrated in their day, such as Lady Clementina Hawarden and Carine Cadby, have fallen into obscurity, and others have been overshadowed by their better known husbands. Few have heard of Geneviève Disdéri, the successful photographer wife of André Disdéri (see pp.56–57), and Lucia Moholy-Nagy is considerably less well known than her famous husband, László (see pp.138–39).

Bertha Wehnert-Beckmann was the first woman to open her own photography studio, in Germany in 1843, while from the 1860s, Harriet Chalmers Adams, Marian Hooper Adams, Laura Adams Armer, Rose Clark, and Alice Austen were all busy in the US, producing work ranging from portraits to landscapes and studies of Native Americans.

Trailblazers
By the 1880s, many women were learning photography at schools such as the Berlin Lette-Verein and the Pratt Institute of Art and Design in Brooklyn, New York. Alice Boughton and Gertrude Käsebier were both students at the Pratt.

In the 1890s, when Alice Boughton opened her own portrait studio in New York, women were among the leading professionals of the day. Boughton ran her studio for 40 years, taking portraits of many well known literary and theatrical personalities. She also produced studies of children, both informal and as tableaux vivants, and of nudes posing in natural or allegorical settings. Others, such as

Anne Brigman, were self-taught. Within a year of starting photography, Brigman was exhibiting in the San Francisco Bay area. One of the two original California members of the Photo-Secession (see pp.110–11), she produced a series of innovative and sensitive tableaux featuring nudes in the landscape, for some of which she posed herself.

In 1894, Eva Watson-Schütze opened a studio in Philadelphia with another photographer but she soon went solo. Spirited about the role of women in

△ **MISS ZAIDA BEN YUSUF**

ZAIDA BEN-YUSUF, 1901

Ben-Yusuf took this pensive self portrait to accompany her article The New Photography – What it has done and is doing for Modern Portraiture, *which was published in* Metropolitan Magazine.

photography, she stated, "There will be a new era, and women will fly into photography...". Asked by Frances Johnston in 1901 to contribute to a show of work by American women photographers, she replied tartly, "I have been very emphatic about [this:] not to have my work represented as 'women's work'. I want [it] judged... irrespective of sex".

Celebrated portraitists
In 1897, both Gertrude Käsebier and Zaida Ben-Yusuf opened their own portrait studios. Ben-Yusuf appears to have been self-taught. She arrived in New York from London in 1895 and worked as a milliner. A year later, her photographs were shown in a Linked Ring exhibition (see pp.100–01) in London. She produced elegantly dressed portraits in an elaborately adorned studio. Her style – modern in gesture but less radical in aesthetics – had much in common with that of Edward Steichen. Ben-Yusuf was also a prolific writer, penning many articles on portraiture and photography for amateurs.

Gertrude Käsebier, a member of Stieglitz's Photo-Secession, was one of the leading pictorialists of her day. Independent-minded, she was against the stilted conventions of studio photography and preferred to pose her subjects in a natural, but carefully considered way, without scenic backdrops or props, to convey the sense of a personal moment caught impromptu.

Her best-known work celebrated the close relationship between mother and child. The visual poetry of her tranquil images conveys an idealized vision of motherhood with unsurpassed delicacy and poignancy.

◁ THE FAIRIES' HAMMOCK

CARINE CADBY, 1908

The British photographer Carine Cadby wrote stories for children and illustrated them with her own pictures, hence the whimsical title of this exquisitely photographed cobweb etched in dew.

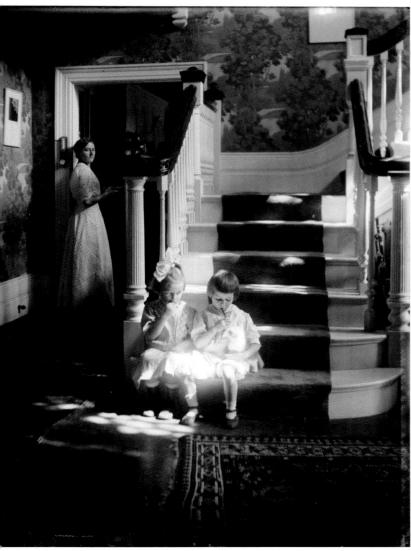

◁ LOLLIPOPS

GERTRUDE KÄSEBIER, 1910

This image displays Käsebier's total mastery of composition, light, and placement of subjects, as well as a meticulous orchestration that catches the gentle moment as if on the wing.

△ EDEN

ANNE BRIGMAN, c.1900–10

Brigman usually set a nude figure within a carefully chosen landscape, often the forests and mountains of California where she lived. She aimed to show the human figure spiritually connected to the trees or other natural elements.

Edward Steichen

AMERICAN / 1879–1973

Steichen was an artistic giant who strode from the soft focus of his early works to the highly polished fashion photography for the likes of *Vogue* that brought him international stardom. He was famously the best-paid photographer of the day, and even won an Academy Award with his war documentary *The Fighting Lady*.

Born Éduard Jean Steichen in Luxembourg, the infant Steichen emigrated with his family to the US in 1880. During a printing apprenticeship, he taught himself photography with a Kodak Detective camera. In 1900, he met Alfred Stieglitz, an encounter that proved fruitful for both. Steichen designed *Camera Work* (see p.108) and was one of the most frequently featured photographers throughout the magazine's life. At the turn of the century, Steichen worked in a pictorialist style, deliberately using soft focus and hand-colouring some of his prints to imitate fine paintings, but he also took portraits and soon switched to photographing celebrities and models.

Challenged to promote fashion as an art form, Steichen went even better. He proved – by his presentation of the beauty of clothing – that fashion photography itself was art. In 1923, Steichen became chief photographer for Condé Nast Publications in New York, and joined J. Walter Thompson as their advertising photographer. He also spearheaded the explosive growth of photography in advertising – from 15 per cent of advertisements using photographs in the 1920s to 80 per cent by 1930. Later in his long career, as director of the department of photography at New York's Museum of Modern Art, he assembled the 1955 exhibition *The Family of Man* (see pp.226–27).

> Photography is a major force in **explaining man to man**.

EDWARD STEICHEN / 1961

△ **THE FLATIRON, NEW YORK**

1904

This twilight study mimics the Nocturnes *of the artist Whistler that Steichen had seen in Paris, harking back to fine-art traditions. Steichen subtly coloured the print to make it even more painterly. The centrally placed skycraper, however, too tall to fit in the frame, looks forward to modern New York.*

▷ **DANCER IN MIDAIR**

1935

Steichen catches the moment when Antonio DeMarco lifts his dance partner, wife Renee, high into the air. Steichen emphasizes the monochrome palette with sharply divided tones and keeps the setting stark in contrast to his softer earlier style.

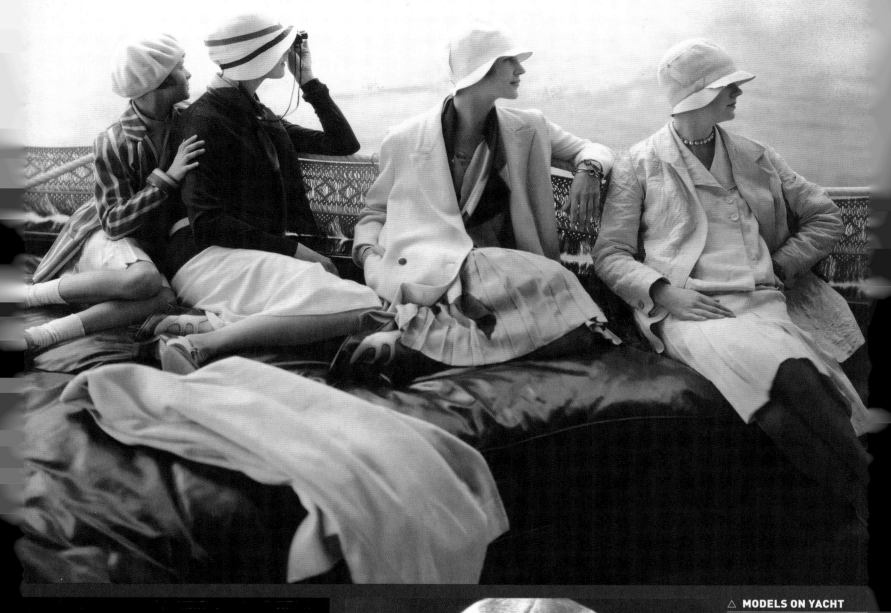

△ **MODELS ON YACHT**

1928

Working for Vogue publishers Condé Nast Publications, Steichen shows the models sporting pleated skirts and cloche hats, two major trends of the 1920s. The elegance of the crisp outfits and the luxury of the yacht combine to create an image of stylish leisure.

◁ **POLA NEGRI**

1925

Strong lighting accentuates Hollywood starlet Pola Negri's chiselled cheekbones and glints off her exotic lamé turban, set off by the surrounding dark tones.

Out in the cold

Cameras could now go anywhere, no matter how hostile the conditions, but photography in the Antarctic also reinforced a growing conviction that nothing of any significance should take place without being photographed.

By the beginning of the 20th century, the Arctic and Antarctica were the last unexplored areas of Earth, and the race was on to be the first country to reach the North and South Poles. Given the weight and bulk of cameras, Arctic explorers had to do without much valuable food and survival equipment if they were to capture a photographic record of an expedition. This sacrifice made a journey costlier and more dangerous. Yet, for many adventurers, a visual record was essential as proof of their travel.

For all that, a photograph of Robert Peary's sledge party, taken in 1909, utterly failed to stop controversy over his claim to have reached the North Pole. The picture proved nothing – it just showed five men posing with flags around an impromptu snow hill that could have been anywhere. Peary's log had suspicious gaps, and incredible claims of travelling 217km (135 miles) per day. Photographic "proof" could not outweigh the doubts these caused.

Roald Amundsen beat Robert Scott's attempt to reach the South Pole by a month, and returned to tell the tale, unlike Scott and his team.

The pictures of Scott's journey are better known, however, because he had a better photographer. A Japanese navy team led by Nobu Shirase was also in the 1911 race, but they too failed to return home with such memorable pictures.

Art in the Antarctic

By the time Herbert Ponting was selected for Scott's *Terra Nova* expedition, he had been a gold miner, fruit farmer, war photographer, journalist, and an adventurer in Asia. In 1911, Ponting set up a small darkroom at the expedition's winter camp at Cape Evans on Ross Island. Using glass plates, because film was extremely fragile in freezing conditions, Ponting made some of the most memorable exploration pictures of all time. He also took Autochrome plates, making the first colour images of the Antarctic, and used a hand-cranked film camera for the first time.

With South Pole fever running high, Australian geologist Douglas Mawson turned down an invitation to join Scott's group in order to lead his own trip. The photographer was Frank Hurley (see p.134–35), who cornered Mawson on a train and talked his way into the job. Hurley had a reputation for crazy risk-taking in order to "get the shot".

In the Antarctic, Hurley made colour photographs using the Paget process (similar to Autochromes and Finlay Colour), as well as black-and-white plates. He also shot a great deal of film footage. He later joined Shackleton's 1914 expedition, creating his best-known work, of the *Endurance* being slowly consumed by ice. In 1917, he joined the Australian Imperial Force in Europe, producing outstanding war photography.

▷ **DEATH OF A SHIP**

FRANK HURLEY, 1914

Ernest Shackleton's ship Endurance *was finally crushed by ice in the frozen Weddell Sea after the crew abandoned it. Hurley managed to rescue his cameras and some of his glass plates but was forced to leave hundreds of them behind.*

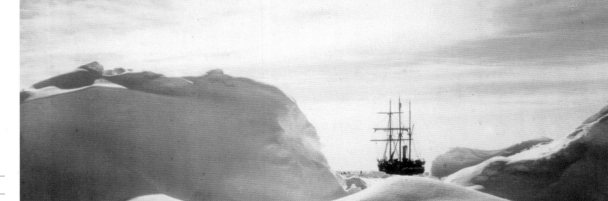

◁ **PEERING OUT**

HERBERT PONTING, 1911

Two members of Robert Scott's team gaze out at the Terra Nova. *The cave, formed in an iceberg, looks as if a wave has flash-frozen whilst crashing, reflecting the brutal nature of the Antarctic landscape and the ship's vulnerability.*

△ **DOOMED DOGS**

FRANK HURLEY, 1915

A member of Shackleton's Endurance *team, Tom Crean holds husky puppies born aboard ship. The dogs were used to pull huge loads across the ice. When supplies ran low, many of them died from overwork and starvation.*

Early colour photography

Unlike the birth of photography itself, which involved a lot of fumbling in the dark, colour photography was worked out in principle long before it was put into practice. It took over 70 years for technology to catch up.

UNIDENTIFIED GIRL, J. GARNIER, c.1850

▷ **WOMAN ON A RED HAMMOCK**

ALVIN LANGDON COBURN, c.1908

One-shot colour photography finally came of age with the autochrome. Patented by the Lumière brothers in 1903, the process utilized dyed starch grains, which acted as colour filters. American photographer Alvin Langdon Coburn travelled to France to learn the process from Alfred Stieglitz.

People's ready acceptance that photography reproduced reality is remarkable considering the most obvious of its many deficiencies – its lack of colour. It is also curious that the photographic work of Scottish physicist James Clerk Maxwell was largely ignored by his contemporaries – perhaps because he was more concerned about supporting his theory of colour vision than about advancing photography. In 1861, however, he produced the very first colour photograph. Using a Scottish tartan ribbon as a subject, he made three black-and-white images through red, green, and blue filters, and then made prints on glass plates. When the images were projected through the corresponding filters, a colour image emerged.

The trichrome process

The first and greatest genius of colour photography was French inventor Louis Ducos du Hauron. From 1859, he spent nine years working out the principles of virtually every colour process that would ever be used by photographers. He cannily took out patents on his ideas in 1868 and published his results the following year in the epochal *Les Couleurs en Photographie, Solution du Problème* (Colours in Photography, Solution of the Problem). He was also a technical inventor, and adapted the carbon printing process of Alphonse Poitevin to make the first colour print, using cyan, magenta, and yellow subtractive filters. It was half a century before anyone caught up with his ideas, but even then, assembly methods for this trichrome process (see box, right), which required three initial exposures, then three more to make the prints, were limited to static subjects.

Fellow Frenchman Gabriel Lippmann made the first one-shot capture of colour in 1891. Building on the work of Edmond Becquerel and Otto Weiner, Lippmann covered one side of a glass plate with an emulsion of silver nitrate and potassium bromide and coated the back with mercury. After processing, a coloured image appeared, created by incoming light interfering with light reflected off the mercury. It was the first direct-positive colour image.

▷ **STILL LIFE WITH ROOSTER**

LOUIS DUCOS DU HAURON, 1879

Scientist Louis Ducos du Dauron produced this colour image by photographing the scene three times through three different colour filters, then printing the exposures on pigmented sheets of bichromated gelatin and combining the final transparencies.

The Lumière Brothers

Lippmann's achievement was greeted with great excitement by French experimenters Auguste and Louis Lumière, who were also working on colour photography. However, they soon encountered the limitations of the Lippmann process – the low sensitivity of the colour plate and its inability to generate copies. (Experience gained with Lippmann emulsions was not wasted, however: in the 1970s, it proved essential for the development of holography.)

In 1895, the Lumières patented a process called ALL Chroma, which used dichromated colloids and dye imbibition, but it was too complicated for general use. Taking a different tack, they then patented the so-called "Autochrome" in 1903, although four years would pass before it could be made commercially. In the words of the patent application: "The invention consists of a... series of layers, characterised by the interposition, between the light-sensitive layer and the glass which acts as a support, of a layered screen composed of coloured elements". These coloured elements were tiny grains of starch that were coloured either red, green, or blue. Although sensitivity was low, the richness of the colour was revelatory. Thus, Autochromes decisively launched colour photography, and they stayed in production until the 1930s. In 1931, the Lumière Brothers introduced Filmcolor, a film-based version of the process, then Lumicolor, a roll-film version, in 1933.

9.606

ON TECHNIQUE
Trichrome images

The first trichrome camera was based on the "magic lantern" projector, which could cast a colour image but not capture it. Designed by Dr Adolf Miethe, the camera exposed a narrow glass in three separate steps, made through red, green, and blue filters respectively. After processing, positive plates were made and projected through their respective filters in a triple projector. The trick, which required great darkroom skills, was to match the contrast and density of the prints to produce a balanced image. The camera went on sale in 1906.

MAGIC LANTERN

BLUE FILTER

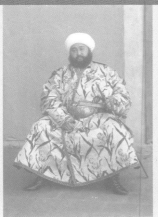

GREEN FILTER

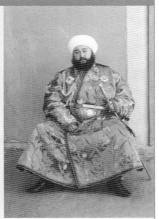

RED FILTER

Sergei Prokudin-Gorskii

RUSSIAN / 1863–1944

Born near Moscow, Russia, Sergei Prokudin-Gorskii was one of the most accomplished photographic technicians of his time. He trained as a chemist and studied photography in Germany under Adolf Miethe, the co-inventor of the camera flash. With him, he learnt about colour processes and used a camera built by Wilhelm Bermpohl to Miethe's design.

For his big project – to document Russia in order to educate children about its empire – Prokudin-Gorskii chose the Miethe method. This involved making three separate exposures through blue, green, and red filters. A holder slid down the plates for each exposure. When the positive images were projected together, they produced a startlingly bright and colourful picture.

Prokudin-Gorskii's presentation of his project to Tsar Nicholas II must have been impressive, because he was given a railway coach kitted out as a darkroom, as well as permits to visit all corners of the Empire. From 1909 to 1915, he photographed landscapes, buildings, and people throughout Russia, Central Asia, and Siberia, recording a way of life that was to change dramatically just two years later, with the October Revolution.

> By words one **transmits thoughts** to another, by means of art, one **transmits feelings.**

LEO TOLSTOY / 1896

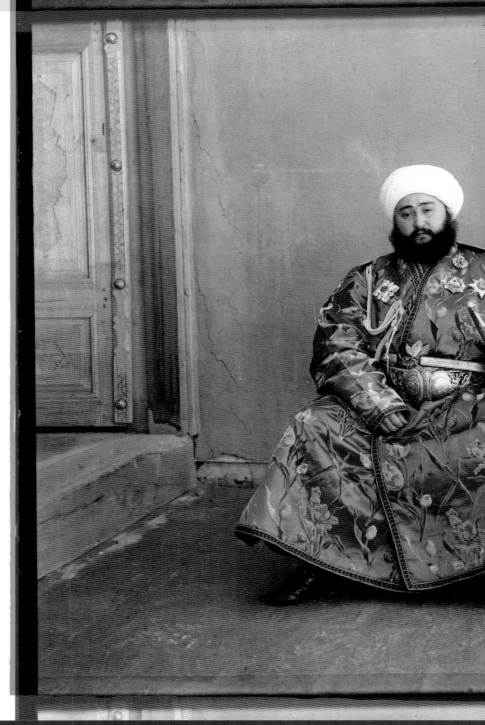

▷ **YOUNG RUSSIAN PEASANT WOMEN**

RUSSIA, 1909

The three-colour process brings out the rich hues of the traditional dress worn by peasant girls. They seem to be dressed in their best clothes because they are being photographed by the tsar's photographer. The coloured borders visible around this and the other photographs are made by the three negatives.

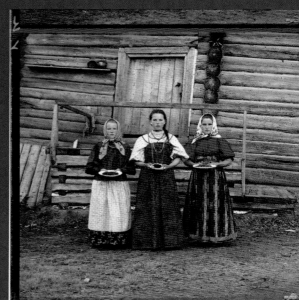

△ THE EMIR OF BUKHARA

UZBEKISTAN, 1911

Prokudin-Gorskii photographed princes and lords as well as the ordinary people. The delicate decoration of the door panels and the Emir's robe, embroidered with chrysanthemums, contrast with the crumbling walls and step.

▽ LEO TOLSTOY

YASNAYA POLYANA, RUSSIA, 1908

The great writer is pictured in his garden, in conditions Prokudin-Gorskii described as "unfavourable". Poor light and stormy weather dim the brightness of the three-colour process.

▽ SETTLEMENT OF GRAFOVKA

MUGAN, AZERBAIJAN, 1910

Strong sunlight bleaches this image of a family of Russian settlers who have moved to Azerbaijan on the borders of the Russian Empire.

◁ BASHKIR SWITCHMAN

SIBERIA, 1912

The Trans-Siberian Railway, the longest railway in the world, was built to cross Russia and connect Moscow to China and Mongolia. This image taken near the border with Kazakhstan shows a railway worker of Bashkir descent – a Turkic person from Bashkortostan.

◁ **TRIUMPHANT AVIATOR**

LÉON GIMPEL, 1915

French photojournalist Léon Gimpel befriended a group of Parisian children who had created their own "air force". Pépète, the little boy featured in this image, was the ace aviator who had just brought down the enemy's plane. The original is an autochrome, a rare colour photograph from World War I.

Eugène Atget

FRENCH / 1857–1927

Jean-Eugène-Auguste Atget is celebrated for his extensive photography of Paris, but few tourists would recognize his city. Although he explored everywhere, he largely ignored the great sights and landmarks, diving instead into dark alleyways and hidden courtyards. Documenting the run-down boutiques, street pedlars, and forgotten churches from 1897 until his death in 1927, Atget roamed and worked incessantly, systematically covering subjects such as statues, parks, and shops to produce a legacy of some 10,000 negatives. He subsisted on a simple diet of bread and milk because more would be "immoderate luxury".

He was not as focused in his early life, however. An orphan from an early age, he went to sea until his 20s, then decided to become an actor, but his lack of success showed that he had not found his true calling. In 1890, after failing as a painter, he set up a photography business in Paris offering "documents for artists" – visual reference for paintings. His clients included Georges Braque, Henri Matisse, and Pablo Picasso.

By that time, Baron Haussmann's new vision for Paris had sliced through medieval streets with grand boulevards, knocking down 20,000 houses and building 40,000 new ones. Traditionalists were horrified, but Atget had found his calling. As he wrote to the Minister of Fine Arts, he worked "in all the old streets of Old Paris to make a collection of 18 × 24cm photographic negatives: artistic documents of beautiful urban architecture from the 16th to the 19th centuries". In 1910, he sold 2,600 negatives to the government for 10,000 francs.

Sadly, Atget's reputation was secured posthumously. While the French seemed unaware of the treasure on their doorstep, American photographer Berenice Abbott exhibited his work to wide acclaim in the USA, and in 1930 published *Atget, Photographe de Paris*, which sealed Atget's international fame.

▷ **BOULEVARD DE STRASBOURG, CORSETS**

1912

The surrealists were interested in Atget's work, which included many images of shop windows. The reflective as well as the transparent quality of the glass held a dreamy appeal – even more so when the subject matter was limbless mannequins.

▽ **LAMPSHADE VENDOR**

1899–1900

Atget placed the street vendor architecturally, to stand at the meeting point of several sets of strongly converging parallels of the street and buildings, underlined by the cobblestones.

▽ **WORKER'S INTERIOR**

1910

Atget made an album of 60 photographs of Parisian interiors. He intended it to be an inventory of artistic, bourgeois, and, as here, working-class homes.

◁ **RUE SAINT-RUSTIQUE, MARCH**

1922

A narrow, cobbled street gave Atget a sample of the Old Paris he was looking for. Sunlight falls on the walls on one side but does not reach the pavement, emphasizing the confines of the street,

Quai d'Anjou

EUGÈNE ATGET / 1924

For all his eccentricities and reclusive ways, Eugène Atget was a careful and systematic photographer. He kept detailed lists, not only of his negatives but also of the prints he made. Each negative had a number scratched on the emulsion side.

Atget's standard, and unremarkable, equipment was an 8 × 10in camera equipped with a normal focal length lens. It was probably of rectilinear design, which gave good correction and low distortion. Atget preferred street-level images so he made almost constant use of the camera's rising front – this raised the lens vertically to view more of the upper part of the scene without having to point the camera upwards, which would make the verticals lean backwards. Atget's often excessive use of rising front settings caused a feature seen in many of his images – darkened top corners.

Exposing on glass plates some 1.5mm (1⁄16in) thick, Atget originally made contact prints using albumen paper (paper brushed with egg white and salts). This image was made using a gelatin-based printing paper, which provides more neutral and sharper tones than albumen. Atget's command of photography improved steadily. By the time he took this image, he had honed his camera placement and sense of lighting, delivering this quietly transcendent view of an early morning by the river – a scene that has changed little since.

NAVIGATOR

1 LOW HORIZON
The line of barges and the road converge towards the bottom quarter of the image. The horizon is slightly below the level of the road, opening up the top section.

2 SLANTING SHADOWS
The early morning – it was 6am – shadows of trees on the apartment buildings add variety and texture to their surfaces. They project from centre to bottom right, an integral part of the image's composition.

3 STEPS TO THE STREET
The steps (which still exist) are strongly positioned in the centre. They are the hub of the image, and lead the eye to the small figures at river level.

4 OUT OF THE CIRCLE
The dark corners – caused by too much upward lens movement – would usually be regarded as technical flaws, but they are so common in Atget's work that they are almost a visual signature.

FORGING AN IDENTITY

1851

1897

1889

The public became aware of photography in the early 20th century not because of the Kodak Brownie – which was still a relative luxury – but because photographs began to appear on the printed page. The invention of the half-tone and the combination of lithography and cylindrical presses were as socially and technologically significant as the World Wide Web was to be towards the end of the century. At first, somewhat hesitantly, designers used photographs singly in magazines and newspapers, but photographs were soon on the covers and occupying more and more inside pages as production costs fell and publishers' confidence grew.

Page design was no longer dictated by that of books, which had scarcely changed since Gutenburg invented moveable type in the 15th century. Photographers gained confidence in the political power of their pictures and their ability to influence the opinions of newspaper readers. Far removed from the cloistered debates it had previously provoked between

academics and artists, photography proved to be an excellent tool for propaganda. Although the camera does not lie, it may be used by those who do. While reformers used photography to speak up for the disenfranchised, others used images to validate the indefensible. Photographs may have appeared to be neutral, but they became an ideological pawn.

Yet photography's ability to record things with fidelity and to immortalize fleeting moments took it to the farthest reaches of the planet. Its dispassionate representation made it the perfect tool for those who wished to preserve the overlooked, to catalogue variety, index criminality, and glory in minutiae. As mechanical skills and the understanding of optics improved, photography became more nimble and capable of doing more with less. Photographers nosed their cameras into ghettoes, flew in the air, and climbed towers. Their project to educate the modern eye by holding a mirror up to society and humankind began to pick up pace.

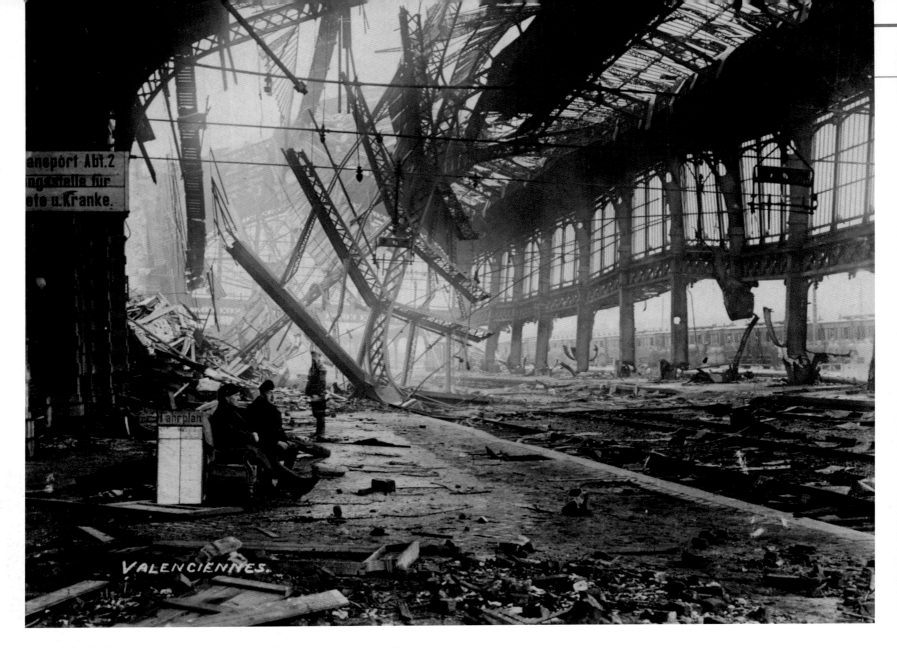

World at war

Photographically, the story of World War I is patchy. Professional photographers had their work censored, so they had to provide images that would stoke public enthusiasm for the war.

On a practical level, World War I generated more photographs than all the previous conflicts put together, the American Civil War included. It was the first war to make administrative use of photography, thanks to the low cost and bulk-processing properties of roll film. To handle the immense task of mobilizing millions of men within weeks, teams of photographers were set up to produce identity pictures. One German team in 1915, for example, had 60 photographers and 250 administrators. Their output was claimed to have reached some 30,000 prints every day.

Any pilot who could use a camera while flying an aeroplane undertook aerial reconnaissance. Pilots took tens of thousands of aerial pictures of trenches, cannon emplacements, and troop movements. One ingenious camera design, the Williamson Aeroplane Camera, used a propeller driven by the airflow to power the film and shutter mechanism.

Propaganda and censorship

Every country had its corp of official photographers, who took much of the record of the war. Military or propaganda departments were in charge of administering their work, supplying the press with the images that the respective governments wished to show, such as destruction caused by the enemy.

Many photographers were recruited from the press – about half of the British team were from the *Daily Mirror* newspaper, for example. They were briefed to take pictures that would buoy up public support for the war. Images of troop losses and violent death were not acceptable.

Photography from any front, particularly the tightly controlled theatre in Europe, had to pass

censorship. Pictures were formulaic, posed documents of what the authorities wanted to promote. Professional photography of any free-ranging kind seems non-existent.

A small amount of personal photography has emerged. German soldier Walter Kössler's photo album, which chronicles his four-year journey from enlistment optimism to records of devastation on the German side, is a rare example. Wilhelm von Thoma took many incidental shots of his fellow soldiers, checking their clothes for lice or sitting in bomb craters, for example. And in 2011, photographs made by 16-year old Walter Kleinfeldt, who fought at the Somme, were rediscovered in the German town of Tübingen. Their frank and honest coverage of the war would not have survived the attention of censors. There were a number of unaccredited American photographers in the battle zone, and one unknown French innovator even took a Jules Richard Verascope stereo camera and colour film to the front line.

Australian photographer Frank Hurley took the most distinguished official coverage of the Western Front.

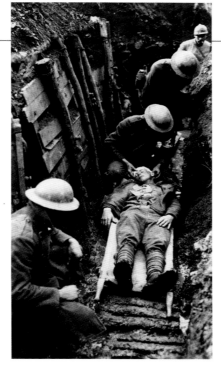

◁ **US MARINE RECEIVING FIRST AID**
SERGEANT H. LEON, 1918

An amateur photographer depicts a fellow marine having his wounds treated before going to hospital. Amateurs operating outside censorship could record real life in the trenches.

He was given the rank of Captain when he returned from Antarctica in 1917 (see pp.116–17) and sent off to photograph the First Australian Imperial Force in action. His assignment turned out to be one of the bloodiest – the Passchendaele campaign in Belgium. He approached the work with such naivety and determination that he was soon

known at the front as "The Mad Photographer". Hurley complained that it was impossible to obtain the photographs he wanted in the chaos of battle and resorted to combining different negatives into a single image. These creations fell foul of the official Australian war correspondent Charles Bean – already a veteran of the Gallipoli campaign – who branded them fakes. To keep the peace, Hurley was assigned to Palestine, but his photographs of obliteration on the Western Front are some of the most haunting images of the war – he described Ypres as "a weird and wonderful sight, with the destruction wildly beautiful".

ON TECHNIQUE
Press camera

Derived from a long line of cameras dating back to 1898, the Top Handle Speed Graphic was in production from 1912 to 1917 in Rochester, New York. Its sturdy, simple construction and generally reliable mechanics made it standard issue for press photographers around the world. These early models had a small lensboard, which limited the speed of lenses. Different models took different-sized sheet film, and the speed and slit size of the focal plane shutter had to be set separately, so it was a slow camera to use. But it was capable of excellent results, and the various viewfinder and focusing methods made it easy to shoot with.

SPEED GRAPHIC, 1912

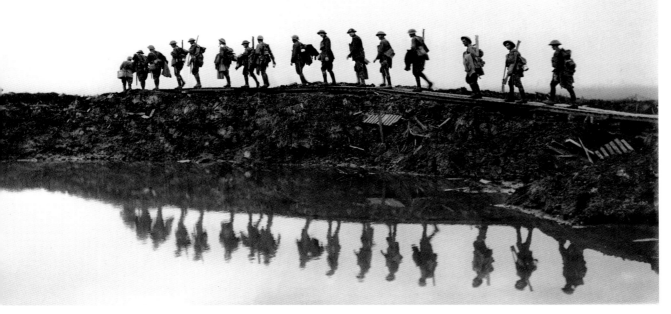

◁ **FLANDERS SOLDIERS**
FRANK HURLEY, 1917

Hurley created an image of bleak beauty from the carnage near Ypres in Belgium, with soldiers walking along a duckboard track reflected in a water-filled bomb crater. The print exists in two variants. Some show three observation balloons as small dots in the sky to the left; others (as here) have no balloons. Either the balloons were removed in one version or they were added by multiple exposure or sandwiching negatives in the other.

Rurales

AGUSTÍN CASASOLA / c.1914

In 1907, Mexican press photographer Agustín Casasola won instant notoriety when he climbed a telephone pole that overlooked a prison wall to obtain exclusive pictures of an execution. He responded to the collapse of the autocratic rule of Mexican President Porfirio Diaz in 1910 with characteristic dynamism. Hauling his large-format camera around Mexico – lugging it on to horse-drawn carriages and trains, and high above streets – he photographed the powerful, the executed, the wounded, revolutionaries both male and female, street scenes, and, as here, the Mexican government's notorious enforcers, the *Rurales*. In 1911, he joined forces with other photographers to form one of the earliest press associations, the *Asociacíon de Fotógrafos de Prensa*.

Casasola's sons, Gustavo and Ismael, were also photographers, as was his brother. They were not always credited for their work, and in the chaos of war, documentation was patchy or went astray. This may help to account for Casasola's vast output over the 10 years of the war, and the impression that he was often in several places at once. After the Revolution, Casasola continued to document life in Mexico. He had amassed nearly half a million images by the time of his death in 1938, and was toasted as the father of Mexican photojournalism.

NAVIGATOR

1 AERIAL PERSPECTIVE
Dust from the horses and troop movement obscure details and reduce contrasts, which has the effect of emphasizing depth in the image and adds to the sense of heat indicated by the sharp shadows in the foreground.

2 CENTRE OF ACTIVITY
The troops of General Carlos Rincon Gallardo herd horses up a ramp and onto a train. The lines of the ramp lead your eye to the centre of the image.

3 CORNER OF CARRIAGE
Casasola was fond of using high vantage points to obtain general views showing all the action, which filled to the edges of the frame. Here, he could not lean out far enough to avoid catching the corner of the train he had climbed onto.

4 SOMBRERO PATTERNS
The high viewpoint enables Casasola to look down on the soldiers' hats, which form patterns that are visually engaging – a picturesqueness that Casasola did not make a practice of seeking out.

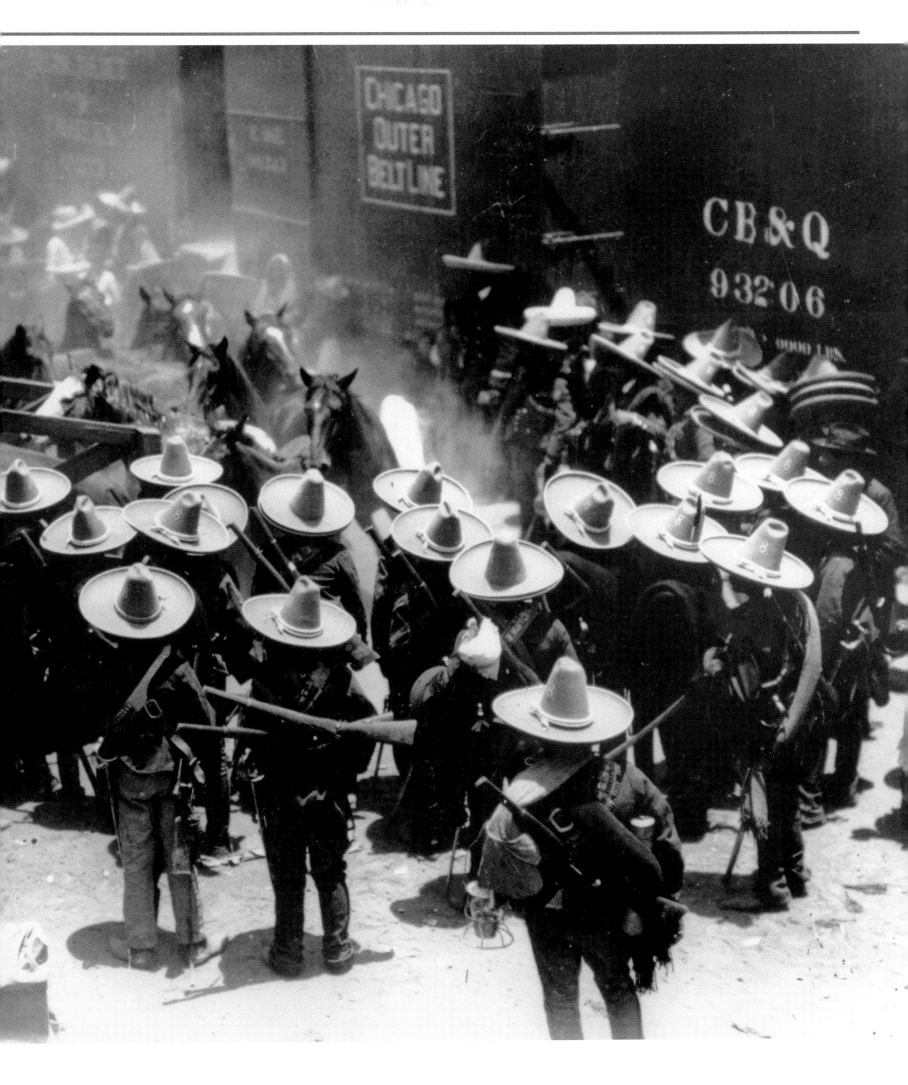

Temples of modernism

As the mechanization of vision, photography was well placed to sweep away the old order and usher in the new world. It had a far-reaching influence at the Bauhaus in Germany, which attracted many famous artists, including Paul Klee, Wassily Kandinsky, and Herbert Bayer.

László Moholy-Nagy
1899–1946

While at the Bauhaus, Hungarian-born László Moholy-Nagy proved to be the perfect kind of Bauhaus artist and threw himself into everything. He photographed tirelessly, exploring radical viewpoints, abstractions, and movement by exploiting the agility of small cameras and faster films. He created photograms; he painted; he sketched; he made prints; he studied typefaces; he designed.

Above all, he inspired students and fellow artists to play, to experiment, and to reappraise each art form. The freewheeling investigations soon untangled photographic prejudices. The old debates about photography as a pictorial art or an art in itself were made redundant at a stroke.

LÁZLÓ MOHOLY-NAGY, LUCIA MOHOLY-NAGY, 1925–26

In the aftermath of World War I, many experiments to change the world sprang into being from the old order. When they involved the visual arts, photographers had to contribute, and none took to photography more completely and with more theoretical rigour than those of the Bauhaus.

German arts and crafts
Founded in 1919 by architect Walter Gropius in Weimar, Germany, the Bauhaus was a radical new art school. It espoused the ideal of "total art", a material world made whole by the unity of the arts. Integrating art with technology was at the heart of it. It began as a sort of Arts and Crafts guild, in which crafts and craftsmen enjoyed the same status as sculpture and sculptors and other fine arts and artists. The aim was to sell their products so the Bauhaus would become financially independent, and students would benefit from contact with people outside the rarefied atmosphere of the art school.

Photography was the ideal vehicle for the Bauhaus agenda, showcasing its products – from furniture and metalwork (two of the most popular courses) to architecture – with crisply defined shapes in precise blocks of tone. No other art was able to capture the stark, strong lines and sparse forms of Bauhaus designs with such objective clarity.

Using a camera to project a specific vision of a modernist world, rather than a purely objective portrayal, had to await the arrival of László Moholy-Nagy and his wife Lucia in 1923. László developed a curriculum for industrial design that integrated media such as photography and film. He made photography compulsory for the school's preliminary courses and encouraged experimentation. Meanwhile, Lucia photographed

> ## It **altered** the **look** of everything from the chair you are sitting in to the **page you are reading now.**
>
> **WOLF VON ECKARDT ON THE BAUHAUS / 1961**

◁ **BAUHAUS EXHIBITION POSTER**
JOOST SCHMIDT, 1923

In an example of Bauhaus artistic unity, this poster integrates the words and their typeface into the design and colour scheme in a way not seen before.

in design – went hand in hand with photography, and it was of major importance at the Bauhaus. Herbert Bayer, László Moholy-Nagy, Joost Schmidt, and others who taught there showed how type, graphics, and photography could work together as complementary elements to create a powerful whole. The groundwork for today's concepts of page layout, typography, and picture use was laid in Weimar and Dessau.

The Moholy-Nagys left the Bauhaus in 1928. Walter Peterhans took over the photography course in 1929 and designed a broad-based curriculum, but his influence, like his photography, was far less exciting than that of his predecessor. The force of Moholy-Nagy's creativity was felt for years.

Bauhaus products, helping to boost their sales. She also documented the Bauhaus's move to Dessau in 1925.

Moholy-Nagy's photography course at the Bauhaus fuelled the explosive growth of photojournalism in German magazines of the day. The imaginative use of viewpoints – often looking straight up or down, or tilting the camera – stark lighting, and making abstract patterns from geometric forms rippled outwards from the Bauhaus. For magazines, typography – the study of typefaces and their use

The Vkhutemas
In 1920, Lenin established an institution which, like the Bauhaus, was a response to the wave of modernism, but on a typically grandiose, industrial scale. Founded in 1920 by merging two schools, the Vkhutemas (an acronym from the Russian, meaning Higher Art and

◁ **BERLIN RADIO TOWER**

LÁSZLÓ MOHOLY-NAGY, 1928

Moholy-Nagy had already taken photographs looking up at the Eiffel Tower in Paris. Now he turned the camera to face downwards for a series of shots of the newly built radio tower, emphasizing its narrowness and creating a semi-abstract picture out of its strong diagonals and the geometric shapes below. He himself gave this image of linear elegance pride of place.

IN CONTEXT
Bauhaus impact

The influence of the Bauhaus spread far and wide. In 1933, the Nazi party closed down the school, which had by then moved to Berlin, denouncing it as a degenerate hotbed of cosmopolitan modernism. Many members of the faculty emigrated to the US, including Herbert Bayer, architect Mies van der Rohe, and the Moholy-Nagys. László, like Mies, went to Chicago, where he founded the New Bauhaus school. Others went to Israel, and Tel Aviv is now a world heritage site thanks to its 4,000-odd Bauhaus buildings.

Bauhaus values also reached Australia, where photographer Olive Cotton's use of abstract forms and hard industrial lighting were pure gestures of modernism. Unlike other modernists who favoured bold drama, her work was gentle and serene. In the study below, she choreographed a simple still life with lighting to resemble dancers on a stage.

***TEA CUP BALLET**, OLIVE COTTON, 1935*

Technical Studios) was intended "to prepare master artists of the highest qualifications for industry". Its faculty was 100 strong, and there were more than 2,500 students. The teaching was not integrated as it was at the Bauhaus. The Arts Faculty taught graphics, sculpture, and architecture, and the Industrial Faculty taught printing, textiles, ceramics, wood, and metalwork. Nonetheless, major avant-garde movements such as suprematism and constructivism emerged from the school. Broadly speaking, the art associated with these movements banished the sinuous curve and subtle shading, substituting them with precise lines, clean-cut angles, and a generous use of empty space.

Many Vkhumetas students did not, however, find jobs, as an analysis by Alexandr Rodchenko (see pp.140–41) and others revealed in 1923. By 1930, the school had closed down and the art movements it spawned – now deemed unacceptably bourgeois – were superseded by social realism and other styles considered more in keeping with the Revolution.

Alexandr Rodchenko

RUSSIAN / 1891–1956

A painter, graphic designer, and sculptor, Rodchenko took to the camera in his early 30s, when he was unable to find photographs suitable for his photomontages. The experience opened his eyes to the ability of small, portable cameras to look at objects from any angle. He realized it was the mechanical equivalent of a disembodied human eye (a property that was rediscovered by millions nearly a century later when they found a camera on their mobile phone). His distinctive style transforms perspective, turning the instantly recognizable into a visual puzzle that needs decoding. Zeal for photography's visual gymnastics led him to declare that, "In order to educate man to a new longing, everyday objects must be shown with totally unexpected perspectives..."

The small camera fitted neatly into Rodchenko's Constructivist ideals – that art was neither private nor autonomous but to be used for the benefit of people and society. Ironically, his ideas were later rejected as "bourgeois formalism" under Stalin, and he spent his last years in poverty-stricken obscurity. But before that, his photography had influenced a generation of film-makers, most famously Sergei Eisenstein and his cameraman Eduard Tisse. Its impact on photographers is clearest in the early, vertiginous work of Germaine Krull.

Rodchenko's use of angles also resonated with modernist photographers, but his viewpoints were bolder and closer to people. Perhaps his strongest legacy is in his instruction "to take several different shots of a subject, from different points of view ... as if one examined it in the round rather than looked through the same key-hole". These words have rung in the ears of photographers ever since.

IN CONTEXT
Montages

In the early 1920s, Rodchenko was inspired by the montages of the German Dadaists (see pp.142–43) to try using found pictures. He soon discovered the limitations of this approach and began shooting his own material. Far from the Dadaist agenda, however, Rodchenko illustrated the poems of his friend Vladimir Mayakovsky, for example, or used his graphic skills for practical purposes, such as advertisements. In this one, he combined a photograph of a face with painted words and shapes. The monochrome face contrasts with the bright colours, but together they deliver a strong message on behalf of the advertiser.

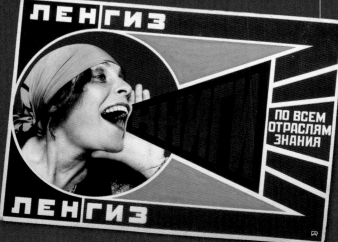

ADVERTISEMENT: BOOKS,
ALEXANDR RODCHENKO, 1925

▽ **WOMAN WITH A LEICA**

1934

A skewed camera angle and a mesh of shadow defamiliarize a perfectly ordinary scene of a woman sitting on a bench and create a surprising and dynamic image.

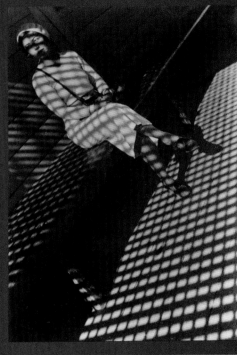

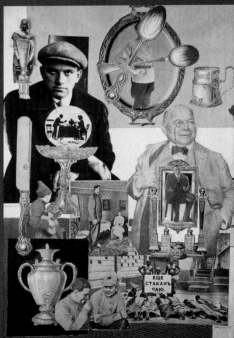

△ **PHOTOMONTAGE**

FOR VLADIMIR MAYAKOVSKY'S POEM
PRO ETO, 1923

Rodchenko created this composite image from found pictures (images taken by other photographers) of people and objects to illustrate his friend's long autobiographical love poem, About This.

◁ **EMERGENCY LADDER**

THE HOUSE IN MJASNITSKA
STREET SERIES, 1925

*Rodchenko was one of the first to
experiment with viewpoint to create a
powerful, graphic image. His dizzying
view here – it is hard to tell whether
the camera is pointing up, down, or
along – plays tricks with perspective
and makes the scene semi-abstract.*

▽ **PIONEER BOY WITH TRUMPET**

FROM *PROLETARSKOJE FOTO*
MAGAZINE, 1931

*Looking straight up gives an
extraordinary view of the young
trumpeter and captures his fierce
concentration. In the magazine, it
appeared alongside a photograph of
a pioneer girl gazing down.*

▷ **DADA ERNST**

HANNAH HOCH, 1920–21

Hoch showed her disaffection with society with a collage of jarring cut-outs. She mixed images from varied sources and used portraits of different scales and sizes to manipulate the picture space. She also jumbled black-and-white images with colour ones to create a dissonant effect.

IN CONTEXT
Dada

Any attempt to define Dada is a self-contradiction because, as one of its founders said, "Dada is nothing, nothing, nothing". The Dadaists had no governing principles. Formed in 1916, their response to the devastation of World War I resonated with a universal desire to start all over again. In art it meant dismantling restrictive rules. Absurd art reflected absurd society. Photographs were open to chance and the accidental, which they welcomed, along with anything irrational, irreverent, or incongruous. German Kurt Schwitters embodied Dada in his studio, called *Merz* (a nonsense word) *bau* (building), which was an abstract walk-in collage of structures, itself a work of art.

MERZBAU, KURT SCHWITTERS, 1923–37

Mounting conviction

Juxtaposing several images to form a single photograph weakened the links between the camera and subject. The composite photograph opened up an opportunity for another form of expression.

When photography was invented, people praised its realism, but photographers soon looked for ways to elaborate on the image. Oscar Rejlander (see pp.64–65) and Henry Peach Robinson (see pp.62–63) both practised combination printing – using more than one image to create a photographic print.

From the 1860s to the 1890s, leisured women attempted to create unique cartes de visite, which were by then circulating in their millions (see pp.56–57). They cut out portraits of their friends and family and glued them onto other images with unexpected and amusing results. Heads on ducks to replace jokers on playing cards, for example, were some of the first photomontages.

Adopting the photomontage

Although the Dadaists of the early 20th century are often credited with inventing the photomontage, they simply adopted it for their own purposes and gave it credibility. While artists such as Christian Schad and Jean (Hans) Arp stuck photographs into their artwork in the early 1900s, Berlin Dadaist Hannah Hoch was perhaps the first to follow the example of the previous century. In 1919, she scoured magazines to cut out images to stick together and used distorted scale, perspective, and representation to articulate her criticism of politics and society. John Heartfield (see right) took up her lead to ridicule Nazism.

Serious absurdity

Dadaists did come up with the term "photomontage". As key Berlin Dada figure Raoul Haussmann explained, they adopted it because of "an aversion to thinking ourselves artists … we meant to construct, to assemble our works". Photomontage made it possible to juxtapose randomly found elements. In fact, the elements were anything *but* random – they were specifically used to cause confusion and reveal absurdities. Photomontage appealed to the Dadaists, who rebelled against institution of any kind.

The photographic process, which made the "found montage" possible – putting elements that normally pass each other transiently and accidentally side by side forever – interested the surrealists too. Like the Dadaists, they loved the work of Eugène Atget (see pp.126–29), and also relished that of Manuel Alvarez Bravo, who superimposed reflections with street signs and mannequins (see pp.186–87). There was a brief vogue for surrealist photomontage portraiture.

Dada followers and surrealists were not the only ones to try photomontage. The first cover of the Bauhaus magazine, for instance, was a photomontage. The technique made only minor reappearances thereafter, as in the pop-art collages of Richard Hamilton and followers in the 1950s and 60s, until digital image manipulation was refined in the late 1990s, producing work that was fantastical, but did not have the radical edge of earlier examples.

◁ **SELF-PORTRAIT**

EL LISSITZKY, 1924

This self-portrait of the Russian puts the act of seeing at centre stage. Lissitzky's hand, holding a compass, is superimposed on a shot of his head that highlights his eye. Made from six different exposures, the picture merges the photographer (eye) and constructor of images (hand). Lissitzky held that montage, by layering one meaning over another, forces the viewer to reconsider the world.

John Heartfield
1891–1968

Born in Berlin, Helmut Herzfeld became one of the greatest political satirists to use photography. He changed his name to John Heartfield as a protest at anti-British feeling in 1916, and in 1917 he joined the Berlin Dada. His fame rests on over 200 photomontages created from 1930 to 1938. Published by the *Arbeiter-Illustrierte-Zeitung* (*AIZ*, "Workers' Illustrated Magazine"), these are by turns darkly humorous, bitterly angry, and scathing parodies, designed to shake readers out of their complacency. At great personal risk, Heartfield created images and assembled existing ones for his *Klebebild* (paste pictures), which he rephotographed to minimize signs of the collage. In 1933, he fled the SS, escaping to Czechoslovakia, and only returned to Berlin after the war.

AIZ COVER, JOHN HEARTFIELD, 1936

Irrational photography

Surrealism grew out of Dada's need to shock, and its deliberately anarchic drift. In an irony not lost on Dadaists, the surrealists' attempt to liberate the imagination by accessing the subconscious relied on written direction.

FIRST EDITION OF *LA RÉVOLUTION SURRÉALISTE*, 1924

▷ **ROOM WITH EYE**

MAURICE TABARD, 1930

Cut-out eyes often feature in surrealist photographic collages and paintings. Superimposed on an empty room, the effect of the eye is deliberately disquieting. Most of Tabard's work, including all his negatives, was lost during World War II.

Dissatisfaction with Dada's lack of direction and its dwindling pool of artistic resources led to the creation of the surrealist movement in Paris. Artists such as Max Ernst, Salvador Dalí, Man Ray, and Jean (Hans) Arp and poets such as Paul Éluard and Louis Aragon, led by the poet André Breton, gathered together to launch the new art movement, publishing their *Surrealist Manifesto* in 1924.

Influenced by a wide range of theories, from Hegel's ideas that conflict and resolution are dynamic fundamentals of life to Freud's use of free association to liberate the imagination from its customary constraints, they sought to "resolve the previously contradictory conditions of dream and reality".

Taking dreams literally

Surrealist writers experimented with automatic, sometimes called stream of consciousness, writing, which was defined by Breton as "dictation of thought in the absence of all control exercised by reason, outside of all aesthetic and moral preoccupation". In art, objects, or distorted versions of them, appeared

in dream-like compositions to represent the "real functioning of thought", as best known in the works of Salvador Dalí.

Photography was the perfect form of expression for these mind experiments. For the first time in its history, the mechanical, automatic nature of its operation was welcome – essential even – and led to its acceptance within an art movement. Artists could point the camera at anything at any time, and the resulting image could qualify as a surrealist

> ## The invention of photography has dealt a mortal blow to the old modes of expression.
>
> **ANDRÉ BRETON / 1935**

expression. This led to a vogue for photograms (see p.18), with their somewhat unpredictable results. Other techniques such as montage, collage, multiple exposure, and partial posterization (which Man Ray called "solarization", see pp.146–47) all offered effective ways to combine disparate elements in juxtapositions that could be jarring or revelatory.

The experiments of the 1930s in Paris were influential all around the world and formed the bedrock for a photographic genre that is still going strong. Surrealist ideas were gleefully adopted in the portrait, theatrical, and fashion worlds (see Angus McBean, p.236) and surfaced again in the late 1990s, when image manipulation became popular.

Constructed unconscious

While Man Ray and other surrealist photographers such as Maurice Tabard, Otto Umbehr, and André Kertész produced images consistent with the aesthetics of the elegant and beautiful, Hans Bellmer really let his unconscious out into the open. He obsessively posed and photographed doll-like forms that he made himself, creating a disquieting body of work that is unique – for which some may be thankful.

HANS BELLMER, 1934–35

*Bellmer's series of dolls are by turns
traumatized, sexualized, distorted,
and transmogrified into bizarre images
calculated to disturb. Initially, Bellmer
used the dolls to protest against Nazi
Germany's cult of physical perfection,
but childhood traumas may have been
part of the genesis.*

▽ **HUMANLY IMPOSSIBLE**

HERBERT BAYER, 1932

*This self-portrait is a photomontage –
Bayer stuck together two pictures of his
armpit so that his arm looks as if it is
severed from his body. The sponge he holds
appears to represent the missing slice of
arm. The mirrored reflection adds another
dislocating layer to this disturbing fantasy.*

Man Ray

AMERICAN / 1890–1976

Man Ray (born Emmanuel Radnitsky) was the epitome of the iconoclast, a restless experimenter who transformed darkroom curiosities into significant art forms. Despite his intuitive use of the camera, photography came second to painting for him. "I photograph what I do not wish to paint, the things which already have an existence", he declared.

Ray grew up in New York City and took up art in 1914, painting and creating experimental objects and machines. One of the instigators of Dada in New York, he came into contact with Alfred Stieglitz (see pp.106–07), and the avant-garde artists Marcel Duchamp and Francis Picabia. In around 1918, Ray made his first photographs and in 1921, he moved to Paris, where the Dadaists gave him a warm welcome. By 1923, he had established himself as a photographer, regularly working for the leading fashion magazines of the day. Much of his best-known work, however, is personal, ranging from still lifes to playful nudes and portraits of friends, such as Jean Cocteau and Gertrude Stein, from his artistic and literary circle.

Man Ray's innovative use of photography made him an influential member of the surrealists (see pp.144–45). His mastery of the solarized print made other people's attempts look like pale imitations. He is said to have discovered the technique by chance, when Lee Miller, his assistant, opened the darkroom door at the wrong time – solarization occurs when a print is briefly exposed to light while being developed: the undeveloped areas become very dark, while other areas turn unnaturally light. Man Ray also experimented extensively with photograms (see pp.18–19), which, without a trace of irony, he named rayographs after himself. Remarkable for the intelligence and wit of his work, the epitaph on Ray's tomb reads, "Unconcerned, but not indifferent".

Just as I work with **paints, brushes, and canvas,** I work with the **light, pieces of glass, and chemistry.**

MAN RAY / 1967

▷ **RAYOGRAPH**

1923

Made without a camera, a photogram results in a negative image – translucent areas appear dark and solid objects appear light. Here, objects are juxtaposed to create an abstract face, by turns witty or sinister.

◁ **WOMAN ON FOLDED ARMS**

1931

Solarizing creates an ethereal shimmer around the form of the figure and makes parts of her hair appear white.

△ **EDWARD JAMES**

PARIS, 1937

This portrait of a man holding a magnifying glass in front of his face shows Man Ray's playful, inventive side, as does the sketched-in crop or frame.

◁ **GLASS TEARS**

1932

This cropped version of a face appeared as the first plate in a 1934 book of Man Ray's photographs. The mournful upturned glance and mascaraed lashes make the eye resemble that of a damsel in distress in a silent film. But all is not as it seems – the tears are glass beads.

Leica 1

Oskar Barnack
1879–1936

A microscope engineer by training, Oskar Barnack became the father of 35mm photography when he adapted a device used to test film stock to take a little more film and added a specially designed lens to create a camera. He used it to document the major events of the day – such as the flooding in Wetzlar in 1914 and 1920 – becoming the first photojournalist to do so.

BARNACK WITH A LEICA

In photographic technology, the best designs always accommodate the changing needs of photographers. This is certainly true of the Leica, one of the earliest 35mm cameras, which still retains its original form today.

The Leica was not the first camera to use 35mm film to make still images. The Simplex of 1914, made by the Multi Speed Shutter Company of New York, loaded enough film to make 400 exposures of 36 x 24mm format.

The remarkable little Sept from André Debrie, Paris, of 1922 could do seven different things, including shooting stills or short film footage and working as a projector or enlarger. But, at US$225 (US$7,000 (£4,200) in today's terms), it was prohibitively expensive.

Film heritage
The 135 or 35mm format that was to dominate photography for much of the 20th century originated with the cine film format adopted by Thomas Edison in 1892, but it was an asthmatic who liked to go hiking and take pictures who really laid the foundations of 35mm photography. As early as 1905, Oscar Barnack, then an engineer at German manufacturer Carl Zeiss (see pp.212–13), was trying to make a compact camera that he could take on his hikes. Barnack's insight was to realize that, given sufficient quality in construction and optics, 35mm film could provide excellent results.

Barnack's inspiration lay in cine film. By running film from left to right, instead of from top to bottom, he realised that he could double the format area with the same width of film. By 1913, now working for Ernst Leitz, he completed a prototype camera for cine film, but it was not until 1924 that he developed a still camera. When he did so, a trial run

of 25 models were given to various managers and photographers. The initial reaction was cool, but to keep his workers busy in the depressed Weimar period, Leitz pressed on with production. The result was the Leica 1 (or Leica Model A), which had a fixed 50mm lens and was shown to the public at the Leipzig Spring Fair in 1925. It was expensive, costing US$114 (US$3,000, or £1,800 today),

but as it had lenses specially designed for 35mm film, the image quality was high. The plaudits and orders soon began to pour in.

Interchangeable lens
Crucial developments were made over time: an interchangeable lens system in 1930, then a coupled rangefinder in 1932 – by which time some 90,000 Leicas had been sold.

◁ **ALFRED EISENSTAEDT**

WEEGEE (ARTHUR FELLIG), 1940

US photojournalist Alfred Eisenstaedt, one of the first photographers for Life *magazine, documented much of the 20th century with a series of Leica cameras.*

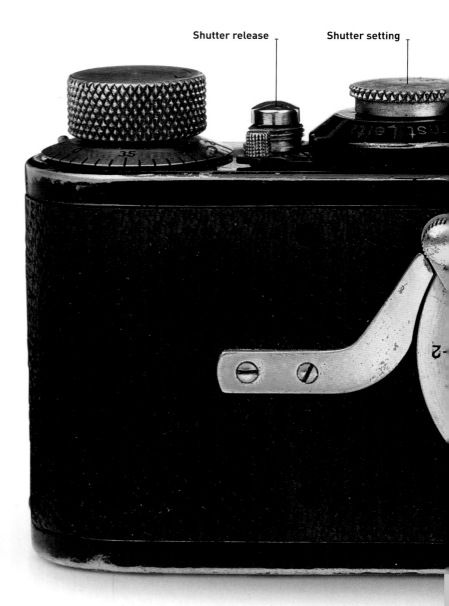

Shutter release Shutter setting

The shutter setting was improved, and adopted the now-familiar series by 1933. While Barnack's design remained in production until 1957, the Leica M3 of 1954 was a radical departure. The Leica attained its mature form in the M3, catching up with the Zeiss Contax, which had been the first camera to offer a combined viewfinder and rangefinder. In 1936, the M3 also used a modern bayonet lens mount, with modern lens designs. Leica cameras and lenses are prized by photographers today, but they are also amassed by speculative collectors and wealthy amateurs. This means that prices are often inflated, making even standard-production Leicas extraordinarily expensive.

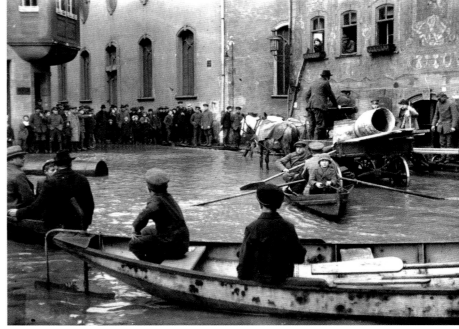

△ **FLOODED CITY**

OSKAR BARNACK, 1920

Barnack used his 35mm camera to capture the historic flooding of Wetzlar, Germany, in 1920. He considered the 3:2 aspect ratio the ideal choice for his invention.

Accessory shoe

Lens aperture setting

Viewfinder

Rewind knob used at end of roll

◁ **LEICA 1**

1925-1936

The first production 35mm camera, and the model for every 35mm camera to come, the Leica 1 came with a fixed 50mm lens.

IN CONTEXT
Rangefinder range

Optical rangefinders work on a principle first described in 1533 by Dutch physician Frisius, and were originally designed for judging the range of naval guns – an innovation attributed to 20th-century US naval officer Bradley Fiske. Rangefinders were crucial to early 35mm cameras, whose image sharpness could not be relied upon. The basic form of two windows – one for the base image, the other for the ranging image – can be found in cameras from the competing Zeiss Contax of 1932, through to compact rangefinders such as the Olympus 35RC and the Minolta Hi-Matic, and in medium-format cameras such as the Mamiya 7 and the Hasselblad XPan of 1998. Even today, the basic Leica M design survives in the digital version.

LEICA M3

LEICA M

Seeing straight

One of the first instances of an exhibition title standing for an art movement, Neue Sachlichkeit (New Objectivity) collected work featuring precise, representational art free of emotion.

In 1925, the German museum Mannheim Kunsthalle mounted an exhibition called *Neue Sachlichkeit*, featuring detailed, realistic paintings. The museum director Carl Gustav Hartlaub explained, "What we are displaying here is distinguished by the... objectivity with which the artists express themselves". Critics soon adopted the title as an umbrella term for any work – literary, musical, theatrical, or artistic – that was coolly detached and, above all, precise in its depiction of reality.

Objective overview
Neue Sachlichkeit artists such as George Grosz and Christian Schad ignored old sensitivities and depicted the harsh realities of life in the Weimar Republic with clean-cut precision or humourless sarcasm.

Other artists in the Neue Sachlichkeit movement demonstrated a wish to return to order, looking for direction from the past to replace the turmoil left by World War I. Before long, any photograph that was clean, sharp, detailed, and objective was dubbed Neue Sachlichkeit. Photographers such as August Sander (see pp.152–53) and Karl Blossfeldt were held up as great examples, and even French exponent Eugène Atget (see pp.126–27) was included.

Three years after the Mannheim exhibition, Karl Blossfeldt published *Urformen der Kunst* (Archetypes of Art). Consisting of 120 gravure plates of plants in engrossing detail, it was recognized immediately as stellar work, and rocketed the obscure professor of applied arts in Berlin to international stardom. Although

lauded as a perfect exponent of Neue Sachlichkeit, Blossfeldt was blissfully independent of any such agenda. Working in three negative formats of $2\frac{1}{3} \times 3\frac{1}{2}$in, $3\frac{1}{2} \times 4\frac{3}{4}$in, and $5\frac{1}{3} \times 7$in (6 × 9cm, 9 × 12cm, and 13 × 18cm), he had made some 6,000 images by the time of his death in 1932.

Straight and straighter
Photographically, there was little difference between Neue Sachlichkeit and the pure photography championed in New York by artists such as Paul Strand and Edward Weston (see pp.159–61). In fact, the admiration of American photography implicit in the work of the Neue Sachlichkeit was criticized in Germany as an "Americanism", modernist, and against the principles of the German spirit.

The term Neue Sachlichkeit technically died out in 1933, with the fall of the Weimar Republic when the Nazis assumed power. They condemned much Neue Sachlichkeit work as degenerate, but it had had a powerful influence in Germany. The work of Bernd and Hilla Becher in the 1960s (see pp.308–09), in particular, was a reaction against Otto Steinert's attempt to resuscitate subjective photography. The clearest way forward for them was to reinstate the values expressed by Neue Sachlichkeit.

◁ ◁ **LANDSCAPES**

ALBERT RENGER-PATZSCH, c.1929

The term Neue Sachlichkeit was first applied to Renger-Patzsch's work in 1927. He was preoccupied with landscapes, buildings, and machinery and paid little or no attention to society. Trees and factory chimneys alike received the same objective treatment under his coolly dispassionate gaze.

Albert Renger-Patzsch
1897–1966

A keen photographer from his teens onwards, Renger-Patzsch opposed the pictorialist and mannered work of his time. He declared, "What those who are attached to the 'painterly' style regard as photography's defect – the mechanical reproduction of form – is just what makes it superior to all other means of expression." His first book was going to be called *Die Dinge* (Things), with 100 plates of woods, industrial landscapes, plants, and machinery. Fortunately, his publisher chose the title *Die Welt ist Schön* (The World is Beautiful) and published it in 1927 to worldwide acclaim.

DIE WELT IST SCHÖN (THE WORLD IS BEAUTIFUL), 1927

◁ **PLATES FROM *URFORMEN DER KUNST* (ARCHETYPES OF ART)**

KARL BLOSSFELDT, 1888–1928

Blossfeldt started taking magnified photographs of plants 40 years before they were published in 1928. His intention was to collect examples and inspire his students with the beauty of nature's forms. He built himself a camera with an enormous extension, which allowed him to magnify images of plants up to 45 times.

August Sander

GERMAN / 1876–1964

It is a miracle that any of August Sander's work has survived. Much of it was destroyed, but what remains is of such delightful humanity, variety, and richness that it has inspired successive generations of artists, filmmakers, and photographers.

Born into a German mining community, Sander was assisting a photographer at the local mine by the age of 16. In 1901, he went to Austria and worked in a photographer's studio, which he ran with a friend from 1902 and on his own from 1904 to 1909, when he moved to Cologne, Germany. Here his style of photography evolved from conventional studio work to "simple, natural portraits that show the subjects in an environment corresponding to their own individuality". Around 1925, he began to develop his grand project – to create a visual encyclopedia of German society in a series of portraits. In *People of the 20th Century*, Sander arranged people in seven groups according to "the existing social order" – farmers, skilled tradesmen, classes and professions, artists, the city, and "the last people".

Systematic organization was central to Sander's work as, like Blossfeldt (see pp.150–51), he considered the project as a whole more important than the individual pictures. Sander said, "Photography is like a mosaic that attains synthesis only when viewed *en masse*".

Sander's book *Face of our Time*, published in 1929, contained 60 of his portraits, but his inclusive approach to German society clashed with Nazi ideology and the plates for the book were destroyed in 1936. In 1942, Sander took photographs, studio equipment, and furniture to a house in the Westerwald region. His wife moved there in 1943 and Sander followed in 1944 after their Cologne home was bombed. They saved more than 10,000 negatives and many prints of landscape, architecture, and industry, as well as portraits. In one of the greatest tragedies of photography, all the work he left behind – some 30,000 negatives – was later destroyed in a fire. Sander continued taking new photographs, printing his old negatives, and compiling his portfolios in the Westerwald, disillusioned by the difficulty of pursuing his dream project.

> Photography is **by nature** a **documentary** art.

AUGUST SANDER / 1931

△ **HIGH SCHOOL STUDENT**

1926

With a plain white background and no props – apart from a cigarette – the suit is the main clue to the young man's identity. The tilt of the body and angle of the arms add interest to the image and lessen the austerity of the three-quarter length pose.

▷ **MASTER POTTER FROM FRECHEN**

1934

Sander's subjects are observed with clarity

▽ **CIRCUS ARTISTES**

1926–32

Sander photographed people on the margins of society, as well as archetypes such as farmers. The inclusion of black and gypsy faces conflicted with Nazi ideas about what German people should look like.

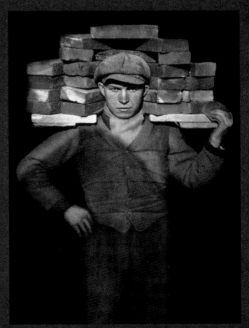

△ **BRICKLAYER**

1928

Intense, directional lighting and a head-on pose make the uncompromising gaze of the man compelling. His strong, stocky body emerges as a mid-tone from the deep surrounding shadow.

Walking the streets

As Europe struggled in the aftermath of World War I, photographers found themselves adrift. Paris gave them a refuge and a subject they could engage with, and new cameras spurred them to experiment with street photography.

▽ **RUE MULLER, PARIS**

WILLY RONIS, 1934

Ronis used the light from the street lamps to illuminate the gleaming cobbles and the car. The lamps also add to the dizzying sense of perspective, as they appear to diminish in size the further they are up the steep flight of steps.

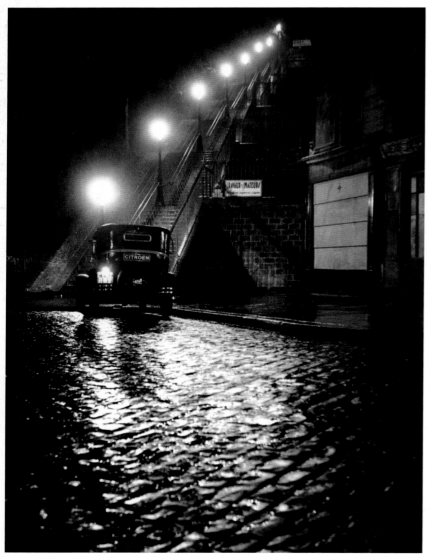

Paris between the wars was home to an international group of artists, brimming with modernist ideas and liberal ideals. Photographers included Man Ray from the US; George Hoyningen-Huene from Russia, Germaine Krull and Horst P. Horst from Germany; Brassaï and André Kertész from Hungary; and Robert Doisneau and Henri Cartier-Bresson.

Street photography took off in Paris around 1930 for several reasons. Illustrated magazines were eager for photographs, and the new lightweight cameras were far more portable than previous models. Camera innovations also made night photography feasible – the city took on a new guise after nightfall, cloaking familiar sights in mysterious allure.

The notion of photographing with available light was born with the Ermanox camera of 1924. Its large lens could swallow up whatever light was available, and it made hand-held photography in low light possible for the first time. The camera was slow to use, however, and just a year after its introduction, the Leica (see pp.148–49) took the Leipzig Spring Fair by storm. It was lightweight and appealed to photographers keen to wander the streets without cumbersome tripods or plates. And there was no better city to roam than Paris.

The eyes of Paris

Born in Brasso (now called Brasov) in Transylvania, Gyula Halász changed his name to Brassaï in 1929. He had moved to Paris in 1924, and initially took photographs to supplement his journalism, but he soon began to take pictures of all aspects of life in the French capital, especially its night-time underworld. His *Paris de Nuit* (Paris by Night, 1933) offers a vision of Paris – its intellectuals and high society, alongside more risqué sights – that has never been equalled. The American novelist Henry Miller dubbed him "the eyes of Paris".

Another Hungarian photographer who delighted in Parisian streets was André Kertész, who moved to the city in 1925. Kertész had a strong incentive to succeed as a photographer – he had left his fiancée at home waiting for him to become sufficiently established to marry her. Kertész had timed his assault on Paris perfectly. His approach was fashionably surrealist and magazines such as *Vu* and *Art et Médecine* had an insatiable appetite for photographs. In 1933, his fiancée did indeed marry him in Paris.

Born in Paris, Willy Ronis originally wanted to be a composer but had to take over the family photography business when his father fell ill. In 1936, he went freelance. His early work on the streets of Paris revealed a flair for lighting, as well as an acute sense of observation and humanity, informed in part by his commitment to communism. He went on to enjoy a successful career as a photojournalist.

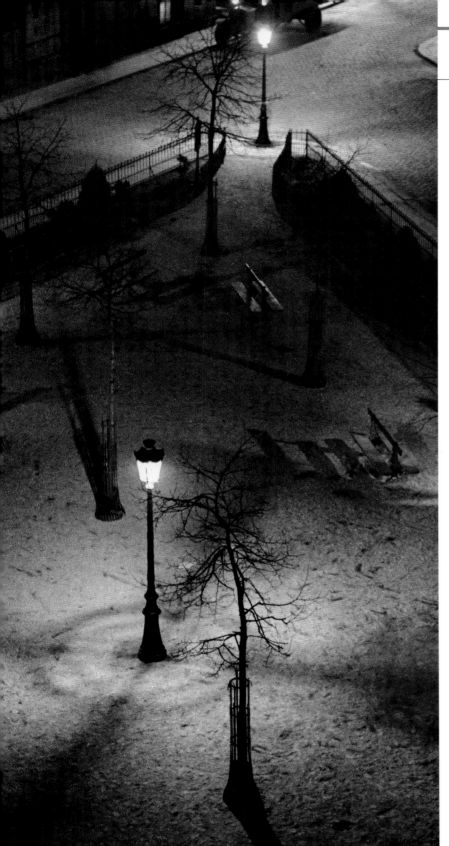

Brassaï
1899–1984

Gyula Halász (later known as Brassaï) served as a cavalryman in the Austro-Hungarian Army, then studied in Berlin. He went to Paris in 1924 and learned French, it is said, by reading the lengthy novels of Marcel Proust.

For his *Paris by Night* series, Brassaï used a Voigtlander Bergheil camera, photographing by any available light. He timed his exposures by his cigarette – a Gauloise if the light was good; a Boyard (a cheap French brand popular among the upper military ranks) when the conditions were gloomier, because it took longer to smoke. Later in his career, Brassaï used a Rolleiflex camera.

△ PARIS NIGHT SQUARE, PARIS
ANDRÉ KERTÉSZ, 1927

Street lights dotted around the square cast criss-crossing shadows that give the night-time scene an air of theatricality. The high viewpoint emphasizes the geometric arrangement of the trees and benches and takes full advantage of the multiple sources of light.

▷ RUE QUINCAMPOIX, PARIS
BRASSAÏ, 1932

Far from glamorizing prostitutes, Brassaï showed them – presumably with their permission, given the long exposure times – in humdrum garb, creating a sense of pathos. This woman is waiting out in the cold street clad in slippers and a felt hat. A street lamp behind her casts her face in deep shadow, granting her anonymity.

Meudon

ANDRÉ KERTÉSZ / 1928

Widely celebrated as a masterpiece of pure street photography – a thin slice of meaning snatched from random events – the appeal of *Meudon* lies in its remarkable coincidence of commonplace events. A smoking train traverses an enormous viaduct just at the moment a sharply dressed gentleman crosses the street while carrying a large painting or canvas. Behind him a group of people occupy the background, their smaller scale indicating distance as well as animating an otherwise empty space. We know, however, that the image was in fact planned – and perhaps partly set up too. Kertész took two other shots of the street made from roughly the same position. In both the street is empty. One features a train, though without smoke. Another was made some time before the others, as shown by changes in the wood pile in the distant background. Kertész had clearly investigated the potential of the location over a period of time.

Kertész does not identify the main figure but evidence from a photograph indicates that he is the German painter Willi Baumeister, who is thought to have known Kertész. Also, both Kertész and Baumeister knew the artist Jean (Hans) Arp, whose studio was located in Meudon, a suburb of Paris. It seems perfectly plausible that an artist visiting another artist would be carrying a roughly wrapped painting. Even so, the picture now begs questions. Kertész had probably asked Baumeister to hold his pose while waiting for the train – over which he had no control – to arrive. If it is true that Kertész partially set the image up – and he certainly cropped it – he infringed basic tenets of pure street photography, which relies solely on observation and timely capture with no intervention. Still, the transgressions do nothing to rob the image of the element of surprise created by the perfect conjunction of events. Learning of the measures that Kertész may have taken to create his picture does, however, take the shine off the visual serendipity.

NAVIGATOR

1 MAIN FIGURE
The man at the bottom right of the image helps to emphasize the height of the viaduct. The small figures behind him reinforce the sense of receding distance and push him forwards visually.

2 WINDOW LINE
The almost horizontal line of the first-floor window sills shows that Kertész was photographing from a slightly elevated viewpoint, to keep his camera level and avoid tilting the verticals of the buildings.

3 PUFFING TRAIN
The train and its trail of smoke catch your eye, drawing it away from the activity in the street, but the train's movement also encourages you to look back down at the scene below.

4 ARTFUL ARCHES
The way in which Kertész framed his shot makes one of the arches overlap with the left-hand building. The whole arch could have been included, but the strong lines of the two arches together might have overwhelmed the composition.

André Kertész
1894–1985

Kertész grew up near Budapest, Hungary, and his first pictures were lyrical images of the countryside. He photographed in the trenches in World War I, then moved to Paris in 1925. In 1927, he had a one-man show and became commercially successful. In 1928, he began to use a Leica, a camera perfectly suited to his poised compositions and free-roaming style. Kertész moved to New York in 1936. He had a few false starts, but by the 1960s he had finally achieved recognition as a world-class photographer of considerable influence. Henri Cartier-Bresson declared, "Everything we know, we learnt from André." Best known for his street photography, Kertész also created an innovative series of nudes distorted in a mirror, and made still-life studies, using a Polaroid SX-70 (see pp.274–75).

FORK, 1928

Small aperture, big ambition

While some photographers were recording the effects of the Depression on the American Heartland, others were beating the drum for photography's retreat from any debt to other art forms.

Almost a century after the invention of photography, the debate over what was or was not pure photography was still rumbling on. Group f/64 emerged – it cannot be said to have been founded – from discussions between Willard Van Dyke, Ansel Adams, and Preston Holder in 1931. Also written "f.64", the group was named after the smallest practicable lens aperture for large-format film. Like the Photo-Secession (see pp.110–11), to which it was conceptually opposed, Group f/64 was a collection of US photographers. They came from the San Francisco Bay Area and shared a belief in unmanipulated photography.

Small membership

When Edward Weston was offered an exhibition at the M.H. de Young Memorial Museum in San Francisco for 1932, he persuaded the museum director to turn it into a showcase for Group f/64. Other photographers were shown in addition to the core group of Ansel Adams, Imogen Cunningham, John Paul Edwards, Sonya Noskowiak, Henry Swift, Willard Van Dyke, and Edward Weston himself.

According to the manifesto displayed at this exhibition, the group sought "clearness and definition of the photographic image". It limited membership to "those workers who are striving to define photography as an art form by simple and direct presentation through purely photographic methods". They also defined pure photography as "possessing no qualities of technique, composition, or idea derivative of any other art form". If this were not clear enough, the manifesto made a point of specifically rejecting the productions of pictorialist photographers.

Large influence

Group f/64 photographers favoured large-format cameras – 10 x 8in (25 x 20cm) was the smallest they used – to produce richly detailed negatives, printed by contact for minimal loss of contrast. They aimed for overall sharpness, with no picturesque softness or blur. Since they idolized clarity, they tended to photograph things – plants, still lifes, landscapes, and buildings. Figures were not totally excluded, however – Noskowiak shot portraits, and Weston and Cunningham made nude studies. Group f/64 photographers processed prints with minimal manipulation, toning only to intensify and preserve the image but not to add colour or special effects. They promoted the pure photograph – one relying only on camera, lens, film, and paper – celebrating the qualities unique to the photographic process. Despite its loose organization, small size, and brief duration – just over three years – Group f/64 was

Imogen Cunningham
1883–1976

Cunningham took her time coming to photography – she bought a camera at the age of 18 but soon sold it. Five years later, she was inspired by Gertrude Käsebier's work (see pp.114–15) to try again. She photographed plants to pay her way before a spell with Edward S. Curtis taught her portraiture skills. She also studied photography in Germany.

As a result, she was a most technically accomplished photographer, whose work extended from plants to nudes, portraits to industrial views. In the 1940s, she turned to street photography, then joined Ansel Adams on the faculty of the California School of Fine Arts. She photographed until her death at the age of 93.

◁ **AGAVE DESIGN 2**

IMOGEN CUNNINGHAM, 1920s

In the 1920s, Cunningham concentrated on botanical photography, taking a particular interest in the close-up pattern and detail of plants in her California garden.

△ **ABSTRACTION**

PAUL STRAND, 1917

Every summer, Strand rented a cottage at Twin Lakes, Connecticut, and created still lifes on the porch. He tilted the objects and rotated his photographs until finally he abandoned recognizable items and concentrated on the pattern of tones. His photographs were the first abstractions of note intentionally created with a camera.

surprisingly influential. Apart from the presence of big names such as Weston, Adams, and Cunningham, the group was also a response to what was seen as the irrelevance of the romantic mists championed by Alfred Stieglitz. Photographers were looking for new artistic direction, and it seemed natural that guidance should come from California, in contrast to pictorialism, which was based in New York. Indeed, the f/64 approach is sometimes known as the West Coast School. Nonetheless, collaborations between Weston and Steichen in 1929, as well as Stieglitz's own changing views – such as his enthusiasm for the work of Paul Strand – show that any East Coast-West Coast dichotomy is simplistic and artificial.

f/64

The group's snappy title had a long-lasting appeal, as it seemed to offer both aspiration and a neat recipe for success in one. Later generations of photographers have been much confused by f/64, believing that setting a tiny aperture is a magic formula to obtain the kind of detailed clarity achieved by Ansel Adams or Edward

Tina Modotti
1896–1942

In her brief life, Tina Modotti created an impact wherever she went. Born in Italy, she emigrated to the US, where she worked as an actress. She met Edward Weston and Margrethe Mather, a major influence on Weston's photography. Modotti soon supplanted Mather as Weston's favourite model and lover. In 1923, Modotti and Weston moved to Mexico, and Modotti began to photograph peasant and local life with an increasingly political slant. In 1930, she was expelled from Mexico for her political activities. Her photography, limited largely to her seven years in Mexico, has had an impact far exceeding her slim output of little over 300 images.

WOMAN OF TEHUANTEPEC,
TINA MODOTTI, 1929

▷ **CABBAGE LEAF**

EDWARD WESTON, 1931

In 1929, Weston started an extraordinary series of vegetable studies, transforming humble aubergines, cabbages, and peppers into sensuous, abstract still lifes exploring shape and pattern.

Weston. For large-format cameras of 10x 8in (25 x 20cm) or bigger, f/64 is indeed a practical setting to deliver the greatest depth of field. With smaller formats such as 2.4 x 2.7in (6 x 7cm), even f/22 may degrade image resolution and contrast. At extremely small apertures, physical optics set limits that degrade lens performance, however high the quality. These limits worsen with small formats and lenses of complicated construction, like virtually all modern optics.

Flagging enthusiasm

As the Great Depression began to affect even the golden shores of the Bay Area, the group found it hard to maintain their idealism. Willard Van Dyke abandoned photography to take up film for social purposes, to document the poverty caused by the Great Depression. "I left still photography because it could not provide the things that I knew films could provide", he explained. Van Dyke's departure in 1935 signalled the final phase of Group f/64.

Dare to experiment, consider any urge, if in a **new direction** all the better.

EDWARD WESTON / 1932

△ **CHARIS**

EDWARD WESTON, 1934

Charis, the daughter of a neighbour, was Weston's most frequent subject and became his second wife. He applied the principles of Group f/64 – sharpness and cool precision – to the nude, just as he did to stll lifes and landscapes.

Ansel Adams

AMERICAN / 1902–84

Best known for the matchless monumentality of his black-and-white landscape prints, which he sold in their thousands, Adams was a versatile photographer totally in command of his technique. He founded key institutions and even now, his influence as a teacher lives on in his classic and ever-relevant manuals. He developed – with contributions from Fred Archer and Minor White – the Zone System, which guided generations of darkroom workers. Although specifics may be out of date, Adams's eloquent promotion of meticulous technique and fidelity to the subject is timeless.

Born in San Fancisco, California, Adams started photographing at the age of 14 and never stopped. At the same time, he was a self-taught concert-grade pianist. His musicianship informed his photography and teaching as much as any other photographer. With highly disciplined and refined darkroom skills, he produced beautifully made, richly detailed, pin-sharp prints, almost all of them created on large-format film. Despite the huge numbers in circulation, original prints still fetch top prices.

Adams was a powerful environmental activist – the conservationist Sierra Club used his photography to further their cause, and Adams collaborated with Dorothea Lange and Walker Evans (see pp.172–75). He also founded a gallery, set up academic photography in San Francisco, helped to establish photography at the Museum of Modern Art, New York, and was a leading member of the purist f/64 group (see pp.159–61). All in all, his life and many varied achievements were a perfect blend of art, science, and service.

> There are always **two people** in every picture: the **photographer** and the **viewer**.
>
> **ANSEL ADAMS**

▷ **NEW CHURCH**

TAOS PUEBLO, NEW MEXICO, 1929

Adams published his first book, Taos Pueblo, *in 1930. It contained 12 prints of the local people and buildings. He framed this church to emphasize its symmetry and to show the characteristic ziggurat stepping of the roof and wall.*

◁ **JEFFREY PINE**

CALIFORNIA, c.1940

*Adams first photographed this tree in 1916,
when he was 14. The image survives from his
first album on a page of Yosemite National Park
landmarks. This later version is much sharper
and composed so that the distant snow-capped
mountains nestle beneath the branch of the tree.*

△ **JAPANESE-AMERICAN INTERNEE**

CALIFORNIA, 1943

*Adams took this shot of a farmer in
Manzanar Relocation Center, California,
during World War II. His low viewpoint
frames the man against the sky and
avoids any contextual detail of the
internment camp.*

◁ **ROSE AND DRIFTWOOD**

c.1932

*In the 1930s, Adams started to photograph
still lifes and close-ups. He used a long
exposure in natural light and a combination
of small aperture and lens tilt to obtain
extreme depth of field, so it all looks sharp.*

Clearing Winter Storm

ANSEL ADAMS / c.1937

Since 1937, Ansel Adams had lived with his family in Yosemite National Park, California. One December, he noticed the morning's storm was clearing around midday. Jumping into his car with his 10 × 8in (25 × 20cm) camera outfit, he drove to Inspiration Point, well known to him from previous visits. The choice of viewpoint is limited here, so Adams's framing was determined mainly by where he pointed the camera and the focal length lens he used. An exposure of 1/5 sec at *f*/16, possibly with a yellow filter, captured the rapidly moving clouds, while a small increase in development from usual ensured normal contrast despite the overcast conditions.

The image is perfectly structured, with a satisfying balance of fine detail and blur in the clouds. It is also a symphony of tones – every shade and nuance of light is ideally placed. One of Adams's most popular images, this is also one of the most valuable – a 1944 print recently sold for a high six-figure sum.

NAVIGATOR

1 MIDDLE GROUND GAP
The steep slope of the mountain joins the floor of the valley in such a way that the top part of the image is harmoniously proportioned to the bottom part, as are portions to the left and right of this junction.

2 FLUFFY TEXTURES
The swirl of soft cloud animates the upper part of the image and forms a contrast with the snow-speckled details below. The fine grain and thick emulsion of 10 × 8in (25 × 20cm) film guarantee a gorgeous tonality.

3 ALIGNED TREES
The two foreground trees counter the mountainside diagonally opposite and act like guides to the gap between the great domes of rock that lead to the background.

4 FLOWING WATERFALL
The distant waterfall is caught in miraculous light. Easily missed at first glance, it is dwarfed by the mountains, giving a sense of the monumental scale of the scene.

Kodachrome

The only photographic film to feature in a top-10 hit pop song – Paul Simon's 1973 _Mama, don't take my Kodachrome away_ – Kodachrome is also the only film invented by a duo of concert-grade classical musicians.

Mannes and Godowsky
1899–1964; 1900–83

Known around the Kodak campus as "Man and God", Leopold Mannes was a concert pianist and composer who studied physics at Harvard, and Leopold Godowsky Jr was a violinist who had studied physics and chemistry at University of California Los Angeles (UCLA). Music was never far from their laboratory work: they are said to have timed reactions by agreeing on a violin sonata movement to play through their heads. They invented an additive colour process whose inadequacies convinced them that subtractive methods were the best way forward.

MANNES AND GODOWSKY REHEARSING

△ **KODACHROME TRANSPARENCY**

UNKNOWN, 1935

Kodachrome transparencies were delivered to customers in yellow boxes, each image ready to project, trimmed, and stuck into cardboard mounts that became an icon for professional colour photography.

Louis Ducos du Hauron had worked out the theory for subtractive colour by 1870 (see pp.120–21) – long before it was possible to put his ideas into practice. In 1912, Rudolf Fisher showed how colour could be created as part of film development, leading to early colour cinema films such as Prizmacolor and Technicolor. However, in 1917, two American teenagers – Leopold Mannes and Leopold

Godowsky – went excitedly to watch film shot on Prizmacolor, but were so disappointed by the quality that they resolved to make a better job of it.

Colour development
While working at their musical careers, Mannes and Godowsky pondered colour in their spare time, and by 1922 they had made enough progress to attract finance for a

laboratory. After eight more years' development, their work came to the attention of the visionary C.E.K. Mees, the director of research at Kodak. Mees invited the duo to work for him, and by 1935, they had created a colour transparency – a positive colour image that could be viewed by shining light through it – the quality of which far surpassed that of any previous colour film. Their revolutionary idea was to

diffuse dyes into the film at the development stage, which allowed flexibility in the choice of dyes and created highly permanent colours and a sharpness that became legendary. However, their approach called for a processing cycle of 28 separate, precisely controlled steps that required highly complicated processing machines.

Kodachrome first appeared in 1935 as 16mm ciné film, but in 1936, it was introduced as 35mm film rated at ASA10. With successive iterations, the film speed had crept up to ASA64 by 1962, and leapt to ASA200 in 1988. Kodachrome's low sensitivity and high cost – and the outbreak of World War II – meant that photographers were slow to adopt it at first. After the war, however, it became the standard colour film – the one against which all others were judged.

Colour prints soon followed Kodachrome. Kodacolor, which was introduced in 1942, was the first colour negative film for making colour prints. Looking at prints was much easier than viewing slides that needed darkened conditions (see box, right). Colour print film was also much simpler to use, as it tolerated inaccurate exposure.

Colour print therefore became the medium of choice for amateurs, as well as for wedding and social photographers, from the 1950s through to the late 1990s. With improvements in emulsion technology, including new types of silver grain, quality and speed steadily improved. Kodak's processing techniques became the standard for colour negative and colour prints and were used by rivals such as Agfa, Fuji, Konica, and GAF.

IN CONTEXT
Slide shows

The image in colour transparencies or slides was designed to be viewed by shining light through it onto a screen using a projector in a darkened room. Slide shows were a popular family entertainment in the 1950s and '60s as images were bright and brilliantly coloured. Early projectors had to be loaded one by one with slides. The arrival of the circular Carousel magazine in 1962 enabled slide shows to run automatically giving rise to a brief period of multimedia based on several projectors synchronized to a sound track. By the 1980s, the rise of TV had caused a sharp drop in the use of projectors.

KODASLIDE PROJECTOR

CAROUSEL PROJECTOR

◁ **CHOPPING COTTON**

JACK DELANO, 1941

Delano was one of many American photographers commissioned to document social conditions during the Great Depression. Unlike others, he was a fan of Kodachrome, using its bright colour rendering to good effect in this image of farm hands labouring in Greene County, Georgia.

△ **KODACOLOR PRINT**

UNKNOWN, 1955

Just over a century after the invention of photography, ordinary people could enjoy their own colour photographs. Easily handled and relatively inexpensive, colour prints became the new cartes de visite – an indispensable part of any family gathering was to revisit previous holidays and feasts by looking at the photo album of prints. However, colours were not as brilliant as seen in colour slides and prints left out in the light quickly faded to leave only the most light-resistant colours, as in the print of a family group above. For these reasons, colour transparency film was preferred by professional and enthusiast photographers.

The bitter years

North America's greatest environmental disaster and a deep economic depression together created the fertile grounds for one of the largest and most influential photography projects of all time.

Roy Emerson Stryker
1893–1975

A keen amateur photographer, Stryker directed the FSA project. He said, modestly, "Perhaps my greatest asset was my lack of photographic knowledge... pictures are pictures regardless of how they are taken". Once prints reached his desk, Stryker's key role became apparent. His ignorance of photography aside, he was a brilliant picture editor. Out of the deluge of photographs – over 30,000 a year – the number of iconic images he located makes his the greatest picture-editing achievement of all time. The work is remarkable for its consistent quality, both artistic and technical.

ROY STRYKER (RIGHT), LOOKING AT PHOTOGRAPHS, c.1940

In the early 1930s, the US was fighting for its life. The Great Depression led to one in four adults being unemployed, five thousand banks had failed, and national output plummeted to around half of what it had been before 1930.

Decades of ploughing up arid plains to grow crops during unusually wet conditions led to disaster when normal weather returned. The wheat failed, and it was also unable to hold the topsoil together, unlike the native prairie grasses that had been so rashly removed. The prevailing transcontinental winds whipped up the fine soil into enormous dust clouds that blew from the midwestern states all the way to the east coast. The struggling farming communities lost hundreds of thousands of penniless families, who fled the Dust Bowl looking for work and food.

Publicity pictures
A series of economic measures known as the New Deal was set in motion following Franklin D. Roosevelt's election as president in 1933, and various agencies were instructed to produce pictures to win public support for the programme. The largest agency by far was the Farm Security Administration (FSA).

The photographers assembled to work for the FSA in 1935 were a star-studded cast. Some already had impressive credentials, such as Walker Evans, Russell Lee, and Dorothea Lange. Others soon would, including Carl Mydans, Gordon Parks, and Marion Post Wolcott. The man holding the strings was Roy Emerson Stryker, Chief of the Historical Section of the FSA, who orchestrated his team with meticulous detail and efficiency.

Stryker sent photographers to record the work of the FSA with detailed lists of what they should cover. He worked out their routes and briefed them – they were primarily to show people in relation to the land. Above all, he wanted pictures that were uplifting, although he repeatedly

reminded the photographers they were not to manipulate their subjects to create more dramatic images. He told an interviewer: "You'll find no record of big people or big events. These are pictures that say 'Depression', but there are no pictures of sit-down strikes, no apple salesmen on street corners, not a single shot of Wall Street, and... no celebrities".

While the attention to farming people is understandable given the FSA's brief, up to a third of migrant families were white collar workers such as lawyers, teachers, and doctors. Many were displaced because their farming clientele had moved. The prominence of FSA photographs has given a skewed view of the true nature of the migrant problems.

Working methods
Although Stryker briefed his photographers on what to shoot, he left them to their own methods. Carl Mydans used a 35mm Zeiss Contax camera, for instance, while Dorothea Lange worked with a 5 × 4in (12.5 × 10cm) Graflex. Walker Evans mostly used 10 × 8in (25 × 20cm) film, but he would also reach for a Leica or Graflex as needed.

Some, but not many, of the photographers used Kodachrome to produce colour pictures. Kodachrome was introduced in the same year as the start of the FSA project – 1935 – but fewer than 1,000 images out of more than 164,000 surviving in the archives are in colour.

Publishing success
Photographers stayed in the field and shipped in their films to be printed, edited, and distributed to newspapers and magazines. The FSA Historical Section was a giant public relations agency whose photographs appeared in all the major magazines such as *Time*, *Fortune*, *Look*, and *Life*; they were exhibited at the Museum of Modern Art and appeared in books. All this was by 1938. By 1940, Stryker's

department was distributing 1,400 prints a week. Over the eight-year project (1935–44), the photographers produced some 270,000 images, on a total budget of about US$1,000,000 (£600,000). Like any documentary, the FSA project was subjective. The job of Stryker and his team was to promote government policies, and they were so successful that their work has eclipsed that of other agencies.

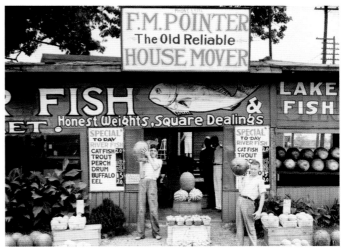

◁ **TRUCK TRANSPORT, MISSISSIPPI**

MARION POST WOLCOTT, c.1940

Kodachrome film makes the red truck stand out against the line of trees blowing in the breeze and picks up the fortuitous colour match with the scarf of the standing woman.

△ **ROADSIDE STAND NEAR BIRMINGHAM, ALABAMA**

WALKER EVANS, 1936

The boys hold up their mighty squashes for the camera but, beyond letting people pose, photographers were not allowed to manipulate their subjects.

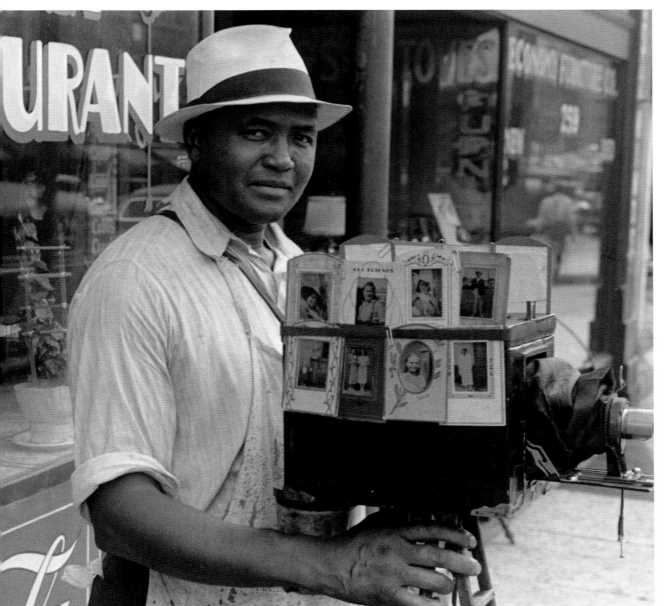

◁ **ITINERANT PHOTOGRAPHER IN COLUMBUS, OHIO**

BEN SHAHN, 1938

The Great Depression affected not just farming folk, but people from all walks of life and professions, such as this photographer setting out his wares.

◁ **VERMONT STATE FAIR, RUTLAND**

JACK DELANO, 1941

Delano was one of the few FSA photographers to take advantage of Kodachrome to record in colour. Working not only in bright conditions, as here, but also in dark factory interiors, he showed an impressive grasp of the possibilities of colour – demonstrated in this strikingly bold composition.

Migrant Mother

DOROTHEA LANGE / 1936

Also known as *Prairie Mother*, *Migrant Mother* is perhaps the most famous, and certainly most resonant image, of the vast output of the Farm Security Administration (FSA) photographers (see pp.168–69). In March 1936, Dorothea Lange was working for the Resettlement Administration (incorporated into the FSA in 1937) in Nipomo, California. On a whim, and despite being in a rush to get home, she turned off the main road to a camp of pea-pickers. Lange recalled, "I saw and approached the hungry and desperate mother, as if drawn by a magnet". According to Lange's notes, the family had recently sold the tyres of their car to pay for food. In fact, the mother and children were waiting for the men in the family to fix the car.

Lange had promised not to publish the photo, and use it only to obtain aid. Food was indeed rushed to the camp when bureaucrats saw the images, but two of the pictures were published, and the second became iconic almost overnight.

Only in 1970 was the mother identified as Florence Owen Thompson. It also emerged that far from being a typical Dust Bowl migrant from Europe, she was in fact a Native American. Thompson was to say of the image, "That's my picture hanging all over the world, but I can't get a penny out of it. What good's it doing me?" But when she was dying of cancer aged 80, an appeal brought in US$32,000 (about £19,000), much of it from those who had been moved by the picture. In 1998, the Getty Museum paid US$244,500 (about £150,000) for a print.

NAVIGATOR

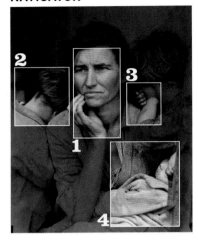

1 CAREWORN FACE
Lange places the mother in the middle of the picture, framed by her shy children. Her mouth is at the visual fulcrum of the image.

2 CHILD'S FRAME
The children turn away from the camera, which throws all the attention onto their mother. The children's dishevelled locks reinforce the message of poverty.

3 AUTHENTIC OR POSED
The child's clenched fist suggests tension and discomfort, perhaps even fear. The awkward pose implies the child had only just turned to that position or had been asked to assume the pose.

4 SLEEPING BABY
In the other images, the baby is cradled upright by its mother. Here it is lying flat instead, as if it has fallen asleep. Florence was holding onto the pole, which suggests posing under instruction, but her thumb has been retouched out.

IN CONTEXT
Behind the image

With the instincts of a seasoned photographer, Lange went straight to one family – out of hundreds – in the camp and immediately began to take pictures. Using a Graflex camera with 5 × 4in (12.5 × 10cm) film, Lange made a total of six exposures of the mother and her children within a mere 10 minutes or so. For each image, Lange moved in closer, with the final composition tight and possibly posed. Her aim at first appeared to be to show the desolate background, but for the final image she cut out all context. Clearly, it met her requirement "to capture not just an image but a mood". Originally, part of the mother's hand was visible, resting on the pole, but Lange touched this out.

THE SHELTER

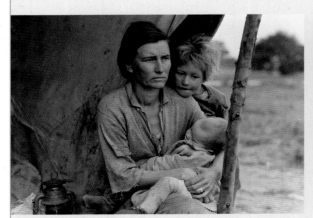

HUNGRY CHILDREN

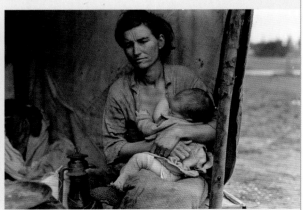

NURSING INFANT

Walker Evans

AMERICAN / 1903–75

Evans was to the human condition what Ansel Adams was to landscape. "I am for man's work; nature bores me as an art form", he declared. An enormous, truculent force in photography, Walker Evans was contrary, yet found irony amusing. Asked if he was a documentary photographer, he replied, "Very often I'm doing one thing when I'm thought to be doing another". He is famed for his documentary work, yet it was a genre that he despised, regarding his most celebrated work – luminous photographs for the FSA (Farm Security Administration, see pp.168–71) – as art.

Born in St Louis, Missouri, to an affluent family, he had a bookish youth and briefly studied French literature in Paris before picking up a camera at the age of 25. Within five years, in 1933, he had the first of his 35 shows at the Museum of Modern Art in New York. In 1935, while working for the US Interior Department, Evans was assigned to Roy Stryker's FSA team documenting small-town America. Stryker credits Evans with teaching him about photography. In just two miraculous years, Evans produced an astonishing range of penetrating portraits, revealing interiors, and lucid townscapes, working with a 10 x 8in camera. Ever the perfectionist, he would even cut his negatives to size to correct an error in framing. In 1937, his inability to keep records, or to do as he was told, led to his being dismissed by Stryker.

Evans's career was erratic. In 1938, he swapped large-format candour for voyeuristic candid portaits snatched in the subway using a Zeiss Contax peeping out from between his coat buttons. In 1945, he joined *Time* magazine as a staff writer, then became Special Photographic Editor at *Fortune* where he set his own assignments. In 1959, he used a Rolleiflex (see pp.246–47) to grab portraits of passers-by, shooting from waist level. By the time of his 35th exhibition at the Museum of Modern Art in 1971, he was professor of photography at Yale and was using the Polaroid SX-70 (see pp.274–75). Its instant prints were to be Walker's last photographs in a career that lasted half a century.

> You see: a **document** has **use**, whereas **art** is really **useless.**

WALKER EVANS / 1971

▷ **LAURA MINNIE LEE TENGLE**

ALABAMA, 1935

Evans cut out context to photograph this girl, a member of the family above. Close up, he captured the soulful look in her eyes, an appeal that outshone the dirty fingernails, grubby top, and roughly shorn hair.

◁ SUNDAY SINGING
ALABAMA, 1935

Although this image of an Alabama sharecropper and his family singing hymns looks like a chance moment, Evans carefully considered his shots. His FSA boss Roy Stryker commented, "Walker's pictures are quite different. They're not the accident. He plans them, he walks around, he looks, and all of a sudden... his is a composed job."

△ UNITED STATES HOTEL
SARATOGA SPRINGS, NEW YORK, c.1931

Evans approached architecture in the same straightforward way as he did portraits, photographing buildings head on and letting the subject matter speak for itself.

◁ SUBWAY PASSENGERS
NEW YORK, 1941

In 1936, Evans worked on a series of candid portraits catching subway passengers as they were snoozing, talking, or absorbed in their own thoughts. He hid under his coat a Zeiss Contax camera that he had painted black, prefocused the lens, and arranged a cable release so he could trip the shutter without attracting the attention of other passengers.

Flash synchronizer

Flash bulbs opened up a whole new area of photography as they could capture images in the dark or in poor light instantly. They greatly extended the reach of photojournalism, although not all cameras could use them at first.

Photographers began to use artificial light as early as 1887, when German inventors Adolf Miethe and Johannes Gaedicke created what they called *Blitzlicht* (lightning light). From then on, photographers used either brief bursts of bright light to supplement existing light, or continuous light from specially rigged lamps.

The first flash units were essentially controlled explosions created by igniting a mixture of magnesium with potassium chlorate and antimony sulphide. Burning magnesium was not only dangerous, however, but also generated a lot of smoke, so photographers rarely used it in their own studios. Nonetheless, photographers such as Jacob Riis (see pp.88–89) showed that flash enabled photographers to take pictures in otherwise impossible circumstances.

The need to enclose the flash in a bulb was obvious, and in 1893, Louis Boutan and French engineer Chauffour experimented with igniting magnesium wire in a jar for underwater photography (which led to some interesting underwater explosions). In 1925,

German engineer Paul Vierkötter used electricity to ignite magnesium foil in a glass bulb, then fellow countryman Johannes Ostermeyer did the same with cheaper aluminium foil. But true flash photography began in 1929, when General Electric offered the aluminium-based Vierkötter/ Ostermeyer bulb as the Sashalite. There was no explosion, no smoke, no drama – just a wonderful, sudden glow of light.

Timed delay

The key to using a flash was to synchronize it properly with the shutter, which usually opened in less time than it took for the flash to reach its brightest point. Since camera shutters were invented long before flash bulbs, there was no automatic way to harmonize them with the flash. The Kalart flash synchronizer solved the problem by introducing an adjustable delay to the shutter: when activated, it ignited the flash between five and 20 milliseconds before it tripped the shutter (depending on the type of bulb used). When the shutter opened, the flash was at its brightest.

The synchronizer worked with any camera using an interlens shutter (a shutter built into the lens), but cameras with focal plane shutters, such as the Graflex (see pp.104–105), needed some modifications. The Kalart Sisto-gun adapted the Graflex to synchronize with flash even up to exposures as brief as 1/1000 second – an achievement not matched by modern focal plane cameras until the Olympus F280 flash of 1987.

◁ **SELF-PORTRAIT IN A POLICE VAN**

WEEGEE, 1940

American photographer Weegee (pseudonym of Ascher Fellig) takes a portrait of himself with a Kalart flash in the back of a police van. The picture celebrates his signature interest in New York City's emergency services.

Holder for different-sized flash bulbs

Handle holder for three round-cell batteries to ignite the flash

Synchronization cord

Highly polished adjustable reflector

Viewfinder matched to lens in use

Bellows for extending the lens

Lens panel for interchangeable lenses

Flash synchronizer with adjustable delay

▷ **GOLDEN GIRL**

WEEGEE, 1950

A passer-by shields his eyes as Weegee photographs a gold-painted dancer. Weegee's name derived from "Ouija Board", a reference to his almost supernatural ability to be in the right place at the right time to take a picture.

▽ **KALART SYNCHRONIZER ON GRAFLEX**

1930–1950s

Kalart made many accessories for press cameras, including a universal flash gun, a flash synchronizer, and a rangefinder. The synchronizer was regularly used with the Speed Graphic camera produced by Graflex.

IN CONTEXT
Modern flash lighting

Studios that depend on repeatable and flexible lighting arrangements are designed around their electronic flash units. A small industry exists to provide light shapers for studio equipment to deliver all grades of lighting, from the softest to harshest. At the other extreme, flash units have been shrunk to smaller than the size of clock batteries so that they fit into compact point-and-shoot cameras, for which they are essential. In between, compact accessory flash units that fit on top of cameras can provide power that far exceeds that of all but the largest flashbulbs. In addition, modern flash units can make thousands of flashes without needing to be replaced.

FLASH LIGHT WITH REFLECTOR

▷ **HINDENBURG EXPLOSION**

SAM SHERE, 1937

One of a group of 22 still and newsreel photographers, Shere waited for more than three hours in the rain to record the landing of the world's biggest aircraft, the Hindenburg, at Lakehurst, New Jersey, US. The publicity surrounding the event horrifically backfired when the airship burst into flames. Shere saw the explosion and shot what has been called the "most famous news photograph ever taken".

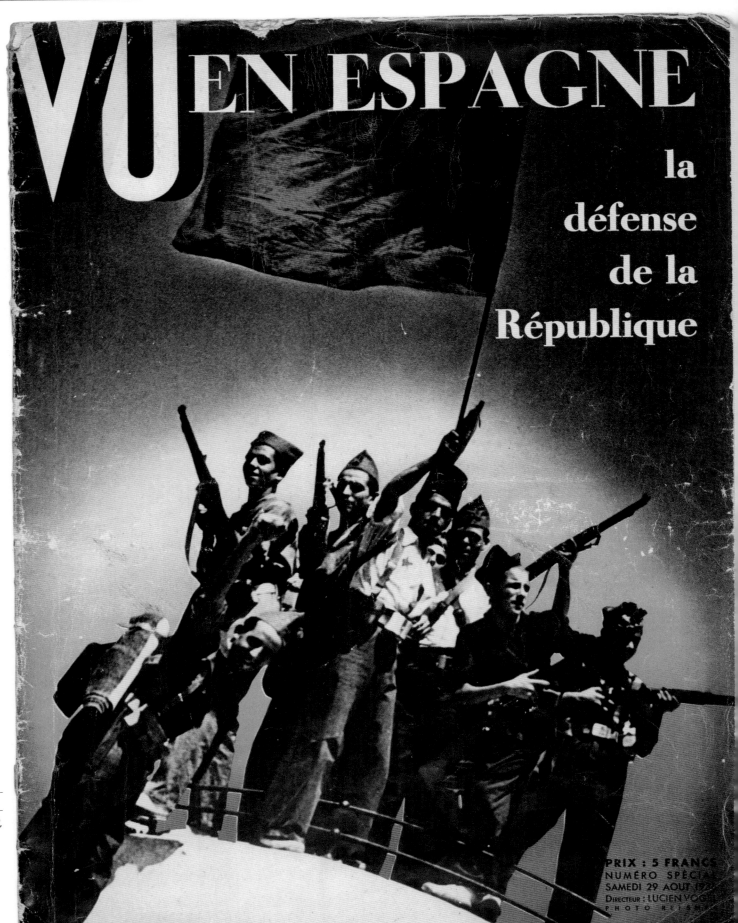

▷ *VU* **COVER**

1936

Published from 1928 to 1940, Vu was a weekly French magazine. It pioneered the use of picture essays, and its special issue on Spain at the time of the Civil War featured for the first time Robert Capa's famous picture of the falling soldier (see far right), taken two weeks earlier.

Illustrated magazines

As photographs increasingly became part of everyday life, so magazine readers expected to see more pictures in print. Improvements in printing led to the rise of magazines illustrated with photographs.

The example set by the *Illustrated London News*, founded in 1842, had been followed in every major European city, so the weekly magazine carrying features and news with illustrations had become a staple of well-read, educated society. If photography was ever used, however, it was only as the basis for engravings.

In 1910, German Eduard Mertens used the rotogravure presses he had invented to print the first newspaper photos in the *Freiburger Zeitung*. As faster and cheaper printing processes using offset lithography became more widely used, magazines illustrated with photographs rather than engravings began to flourish.

Growth in Europe

Magazines such as the German *Berliner Illustrirte Zeitung* (*BIZ*), and French *Vu* and *L'Illustration* launched the careers of photographers such as Erich Salomon, Martin Munkácsi, Felix Man, Kurt Hutton, and Robert Capa. The rise of Nazism in Germany, however, dispersed talented editors and photographers, and World War II put a stop to many magazines.

Life

In the US in 1936, however, Henry Luce relaunched *Life*, which had originally been an illustrated light entertainment magazine. The new *Life* was the first completely photographic American news magazine. Luce's vision, to "edit pictures into a coherent story – to make an effective mosaic out of the fragmentary documents which pictures... are", soon came to dominate photojournalism.

It was a brave time to launch a new magazine. The US was still recovering from the Great Depression and Europe was heading irrevocably for war. Although the magazine initially sustained big losses, sales of *Life* leapt from 380,000 copies at launch to over a million four months later. Its format of 50 pages of pictures with brief captions perfectly met the needs of the time. Using top photographers and writers, *Life*'s weekly circulation peaked at about six million by 1960.

Foreign talent

Picture Post was another pioneering example of photojournalism. Founded in London in 1938 by Stefan Lorant, formerly editor of the *Münchener Illustrierte Presse*, the main competitor of *BIZ*, it was a major beneficiary of the flood of talent from Europe in the mid-1930s. Lorant hired émigrés with whom he had worked, such as Tim Gidal (originally Ignatz Gidalewitsch), Felix H. Man, Kurt Hübschmann (later Hutton), and Gerti Deutsch. Fearful that he might be imprisoned if Hitler invaded Britain, Lorant fled to the US in 1940, leaving Tom Hopkinson in charge.

Around this time, spy fever gripped the UK, and many citizens and refugees of Italian, Austrian, or German descent were interned. Their positions on *Picture Post* were filled by British photographers such as Bert Hardy, Thurston Hopkins, and Grace Robertson. As a principal source of news and pictures about the war, circulation soared to nearly two million in 1943, but had dropped to 600,000 by the time the magazine folded in 1957.

△ **FIRST *LIFE* COVER**
MARGARET BOURKE-WHITE, 1936

Life magazine wore its American heart on its sleeve by featuring a triumph of US engineering – Fort Peck Dam – on its first cover. The dam was a signature project of the New Deal, designed to counteract the Great Depression of the 1930s.

IN CONTEXT
New layouts

The new cylindrical printing presses used wraparound printing plates that carried entire pages. Publishers could therefore plan and lay out whole pages or double-page spreads at a time – pasting pictures in position and arranging text elements as they liked. They no longer had to set type in rows and columns, with a centred box for the picture. Innovators such as Stefan Lorant, Alexander Libermann (later at Condé Nast Publications), and Lucien Vogel (of *Vu* magazine) seized on the chance to juxtapose photos and text, dramatically emphasize type, and use pictures at different sizes or overlapping. Freed of their former constraints, they were able to produce innovative new layouts.

DOUBLE-PAGE SPREAD IN *VU* ON THE SPANISH CIVIL WAR, ROBERT CAPA, 1936

Mainbocher Corset

HORST P. HORST / 1939

The enduring timelessness of Horst P. Horst's most famous photograph – one that he himself recognized as his iconic image – is all the more poignant because it reveals nothing of the turbulent times in which it was made. It depicts a woman in a corset – one made by the Chicago-born designer Main Rousseau Bocher, who had been the editor-in-chief of French *Vogue* before founding Mainbocher, his own fashion house, in 1929. Mainbocher's most famous client was Wallis Simpson and he had designed her wedding gown, which was typical of the house's slender, sinuous designs, often enhanced by corsets.

The sculptural elegance of the model's pose, thrown into relief by dramatic lighting, references classical statues, yet the picture, staged in the Paris studios of *Vogue*, was taken in August 1939, only days before the outbreak of World War II. "It was the last photograph I took in Paris before the war", Horst explained. "You knew that whatever happened, life would be completely different after... the clothes, the books, the apartment, everything [would be] left behind... The photograph is peculiar... it is the essence of that moment". With that surprising comment in mind, details in Horst's image suggest new meanings. The willowy model, the artful disarray of the corset lace, and the incongruous shelf all seem to represent the end of an era now revealed to have been all too artificial, all too insubstantial.

> I don't think photography has **anything remotely to do with the brain**. It has to do with **eye appeal.**

HORST P. HORST

Horst P. Horst
1906–2000

At a time when the trend in fashion photography was to chase after models on a beach with a 35mm camera, Horst worked at a fastidious pace in his studio with a 10 x 8in camera, at least four lamps, and several assistants.

Born in Germany in 1906, Horst Paul Albert Bohrmann moved to Paris in the 1920s, where he began his association with *Vogue* and met his mentor, George Hoyningen-Huene. In 1939, he moved to the US and worked as an army photographer, changing his name to Horst P. Horst. After the war, he resumed his former career, specializing in celebrities, architecture, interiors, and fashion. For his fashion work, which he shot mostly in black-and-white, he favoured minimal but carefully contrived props and elaborate lighting. He exploited the height of a tall studio fully by setting up large tungsten spotlights and used reflectors and baffles to cast light and shadow onto a scene.

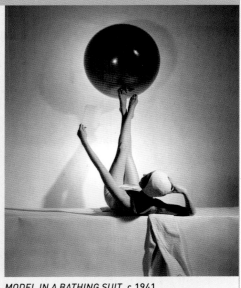

MODEL IN A BATHING SUIT, c.1941

NAVIGATOR

1 FRAMING SHADOW
A strong diagonal band of shadow forms the base of the entire image, which is full of light. The dark shadow serves to define the loops of corset lace.

2 "A LITTLE MESS"
Horst regularly introduced "a little mess" into an image, to highlight the grace of the rest of the picture and to breathe life into what might otherwise be clinical perfection.

3 SMOOTH GRADATION
Meticulous lighting from a distant lamp produces a smooth gradation of light – from the pale foreground to the overhanging darkness. The deep shadow on the model's upper arm mades a strong, sensual shape against this background.

4 CROSSING SHADOWS
The shadow that comes from nowhere is characteristic of Horst's work – there is no sign here of what is casting the shadow on the model's right arm. This creates a disconcerting, if subliminal, effect.

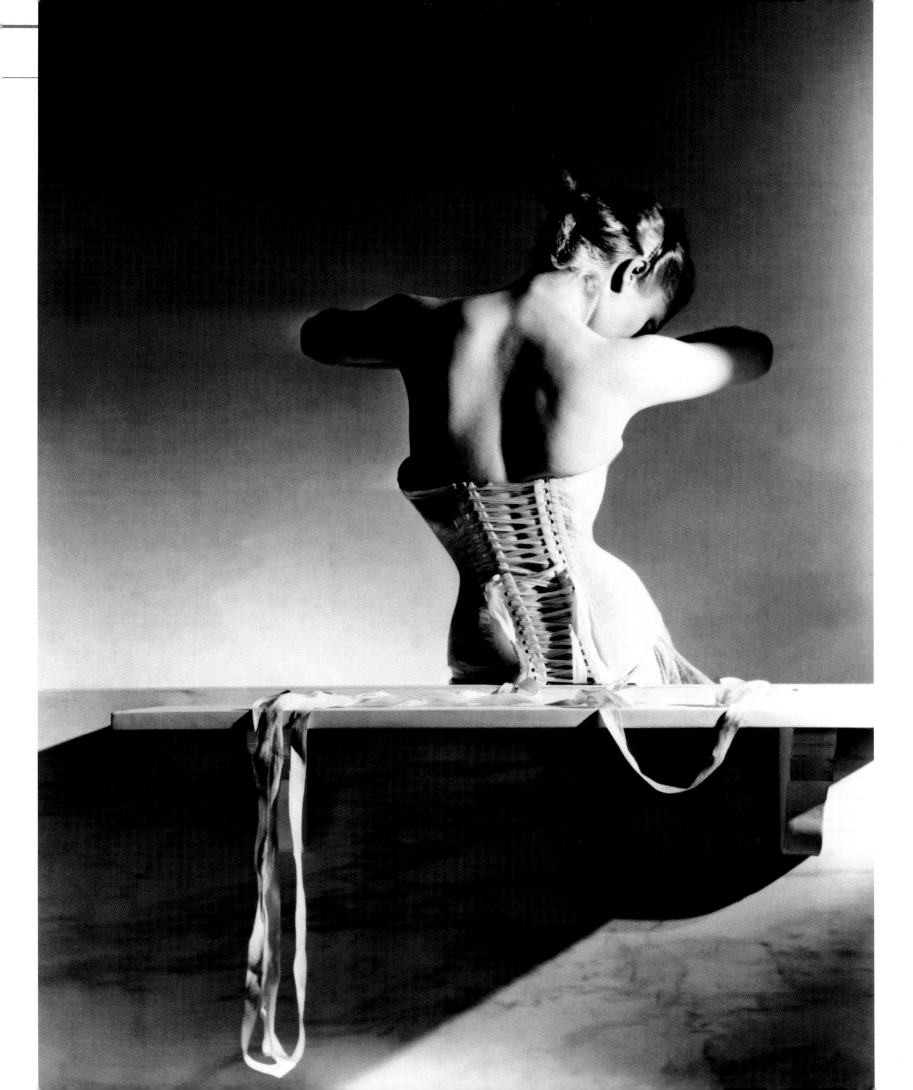

Effortlessly gorgeous

When the talking film was introduced, photography faced a challenge, but stills remained essential to the success of a film – and of its alluring actors. When the subject is transcendentally beautiful, photography is in its element.

George Edward Hurrell
1904–92

On the strength of just two portrait sessions, with stars of the silent films Ramon Novarro and Norma Shearer, George Hurrell was offered a job as the head photographer at the MGM studios. His original ambition had been to paint and he had only done the portrait sessions as favours to friends. Despite being self-taught, Hurrell had a genius for lighting and went on to photograph all the major stars of the day. After his stint at MGM, he worked for Warner Brothers in the 1940s, then Columbia Pictures during the 1950s.

OLIVIA DE HAVILLAND,
GEORGE HURRELL, 1938

The Jazz Singer of 1927 was the first mainstream "talkie". The film itself may have been the headline act, but all the advertising posters, publicity in newspapers, and, above all, the promotion of the stars, depended on the photographic print. The movies may have created the myth, but photographs made the myth persist.

First published in Chicago in 1911, the American magazine Photoplay offered stories based on current films – snappy plot summaries and profiles of main characters. By 1914, large parts of the magazine were devoted to portraits of film stars or features about them – the emphasis had shifted from fiction to mythology.

The covers of Photoplay and its rival Motion Picture Magazine were colour artwork up to around 1937, but inside, the magazines were packed with photographs, including full-page portraits. Stars vied for the top spots, and the skill of their photographers was crucial to their success.

Hollywood glamour

Commercial portrait studios such as Underwood & Underwood Studios met the call for portraits of stars until the film studios began to use their own photographers. Clarence Sinclair Bull, a cameraman in the Metro Pictures studio, started to take portraits of stars during production breaks. In 1924, he was made head of Metro Goldwyn Mayer's (MGM's) stills department, which gave him access to many of the stars of the day. Greta Garbo, in particular, would work with virtually no other photographer. From 1929 to 1941, the department produced portraits with such a range of expression and character that they constitute a veritable textbook on portrait lighting.

During the Great Depression of the 1930s, Hollywood film studios had to tread a fine line between reality and make-believe. Glamour portraits, millions of which were sent out by the studios, bridged the gap between worlds that were poles apart. Indeed, the work of Harriet Ruth Louise and George Hurrell seemed to cast a spell. Exquisitely beautiful or ineffably handsome, stars were portrayed bathed in an unearthly light that seemed to emanate from them as if they were gods – an antidote to the Great Depression. Anyone could own one of these pictures, which provided a touch of comfort – a relationship to the star by proxy.

Technical measures

Most of the images were made with 10 × 8in cameras, in studios with elaborate lighting managed by a team of assistants. The basic lighting would be set up with an assistant standing in, so that everything was ready when the star arrived. When the wardrobe department had dressed the star, the make-up department took over and the lighting would then be finalized with the actor in position.

Exposure times were deliberately kept long – up to 10 seconds if the actor could hold it – in order to intensify the pose and emotion. Some images were sharply detailed, but photographers often used soft-focus lenses (with undercorrected spherical aberration) or scrims (netting) to diffuse fine features and envelop the stars in a dreamlike glow. The large negatives were essential both for the richly smooth tone they bestowed upon a star's skin and because they were easy to retouch. Off would come Greta Garbo's mole, and Joan Crawford's freckles would be smoothed out. Before distribution, every photo had to pass the scrutiny of studio bosses and eagle-eyed censors looking out for any trace of indecency.

> It's all so simple... you **strike a pose**, then you **light it**. Then you... get some **action** in the **expressions.** Then, you **shoot.**
>
> **GEORGE HURRELL / 1992**

MPGP-7536

◁ **JEAN HARLOW**

CLARENCE SINCLAIR BULL,
c.1932

*Backlighting defines the profile of
the Blonde Bombshell and shows
off her famous platinum locks.
Harlow starred in a string of films
in the 1930s, including* Platinum
Blonde *(1931).*

△ **JOAN CRAWFORD**

RUTH HARRIET LOUISE, 1926

*Dressed in a fanciful slave-girl costume,
the MGM actress posed in many guises for
Louise. Standing on one leg in this position
would have been quite a challenge
considering the length of the exposure.*

▷ **CLARK GABLE**

GEORGE HURRELL, 1931

Best known for his role as Rhett Butler in
Gone with the Wind *(1939), Clark Gable
was posed to look as if he was nonchalantly
lounging in a studio chair, caught in a
candid moment. In fact, the scene was lit
with consummate skill to appear casual.*

Manuel Álvarez Bravo

MEXICAN / 1902–2002

The work of Mexico's most famous photographer straddles surrealism and the documentary, in search of *la mexicanidad* (Mexicanness). The people, culture, and landscape of Mexico were his recurrent themes. Álvarez Bravo's images can be strange – poet Octavio Paz referred to his work as "realities in rotation". During Álvarez Bravo's surrealist phase, Henri Cartier-Bresson described him as "the real artist". Born in 1902, Álvarez grew up during the turbulence of the Mexican Revolution. While working for the government, he bought himself a camera and taught himself photography. With modest success to spur him on – he won a competition in 1925 – he started working in 1928 for *Mexican Folkways*, documenting cultural history, but he gave up his day job only three years later. His circle included many of the leading artistic lights of the day, such as the painter Diego Rivera and photographers Tina Modotti, Edward Weston, and Paul Strand.

Álvarez Bravo's outstanding achievement was to use exotic and picturesque elements to mould images that step back from showing the obvious. Working with a Graflex camera even in the street (he refused to buy a Leica), his work is the reverse of surrealism – he turned the commonplace event into a mystery. Álvarez Bravo reminds the viewer they do not really know what is going on. These elusive meanings are mirrored in titles like *Optical Parable*. Álvarez Bravo once said, "An obscure title is the... one which most accurately defines the picture". By the 1940s, Álvarez Bravo was spending more time on landscapes, then turned to film production and teaching. His 100th birthday – after more than 70 productive years as Mexico's greatest living photographer – was a cause for national celebration.

I work for the pleasure, for **the pleasure of the work**, and everything else is a matter for **the critics**.

MANUEL ÁLVAREZ BRAVO / 1991

▷ **TWO PAIRS OF LEGS**

MEXICO, 1928

The disembodied limbs of a shoe advertisement give this image a surrealist bent, but the mundane electrician's sign above tethers it to an everyday location in Mexico.

◁ LAUGHING MANNEQUINS

MEXICO, 1930

At first glance, this could be a group portrait of happy girls, but closer scrutiny reveals a row of cardboard cutouts. Álvarez Bravo juxtaposes the expressions of the models, cloned into an inviting smile, with the stern face of a real woman at their feet.

▽ TWO WOMEN IN THE CASTLE

MEXICO, 1920

In this early work, the silhouetted figures are diminished by the grand scale of the interior. The two women lead the viewer up the magnificent staircase, where the focus is on the pattern of light cast on the wall from a round window.

◁ THE CROUCHED ONES

MEXICO, 1934

Álvarez Bravo saw how the harsh shadows thrown by the strong Mexican sunlight decapitated the figures – an artistic use of light in an otherwise banal image of workers lunching at a café.

Partisan objectivity

The desire to impeach injustice, to bear witness to oppression, or to report on conflict does not guarantee the truthfulness of the resulting photographs. The line between observation and misrepresentation is perilously fine.

Agustí Centelles
1909–85

By the time of the 1936 coup in Spain, Centelles was an experienced and well-published photojournalist. In 1937, he was appointed official photographer of the Eastern Army, and worked for, among others, the Military Investigation Service. He fled to France when Franco came to power but was imprisoned. While in the prison camp, he managed to create a darkroom. From 1942, he produced counterfeit documents for the French Resistance in a secret laboratory, then fled the Gestapo back to Spain. Under Franco, he had to keep out of trouble by giving up photojournalism.

FIGHTING IN BARCELONA, SPANISH CIVIL WAR, AGUSTÍ CENTELLES, 1936

Scarcely had people begun to recover from World War I, when the battle drums began to roll across Europe once again. Germany and Spain were just two of the countries in which political conflict led to violence.

Photographic story of Spain

The Spanish Civil War, which began after a military coup in 1936, was the first modern war in which many photographers used compact 35mm cameras, such as the Zeiss Contax and Leitz Leica (see pp.148–49). These transformed war photography – they were unobtrusive, responsive, portable, did not need tripods, and could make 36 images before being reloaded. Simple cameras such as the Kodak Brownie (see pp.92–93) were also widely available, so amateur photographers were also able to document events.

As a result, many photographers – not just the professional reporters sent by magazines and newspapers from across Europe and the US – covered the Spanish Civil War, yet its visual history is dominated by the best known – Robert Capa, Gerda Taro, and David Seymour (all of whom were Republican sympathizers). Even they are known by a mere handful of pictures, which themselves distort the record as they only show a fraction of the conflict.

The best-known image – Capa's *Death of a Loyalist Militiaman*, also known as *The Falling Soldier* – has been dogged by controversy about its authenticity. Many authorities are convinced that it was a setup, and that the soldier just slipped on the grass. The latest view – based on analysing the landscape visible in Capa's adjoining negatives – is that the picture was made near the town of Espejo, Andalucia, which did not see any fighting until after the photograph was published. Some even question who took the photograph, attributing it to Gerda Taro. But Capa was only 22 years old, and on his first big assignment he managed to capture an iconic image. The debate continues not because the truth is hard to bear, but because it is so difficult to relinquish the myth.

Jewish life

Russian-American Roman Vishniac's photographs of Jewish life in the towns, *shtetls* (small towns) and cities of Eastern Europe in the 1930s, before the Holocaust, are celebrated as a powerful documentary. The American Jewish Joint Distribution Committee, a relief organization, commissioned the photographs as part of a fundraising initiative started in 1935, and their brief to Vishniac was to record "not the fullness of Eastern European Jewish life but its most needy, vulnerable corners". He followed the brief, and his published and reproduced images from that time concentrated solely on depicting the life of the poor.

Vishniac, who was living in Berlin in the 1930s, travelled to Poland, Romania, Czechoslovakia, Lithuania, Hungry, Latvia, Slovakia, Belarussia, and the Carpathian region, covering around 8,000 km (5,000 miles). Some of his accounts, however, such as lugging 52kg (more than 8 stone) of equipment on his back – Leica, Rolleiflex, movie camera, tripods – pretending to be a fabric salesman, seem exaggerated. Analyses of his

▷ **DEATH OF A LOYALIST MILITIAMAN**

ROBERT CAPA, 1937

Capa claimed he grabbed this shot by holding his camera over his head and clicking just when militiamen jumped out of their trenches to attack a machine-gun post. Doubts remain, but Capa described it as "the best picture I ever took".

◁ **SARA, THE ONLY FLOWERS OF HER YOUTH**

ROMAN VISHNIAC, 1939

Vishniac explained that this girl's parents had no money to buy her shoes, so she had to stay in bed all winter in Warsaw, Poland. Her artist father painted the flowers on the wall to cheer the place up.

negatives also show that some images that he claimed were shot in the same place at the same time were in fact made at different times and in different towns.

Apart from his extensive coverage of Europe before World War II, Vishniac was a world-class scientific photographer. He pioneered photomicrography techniques that have now been adopted as standard practice, and he also taught art, philosophy, and photography.

His work was driven by passion and bravery, and some of his coverage of Jewish life was uniquely powerful. Understanding that this iconic work was the product of an assignment to depict poverty repositions this work in the broader context of social documentary photography.

IN CONTEXT
The Mexican suitcase

Three cardboard boxes filled with 126 developed rolls of film – the so-called Mexican suitcase – found their way to New York in 2007. The films were the famous Spanish Civil War negatives that had disappeared from Robert Capa's studio in Paris in 1939. The collection uniquely shows photographs taken by Capa, Gerda Taro, and David Seymour in Spain, as well as some work of Fred Stein. Capa abandoned the film when he fled Paris from the Nazis. Somehow, it reached General Francisco Aguilar González, the Mexican ambassador to the Vichy government from 1941 to 1942. The negatives were eventually discovered in Mexico City in 1994 by the filmmaker Benjamin Tarver.

NEGATIVES FROM THE MEXICAN SUITCASE

Winning hearts and minds

Starting with Fenton's diligently bland coverage of the Crimean War, many photographers have worked for a political cause. The German Ministry of Propaganda in World War II pressed both amateur and professional photographers into service to provide the pictures they wanted.

▽ **HAPPY BIRTHDAY**

HEINRICH HOFFMAN, 1934

A young country girl wishes Hitler a happy birthday in a photograph published in a radio programme listings magazine. Hoffman produced a continuous stream of pictures of Hitler meeting little children, bouncing babies on his lap, and patting fair-haired girls on the head.

In a speech to the 1934 Nuremburg rally, German propaganda minister Joseph Goebbels explained that, "Creative people made propaganda and put it in the service of our movement. We must have creative people who can use the means of the state in its service". He certainly did so, marshalling the best professional photographers and persuading thousands of amateurs, "willingly, and without internal resistance, to devote [themselves] to the tasks and goals of a superior leadership".

Promoting an image
By the 1930s, the institutions of amateur photography had developed sufficiently to make them ripe for exploitation in Germany by the Ministry of Propaganda. Joseph Goebbels's stated mission was "mental mobilization". To this end, amateur photography, with its petty hierarchies and rules, was perfectly placed to bolster the myth of the ideal German family – happy, healthy, strong, and Aryan.

The ministry encouraged amateur photographers to document their home lives and athletic prowess, and to compete with each other to try to provide the most attractive images of themselves. Thanks to the Ministry, there were plenty of magazines whose editors were waiting to publish these efforts, offering what Goebbels called "productive fantasy".

By rewarding only positive images – sunny, spirited, handsome (and featuring only one race) – Goebbel's programme nurtured self-censorship in photographers and conflated racist ideology with praiseworthy, aspirational imagery. Not unique to fascist regimes, similar strategies can be seen in the photography used for communist and capitalist propaganda.

Professional contribution
Heinrich Hoffmann, as Hitler's personal photographer, was as essential to the Führer's image as Goebbels was to his speeches. Hoffman skilfully orchestrated casual poses, perfect lighting, genial but relaxed expressions, and appropriate backgrounds. Paul Wolff was another master who went to great pains to conceal his refined professionalism. He contrived perfect examples of amateur photography by carefully planning and executing his shots in well-equipped studios to *stop* them

△ **LET'S FULFIL THE PLAN OF GREAT WORKS**

GUSTAV KLUTSIS, 1930

Germany was not the only country to use photography for propaganda. Latvian artist-photographer Klutsis turned photomontage into striking agitprop posters for the Russian regime.

looking professional. Of the other prominent photographers for the Third Reich, Helene Bertha Amalie "Leni" Riefenstahl is the only one to have achieved world fame. While her chief contributions were films – *Triumph of the Will* (1934) and *Olympia* (1936) – her use of relatively new effects, such as slow motion, masterful camerawork, and dramatic perspectives, bear all the marks of truly great visual artistry. She was aided by generous budgets approved at the highest level.

With the Nazi defeat, Riefenstahl become infamous for her virtuosity with the half-truth and glib denial, refusing to admit that she had willingly supported the regime.

IN CONTEXT
Leica freedom train

With Adolf Hitler's election in 1933, the need for Jews to escape German became more urgent. Ernst Leitz II, director of Ernst Leitz of Wetzlar (makers of Leica cameras), adopted a remarkable scheme. He appointed Jews as Leica representatives and sent them to Leitz sales offices in France, the UK, Hong Kong, and the US. The refugees were trained before being sent abroad and given a Leica camera to strengthen their cover story and provide a source of cash.

Leitz was not strictly supervised by the Nazi authorities because the Leica brand had high status and because US sales were bringing in hard currency. He was therefore able to help some 73 refugees to escape.

ERNST LEITZ II

◁ **THE EAST-WEST AXIS, BERLIN**
HUGO JAEGER, 1939

This is one of many colour images made by Jaeger of the vast military rally in honour of Hitler's fiftieth birthday. During the late 1930s and '40s, Jaeger made around 2,000 photos of Third Reich rallies and parades. At the end of the war, fearing retribution, he packed his colour slides in metal cans and buried them. He retrieved them in the late 1950s and later sold his entire archive.

Propaganda is what gives us the freedom to do as we are told.

MARKUS W. LUNNER

1909

SPIRIT OF
THE TIME

The years leading up to and following the war saw the greatest migration of artists and intellectuals ever, as people fled Fascist alliances. Almost overnight, writers, artists, playwrights, and photographers fled the cultural capitals of continental Europe and found shelter and work in the New World and elsewhere, to the lasting benefit of the US and Britain in particular. Photography was one of many areas of art to flourish as a result of this dispersal of talent.

Photography grew in influence and power. The half-tone print, the small camera, and high-sensitivity film helped to transform modern society into a predominantly visual culture, in which information and news is led by photographs rather than words. New technology enabled photographers to work in places and at speeds once thought impossible, and pictures could be disseminated far and wide because the costs of print reproduction fell. As global communication systems multiplied, pictures could be sent at the speed of an electrical signal.

But all was not well. Photographers could not ignore a world in turmoil. Filling magazines and newspapers with images far removed from domestic bliss, photographers brought the hellish realities of war into people's homes. For the first time in history, the public was starkly confronted with real, graphic images of man's inhumanity to man, as photographs of death, starvation, disease, and poverty entered the mainstream press. There could be no hiding and photographers' choices of what to shoot were projected onto a moral canvas that provided no clear answers.

Increasingly, the public's perception of the world was shaped and informed by the photographs published in newspapers and magazines. Jarring juxtapositions were commonplace – photographs showcasing the latest designer gowns would appear alongside reports of a devastating war or a famine. Editors wielded enormous power and photographers became heroes and heroines who took the pulse of the times.

Close to conflict

Photography has an unhealthy relationship with war, repelled and fascinated at the same time. The search for the photogenic in destruction, for well-composed images of conflict, and for humanity in the victims all lead to deep contradictions in the image.

No conflict in history was as disruptive and transformative as World War II. Cities were obliterated and national borders altered. Revolutionary – and often fearsome – inventions in military, industrial, and transport technology powered lasting social change. Tens of millions of people were killed, the majority of them civilians. World War II became the most fully documented event of all time, with ordinary citizens, soldiers at the front, and professional reporters all taking out their cameras.

Theatres of war

Photographs of war action met the acute public need to see what was happening, not just read about it. Magazines enjoyed a boom in circulation – *Picture Post* reached a million and *Life* magazine never bettered its war years' circulation of over 13 million. From its base in the US, far from the war zones of Europe, *Life* fielded 21 photographers who logged some 13,000 days, half that time spent close to active fronts. In theory, images could be sent from the front line in a flash. Wire photos – picture transmission using telephone lines – had been available since 1921, and Associated Press had begun its Wirephoto service in 1935. But the service required dedicated phone lines, which were set up only in major hubs because of the expense. Exposed films would usually have to be handed to soldiers to take back to base, so the photographs could take weeks to reach the editor's desk. Countless films were lost in the process.

One of the reasons why Robert Capa's images of the Normandy beach landings are so well known is because the other photographer on Omaha Beach, Bob Landry, lost his films (and his shoes) in the sea. Even Capa's set was almost ruined by an inexperienced darkroom technician. All photography was subject to military censorship: photographers

> ## Why print this picture...
> ## The reason is that **words are never enough.**
>
> *LIFE* **MAGAZINE / 1943**

◁ **BATTLE OF STALINGRAD**

DMITRI BALTERMANTS, 1942

A column of tanks advances towards Stalingrad, Russia, under a grey sky. The vastness of the Soviet war machine is shown here in the wide, flat composition, anticipating the dramatic action of battle.

△ **THE REINDEER YASHA**

YEVGENY KHALDEI, 1941

A confused Russian reindeer, later named Yasha by the photographer, is caught in the middle of an air raid. The effect of war on animals is poignantly revealed.

◁ **LANDING OF THE AMERICAN TROOPS ON OMAHA BEACH**

ROBERT CAPA, 1944

The haste with which Capa took this famous shot, one of the few to survive from the attack, shows in the motion blur. The soldier is struggling in the water with his heavy gear.

had to be accredited, films were transported by military personnel, and all images and captions were vetted before release. US publications had to operate a pool system to which all films were submitted, and released pictures could be used by any publication in the pool. However, such was *Life*'s clout that its editor negotiated the right to prevent its photographers'

△ **PAPUA NEW GUINEA**
GEORGE STROCK, 1943

Three marines who died at the Battle of Buna-Gona have been left on the beach alongside a damaged boat. The angle of the photograph obscures the men's faces to accord them anonymity.

work from being used by any of its rivals before it had appeared in the magazine. The jingoistic image of Iwo Jima (see pp.200–201) crossed the Pacific to editors' desks in the US within 18 hours. In contrast, George Strock's picture of three dead marines slowly being submerged by sand was taken in February 1943 but was not published until nearly seven months later. President Roosevelt did eventually authorize publication of images of the war dead because he feared that the American public was growing complacent.

Seal of approval

By far the largest number of pictures of the war were taken by official war photographers. In Britain, some two million such images were made, both for record-keeping and propaganda purposes – the latter featuring numerous pictures of Allied troops relaxing. The glossily illustrated Nazi propaganda magazine *Signal* had a circulation of up to 2.5 million in occupied and neutral territories and was even available in the US until 1941. It illustrated battle conditions for Axis troops and included general-interest articles, presenting the German armed forces as benevolent liberators.

One unexpected turn was the sudden utility of amateur holiday shots. From June 1941, the British Admiralty had the public rifling through their shoe boxes and family albums in search of snaps of Europe for its Ground Photographic Information Library to complement aerial photography and provide information for ground operations.

△ **CONCENTRATION CAMP OFFICERS**
UNKNOWN

Nazi staff relax at a resort near Auschwitz. Karl-Friedrich Höcker, on the left, kept an album of snapshots during his time there.

Robert Capa
1913-54

Robert Capa's Magnificent Eleven, the only surviving photographs of the assault on Omaha Beach in the Normandy Landings, almost failed to make it at all. Capa, by then on his third major war, was assigned to the first wave of infantry to land. He paused to photograph but the landing craft botswain, "who was in an understandable hurry to get the hell out of there", kicked him out of the boat. Capa landed waist-deep in the water but kept his camera dry and shot four rolls of film. He then hurriedly left, knowing that the prints had to reach the courier to the US by the following morning to make the deadline for the week's edition of *Life*. In the rush, the films were dried at too high a temperature, and the emulsion on all but 11 frames melted.

ROBERT CAPA WITH HIS ROLLEIFLEX CAMERA, 1945

The **truth** is the best picture, the **best propaganda.**

ROBERT CAPA / 1937

◁ DRESDEN BOMBING

WALTER HAHN, 1945

A stone figure, miraculously intact, looks out over the devastated German city of Dresden. The statue represents a moral judgment on those who dropped the bombs.

▽ JEWISH PRISONERS

UNKNOWN, 1945

Child prisoners, about to be liberated, wear the striped uniform of the concentration camp. These children were the subject of experiments carried out by notorious physician Josef Mengele. The picture is itself propaganda – a still from a Russian film.

Raising the Flag on Iwo Jima

JOE ROSENTHAL / 1945

The moment was not auspicious. Rosenthal had poor eyesight and he was too short for a good view. Then he almost missed the shot by talking to someone, but the image he managed to snatch is so perfect in composition and symbolism that its status as an icon of war is assured for all time. Small wonder that it won the Pulitzer Prize, the only photograph to do so in the same year as its publication.

Joe Rosenthal had been rejected from serving as a US Army photographer in World War II because he had failed two eye tests. Instead, Associated Press took him on and assigned him to the Pacific. Four days after landing on the Japanese island of Iwo Jima, a group of US Marines captured its highest point, Mount Suribachi, and raised a flag in triumph. Seeing the flag atop the mountain, their superiors wanted it for a battle souvenir and sent a detail to replace it. By the time Rosenthal reached the summit, the soldiers had taken down the first flag and were attaching the second to a salvaged water pipe. To improve his vantage point, Rosenthal piled up stones on a sandbag. As he moved into position, first a soldier, then film cameraman William Genaust walked in front of him. Genaust asked, "I'm not in your way, Joe?" Rosenthal turned to reply, but just then he saw some movement. He swung his camera round and grabbed the shot. The footage made by Genaust shows the pole was raised in about 4.3 seconds. Rosenthal was using a Speed Graphic, set to 1/400sec at about f/11. The war had honed his skill, enabling him to shoot at precisely the best split second.

IN CONTEXT
Posed version

Rosenthal took this gung-ho group to back up his snatched shot. His film was flown out and shots wired to the mainland. Within 18 hours, the images were on editors' desks and on breakfast tables across the US the next morning. Ironically, even days later Rosenthal had still not seen his shots. When asked whether he had posed "the" picture, he thought they were referring to the gung-ho version and said, "Sure". That careless reply was to dog his reputation for years.

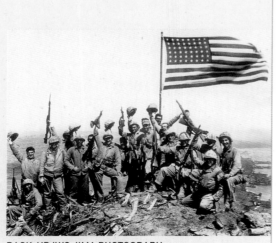

BACK-UP IWO JIMA PHOTOGRAPH

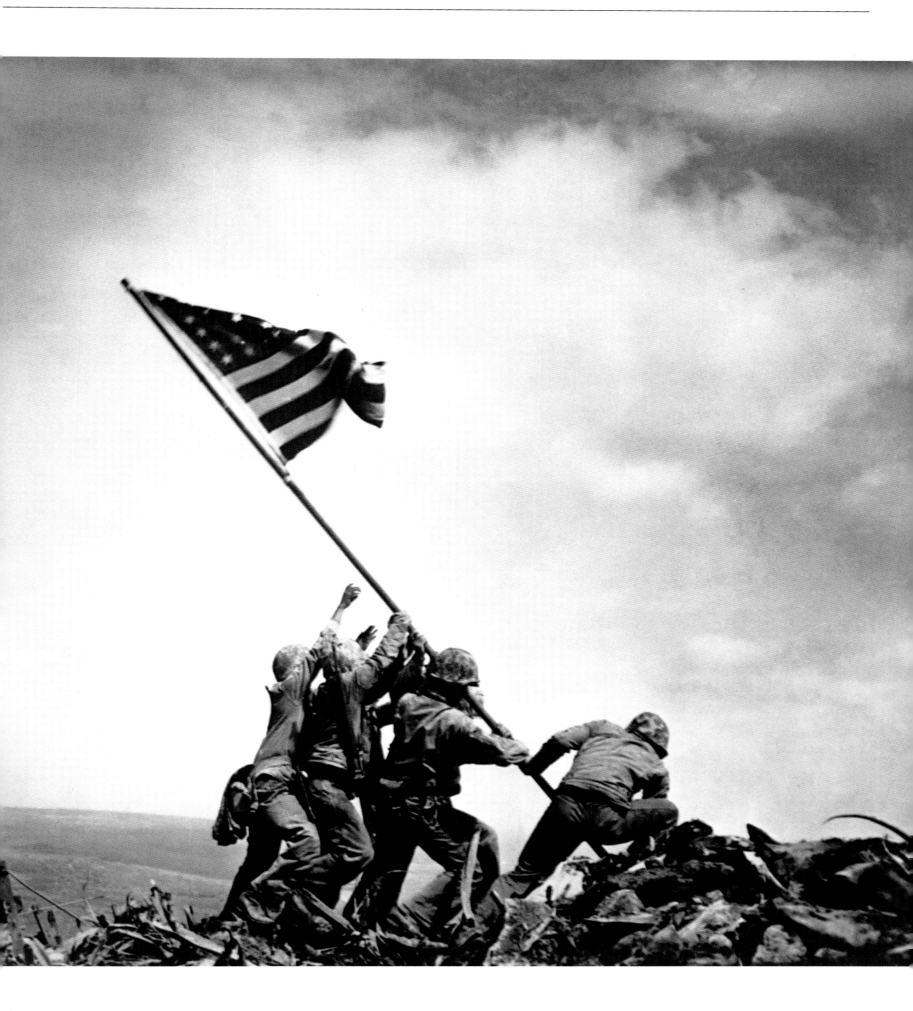

Flashes of light

One of photography's most profound technical innovations came from an engineering laboratory. The tiny flash gun indispensable to every modern compact camera started out as a massive machine carrying lethal voltages.

Harold Edgerton
1903–90

Anything was possible for Edgerton. In World War II, he invented a flash for night-time aerial reconnaissance, which was used to check that the defenders on the Normandy beaches were napping while the Allied invasion was underway. He invented the first high-speed motion cameras, shooting up to 15,000 frames per second. Edgerton also loved the challenge of working underwater. From 1953, he helped Jacques Cousteau with underwater flash equipment. Finding that flash did not work in murky waters, he responded by designing a side-scan sonar that used sound waves to see. He dramatically located a fallen H-bomb off the coast of Spain with his system. In 1986, inventive to the last, he pioneered an underwater flash time-lapse system to reveal the motion of slow-moving marine life.

HAROLD EDGERTON AND HIS DEEP SEA CAMERA, 1959

In 1926, American engineer Harold Edgerton was studying spinning electric motors when he noticed that pulses of light from his equipment appeared to slow them down. By 1931, he was using stroboscopic (repeated) flashes to analyse industrial processes. For one patent dispute, he showed that two methods of making soap powder – which were too rapid for the eye to follow – were, under stroboscopic analysis, quite different and so there were no grounds for dispute. For these experiments, Edgerton refined flash-tube technology to make it more compact and safe. By the mid-1930s, he was using stroboscopic light to analyse golf swings and the movements of ballerinas, following on from Étienne-Jules Marey (see pp.80–81).

Flash of understanding

Edgerton was the first to understand fully that the duration of a flash of light is the same as the exposure time for a photograph in which all the light comes from the flash. The shorter the flash of light, the shorter the exposure time. This solved two problems at once – in low light, the flash provided illumination while its short duration could stop action. Through electronic control and by using enormous capacitors, Edgerton was able to squeeze sufficient light into flashes short enough to freeze the motion of a bullet, a balloon bursting, or a drop of milk landing. Recognizing how useful his invention could be for photography, Edgerton made the equipment relatively easy to carry.

The first photojournalist to spot the potential of portable flash was George Woodruff in the late 1930s. Around the same time, a fellow engineer, Albanian-American Gjon Mili, had been working to improve lamps for photography. Mili and Edgerton collaborated from 1937 and soon, the two engineers and self-taught photographers were producing breathtaking images.

In 1939, Mili – an untrained amateur – began to freelance for *Life* magazine. This was the start of a 40-year career of brilliant portrait studies, which were characterized by inventive combinations of strobe, single flash, and continuous light, seen at their most famous in the series of Pablo Picasso painting with light.

Atomic flash

In the 1950s, Edgerton was asked to photograph a nuclear explosion. This called for a camera with a shutter capable of giving an extremely brief exposure – a billionth of a second with a delay of less than a 10 millionth of a second. For safety, the camera had to be located 11km (7 miles) away and, for a good view, up a 23m (75ft) tall tower. To meet the challenge, Edgerton and his team came up with the Rapatronic camera (see right).

◁ **MOVING BULLET**

HAROLD EDGERTON, 1964

The duration of the flash was about 0.3 microsecond, triggered by a microphone that picked up the sound of the rifle shot. The apple disintegrated completely moments after the 0.30 calibre bullet pierced it.

IN CONTEXT
Rapatronic camera

Edgerton created the Rapatronic (Rapid Action Electronic) camera to take shots of a test nuclear explosion. The camera had a 3,000mm (10ft) focal length lens and a shutter with no moving parts, using a magnetic field to change the polarization of a crystal sandwiched between two polarizing filters. The Rapatronic was a precursor of modern cameras, which essentially work on the same principle. Edgerton used 10 or more Rapatronics, each set to a different delay to capture a sequence of images of the atomic blast. This one shows the early stages of the fireball.

NUCLEAR DETONATION, c.1952

◁ **BALLET DANCER**

GJON MILI, 1943

Mili used stroboscopic (repeated) flashes to make a multiple exposure of Cuban ballerina Alicia Alonso performing a gliding step called a pas de bourrée.

Henri Cartier-Bresson

FRENCH / 1908–2004

The most elusive of people, but the most approachable of photographers, Henri Cartier-Bresson was one of the art's most articulate spokespeople. His prodigious early work of the 1930s, his influence on Magnum Photos throughout the 20th century, and his continually peerless output made him the giant of photojournalism, the standard by which all others are judged.

As with many great photographers, Cartier-Bresson's first love was painting, to which he returned from time to time, but in 1932 he saw an image by Martin Munkácsi that opened his eyes to photography's ability to extract meaning from the flux of life – a flurry of boys rushing into the sea created a balletic moment of eternity (see far right). Cartier-Bresson immediately abandoned his art studies and took up a camera. He admitted to prowling the streets all day, and his output proves it: many of his greatest images were produced in a few miraculous years during the 1930s. Blessed with determination and good luck, he covered the Spanish Civil War, was captured by the Nazis – but escaped to work for the French Resistance – and filmed the return of Paris to French hands. After the war, he founded Magnum with Robert Capa and others (see pp.206–07), and was a leading figure, until his withdrawal in 1966. Cartier-Bresson's photography is inseparable from the Leica camera. He used various models, usually with 50mm lenses. He only ever used black-and-white film, processed and printed by others, mostly by master printer Voja Mitrovic from 1967 to 1997.

Cartier-Bresson borrowed the term "decisive moment" from the 17th-century French writer Cardinal de Retz (who had applied it to politics) to explain that "photography is the simultaneous recognition, in a fraction of a second, of the significance of an event, as well as of a precise organization of forms which gives that event its proper expression". The phrase perfectly summarizes a style that was to inspire photographers for much of the 20th century.

The camera is **a sketch book,** an instrument of **intuition** and **spontaneity.**

HENRI CARTIER-BRESSON / 1976

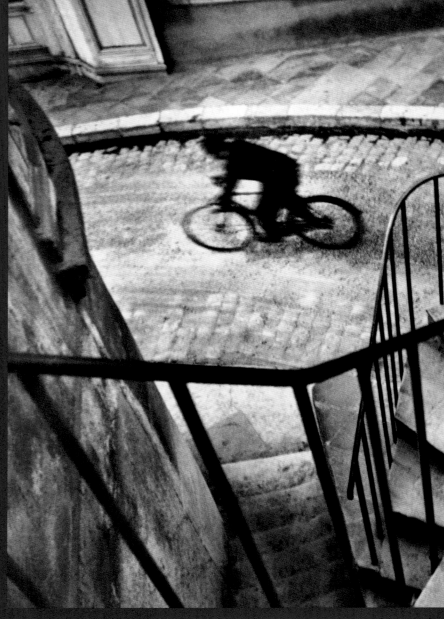

▷ **FOOTFALL IN FLOODED SQUARE**

PARIS, 1932

A perfect example of Cartier-Bresson's "decisive moment", when an idea and its form of expression merge, the drama and wit of this image hinge upon the foot about to get wet.

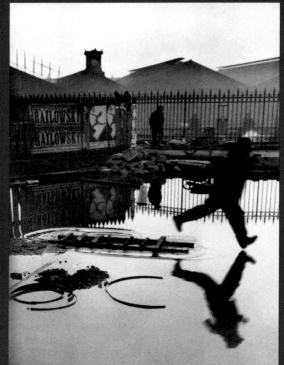

◁ **PASSING CYCLIST**

PARIS, 1932

Cartier-Bresson's technique relied heavily on the Leica's brief shutter lag – the interval between pressing the button and the film exposure – to capture moments instantaneously, with minimal delay. The winding stone staircase and iron banister lead the eye down to the street.

▽ **FARM WORKERS**

TAMILNADU, MADURA, 1950

The men work in unison to irrigate farming land in India, three years after the country gained independence. Three bushes in the left foreground form a visual counterpoint to the three figures and three pulleys.

IN CONTEXT
Martin Munkácsi

Chance photographs of a deadly street fight in 1928 affected the outcome of a murder trial and helped Munkácsi get a job with the *Berliner Illustrirte Zeitung*. Two years later, he took the shot (right) that inspired Cartier-Bresson to become a photographer. He emigrated to the US in 1934 after the Nazis nationalized his newspaper.

A specialist in sports photography, Munkácsi also shot fashion (see pp.234–35). In 1934, he impressed the US *Harper's Bazaar* team with an outdoor fashion shoot – a historic first – and they gave him a highly paid job.

THREE BOYS AT LAKE TANGANYIKA, MARTIN MUNKÁCSI, 1930

◁ **WEARING WOOD CHARCOAL**

KASHMIR, 1950

Workers in India laden with baskets of charcoal listen to the orders of their immaculately white-suited supervisor. The direct gaze of the man second left adds poignancy to the contrast between the workers and their superior.

Pulse of the time

Magnum Photos – an agency organized by its photographer members – is by far the best known and most respected name in photography. A formidable collection of stellar talent, its reach and influence are enormous.

William Vandivert
1912–89

Trained as a chemist, Vandivert got a staff job with *Life* magazine in 1935, just a year after taking his first photographs. He covered the US Midwest and was assigned to London in 1938. He photographed World War II in Europe (where he met Robert Capa in 1941), documenting the destruction of cities such as Berlin after the D-Day invasion. He also photographed Soviet Central Asia, which was virtually inaccessible at the time. His war experience and willingness to cover the US made him a good fit with the other founders of Magnum, but his photographic style and approach did not. In 1948, he and his wife Rita left to pursue industrial and advertising photography and worked together on wildlife books.

UIGHUR GUIDE, XINJIANG, CHINA, WILLIAM VANDIVERT, 1942

▷ **ASTROLOGER'S SHOP, BOMBAY**
HENRI CARTIER-BRESSON, 1947

Cartier-Bresson had a childhood fascination with India. He made his first trip to India in 1947, the first of many visits over a period of 40 years. This image was taken in the millworkers' quarter of Parel, Mumbai.

The glint in André Friedman's eye that was to become Magnum Photos first appeared in 1934, but took 13 years to develop into something more. By that time, Friedman had changed his name to Robert Capa, and the small coterie of photographers around him had been to hell and back, covering World War II.

In a penthouse restaurant at the Museum of Modern Art, New York, in 1947, Capa, Henri Cartier-Bresson, George Rodger, David (Chim) Seymour, and William Vandivert agreed to join forces. Rita Vandivert was elected president, and the office was to be run by Maria Eisner.

Capa's vision
Robert Capa had long dreamed of creating a group of photographers that would develop their own assignments, keep the copyright to their work, and be run as a cooperative. His mission was to take "the pulse of the time". As John G. Morris, a picture editor who was instrumental in Magnum's success, said, it was a "family for photographers who cannot maintain a family... working together they have more bargaining clout, share overheads like secretaries (and marry them) and slide libraries, share big projects." The photographers carved up the world among themselves. David Seymour assigned himself Europe; Cartier-Bresson chose India and the Far East; Rodger's area was Africa and the Middle East; while William Vandivert covered the US. Naturally, Capa could go anywhere he pleased.

Capa's vision was typically daring. He sought independence from the very magazines the photographers relied on for their living. Not only that, Magnum had the temerity to insist on controls such as forbidding the cropping of pictures. It was a winning gamble because the timing was perfect. Illustrated magazines in the post-war years were booming and hungry for their work.

Taking on the world
As Cartier-Bresson recalled, "...when we started Magnum, the world had been separated by the war and there was a great curiosity from one country to know how the other was. People couldn't travel, and for us it was such a challenge to go and testify – I have seen this and I have seen that. There was a market". Magnum flourished.

It also succeeded in raising the status of photographers from that of servile providers of images to creative and independent self-directors. Capa and Cartier-Bresson defined a style that was to be the hallmark of generations of Magnum photographers. Whereas Capa was an extrovert shooter, a sensitive humanitarian who grabbed images, Cartier-Bresson was an introvert, a deft creator of fully realized photographs, but both drew inspiration from the people they saw. As Ernst Haas (see pp.290–91), who joined in 1948, explained, "There are two kinds of photographers: those who compose pictures and those who take them. The first work in studios. For the latter, the world is their studio. The constant flux of life exerts a power of fascination over them. They are alert to it at all times. By creating Magnum, Capa, Chim, and HCB intended to put it on film".

The Capa–Cartier-Bresson pairing was so strong that it soon led to the parting of ways. Within a year of founding, William and Rita Vandivert withdrew from Magnum. A long roster of brilliant photographers, including Werner Bischof (see pp.208–09), Eugene Smith (see pp.248–49), René Burri, and Elliott Erwitt (see pp.262–63), replaced Vandivert.

Continuity
The group survived the deaths of Robert Capa and Werner Bischof in 1954, and of David Seymour in 1956. It also survived the collapse of the magazine market – a victim of the growth of television – by taking on corporate work. At the same time, it tortuously redefined its style – achieved over years of internal dissensions that nearly tore it apart.

Still, Capa's vision succeeded beyond his expectations. Magnum attracted, and continues to attract, photographers who progressively define and redefine the art of photodocumentary with innovation, skill, and obsessive dedication.

△ CHILDREN FROM THE WAGOGO TRIBE, TANZANIA
GEORGE RODGER, 1947

Daubed in mud and wearing ritual headgear, these boys were about to undergo their circumcision ceremony. Rodger photographed many aspects of life in Tanzania for his Africa assignment, including snake-charmers, Masai warriors, and underground miners.

▽ MOSCOW CELEBRATIONS
ROBERT CAPA, 1947

In 1947, the author John Steinbeck accompanied Robert Capa on a tour of Russia. The goal was to produce, Steinbeck explained, "honest reporting, to set down what we saw and heard without editorial comment". This image shows Muscovites watching fireworks commemorating the city's 800th anniversary of its first appearance in history.

▷ SCHOOLCHILD WAITING TO BE FED
DAVID SEYMOUR, 1948

Assigned to Europe, Seymour documented the lack of food in post-war Vienna. UNICEF and the Austrian government had joined forces to give all children who were six kilos (one stone) or more underweight one full meal per day in school. It was not just the poor who suffered from malnutrition.

Werner Bischof

SWISS / 1916–54

Although he was only 38 when he died, Werner Bischof helped to define the dominant style of Magnum Photos – photojournalism that was humane and sympathetic in content, and finely crafted, thanks to impeccable timing and choice of viewpoint. Born in Switzerland, but raised in Germany, Bischof trained with fellow Swiss Hans Finsler of the *Neues Sehen* (New Vision) school, from whom he learnt technical skills that became evident in all his subsequent work.

After a brief dalliance with painting in Paris, Bischof fled back to Switzerland at the outbreak of World War II. His outstanding early work from the 1940s consisted of nude studies lit in spots or swirls of light. His reportage was published from 1944 onwards. To cover the devastation of the war, he travelled to France, Germany, and Holland. He was deeply committed to bearing witness to the misery caused by the war, but his uncompromising coverage, which included an image of a mutilated child, was more than the general public could bear and a projected book was shelved.

Bischof's extensive travel and his work with international relief organizations and publications such as *Life*, *Picture Post*, and *The Observer* made him an obvious new recruit for Magnum Photos. He joined in 1949, following Ernst Haas (see pp.290–91) as its seventh member. In 1951, he was assigned to cover a famine in Bihar, India, where he produced some of his best-known reportage. Later that year, *Life* sent him to Japan. His relief at being removed from war and famine is evident in the lyrical series of works he made under the influence of Zen philosophy, which celebrated traditional Japanese values that had survived the war. By then, Bischof was losing faith in photography's ability to make a difference.

In 1954, Bischof went missing while on a trip to Peru and was found with two other passengers in a car that had careered off a mountain road. By then, he had captured his most famous image, a boy playing a flute near Cuzco, Peru. Made with his favourite Rolleiflex camera, it is a perfect example of his understated skill and impeccable craftsmanship.

▷ **FARMER**

CAMBODIA, 1952

Using a low viewpoint, Bischof crisply outlines the flower-like umbrella and the farmer silhouetted against the sky. The candid gaze of the cow adds a touch of humour.

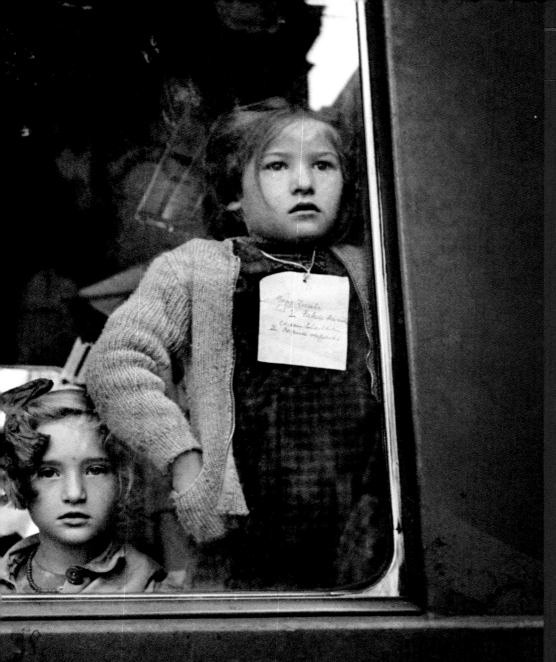

◁ **RED CROSS TRAIN**
HUNGARY, 1947

A Red Cross train transports children to Switzerland from Budapest, Hungary. The squares of paper around the children's necks visually parallel the reflections on the glass window. But whereas the papers preserve the children's identities, the reflection conceals the face of the girl on the left.

◁ **ON THE ROAD TO CUZCO**
PERU, 1954

In this famous photograph of a flute-player, the lines of the background foothills provide horizontal movement, echoing the boy's route.

△ **FAMINE**
INDIA, 1951

In 1951, the province of Bihar was stricken by famine. The low viewpoint draws attention to the mother's gaunt face, the child's swollen belly, and their mirrored hand gesture.

When **the war** came, with it came the **destruction** of my **ivory tower.**

WERNER BISCHOF, 1943

Kiss by the Hôtel de Ville

ROBERT DOISNEAU / 1950

Born in Paris, Robert Doisneau spent a long and distinguished career photographing life in the streets of his native city. His approach, and the secret to his success, was "To walk, and walk. And walk some more", immersing himself in the lives of the people he photographed. Nearly all of his best-known images are chance moments caught *sur le vif* (on the hoof). A period of work with *Vogue* magazine was short-lived because Doisneau found he did not enjoy posing models.

In 1950, *Life* magazine commissioned Doisneau to photograph couples kissing around Paris for a feature on the capital of romance. Surprisingly, given his liking for candid shots, he decided to hire couples to pretend to kiss spontaneously. He later justified himself: "I would never have dared to photograph people like that. Lovers kissing in the street? Those couples are rarely legitimate". The publication of *Kiss by the Hôtel de Ville* gave the world an icon of young love in Paris, which found its way onto postcards, calendars, and posters. The identity of the couple, however, remained a mystery.

In the 1980s, Doisneau met Jean and Denise Lavergne, who thought they recognized themselves in the picture. Reluctant to shatter their dream, Doisneau was noncommittal. His kindness proved ill-placed, as the couple sued him for photographing them without permission. Doisneau was forced to reveal that the couple were, in fact, hired models Françoise Delbart and Jacques Carteaud. Delbart saw a chance and also sued Doisneau for earnings from the picture. Fortunately, he had given her a signed print, which fatally undermined her case. She later sold the print at auction. The litigation deeply shocked Doisneau. His daughter Annette said, "We won in the courts but... *The Kiss* ruined the last years of his life".

NAVIGATOR

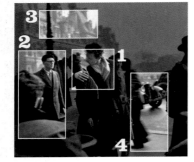

1 GOLDEN KISS
By using a wide aperture on his Rolleiflex, Doisneau keeps the focus on the couple. He locates the woman in the image so as to divide the left and right portions of the picture into harmonious proportions.

2 URBANE FRAMING
Passers-by in the foreground and background frame the couple, and place them in the context of stylish Parisian life.

3 DEPTH OF BLUR
Doisneau's use of a wide aperture throws the background buildings out of focus, which blurs details and blends tones. The combination of blur and pallor defines space through aerial perspective to frame the couple.

4 SPACE AHEAD
The space in front of the couple is empty of people but full of implied movement. This gives the couple room to move forwards, suggesting the bustle of city life.

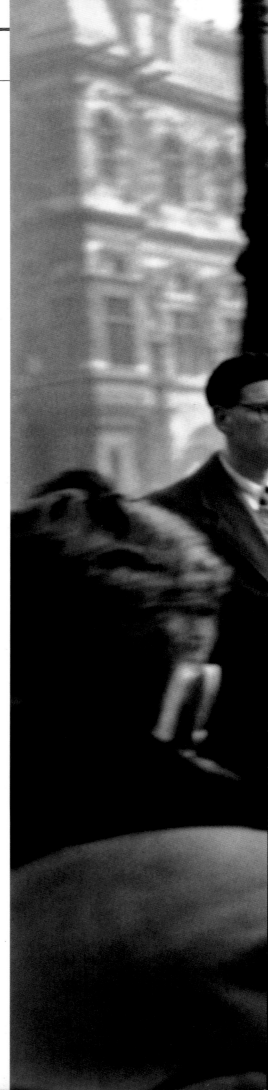

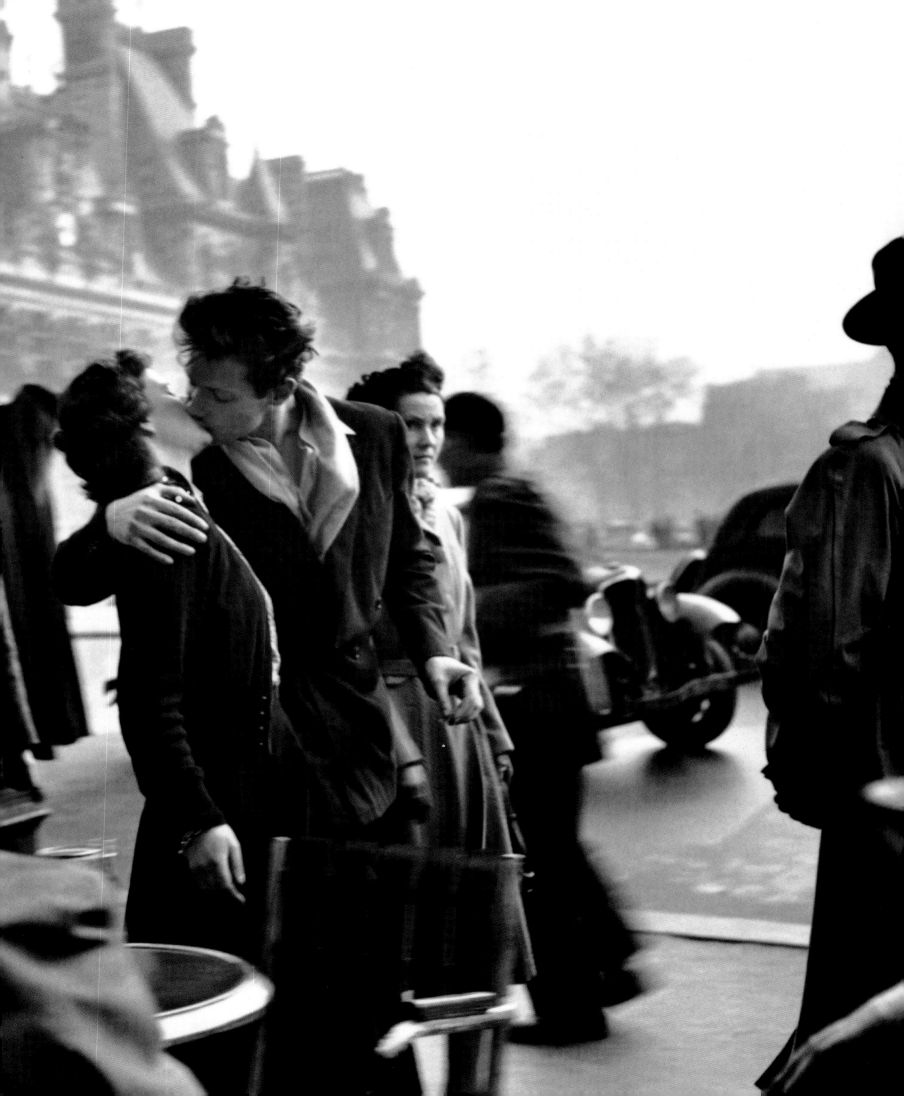

Zeiss 80mm Planar

Lenses that achieve an optimal balance of detail, colour, and contrast become the eyes for generations of photographers. One such lens was the Zeiss 80mm Planar, which reigned supreme among fashion and portrait photographers for 50 years.

Carl Zeiss
1816–1888

Carl Zeiss was 30 when he opened an optical instruments shop in Germany in 1846. Unsatisfied with contemporary methods of microscope design, he asked physicist Ernst Abbe to give the field a mathematical foundation. Abbe's work put Zeiss in the forefront of the industry, along with his partner Otto Schott – a glass-maker who could make special types of glass to order. Together, they founded what is now one of the leading optical companies, able to supply instruments and devices ranging from spectacle and camera lenses to planetarium projectors.

Many of the first camera lens makers, such as Charles Chevalier and John Henry Dallmeyer, were already skilled in telescope and microscope design, but photography posed particular challenges, such as projecting a large, flat image onto the photographic plate. The first lenses were the result of educated guesses, but in 1840, Josef Petzval (see p.28) bypassed this artisan approach by computing a lens before he made it. Further progress had to wait for Philipp Ludwig von Seidel's investigations into lens aberrations, but this turned lens computation into a complicated and repetitious process.

Nevertheless, Paul Rudolph, who worked at Carl Zeiss, computed the Planar lens in 1896, by elaborating two telescope elements collectively called the Gauss couplet. Its quality was evident from its very flat field – the image lay evenly on the film – but because it used six components, it suffered from flare, which limited its usefulness in the field.

Improving quality

The true potential of the lens had to wait for Alexander Smakula's invention of anti-reflective coatings in 1935. Once introduced to the 80mm Planar for use in medium-format cameras (such as the Rolleiflex 2.8E from 1956 and the Hasselblad 500C in 1957), the lens quickly won a favourable reputation. As a result, much of the portrait and fashion photography from 1960–2000 passed through the 80mm Planar.

Back in 1927, Willy Merté evolved the Planar design to create fast lenses (those with large maximum apertures). The influence of this design can be seen in famous lenses such as the Leica 50mm f/2 Summicron and the Nikon Nikkor 50mm f/1.4 (see pp.270–71). In fact, nearly all modern, fast 50mm lenses, and many of longer focal lengths, can trace their ancestry back to the Planar design, and rejoice under the technical name of Double Gauss Derivatives.

▷ **ANSEL ADAMS AND GEORGIA O'KEEFFE**

ALAN ROSS, 1994

Alan Ross, Ansel Adams's photographic assistant from 1974 to 1979, captures the great photographer setting up a scene through a Planar lens. The artist Georgia O'Keeffe is sitting in the background.

▷ THE LAST SITTING

BERT STERN, 1962

Six weeks before she died, Marylin Monroe spent three days posing for Bert Stern in a shoot commissioned by Vogue. Monroe herself chose to pose nude with the scarves although she was worried about the scar on her stomach.

IN CONTEXT
Fast lenses

Ever since German inventor Ludwig Bertele developed a 85mm *f*/2 lens in 1923 that made it possible to take photographs indoors without a tripod, fast lenses have topped photographers' shopping lists. Bertele's Ernostar lens for the Ermanox camera led to the line of Sonnar fast lenses, such as the modern Zeiss 135mm *f*/1.8. The Double Gauss grouping gave rise to the fastest lens ever – 50mm *f*/0.7 – which weighed 1.85kg (4lb). Only two of the latter were made – both for NASA, and subsequently mounted onto a film camera for director Stanley Kubrick.

LEITZ 50mm *f*/2 SUMMICRON

ZEISS 135mm *f*/1.8 ZA

NIKKOR 50mm *f*/1.4

Outer bayonet
for lens hood

Inner bayonet tab

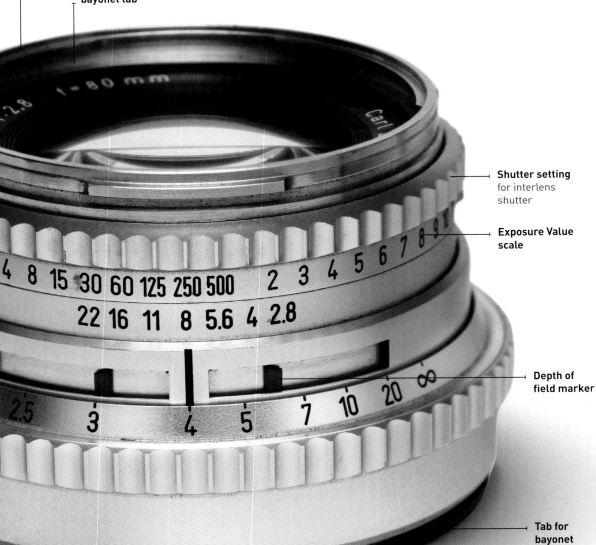

Shutter setting
for interlens shutter

Exposure Value scale

Depth of field marker

Tab for bayonet mount

◁ 80mm PLANAR

HASSELBLAD STANDARD LENS

One of the best-known applications of the Planar lens was its use in the Hasselblad 500 series. It offered automatic depth-of-field markers and an interlens shutter.

Subjective photography

After World War II, German photographers agreed that anything the Nazis had thought degenerate was probably acceptable, while art that could be construed as nationalist was repugnant. Abstraction was the way forward.

▽ **VOLKSWAGEN REAR WINGS**

PETER KEETMAN, 1953

Keetman spent a week photographing the Volkswagen factory in Wolfsburg, Germany. With his eye for shape and texture, he produced 71 images that brought out the beauty of the component pieces of the cars.

Four years after World War II, artists in Germany were gingerly picking through what remained of art and wanted to distance themselves from the strictures of Nazi culture. As a result, the first Fotoform exhibition, shown in Köln (Cologne) in 1950, featured abstract forms from nature, shadow patterns, multiple exposures, and other darkroom manipulation. The photographers were inspired by the Bauhaus (see pp.138–39) and Neue Sachlichkeit (see pp.150–51), and they were proud to acknowledge their debt. Exhibition contributors included Wolfgang Reisewitz, Otto Steinert, Peter Keetman, Siegfried Lauterwasser, Toni Schneiders, and Ludwig Windstosser.

The exhibition's explicit backlash against Nazi ideals caused an equally strong – and expected – reaction among its largely German audience. As one reviewer put it, the exhibition "was an atomic bomb in the manure pile of German photography".

Original talent

It soon became clear that the main force to reckon with was Otto Steinert, a former doctor and the only member of Fotoform who had taught himself photography. Due to his prominence, he is usually credited with starting Fotoform. In fact, it was Wolfgang Reisewitz who first decided to lead a breakaway group, having clashed with a jury – who represented old-guard values – over a proposed exhibition.

Born in Saarbrücken in 1915, Otto Steinert served as a medical officer during World War II, but abandoned medicine in 1947 to work as a portrait photographer. A natural teacher, he set up a photography course in his local state school the following year.

Steinert found the 1950 Fotoform show too restrictive, and feared that its photographers were in danger of developing the kind of conservative rules they wanted to escape. Coming up with the term *Subjective Fotografie* (subjective photography), Steinert gathered the Fotoform group to put on another exhibition. This time, he openly welcomed any work that appeared creative and unfettered by the past or by outdated theories.

Creative forces

Fotoform and *Subjective Fotografie* did not constitute an art movement – like pictorialism or surrealism – but were a broad-fronted reaction to right-wing ideals. The group celebrated individual creativity and allowed a wide variety of styles to coexist, as is evident in the contrast between Steinert's work and that of Peter Keetman.

A near-contemporary of Steinert, Keetman was born in 1916 and had his own camera by the age of eight. He was formally trained, with a Master's degree in photography, and worked for large industrial clients. Keetman's approach was to study a form thoroughly and systematically, as he believed that the best way to express his feeling for it lay in showing the purity of the form itself. Although he also experimented with photographing moving lights, Keetman is best known for his beautiful, precise, flawless images

◁ **PEDESTRIAN'S FOOT**

OTTO STEINERT, 1950

The high viewpoint makes a feature of the pattern of paving stones around the tree, and the long exposure turns the solitary figure into a disorienting blur, grounded by the feet. Steinert adopted many of the experimental techniques, such as startling viewpoints, practised at the Bauhaus before the war, but his work had a darker edge.

▽ **DANCER'S MASK**

OTTO STEINERT, 1952

Using montage to double the image and solarization to reverse some of the darks and lights and introduce a highlighted aura, Steinert conjured up a disturbing and hallucinatory vision of a face.

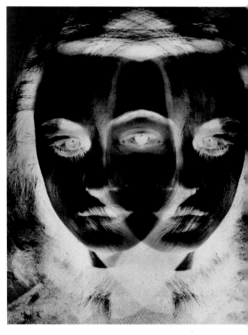

of the patterns and structures inherent in machines, and for his factory still lifes.

Subjectivity

Steinert gave photography a change of creative direction with *Subjective Fotografie*. His horror of servitude extended to rejecting photographers' slavishness to their subjects. According to Steinert, the purpose of photography could no longer be to represent a subject realistically (objectively), let alone follow any political or ideological agenda. Its sole aim was to give a subject personal (subjective) and artistic significance by photographic means – even if, as in Keetman's case, the work looked realistic. Steinert

encouraged photographers to explore all the creative possibilities at their disposal as a form of self-expression that was valid in its own right. This notion of self-worth or self-standing was already deeply entrenched in German philosophy and literature, but applying it to photography struck a chord with photographers all around the world.

Fotoform had run out of steam by 1958, but the ethos behind *Subjective Fotografie* continued well until the late 20th century, when postmodern navel-gazing made photographers begin to lose their nerve.

Photography gives us... a feeling of the **structure of things** with an **intensity** which the **eye**... has hitherto been quite unable to perceive.

OTTO STEINERT

Josef Sudek

CZECH / 1896–1976

Within the limits of his native city of Prague, Josef Sudek found most of what he needed. He shunned fame, and when the world caught up with him towards the end of his life, he retreated to the sanctuary of the shed in which he lived. There he rediscovered the serenity and the wealth in everyday detail he had always sought. Sudek enlisted in the Austro-Hungarian army during World War I and served on the Italian Front. In 1917, he lost his right arm in an incident of friendly fire, which forced him to give up his profession of bookbinding. Despite his disability, he used large-format cameras almost exclusively, making contact prints as large as 12 × 16in (30 × 40cm). In the 1940s, he acquired a panoramic camera, which he used intensively for a time, making what he called "sausages".

Sudek found his truest expression in images lovingly teased out of his home – essentially a large garden shed – using the watery light typical of Prague to capture fruit, glassware, and raindrops on the window. He also documented the streets of Prague and the reconstruction of its great cathedral, St Vitus. His books are full of luminous, quiet studies, half-hinted at melancholy, and deserted spaces. "I love the life of objects", he explained, "When children go to bed, the objects come to life".

His first one-man show was in 1932, but Sudek did not achieve international recognition until the 1970s. By then, he had been dubbed the "Poet of Prague" – a remarkable achievement in a city packed with great musicians and writers – for his skill in capturing the soul of the city. Upon his death, his estate included over 21,000 prints and over 54,000 negatives.

> # I believe a lot in instinct. One should never dull it by wanting to know everything.
>
> **JOSEF SUDEK**

△ **FROM THE WINDOWS OF MY STUDIO**

PRAGUE, 1940s

Sudek seemed to breathe life into the inanimate structures and bare winter trees of his humble back garden. Photographing through a window, he made a feature of rain or condensation on the glass panes to express typical Prague weather and light.

◁ PANORAMIC VIEW

PRAGUE, 1959

Sudek acquired a No. 4 Panoram Kodak camera during World War II, and used it to create panoramic photographs of Prague. He released them as a collection, Praha Panoramaticà, in 1959. This example uses the full width of the format to frame the view through the arch of a bridge.

△ STREET SCENE

PRAGUE, 1960

In his pensive night-time images of the back streets of Prague, Sudek revealed what he called the "life of objects", which came into their own when everyone went to bed.

◁ ST VITUS CATHEDRAL

PRAGUE, 1924

Documenting the completion of the vast Prague cathedral, Sudek portrayed shafts of sunlight as if they were as tangible as the pillars and arches themselves.

▷ **MIDTOWN MANHATTAN SEEN FROM WEEHAWKEN, NEW JERSEY**

ANDREAS FEININGER, c.1945

French-born Feininger trained as an architect in Germany before emigrating to the US, where he built a reputation as the most formidably technical of photographers. He produced perfectly lit and sharp images of subjects as diverse as a snake's skeleton to the architecture of cities such as New York.

Belgravia, London, 1951

BILL BRANDT / 1951

An eccentric master, Brandt left an indelible mark on every genre of photography to which he contributed, although his output was surprisingly small. Born in Hamburg, Germany in 1904, Hermann Wilhelm Brandt was later to claim London as his birthplace. In the 1920s, he assisted Man Ray (see pp.146–47) in Paris, drinking in the charms of surrealism and losing any inhibitions he may have had about photography. Brandt acquired a free and experimental attitude to the photographic process and was unconcerned about details of technique when pursuing "results that count". He would crop images dramatically, overprint, draw, and mark prints, and then photograph them again if necessary to achieve the desired effect. His work illustrates his view that, "Photography is still a very new medium and everything is allowed and everything should be tried. And there are certainly no rules about the printing of a picture".

In 1933, Brandt moved to London and started photographing people from all walks of life – from the wealthy to those who lived in the suburbs or slums. Motivated by a mix of humanitarian and left-wing views, his ambition initially lay in documentary work, but he lost enthusiasm for this after World War II and turned instead to photographing nudes, portraits, and landscapes. His most celebrated post-war work is the series of nude studies which he himself regarded as his major artistic statement. Delighted by the effects created by his Kodak camera (see below), he stated: "When I began to photograph nudes, I let myself be guided by this camera, and instead of photographing what I saw, I photographed what the camera was seeing. I interfered very little, and the lens produced anatomical images and shapes which my eyes had never observed". Brandt worked on nudes for a period of 30 years, exploring daring close-up wide-angle perspectives and exaggerations of the human body that recall the three-dimensional forms of his contemporary, the British sculptor Henry Moore. His seminal book *Perspectives of Nudes* was published in 1961.

NAVIGATOR

1 TRIANGULAR CORE
The centre of the image is a sexually suggestive triangle, reminiscent of the holes at the heart of modernist sculptures, set within swelling curves and bold forms.

2 HIGHLIGHTS
The leg points straight towards the chair and window, where highlights in the window frame reveal Brandt's source of light. The gleam on the floor reflects the ambient light from outdoors.

3 BURNT WINDOWS
The blackness of the window frames and roofs in the terrace outside reveal Brandt's use of heavy-handed burning in (giving extra exposure during printing) to evoke a suitably gloomy British sky.

4 DOOR TO NOWHERE
With a simple but unnerving touch, Brandt creates surrealist uncertainty. By aligning the left knee with the door frame, it is impossible to tell whether it is in fact a door or an empty picture frame. Suddenly, the whole space feels unsettled.

ON TECHNIQUE
Wide-angle camera

A tireless experimenter, Brandt worked with several cameras including a Rolleiflex and Hasselblad, but felt frustrated by modern cameras that were designed to mimic human vision and wanted a camera with a wide-angle lens. Eventually, in 1945, he found a 70-year-old wooden Kodak wide-angle camera with either a Zeiss Protar 85mm *f*/18 or 110mm *f*/18 lens, all of which he bought from a secondhand shop. The wider lens gave a field of view of around 110 degrees, the equivalent of about 16mm focal length on 35mm format. The camera took whole plate 6½ × 8½in (16.5 × 21.5cm) and had no shutter or focusing, but the images were sharp from very near to infinity.

Brandt said of his Kodak, "My new camera saw more and it saw differently. It created a great illusion of space, an unrealistically steep perspective, and it distorted". He was influenced by the deep-focus, wide-angled shots in the film *Citizen Kane* in the feeling he aimed to evoke and wanted to be able to "see like a mouse, a fish or a fly".

WIDE-ANGLE CAMERA

Theatre of the street

The street photograph was the genre of the everyman. Equipped with a small, portable camera, anyone could prowl the neighbourhood to record the bustle of life on the streets – and discreetly catch the weird, the funny, and the beautiful in the world around them.

Robert Frank
1924–

Robert Frank was born in Zurich, Switzerland, and emigrated to the US in 1946, where he worked as a fashion photographer for *Harper's Bazaar*. Bored of commercial work, he turned to street photography. "Like a boxer trains for a fight," Frank advised, "a photographer needs to practise by getting out and taking pictures every day". In 1955, he secured a grant to photograph the US. Travelling the country for nine months spread over two years, and covering thousands of miles, he exposed 767 rolls of film. When it was published in US in 1959, *The Americans* received hostile reviews, both for its frank portrayal of American life, and for its unconventional cropping, exposure, and focus techniques. Even MoMA, New York, refused to sell it – but it weathered the storm and is now regarded as a seminal work.

The early masters of street photography kept their distance from their subjects. Their images were a pause button on life, used to capture the poetry of transient compositions, stilled so that we could contemplate them and marvel. Such was the view of photographers such as André Kertész (see pp.156–57), Henri Cartier-Bresson (see pp.204–205), and Robert Doisneau (see pp.210–11). They also kept their opinions to themselves, absolving themselves from social comment by hiding beneath a veneer of artistic integrity, and producing work that was markedly apolitical.

In the 1950s, however, street photographers developed a more critical stance, towards bourgeois values in particular. One visionary who articulated this disquiet was Robert Frank (see box), who could not find an American publisher for his seminal work, *The Americans*, at first, because of its apparently anti-American sentiments.

Its 83 images, which had been whittled down from some 20,000, were finally published in 1958 in France by the great picture editor Robert Delpire. When the book appeared in the US the following year it was ridiculed for its "meaningless blur... and general sloppiness", but its honesty made a deep impression on late-20th-century photographers.

The heart of the action
Frank's contemporary, William Klein, photographed New York in 1954 by pushing his camera right into the thick of the action – and even close up to people's faces (see pp.224–25) His aim was not so much to catch a decisive moment, as a decisive emotion – one that exposed the violence lurking beneath the surface of people's lives. His breakthrough collection, *New York*, won him the Prix Nadar in 1957.

Legendary photographer Gary Winogrand was also working in New York at the time. Famous for getting through a 36-exposure roll of film before breakfast, he was perhaps the most prolific film-user of all. When he died, some 2,500 undeveloped rolls were discovered, and over 6,000 more that were developed but did not have contact sheets – and there were already 100,000 rolls and 30,000 colour transparencies in his archives. It is estimated that in his working lifetime, he exposed an average of 12 rolls of film each day.

Candid cameras
People were far less knowledgeable about photography in the years immediately after the war than they are nowadays. Cameras were not commonplace and photographers belonged to a privileged minority, so street photographers were able to pursue candid moments in their subjects' lives without arousing much attention or suspicion. As late as 1959, even a Mafia boss – the epitome of caution – let himself be persuaded

▷ **RED LIGHT DISTRICT, BARCELONA**

JOAN COLOM, c.1958

For many years Catalan photographer Joan Colom favoured the Rolleiflex (see pp.246–47), as its waist-level viewfinder made it possible to take discreet – if low-level – pictures. One of Colom's earliest influences was Henri Cartier-Bresson.

△ **MAIN STREET OF CORLEONE**

SERGIO LARRAÍN, 1959

A young girl is caught unawares in this atmospheric picture of the town of Corleone, Sicily. Her look of wonder at the sky contrasts with the apparent mood of the adults and animals around her.

that a Leica wielded by a photographer was merely the toy camera of a tourist. That particular boss was Giuseppe Russo, and the photographer was no tourist but Sergio Larraín – Chile's greatest photographer – on assignment to photograph a man wanted for multiple murder charges.

Famed for his delicacy of touch when framing street scenes, and for making use of both high and low viewpoints, Sergio Larraín worked for Magnum Photos in the 1960s, then withdrew from photography. Since around 1970, he has lived in the mountains of his native Chile, where he writes, paints, and still takes the occasional photograph.

◁ **UNTITLED**

GARRY WINOGRAND, 1950s

Hesitation is anathema to the street photographer, as is demonstrated by this perfectly timed picture by Garry Winogrand. The onlookers' expressions heighten the picture's exuberance.

◁ **BIG FACE, BIG BUTTONS, NEW YORK**

WILLIAM KLEIN, 1954–55

Uncompromising and equally unconventional, American William Klein ignored received wisdom about sharpness with this blurry face of a woman taking part in a New York street parade. Klein also took fashion shots but he preferred "real pictures, eliminating the taboos and clichés" of gritty street life.

The Family of Man

Exhibitions of photography can inspire, explain, and sometimes cause controversy. No show has demonstrated this better than Edward Steichen's monumental photographic project of 1955.

In 1858, as the US slid into civil war, future president Abraham Lincoln gave a speech in Lewistown, Illinois, in which he described all of humanity as one great "family of man". Almost a century later, in the early 1950s, Edward Steichen, Director of Photography at MoMA, New York, borrowed the phrase as the title for an exhibition of global photography.

Steichen's mirror
In a world again fragmented by the threat of war – this time, the Cold War – Steichen believed that photography could be a tool for "explaining man to man", promoting a sense of global community and understanding. The show was to become one of the most discussed, visited, and – despite its noble aims – divisive photography exhibitions of all time. In 1952, Steichen began work on *The Family of Man* by making a worldwide call to photographers for contributions, requesting "photographs made in all parts of the world, of the gamut of life from birth to death, with emphasis on the daily relationships of man to himself, to his family, to the community, and to the world we live in." The response was overwhelming. Steichen had to whittle two million photographs down to ten thousand before what he called the "almost unbearable task" of making the final edit. He eventually selected 503 images that represented the work of 273 photographers from 68 countries.

Unusually, these photographers entrusted Steichen with their original negatives, probably because of the great respect that he and MoMA commanded. This meant that he could ensure all prints were of uniform quality and tonally matched. They were all displayed without borders or frames, and either poster or normal size. Despite the wide availability of colour film at the time, all the images but one – the giant, glowing, blood-red image of a nuclear explosion – were black and white.

The architect Paul Rudolph created the exhibition's mazelike layout, designing it to lead visitors through the show's major themes – love, birth, work, religion, old age, and conflict.

△ **STEICHEN INSTALLING EXHIBITION**

1955

Photographs for the exhibition were suspended from the ceiling, hung on transparent boards, cut into silhouettes, and presented on rotating stands, according to the thematic design of Steichen (standing, centre).

Mixed reception
The exhibition opened in January 1955. It met with a cool reception from critics and photographers, who argued that the exhibition lacked cohesion, despite its uniformity of presentation. Steichen was also accused of downplaying cultural differences in order to slot photographs into his thematic groups – tribal story-telling was lumped with university lectures, and drought in the US was shown alongside African famines. *The Family of Man* has subsequently been accused of reducing the cultural awareness of generations of travel photographers.

Despite these criticisms, the public loved the exhibition. It was put on in 88 venues in 37 different countries, and around nine million people formed

▽ **BUSHMAN CHILDREN PLAYING**

NAT FARBMAN, 1947

Boys in Botswana run and jump in the desert sand, demonstrating the delight in innocent play that unites children of all cultures. Steichen wanted plenty of pictures of the young as, among children, "the universality of man is not only accepted but taken for granted".

△ **PERUVIAN FLUTE PLAYER**

EUGENE HARRIS, 1955

The smiling flautist from Peru was used to mark sections of the exhibition, and appeared on the cover of some editions of the catalogue.

long queues to visit it. The catalogue is also one of the most influential photography publications ever. Its 2.5 million sales far outnumber those of all the most successful photographic monographs put together. The show lives on – more than 50 years after opening, it is still on display, at Clervaux Castle, Luxembourg.

The Family of Man

The 30th Anniversary Edition of the classic book of photographs created by Edward Steichen for The Museum of Modern Art, New York

Prologue by Carl Sandburg

EXHIBITION CATALOGUE

IN CONTEXT
The only colour photo

As they neared the end of the original exhibition, visitors entered a darkened room. There they were confronted with a large backlit transparency glowing bright orange. It showed the fire ball from Ivy Mike, the first test of a thermonuclear device, conducted in 1952. It never appeared in the catalogue and was removed from the travelling show. It is not known why the image was removed; perhaps because it was Steichen's anti-nuclear statement. It appears now to be lost – this image shows the fireball at an earlier stage from that shown in the displayed photograph.

FIREBALL FROM IVY MIKE, 1952

Hot Shot Eastbound

O. WINSTON LINK / 1956

American Ogle Winston Link raised train-spotting to a project of epic proportions, carried out with consummate skill. He had trained as an engineer but spent much of his life working as a photographer in industry. He made his first night-time picture of a train in January 1955. In May that year, he learnt that the Norfolk & Western Railway was to phase out its steam locomotives. Now working against time, Link set himself the task of documenting the last days of steam.

From his industrial experience, he was expert at planning and executing complicated lighting setups with flash. For the night-train photographs, he devised a system of multiple flash units wired to condensers and portable batteries. He would string out the flash along the route to light both the train and nearby objects. When the train came, he would press a button to set off the flash, hoping it would all work.

In the summer of 1956, in Iaeger, West Virginia, Link persuaded a young couple to watch an open-air movie from his own car. "What's the catch?" asked the young man. There was no catch, but there was US$10 (£6) in it for them. Overall, Link spent more than US$20,000 (£12,000) on the project (at least US$150,000/£90,000 in today's terms) and five years of his life. His own assessment was, "I was one man, and I tackled a big railroad. I did the best I could".

NAVIGATOR

1 COUPLE IN CAR
It is not known whether Link posed the couple, Willie Allen and Dorothy Christian, for the exposure. Either way, they – and especially the girl's bare shoulders – are perfectly placed and lit.

2 CONTEXT LIGHTING
Link used multiple systems of connected flashes to light details such as the parked cars. As the flashes were wired in series, one misconnection could leave a whole section in the dark.

3 THE CINEMA SCREEN
The blasts from the flash burnt out the screen image, so Link had to put that back in a separate exposure of a still from the film.

4 STEAM TRAIL
Lights placed high up to the right in front of the train beautifully light both locomotive and its steam. The railwaymen approved of Link's work and gave him help, access, and perhaps even suitable puffs of steam at the right time.

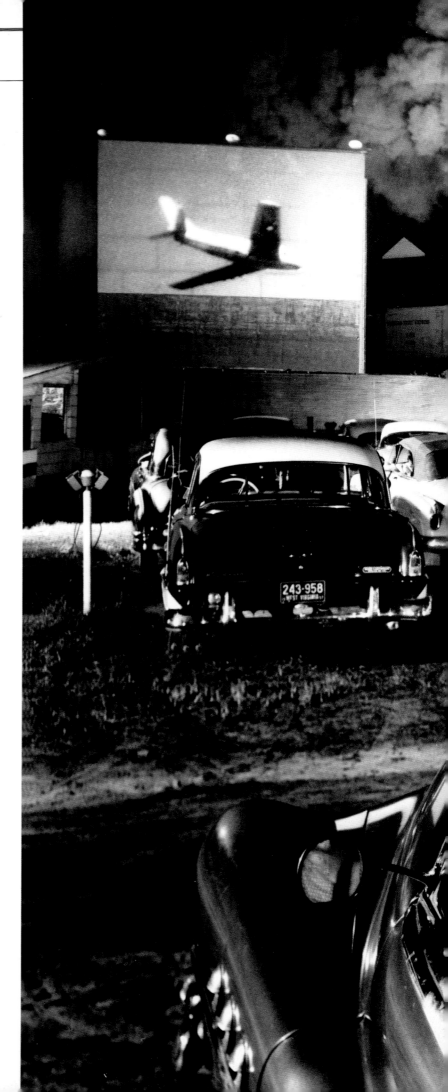

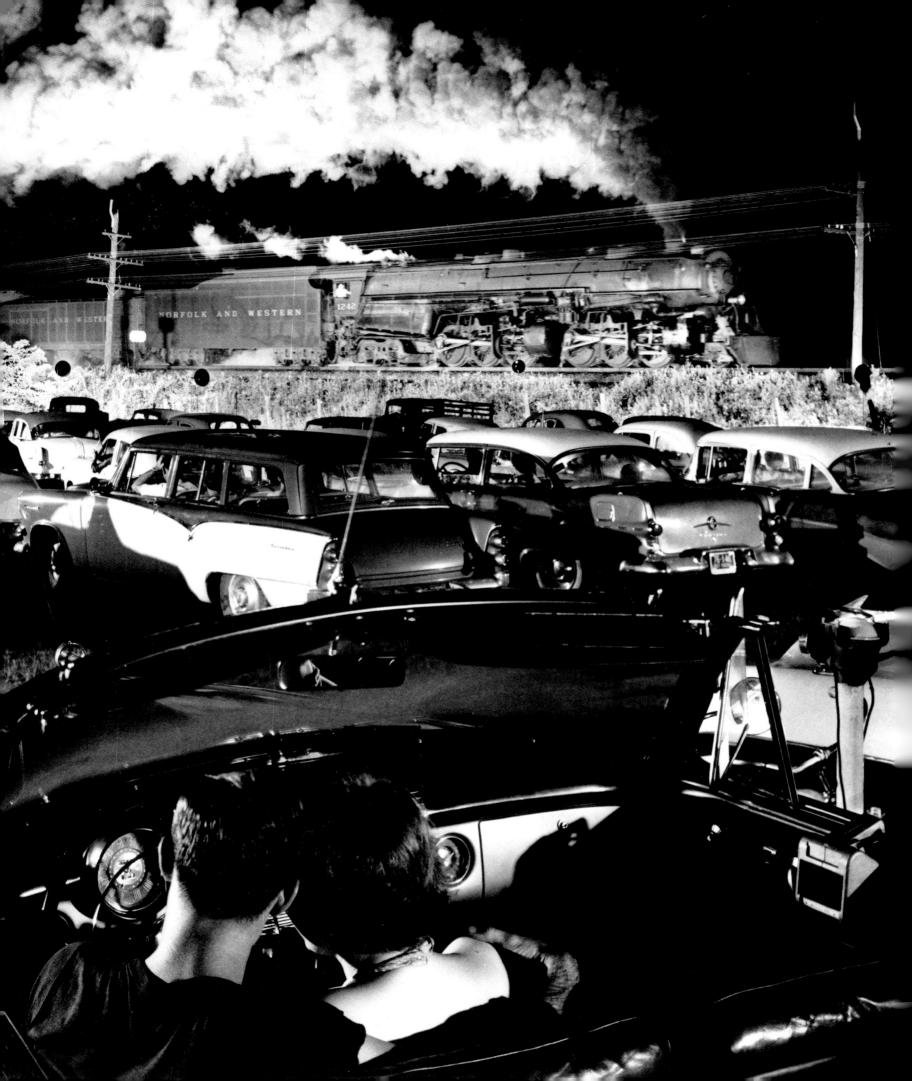

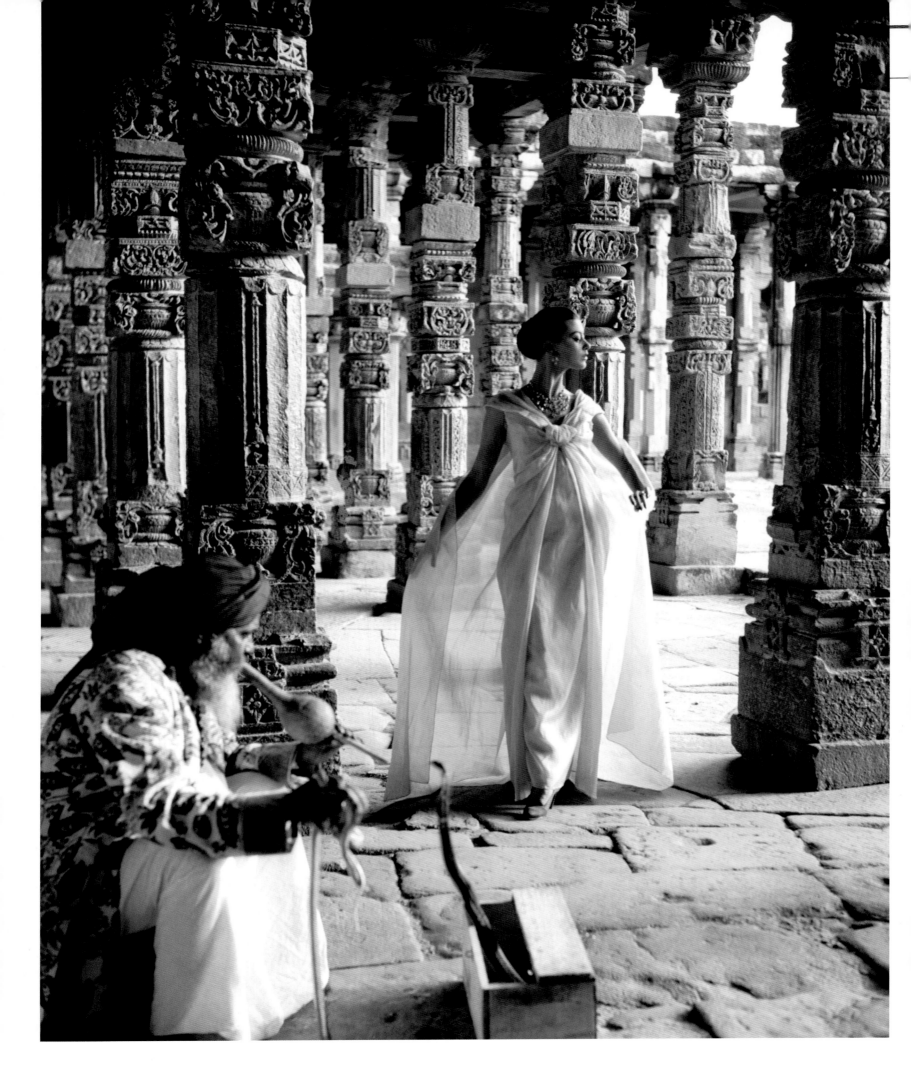

Rise of fashion magazines

The symbiosis between magazines and advertising is most obvious in fashion. The lifeblood flowing between them is photography, the more creative and inventive the better, as fashion thrives on style and an element of surprise.

Fashion photography is not merely about illustrating clothes but also about selling them. The fashion industry was therefore dependent on the development of illustrated magazines, which became its chief promotional vehicle.

First cut

The 1794 magazine *The Gallery of Fashion* appears to have been the first fashion magazine published in Britain. Aimed at the leisured and wealthy, it featured coloured and gilded plates of the best-dressed ladies at balls and operas. In a prescient promotion, it promised to show "all of the most fashionable and elegant dresses in vogue". In the US, *Harper's Bazar* (later spelt *Bazaar*) was the first fashion magazine, debuting in 1867 with illustrations to showcase fashion. When photographs were used – from 1888 – they were made by commercial or portrait photographers.

Then in 1911, Edward Steichen (see pp.116–17) photographed gowns by Paul Poiret for *Art et Décoration* to demonstrate how pleated silk could be infused with languid sensuality and become an object of desire. Overnight, out went the staid and musty illustrations of clothes and in came the elegant, airy, and stylish: fashion as art. By then, the publisher Condé Montrose Nast had bought a society weekly called *Vogue* to shape a competitor to *Harper's Bazar*.

Creative cast

Taking Steichen's lead, *Vogue* and *Harper's Bazar* used a battery of the finest photographers (many, refugees from Europe) – George Hoyningen-Huene, Horst P. Horst, Louise Dahl-Wolfe, Cecil Beaton, Erwin Blumenfeld, and Norman Parkinson – to slug it out for the premier position. This was no empty competition: the best circulation figures won the highest advertising earnings and the editorially invaluable first refusal on the latest *haute couture*.

US fashion magazines did not just benefit from the influx of top talent from Europe fleeing the rise of National Socialism in Germany.

As war forced fashion houses in Paris, London and Milan to roll down their shutters, New York found it had its entire domestic market to itself, and it could afford to take risks such as allowing Martin Munkácsi (see pp.234–35) – another émigré – to locate a swimwear shoot daringly on the beach. The lively action caught without studio artifice was to prove a template for later fashion shoots in a quasi-documentary style.

▷ **CHARLES JAMES GOWNS**

CECIL BEATON, c.1948

An interior designer as well as one of Britain's leading fashion photographers, Cecil Beaton posed the models as if they were in the midst of a scene from a play, in a dramatically lit neoclassical setting in New York worthy of their sumptuous ballgowns. The theatrical, high-society glamour was all the more striking during post-war austerity.

Carmen (Homage to Munkácsi), coat by Cardin, Place François-Premier, Paris, August 1957

RICHARD AVEDON / 1957

A towering presence in photography for more than half a century, Richard Avedon spent a lifetime paring his fashion and portrait photography down to the minimum of artifice in an unremitting search for truth in his images. Born in New York in 1923, he was first struck by fashion photography at an early age (see below), when he saw a picture taken by Hungarian photographer Martin Munkácsi. After being enlisted in the US Merchant Marine, where he photographed recruits (and learnt the strength of a white background), Avedon studied under Alexey Brodovitch, the inspirational art director of *Harper's Bazaar,* from 1944.

By 1947, Avedon's work, inspired by Munkácsi, was appearing in the magazine. His early fashion photography shows an astonishingly mature grasp of lighting and framing and is imbued with youthful energy and inventiveness. In his fashion shoot in Paris in 1957, Avedon paid a debt to the old master: "He brought a taste for happiness and honesty and a love of women to what was, before him, a joyless, loveless, lying art". Avedon's image of Carmen Dell'Orefice is a fitting tribute to Munkácsi. The athletic sensuality of Carmen's straight-kneed leap caught in suspension has made the picture a timeless classic.

At first, Avedon revelled in outdoor fashion shoots in revue bars, parks, and streets, but by the 1960s, he preferred the control of working in a studio. His studio images were still full of energy however, with his models jumping or dancing, often against a white background.

I hate cameras... they are always in the way. I wish... I could work **with my eyes alone.**

RICHARD AVEDON

NAVIGATOR

1 PLACE FRANÇOIS-PREMIER
Avedon chose a location in Paris that provided a clear middle ground and an identifiable background. The van – perhaps there by chance – appears to be a reference to the carriage in Munkácsi's image.

2 ATHLETIC MODEL
The final shot was probably the result of many exposures, for each of which the model had to leap off the pavement and land safely on the uneven paving while wearing heels. An assistant may have stood just out of shot to catch her.

3 PERFECT POISE
With her back straight, her head held high, and her hand casually in her pocket, the model had to look as if she always stepped off a pavement in this way.

4 PERFECT TIMING
The leap was framed so that the umbrella is just clipping the buildings in the background, which are blurred. Avedon's composition uses the background to frame the model without introducing any form of distraction.

IN CONTEXT
Paying tribute

One cold November day in 1933, Carmel Snow, the editor of *Harper's Bazaar*, sat shivering on a beach on Long Island, asking herself why she had commissioned an unknown sports photographer, Martin Munkácsi, for a swimwear shoot. He did not speak a word of English and the model, Lucile Brokaw, was trembling with cold. Suddenly Munkácsi started waving his hands. Lucile understood what he wanted and began to run around, and Munkácsi photographed her with her cape billowing behind her. When the pictures were published, they paved the way for a completely new style of fashion shoot.

When he saw the pictures at the age of 11, Richard Avedon was inspired: "His women [ran] parallel to the sea... freed by his dream of them, leaping straight-kneed across my bed". He tore the pages out and stuck them on his bedroom walls. Avedon's photograph of Carmen Dell'Orefice draws directly upon Munkácsi's earlier shot *Jumping a Puddle*, framed from a lower viewpoint, but referencing the vehicle in the background and even a small puddle.

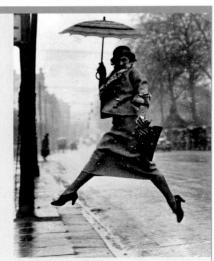

JUMPING A PUDDLE,
MARTIN MUNKÁCSI, 1934

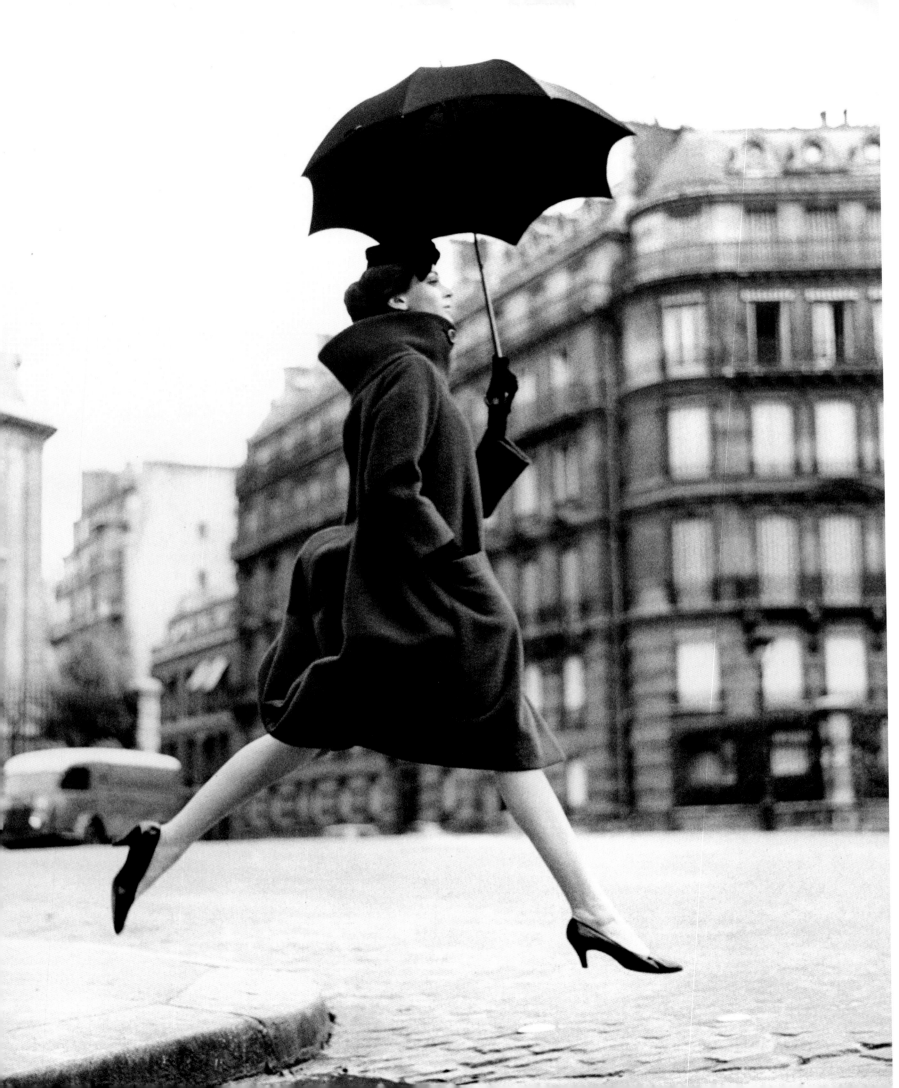

Staging a portrait

By the 1940s, amateur photographers had made portrait studios redundant other than for important events such as weddings and graduations. Portrait photographers had to innovate, and they opted for drama.

Any service that professional portraitists offered, a skilled amateur could now imitate, with results that satisfied the family and without the expense or inconvenience of traipsing to a studio. Amateurs had increasing access to better cameras and materials, so portrait studios had to raise their game. One tactic was to go theatrical, using dramatic lighting and elaborate props beyond the capacity of most amateurs.

Riot of colour

Yevonde Cumbers Middleton, who was English but worked under the name of Madame Yevonde, was a pioneer of dramatized photography and an early exponent of colour. In 1914, after an apprenticeship with the photographer Lallie Charles, during which she had made only one exposure herself, she set up a studio in London.

In the 1930s, Yevonde experimented with the Vivex colour print process, producing richly saturated and boldly coloured portraits. "If we are going to have colour photographs, for heaven's sake let's have a riot of colour, none of your wishy-washy hand-tinted effects!" she said in 1932. She is best known for her portraits of friends dressed up as deities, and a series on signs of the zodiac.

Professional theatricals

Angus McBean was born in Wales and grew up loving theatre and the cinema. In 1932, he became assistant to the high-society photographer Hugh Cecil and practised what he had learnt after hours. He set up his own studio in 1934 and in 1936, he photographed Ivor Novello's leading lady, Vivien Leigh. So delighted were the director and actress with the shoot that McBean's reputation was made. For 30 years, he photographed Leigh in almost every one of her productions, in a relationship McBean described as "a love affair in camera".

Inspired by the 1936 Surrealist Exhibition in London, McBean made extensive use of surrealist devices to create startling juxtapositions that induced a frisson of "magic, illusion, fairies... and always happy endings". He also skated close to social taboos to create idiosyncratic, irreverent portraits. Actresses loved his work.

"It's simple; they want to be beautiful", he explained. McBean's sense of whimsy and adventure left a lasting mark not just on portrait photography, but also on advertising work.

Philippe Halsman was also influenced by surrealism. Born in Riga, Latvia, he became a leading portrait photographer in Paris before emigrating to the US in 1940, where he began a lengthy collaboration with artist Salvador Dalí. The playful nature of the tableaux they created spilled over into his sparkling portraits of actors, intellectuals, and politicians.

△ **LADY DOROTHY WARRENDER AS CERES**

MADAME YEVONDE, 1935

Inspired by a fancy-dress party, Madame Yevonde embarked on an inventive series of portraits of society ladies dressed as ancient gods and goddesses. Ceres was the Roman goddess of farming and fertility, hence the corn-coloured lighting and cornucopia of fruits and flowers.

Be original or die!

MADAME YEVONDE

◁ **ACTRESS DIANA CHURCHILL**

ANGUS MCBEAN, 1940

McBean's image of the disembodied head of leading lady Diana Churchill (no relation to Prime Minister Winston Churchill) caused such an outcry that the police put him under investigation.

△ **THEATRICAL TRIO**

PHILIPPE HALSMAN, 1949

Halsman's portrait of the poet and film-maker Jean Cocteau painting the lips of actress Ricki Soma, the frame supported by dancer Leo Coleman, has the dreamlike irrationality of a canvas by his friend, the surrealist artist Salvador Dalí.

Alfred Eisenstaedt

GERMAN / 1898–1995

Attracting labels such as the "father of photojournalism", Alfred Eisenstaedt was a sensitive humanitarian first and a photographer second. Throughout a long career spent almost entirely in the top ranks of photojournalism, he never lost his sense of modesty, nor his capacity to be be amazed by life. Even when he botched one of his first jobs (in Ethiopia), the pictures he brought back turned out to be more important than the story he had been sent to cover.

Born in Prussia, Eisenstaedt began photographing in his early teens and by the 1920s, he was moonlighting as a freelance photojournalist while working as a button and belt salesman. After emigrating to the US in 1935, he became a staff photographer for *Life*, the start of 36 years with the magazine, during which he contributed to some 2,500 stories. *Life* was pivotal in establishing the picture essay, and Eisenstaedt's numerous contributions defined a particular type of essay – shot quickly and narrowly for maximum impact. His aim, he explained, was the "story-telling moment".

A confirmed user of the Leica camera within four years of its introduction, Eisenstaedt was a master of the candid shot, whether he was photographing the president or a farm labourer affected by the Great Depression. A sparing use of equipment helped – he often worked with only one camera – as did his unobtrusive presence. Eisenstaedt also pioneered the celebrity profile, giving a publicity exercise the respectability of a picture essay. The golden thread that ran through his work was his sheer love of people: "It's more important to click with people than click the shutter", he affirmed.

IN CONTEXT
Life covers

Eisenstaedt contributed 86 covers to *Life* magazine – more than any other photographer. Although he mainly worked in black and white, some covers are in colour. His success amply shows that he worked with few preconceptions, but also kept a keen eye on the changing tastes of his editors. He was adept with the celebrity portrait, ranging from the cheeky – Sophia Loren in lingerie – to the more sober – a scowling Ernest Hemingway. Eisenstaedt even appears in some portaits himself, with his arm around Marilyn Monroe for example. He was also quick to spot quirky details, such as a star filling in time during production breaks (right).

LIFE MARCH 14, 1938 10 CENTS

SINGER JANE FROMAN KNITTING BETWEEN REHEARSALS, 1938

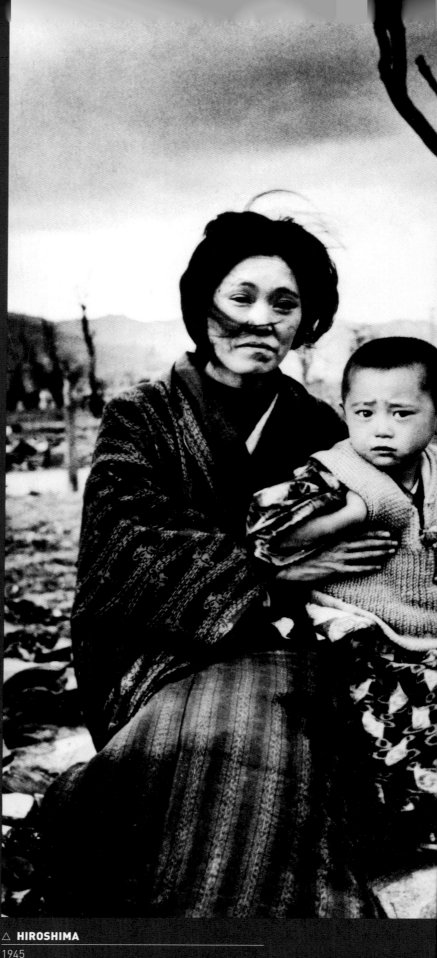

△ **HIROSHIMA**

1945

Even in the most horrific circumstances, Eisenstaedt's humanity and respect for people's dignity comes through. Here, he conveys the quiet strength of a Japanese mother in the aftermath of the nuclear explosion over Hiroshima.

◁ SOPHIA LOREN
1961

Actress Sophia Loren relaxes on the set of the 1961 film Madame. *With his sensitivity and good-natured humour, Eisenstaedt revealed moments of genuine emotion in his celebrity subjects.*

▽ JOSEPH GOEBBELS
1933

In an example of his eye for the "story-telling moment", Eisenstaedt caught the split second that Joseph Goebbels, the Nazi propaganda minister, found out that the photographer was a Jew. "Here are the eyes of hate", Eisenstaedt later wrote.

◁ DRUM MAJOR
1950

This candid shot of a group of children forming an impromptu drum line with the University of Michigan Drum Major has been called the "happiest photo ever taken".

Nikon F

In a single, brilliantly executed stroke, the Japanese camera industry stole the limelight from its German competitors with the Nikon F. With bold ambition, it was designed from the outset to sweep competition aside.

Yusaku Kamekura
1915–97

Born in 1915, in Niigata, Japan, Yusaku Kamekura graduated from the Bauhaus- and Constructivist-inspired Institute of New Architecture and Industrial Arts in Tokyo. In 1938, his job at a design studio led him to design posters for Nikon. His designs blended modernism with old-school Japanese styles. For the Nikon F project, he worked in secrecy for two years. His designs for the Tokyo Olympic Games in 1964 symbolized the successful post-war reconstruction of Japan.

By the 1950s, the limitations of the rangefinder camera (see p.149) were beginning to bite. Photographers wanted to use extreme wide-angle as well as long-focal-length lenses, but rangefinder cameras worked well only with a modest range of focal lengths. The best solution at the time was the single-lens reflex camera (SLR), which framed and focused through the single taking and viewing lens. The first SLR camera, the Ihagee Kamerawerk Exakta, had been available since 1936, but it had not been widely adopted. And so, in 1955, the forward-thinking minds at Nippon Kogaku (Nikon) launched a secret project to create the definitive user-friendly SLR system.

By this time, Nikon had enjoyed considerable success with their rangefinder cameras, which were based on the Zeiss Contax design.

Under the guidance of Masahiko Fuketa, the camera designer responsible for all models since the Nikon 1, the company decided to cannibalize their successful Nikon SP camera, retaining the body but adding a mirror box to reflect the image from the lens into the viewfinder and a new bayonet mount for the new lens system.

Designer designs

In an innovative move, Nikon hired Yusaku Kamekura, the company's poster designer, to sculpt the overall look of the camera. An ardent student of European art movements, the Bauhaus in particular, Kamekura reduced shapes to their fundamentals, using rectangles, triangles, and circles to articulate the body. Working in secret, he sketched designs that were sneaked out to engineers for testing. Despite complaints that some parts of the camera were difficult to manufacture – needing multiple machine pressings where one usually sufficed – Kamekura's design was adopted. Its introduction in 1959 was a storming success, and reviewers vied to outdo each others' superlatives. The viewfinder, in particular, was bright and showed 100% of the view – a tricky technical feat – and a wide range of accessories and lenses (from 21mm to 1000mm) was available from day one. Six years after its introduction, the 200,000th camera was produced, and by the time production ceased in 1973, over 862,000 cameras had been made. The Nikon F was a major step in Japan's post-war reconstruction and its growing confidence in manufacturing.

◁ **LARRY BURROWS**

UNKNOWN, 1965

Before boarding, photographer Larry Burrows attaches a Nikon to a US helicopter gunship during the Vietnam War. He is carrying three Nikons and one Leica.

Exposure counter

Shutter button

Lever for setting the self-timer

Housing for viewfinder

Shutter setting dial

Rewind crank

Lens stop-down button

△ **NIKON F**

WITH FAST STANDARD LENS, 1959–73

Nikon's first SLR camera proved to be practical, robust, and reliable. Its angular style has since become a design classic.

IN CONTEXT
SLR developments

Overnight, the Nikon F became the camera that other manufacturers had to beat. It was not until Canon's F1 of 1971 that it received anything like serious competition. By then, the Nikon had evolved to the F2 model, which had new accessories and even more lenses. No other camera manufacturer has produced systems to match, but by the late 1970s, it was clear that only a very small percentage of photographers took full advantage of the range of lenses available. Nevertheless, the basic elements of the Nikon F dominated SLR photography until digital cameras provided alternative ways to view the image, leading to compact cameras such as the Sony A7 that dispensed altogether with mirrors for viewing.

CANON F1

NIKON F3

SONY A7

08
09

DIVERSITY
AND CONFLICT

Hopes that World War II would be the last armed conflict proved to be woefully optimistic. After a slow start in the 1950s – with "only" 18 major conflicts – there were more than 70 new wars by the 1970s. All were dwarfed by the Cold War between the nuclear powers of the North Atlantic Treaty Alliance and the USSR. Even without the disturbance of armed conflicts, nations supposedly at peace experienced considerable change, such as the civil rights movement in the US, and in many industrialized countries women had to fight for equality at the polling booth, as well as in the home and workplace.

During this tumultuous time, articulate and educated young people rejected old institutions by leading counterculture rebellions, but they also subscribed to a consumerist explosion of music, fashion, and electronic gadgets. The social conflicts, from a personal level to local or global dimensions, gave photographers an enormous charge and a great boost in confidence. A new creed emerged – photography could make

a difference. Photojournalists were admired for dodging bullets to catch the right picture and worshipped for bravely holding a mirror up to society. Celebrity and fashion photographers joined the glamorous jet set of their subjects, jostling with them for fame and column inches. Booming consumerism swelled advertising accounts, making fortunes for skilled photographers. Not surprisingly, photography became an extremely desirable choice of career.

The foundations for a glorious half-century of photography came with holistically conceived camera systems. Advances in film technology, coupled with refinements in optics, raised image quality to hitherto unimaginable heights, challenging the human eye for performance. By the end of this period, photography was inextricably lined with urban life. Without it, life could not be modern. Photography fed people's need to see everywhere and into everything – it was on its way to becoming the eyes of the world.

Rolleiflex

The Rolleiflex was the first camera to solve the problem of how to keep a subject continually in view during an exposure. It became a classic and was not bettered until the arrival of the digital camera.

In early photography, several seconds could pass between deciding to make an exposure and actually being in a position to make it. Once framed and focused, the lens had to be covered, a film or plate holder had to be put into place, the light-capping slide had to be removed or a lever moved, and then the whole contraption had to be given a second or two to stop wobbling before removing the lens cover for the exposure. This clumsy procedure incensed photographers, whose cameras were also cumbersome: plate cameras were bulky with only one lens, and cameras with two lenses called for muscle as well as dedication.

Amidst all this, the sheer neatness of the Rolleiflex was nothing short of a dream. It appeared in 1929, after three years of development. The camera's designer, Reinhold Heidecke, had

decided to revive the twin-lens design while keeping his head low in the trenches during World War I, and the resulting Rolleiflex was a small, light camera whose roll-film ran across the bottom corner of the body to maintain film tension. Its viewing and taking lenses matched precisely in focal length for accurate focusing, and were fast enough to produce a bright viewfinder image.

Two eyes better than one

Unable to interest Voigtländer, the German camera company he worked for, and finding his request for a loan rejected by his bank, Heidecke found a business partner in an ex-colleague, Paul Franke. Once in production, the Rolleiflex proved extremely popular, thanks to its combination of rapid, precise focusing, silent operation, and high quality. Above all, the ability

to keep the subject in view during exposure, and being able to make the exposure without any delays, were boons for portraiture and fashion photography. It was also very robust in the field, making it perfect for photojournalism. The range was steadily refined, without any change in fundamental design, and reached its peak in 1960 with the 2.8F model, which featured a semi-automatic meter and the superlative Zeiss 80mm f/2.8 Planar (see pp.212–13).

Film wind crank, with characteristic forwards and backwards motion

Viewing lens, enabling bright, uninterrupted viewing

Exposure controls dials for setting aperture and shutter time

80mm f/2.8 taking lens

◁ **SELF-PORTRAIT**

VIVIAN MAIER, 1956

Chicago photographer Vivian Maier, whose decades of work were only discovered in 2007, took most of her pictures with a Rolleiflex. Here she poses with the camera in her bathroom, holding a light above her head.

Viewfinder hood containing focusing magnifier and sports finder

Focusing knob and exposure meter

Spool holder for loading new film

△ **CHILDHOOD GROOM**

ÉDOUARD BOUBAT c.1960

One of France's most celebrated post-war photographers, Boubat was best known for his poetic images of children and women. This street shot is taken from a typical Rolleiflex angle, the three faces give it complexity, and it has great charm.

◁ **ROLLEIFLEX**

2.8F AURUM, 1983

Alligator skin replaces the usual leatherette covering on this gold-plated commemorative Rolleiflex. Approximately 450 of these were produced. This model uses a Schneider 80mm Xenotar lens in place of the Zeiss 80mm Planar.

IN CONTEXT
Other developments

The Rolleiflex spawned many imitators, but none attained the refinement and standards of the original. Voigtländer, who rejected Heidecke's idea, made a copy in 1938, and Zeiss and Agfa introduced 35mm versions. However, the real advance came in 1968 when, after producing a string of Rolleiflex imitations, Mamiya introduced the Mamiya C220, which took interchangeable lenses. The twin-lens reflex lives on in the Gekken and Recesky TLR (twin-lens reflex) cameras, which are supplied as a flat packs for photographers to assemble. Made of plastic in various colours, both have 35-mm f/11 lenses and take 35mm film.

MAMIYA C220

DIY RECESKY CAMERA

Eugene Smith

AMERICAN / 1918–78

As legendary for his irascibility as for his darkroom skills, William Eugene Smith was a virtuoso of the camera with a superb talent for combining light and the arrangement of elements in the frame into a tense balance, full of pent-up energy. An early starter, Smith was selling photographs to newspapers in his mid-teens and began working for the leading weekly, *Newsweek*, before he was 20. This was the first of many brief and stormy relationships with his client magazines, which included *Life*, *Parade*, and *Flying*. He demanded editorial control, and even photo agencies such as Black Star and Magnum (see pp.206–07), well used to stubborn eccentrics, were unable to keep him for long.

Smith's war coverage was outstanding and his stories for *Life* became classics. Inspirational in his ability to narrate a story entirely from finely crafted images, Smith was the purest of photojournalists, a virtuoso of the picture essay. His perfectionism came at a high price however – he would spend all night printing one version after another in search of the perfect print. His picture essay on Pittsburgh, started in 1955 with support from Guggenheim Fellowships, is a pinnacle of documentary photography. It was meant to take three months, but occupied him for three years, showing he was outgrowing the limitations of magazine stories. His work in Pittsburgh refined his already uncanny compositional ability, which reached its peak in Minamata, Japan, where he made his most famous images. Although Shishei Kuwabana had photographed the effects of mercury poisoning in the 1960s, it was Smith's sensitive and humanitarian work from 1972 to 1974 that made an international impact – for which he was beaten up to within an inch of his life by hired thugs.

Smith did not mind which camera he used – from a Graflex, Zeiss Contax, and Rolleiflex to a Leica rangefinder and Minolta SLRs. He was disparaging when asked about technique: "What use is having a great depth of field, if there is not an adequate depth of feeling?"

> **"Available light"** means any damned **light** that is available.

EUGENE SMITH

▷ **STEELWORKER**

PITTSBURGH, PENNSYLVANIA, 1955

In this highly charged close-up, the sky creates a halo around the man's head, while his goggles reflect fire and hide his expression. The heightened contrasts in tone create drama and suggest that Smith is interpreting rather than neutrally recording events.

◁ **STEEL PLANT**

PITTSBURGH, PENNSYLVANIA, 1955

Using the flaring sparks of the furnace as backlighting, Smith turns the steelworker into a silhouette – a type rather than an individual. The eerily human shape the man is working on is equally anonymous. Taken together, the elements of the scene suggest a hellish inferno.

▽ **WALK TO PARADISE GARDEN**

US, 1946

In contrast to the tough documentaries, this image of Smith's children on a woodland path has a sweet note of hope for the future. It was the first picture Smith took after being severely wounded in World War II, and was shown at the end of the Family of Man exhibition (see pp.226–27) in 1955.

◁ **FISHING**

MINAMATA BAY, JAPAN, 1972

This fisherman faces added danger. Mercury had been dumped in the bay and toxins accumulated in the fish and shellfish. Many local people developed what came to be known as Minamata disease, caused by severe mercury poisoning, which also led to congenital deformities.

Japan reconstructs

As an art form, photography was an outsider to Japan's post-war reconstruction, a foreign import with no roots in traditional Japan. Photographers could observe but it was only in the 1960s that they began to participate in it as an art.

When two nuclear bombs were dropped on an already stricken Japan in 1945, the resulting devastation stopped the country in its tracks, but more was to come. Harsh reparations and the systematic dismantling of social, political, and industrial structures further weakened Japan.

Thanks to US loans and unburdened by military spending, however, Japan's economy grew rapidly. This renewal, and the growth of a young generation exposed to Western influences, led to a rebirth of the arts in the 1960s.

Love-hate relationship

Toshihiro Hosoe was born in 1933 and changed his given name to Eikoh in 1949 because it was "one more suited to the new era", possibly in reference to the US president Dwight "Ike" Eisenhower. His early work, such as *An American Girl in Tokyo*, was about Americans, but by the late 1950s, his infatuation with the West had waned. In 1960, he published *Otoko to Onna* (Man and Woman), which showed the results of his thoughts on being Japanese. With striking contrasts, stark shadows, and truncated views of bodies cut into abstract yet sensual shapes, *Otoko to Onna* broke new ground for Japanese photography with its hitherto undeveloped corpus of nude photography. Hosoe also took considerable pains to distance himself from the Western traditions of the nude in photography.

A key feature of Hosoe's work was his collaboration with avant-garde creators, such as the writer Yukio Mishima and the dancer Tatsumi Hijikata. All of them were exploring non-Western or anti-Western modes of expression and they worked closely together. Mishima claimed, "Before Hosoe's camera, I realized that my mind and my soul were both superfluous". On his work with Hijikata, Hosoe commented: "Between photographer and dancer who moves whom – the cooperative relationship – is not so clear".

The legacy of occupation

Born a mere five years after Hosoe, Daido Moriyama's attitude to the US occupation was more relaxed: "We found the mixture of the Japanese and the Western already there. We just accepted it". Inspired by William Klein's work (see pp.224–25), he sought out people living on the margins of society, in seediness and squalor. Moriyama favoured the use of inexpensive point-and-shoot cameras and producing grainy, often blurred images. He has stated: "If the image is shaking, it's OK, if it's out of focus, it's OK. Clarity isn't what photography is about". In contrast to Eikoh Hosoe, photographers such as Miyako Ishiuchi and Shomei Tomatsu

▽ **FROM *YOKOSUKA STORY***

MIYAKO ISHIUCHI, 1976–77

Yokosuka is the port where Ishiuchi grew up after the war during military occupation. It was the site of a large US naval base, so American values permeated the small town. Empty apart from a lone child, this street scene is part of a series describing tensions in post-Hiroshima Japan. The tilted horizon is typical of Ishiuchi's work.

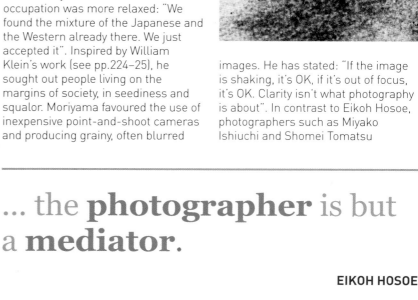

... the **photographer** is but a **mediator**.

EIKOH HOSOE

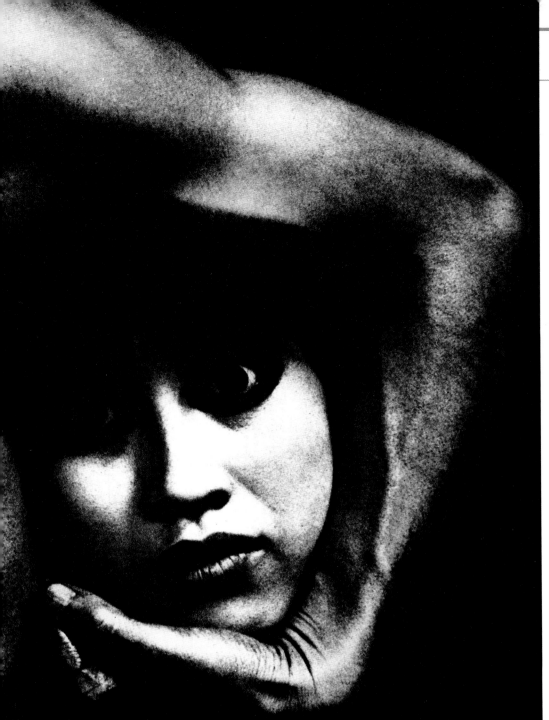

◁ ***OTOKO TO ONNA* (MAN AND WOMAN) NO. 20**

EIKOH HOSOE, 1960

With Japanese culture shattered by World War II and its aftermath, Hosoe explored the art form of the nude, a previously non-existent concept in his country. This grainy shot of a seemingly disembodied female head cradled in a man's arm is from the book that started the genre in Japan.

▽ **SHINJUKU**

DAIDO MORIYAMA, 2000–04

Both jaundiced and attracted by American consumerism, Moriyama visits the districts of Tokyo that tourist guidebooks avoid. Dream or nightmare, his images show people on the margins of society, including those whose very gender is ambiguous.

(see pp.252–53) have used their art to confront the military occupation, pushing it aside to counter the alienation of Japanese identity.

Miyako Ishiuchi (born in 1947) did not start taking photographs until she was 28, under tutelage from Moriyama and Tomatsu. She adopted the same technical trademarks as her contemporaries – dark and gritty monochrome tones, heavy blacks, and sharp contrasts, but her main concern has been with the passing of time in a country that is torn between the past and the present, and is still uncertain of its future.

IN CONTEXT
Industry revival

Immediately after World War II, film production had to give way to X-ray film, but camera manufacturers formed coalitions so they could use patents from Germany that had been rescinded as war reparation. Innovations flowed from Japan – the first automatic lens diaphragm (Pentax, 1947); the first twin-lens reflex with flash synchronization (Mamiya, 1947); the first X-synch in a 35mm camera (Canon, 1952). The Asahiflex II of 1954 was the first 35mm single-lens reflex with instant-return mirror, leading the way for the Nikon F (see pp.228–29). By the 1970s, Japan was the market leader of 35mm cameras and lenses.

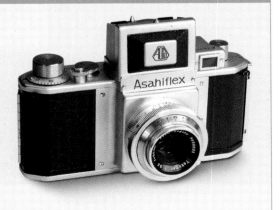

ASAHIFLEX IIB, INTRODUCED IN 1954

Shomei Tomatsu

JAPANESE / 1930–2012

A profound influence on Japanese post-war photography, Tomatsu distilled complex emotions and layered them with a reflective interpretation of history. Reacting to the horrors of a Nagasaki demolished by an atomic bomb and the occupation of Japan by American forces, he took street photography deep into the soul, infusing it with his emotions. Tomatsu recorded the collisions of East with West, and of traditional Japanese culture with consumerism, to express profound emotions usually glossed over in the photographs of his European and American counterparts.

Born in Nagoya in 1930, Tomatsu witnessed the rise of right-wing fanaticism and its destruction in Japan, followed by the post-war explosion of rampant consumerism. A graduate in economics, he had photographs published while still a student, then began to freelance as a photojournalist in 1956. Three years later, he formed the VIVO cooperative, together with photographers Ikkō Narahara, Eikoh Hosoe (see pp.250–51), Kikuji Kawada, Akira Sato, and Akira Tanno, with whom he had mounted the 1957 exhibition *Jūnin no Me* (*Eyes of Ten*), and they shared offices and darkrooms in Tokyo for both personal and commercial projects. Despite VIVO's short life – it disbanded in 1961 – it gave birth to many of the post-war movements in Japanese photography.

Tomatsu was one of the first to have the courage to look unflinchingly at Japan's struggle and difficulties after World War II, and in doing so, he uncovered a sensibility that was essentially Eastern. He regarded photography as a visual *haiku* – a concise poetical form – that evokes worlds beyond and beneath direct representation. He saw the world, he once said, "through the eyes of a stray dog", but he was aware of the limitations of his art.

> **A photographer**... cannot cure like a doctor... but can merely **look**. That's good enough... that's all there is.

SHOMEI TOMATSU

◁ **MELTED BOTTLE**

NAGASAKI, 1961

*Tomatsu's series Nagasaki 11:02 (1966) told
the tale of the atomic bombing of Nagasaki.
He photographed this distorted bottle
hanging up, which makes it suggest a flayed
carcass or Christ nailed to the cross.*

▽ **UNTITLED**

YOKOSUKA, 1959

*The image is full of references to the
American occupation, such as the sailor
and the posters advertising bars in English.
The main Japanese item is the little girl,
who is concentrating on a bubble (another
American import) that is about to burst,
offering an irony that would not be lost
on Tomatsu.*

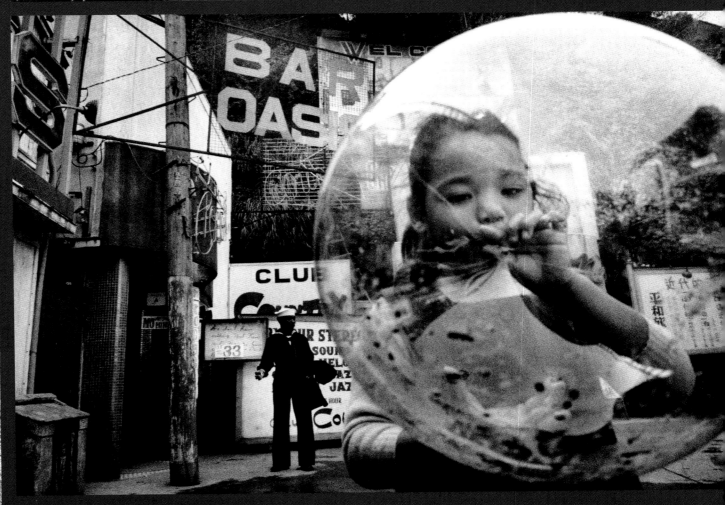

◁ **BOY AND THE SEA**

TOKYO, 1969

*Together with his other photographs of boys at the
seaside, this image hints at a darker reality beneath
the surface. It shows Tomatsu at work to grasp what
he calls "fragments of reality far beyond the reach of
pre-existing language."*

Cult of celebrity

Photographers bridge the gap between famous people who need media attention and a public hungry for dreams. Everyone loves to hate the go-betweens, but they are essential to the process.

There is a certain rough justice in the fact that some honourable news photographers were turned into reviled characters by an Italian film about a dissolute, feckless journalist. One day, news photographers who shot film stars were simply specialists, but after Federico Fellini's film *La Dolce Vita* (The Sweet Life, 1960) they became paparazzi – photographers who invaded people's privacy for riches and glory.

Predatory photographers
The Italian photographer Tazio Secchiaroli was the model for the character Paparazzo in the film, and he contributed to Fellini's research by recounting tales of his exploits chasing celebrities on his Vespa scooter. Secchiaroli was one of the first to realize that magazine editors were bored by posed portraits but would pay well for "surprise pictures" – stars caught off-guard. The more compromising or embarrassing the situation, the better the pay.

Famed for his aggressive methods – Secchiaroli was known as "the assault photographer" – his scoops included an indiscreet King Farouk of Egypt with two women, unfaithful film stars, and inebriated celebrities. Ironically, the film made Secchiaroli more acceptable to film stars.

Growing unpopularity
The early days of celebrity culture were relatively relaxed. Pascal Rostain, one half of a famed Paris-based paparazzi duo with Bruno Mouron, reminisces, "We were working with small lenses and flash so people would see us... It was not aggressive. They were playing with us. Posing, sometimes".

However, photographers discovered that the single truly compromising image – measured by how disastrous the impact was on someone's life or career – could earn them a fortune. Precipitating a scandal meant many magazines would want the picture. As numbers grew, such attentions became less welcome. "You are a pest", spat Britain's Princess Anne at a photographer, "By the very nature of that camera in your hand".

Celebrity magazines
One evening in 1948, Italian photographer Benno Graziani recounts, he met a group of journalists who invited him to join them because they were starting a magazine and looking for reporters. Working in a first-floor flat with the bathroom as the darkroom, the photographers were told to "live like kings" as long as they brought in the stories. And this they did, creating the legendary *Paris Match* magazine, which has provided France with a weekly staple of illustrated celebrity and sensational news ever since.

Graziani shared the lives of stars and celebrities, enjoying friendships with Jackie Kennedy, Charlie Chaplin, Jane Fonda, Brigitte Bardot, Kirk Douglas, and Audrey Hepburn. These personal relationships gave him access – and the photographs – that were the envy of other paparazzi. But Graziani was a rare type of celebrity photographer – one whom the stars trusted. By the 1970s, the widespread use of extremely long focal length lenses enabled photographers to take pictures from outside private compounds and obtain recognizable images from as far away as 1.5km (1 mile). Paparazzi used helicopters to peer down into gated properties and trained their lenses onto private beaches from boats. Few places were safe from prying eyes.

The criticisms reached fever pitch when Diana, Princess of Wales, died in a car chased by photographers in 1997, but the public still rushed out to buy celebrity gossip magazines, such as *Hello!*, *Bunte*, *¡Hola!*, *OK!*, and *People* – extensively illustrated by paparazzi images – in their millions.

▽ **ELIZABETH TAYLOR AND RICHARD BURTON**

GIROLAMO DI MAJO, 1962

The photographer snapped the two famous actors – both married to other people at the time – on the deck of a supposedly private yacht off the island of Ischia in Italy while they were relaxing from filming Cleopatra.

◁ **BRIGITTE BARDOT**

LONDON, UK, 1959

Cheerfully cooperating with a throng of press photographers, French actress Brigitte Bardot poses for the cameras in front of a hotel mirror.

▽ **JOHN LENNON AND RINGO STARR**

BRAD ELTERMAN, 1975

Pop stars Yoko Ono (her hair visible on the left), John Lennon, and Ringo Starr arrive at a nightclub in Los Angeles, California. Cameras able to focus in total darkness coupled with flash enabled photographers to "doorstep" celebrities, waiting for them outside clubs and restaurants.

IN CONTEXT
La Dolce Vita

Directed by Federico Fellini, the 1960 film *La Dolce Vita* (The Sweet Life), was both celebrated by the critics and censored by the authorities. The character Paparazzo (played by Walter Santesso) is the photographer who accompanies the protagonist Marcello Rubini (played by Marcello Mastroianni) in search of an actress and to cover a miraculous sighting of the Madonna. The film depicts unruly mobs of photographers jostling each other for best place and swarming around a star.

STILL FROM *LA DOLCE VITA*, 1960

▷ **MARILYN MONROE AND CLARK GABLE**

EVE ARNOLD, 1960

American Eve Arnold photographed Marilyn Monroe many times, often in unguarded and casual poses. Here she shows the actress with her co-star Clark Gable on the set of The Misfits (1961). It was the last film for both actors and came out a year before Marilyn Monroe died.

The anti-portrait

Traditionally, a portrait photograph was a contract between the sitter and the photographer. Although the outcome was nominally in the photographer's control, it actually dictated by the sitter, who usually wanted to be shown in a flattering light. This was to change.

Mike Disfarmer
1884–1959

The American photographer Mike Disfarmer had taken disengagement further – his portraits were no longer what the sitter might want to look like, but what the photographer wanted to show of him or her. Undeterred by this, clients still flocked to the studio of the reclusive maverick in the small town of Heber Springs, Arkansas. Largely unsmiling, the portraits of local folk are disarmingly honest in their awkward revelations. The 4,000 glass plates that Disfarmer made between 1917 and 1956 were published only in 1976.

PORTRAIT, DISFARMER, BEFORE 1959

Once photographers could leave the studio and work out of doors, they could choose subjects from passers-by, thus eroding sitters' control. Photographers' motives ranged from the grandiose to the predatory, and after the upheaval of the world wars, sitters finally lost the battle. Given two minutes to make a portrait of Winston Churchill for a Government commission, the Armenian-Canadian photographer Yousuf Karsh snatched a cigar out of Churchill's mouth to elicit an aggressive snarl. It was far more revealing than a smiling portrait. Even if the sitter is a giant, the photographer is in control.

Photographer is all
In her 30s, Austrian-born Lisette Model gave up a career in music to pursue photography. Commercially successful in the 1940s and early 50s, she is best-known for candid portraits made close up and with disconcerting directness. She was an influential teacher and her striking portraits inspired her famous protegée, Diane Arbus, to cease fashion photography and seek "the forbidden... the freaks".

One day, for example, Arbus met a boy playing in a park. The most famous image of her sequence shows him grimacing like a maniac, clutching a toy grenade. Arbus took the photograph when the boy, as he later recalled, was "in a moment of exasperation... I was just exploding". The outtakes show him smiling, so Arbus had timed her shot to catch him at that moment.

▷ **ANDY WARHOL**
ARNOLD NEWMAN, 1973

Newman tore out a photograph of pop artist Andy Warhol's head, distorted by an unsettlingly low viewpoint, and stuck it on to another photograph. Although the photographs were taken at Warhol's workplace, the Factory in New York, Newman – unusually for him – stripped out any background that could provide context.

The photographic portrait creates a struggle for supremacy between the sitter and photographer. A sitter with sufficient power can insist on a veto; a photographer with sufficient standing can override a sitter's wishes.

When asked to photograph ex-Nazi German industrialist Alfred Krupp, the Jewish photographer Arnold Newman remembers, "I was trying to figure a way to show who he really was without being obvious". He lit Krupp from both sides, then asked him to lean forwards.

The lighting made Krupps "look like the devil... I deliberately put a knife in Krupp's back, visually", Newman confessed afterwards.

For his portrait of Andy Warhol, Newman's approach was not flattering, but insightful. His collage of a torn-up print taken from a normal angle with an unflattering perspective of a head is bizarrely revealing.

◁ **WOMAN WITH VEIL**

LISETTE MODEL, 1949

Model mocked the American obsession with glamour and image, showing the sadness behind the facade. She was intrigued by the proud bearing, along with the extravagant makeup and accessories, of this stranger, whom she found sitting on a park bench in San Francisco.

... there are things which **nobody would see** unless **I photographed** them.

DIANE ARBUS

Human Foetus

LENNART NILSSON / 1965

For sheer perseverance and dogged determination, Lennart Nilsson leaves all other photographers far behind, wide-eyed in wonder. His epochal story for *Life* magazine on human reproduction, for example, which was published in 1965, took him 12 years. It was published in 1965 and formed part of the book *A Child is Born*. When he was forbidden to photograph a foetus *in vivo* – live inside a woman's womb – unless he was medically qualified, he was undeterred. He simply applied to medical school and studied for years with the other students.

Nilsson was born in 1922 in Strängnäs, Sweden. Photographing from the age of 12, he was influenced early on by Louis Pasteur, who inspired a love of microscopy. A pioneer of the scanning electron microscope, Nilsson also pioneered the photography of the human foetus. For the early stages, he relied on miscarriages or ectopic pregnancies - when the egg is fertilized and develops outside the womb. He was on constant alert from any of the five hospitals collaborating in the project. For older foetuses, Nilsson used the latest and best endoscopes – tubes densely packed with fibre optics ending in a tiny lens. Some endoscopes have focal lengths as small as 5mm (less than ¼in) with a field of view of 170 degrees; others have a light at the operator's end, so they pipe light into the womb.

Equipped with his medical qualifications, Nilsson could manipulate the endoscopes himself, choosing the best angles and lighting effects. The first time he saw a foetus sucking its thumb, he was ecstatic and took a picture. Nothing happened – the flash was not working. "It was years before I saw another", says Nilsson. More controversially, he also used aborted foetuses as these offered the best opportunity to light and frame. The image shown here is of an aborted 18–20-week-old foetus. Its ethereal beauty has led to it being adopted by anti-abortionists in their campaigns.

NAVIGATOR

1 LIMITED DEPTH OF FIELD
Using a close-up lens on his Hasselblad camera, depth of field is limited even with the use of flash lighting, so the hand in the foreground is blurred.

2 THE AMNIOTIC SAC
Sidelighting the foetus brings out the gossamer-like texture of the amniotic sac. Its neutral-cool tones frame the foetus's face and hands.

3 THUMB IN MOUTH
It is not known whether the foetus was aborted with its thumb in its mouth or whether this was manipulated.

4 NEUTRAL FRAME
With lighting from the back left, the right foreground zone is the darkest area of the picture, emphasizing by contrast the poignantly clear outline of the profile and tiny hands.

> **Patience** is the most important tool. **Patience. Patience. Patience.**
>
> **LENNART NILSSON**

Elliott Erwitt

AMERICAN / 1928–

A master of the photographic witticism, Erwitt describes himself, with typical wry self-deprecation: "I'm not a serious photographer like many of my contemporaries. That is to say, I am serious about not being serious". He times and frames his photographs with a precision that almost looks staged.

Born Elio Ewitz to Russian immigrants in Paris, Erwitt emigrated to the US in 1939. He served as a photographer in Germany and France during World War II and by 1953 had been elected into Magnum Photos (see pp.206–07). His growing reputation as the comedian of photography was sealed in 1974 with his book on dogs entitled *Son of Bitch*. Although it has been followed by more collections of dogs since then, it remains unchallenged as the funniest book in photography.

Erwitt's ability to make people laugh with his pictures can obscure his versatility as a photojournalist and commercial photographer. He is a sensitive documentarist and successful at advertising – his reputation for being easy-going is merely a front for a highly tuned sensibility and razor-sharp instincts. "Keep working", he says, "Because as you go through the process... things begin to happen". Since the 1970s, he has concentrated on making and contributing to documentary films, and he uses his alter-ego André S. Solidor (acronym ASS) "to satirize the kooky excesses of contemporary photography". He doesn't care for altered images either, stating: "I'm almost violent about that stuff – electronic manipulation of pictures. I think it's an abomination. I reject it all". His secret is to look for the interesting among the commonplace: "It has little to do with the things you see and everything to do with the way you see them".

▷ **WEDDING**
SIBERIA, RUSSIA, 1967

Whatever has made the best man smirk, the joke is not shared by the bride and bridegroom as they nervously wait to take their vows.

[**Electronic manipulation**] ... is OK for selling cornflakes ... but it undermines the thing that **photography** is about, which is **observation**.

ELLIOTT ERWITT

◁ **DOG'S LIFE**

NEW YORK CITY, 2000

Following on from the success of his 1974 dog book Son of Bitch, *Erwitt continues to catch the exact moment of canine humour with deft – and daft – accuracy.*

▽ **MOTHER AND CHILD**

NEW YORK CITY, 1953

Erwitt's personal photographs can be tender rather than humorous, as in this intimate picture of his wife and their six-day-old daughter, overseen by the family cat, and gently sidelit from the window.

△ **GALLERY**

PALACE OF VERSAILLES, FRANCE, 1975

Engrossed in the label on a blank canvas, the earnest trio neglect to notice that their stance mirrors the composition of the painting on the left – despite the watchful gaze of the gentleman in the portrait.

Queen

BRIAN DUFFY / 1963

All outsiders, David Bailey, Terence Donovan, and Brian Duffy – dubbed the "Terrible Three" or the "Black Trinity" – barged into the fashion world, then dominated it during the 1960s. Of the three, the most perceptive and articulate was Duffy. Born in London, he worked as a fashion illustrator from 1955, then decided that photography would be easier. However, during his first fashion commission a lamp blew up, and after an early portrait session during which he was using a borrowed Leica, the sitter was on his way out of the room when he asked, "Mr Photographer, is it normal that when you take the photograph, you leave the lens cap on?"

By the 1960s, Duffy's technique was assured. Ever inventive, his work appears fresh and can surprise even now. He gave location fashion shots a documentary twist, placing models so he could take advantage of the reactions of passers-by. His anarchic framing – shoving a model into the edge of the frame with empty space below or filling the picture with contrasting shapes and colours – was daring for the time, but anticipated much photography today. His quirky style is captured in this lingerie shoot for *Queen* magazine.

NAVIGATOR

IN CONTEXT
Colour projection

Duffy was a pioneer of compositing by projecting images from a slide projector onto a subject to add colour. For these shots, he at first cut holes in coloured gelatin light filters (gels) and projected them onto the model, who was wearing flesh-coloured lingerie. In the late 1970s, he reprised the technique for a series of advertisements for Benson & Hedges.

OUTTAKE 1

OUTTAKE 2

1 BURNT GELS
To create the bands of colour, Duffy burnt holes in gels and cut them to soften the outlines, then projected them onto the model. Outtakes (see left) show that he was not satisfied with only two colours.

2 PLAIN BACKGROUND
The model was placed close to a plain, white background so that the colours of the gels showed. The absence of shadows on her right shows that the projector was placed to the left of the camera. No other light was used, as it would have diluted the colours.

3 CHEEKY EXPRESSION
The model's expression diverts attention from the heavy shadows below her chin and hand. These reveal that although the projector was placed really close to the camera lens, it could not eliminate the shadows.

4 EYE CONTACT
The model's eyes, appearing to peep over the band of magenta, look straight at the camera and engage with the viewer. A catchlight from the projector is visible in her right eye.

Guy Bourdin

FRENCH / 1928–1991

Widely regarded as the closest thing to a fine artist that fashion photography has ever produced, Guy Bourdin created images meticulously constructed to shock. His reputation was such that, uniquely, other photographers were happy to acknowledge his influence.

Guy Louis Banarès was born in 1928 in Paris and abandoned by his parents while an infant. As Guy Bourdin, having taken the name of his adoptive parent, he learnt photography in the French air force while carrying out aerial reconnaissance in Senegal. On his return to Paris in 1950, he studied art under Man Ray (see pp.146–47), exhibiting paintings under his own name, but his photographs under the *nom de guerre* of Edwin Hallan. Inspired by the work of Edward Weston and Ansel Adams (see pp.162–65), he took up commercial photography and worked first for *Vogue* in 1955, beginning a legendary relationship that lasted until 1987.

Bourdin's instantly recognizable compositions, graphic and unsettling, and making full use of saturated colour, were sought after by fashion houses such as Chanel, Versace, and Miyake. An uncompromising perfectionist, he insisted that models hold poses – however uncomfortable – while he finessed the lighting or framing, or made them repeat moves until he got the shot he wanted. He was capable of presenting just a single transparency from a shoot, even after two weeks' work with four models in an exotic location. In 1967, Francine Crescent, the then editor-in-chief of French *Vogue*, introduced Bourdin to Charles Jourdan, sparking 14 years of the most daring and darkly humorous fashion photography ever. New collections of Jourdan shoes were eagerly awaited, not just for the shoes but for Bourdin's startling photography. Shy of publicity, he seldom exhibited, did not sell prints, refused interviews, and published no books. He died in 1991, leaving his estate in chaotic disarray.

> For Bourdin, beauty never appeared without… **death, filth, and laughter.**

LUC SANTE / 2003

▷ *VOGUE* **SHOOT**

PARIS, 1970

Bourdin's love of vivid colour is evident in this beauty shot of multiple sets of tapering fingers painted with scarlet nail varnish that matches the model's glossy lipstick.

◁ RECLINING IN THE SUN

SPRING, 1978

Bourdin created thought-provoking, cinematic scenarios tinged with eroticism. This image for Charles Jourdan has many of the hallmarks of his work – blocks of saturated colour (note the use of the pink swimsuit), the striking interplay of light and shade, and cropped elements.

▽ CHARLES JOURDAN SHOE ADVERTISEMENT

SPRING, 1979

With his unconventional sense of composition, Bourdin transforms a shoe advert into a fetishistic, surreal scenario. The model's head and arms are hidden from view, so her only identifying features are the dominatrix stiletto heels.

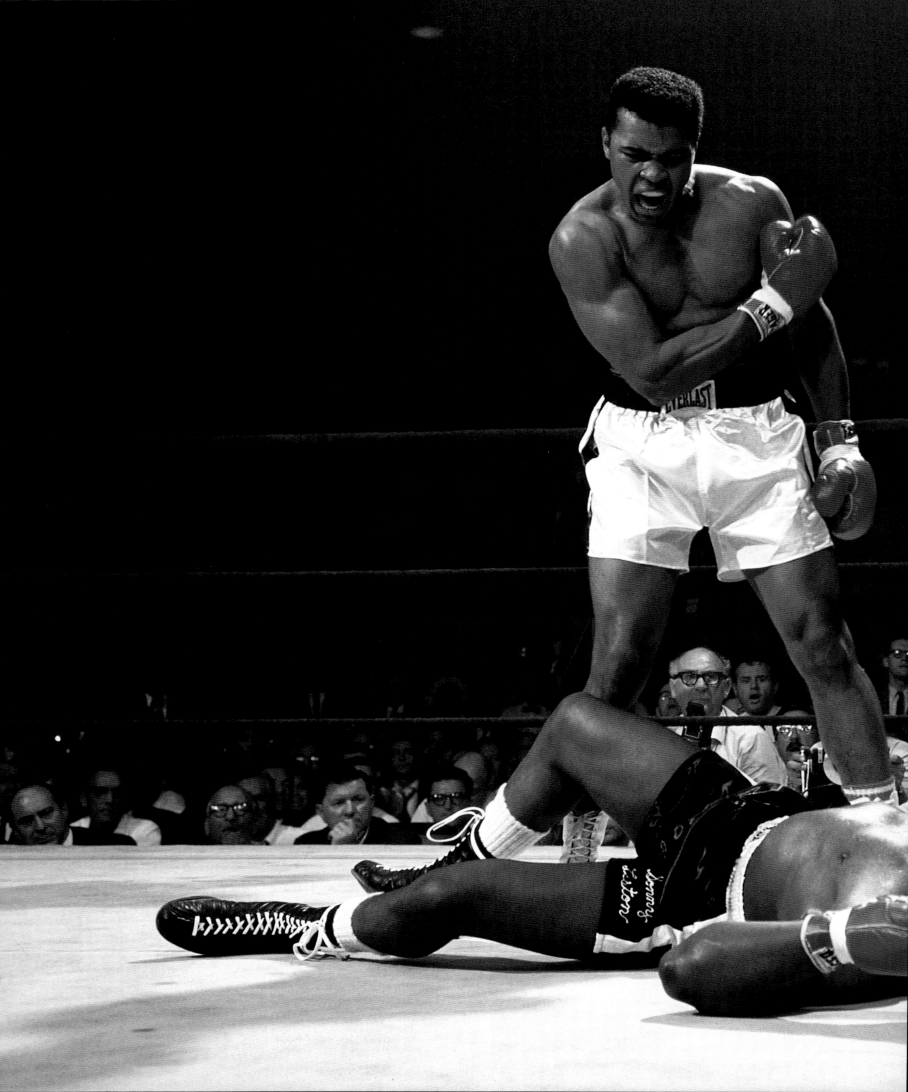

◁ **MUHAMMAD ALI
VS SONNY LISTON**

NEIL LEIFER, 1965

*When he took this iconic picture of
the World Boxing Championship
Heavyweight Title, American Neil
Leifer was just 22 years old and one
of only two photographers at the event
whose camera was loaded with colour
film. He caught the moment two
minutes into the first round when
Liston collapsed on the floor and Ali
stood over him, yelling, "Get up and
fight, sucker!" Liston finally struggled
up, but was knocked down and
counted out seconds later.*

Nikon 80–200mm f/4.5

The zoom lens was an advance that proved to be indispensible, but it was treated with scepticism at first. For over a hundred years, lenses with a variety of focal lengths had been available, but they had offered poor image quality.

Frank G. Back
1902–1983

Frank Gerhard Back was born in Vienna in 1902 and emigrated to the US in 1939. In 1945, he formed Zoomar Inc. and produced an optically compensated zoom lens (one that maintains focus during zooming), first for television in 1948, then for still cameras in 1959. Responsible for many optical innovations, Back photographed a solar eclipse in 1955 to measure gravitational lensing – the bending of light in gravitational fields – an effect predicted by Einstein's General Theory of Relativity.

CAMERAMAN OPERATING A TV ZOOM

In 1840, Charles Chevalier invented a landscape lens that could be converted into a portrait lens by mounting another lens component. The concept of the convertible lens was taken further in 1858 by Eugène Derogy, who offered a Petzval-type lens (see p.28) featuring extra components that gave ten different focal lengths. Darlot's Universal Lens of 1885 was a gadgeteer's delight: its basic lens could be taken apart and came with six achromatic lenses that could be screwed together in various combinations to give a focal length range of 140–451mm.

Needless to say, photographers wanted an easier way of taking long-distance pictures. Telescopes that could vary their focal length had been in use since the 1830s, but photographers needed lenses that stayed in focus while their focal lengths were changed. In 1902, Clile C. Allen filed a patent for just such a zoom for cine cameras, but the first really practical model, the Paramount zoom, which was used in silent films, only appeared in 1931.

The first production zoom lens for still photography was the ambitious 36–82mm f/2.8 Zoomar, designed in 1959 by Frank G. Back in New York and manufactured by Voigtländer in Germany. The word "zoom" is often thought to originate with this lens, but in fact it was already in use among cinematographers in the 1930s. The Zoomar, which used rare-earth glass in 14 elements, was a substantial breakthrough optically, but it had its shortcomings – it was cumbersome, its lack of multi-coating limited its performance, and at US$298 (US$2,700, or £1,600, in today's terms) it was expensive.

The Zoom-Nikkor

In 1970, the announcement of Nikon's 80–200mm f/4.5 Zoom-Nikkor raised only mild interest. Nikon's poor track record in the field of zoom design had done much to fuel the pessimism about zoom lenses ever equalling the quality of single-focal length or prime lenses. The Zoom-Nikkor changed all that. It was surprisingly compact, was easy to use, and focused to a close 1.8m (6ft). On top of this, it delivered stunning image quality. It also sported prettily coloured aperture numbers with impressive depth-of-field scales. Designed by Takashi Higuchi, who was responsible

△ **SPORTS PHOTOGRAPHY**

ASUSHI TOMURA, 2008

Photographers follow the swimming at the National Aquatics Centre in Beijing, China, during the 2008 Olympics. Confined to a fixed position, those using zoom lenses enjoy flexibility in framing denied to those using fixed focal length lenses.

Front thread
accepts
filters and
accessories

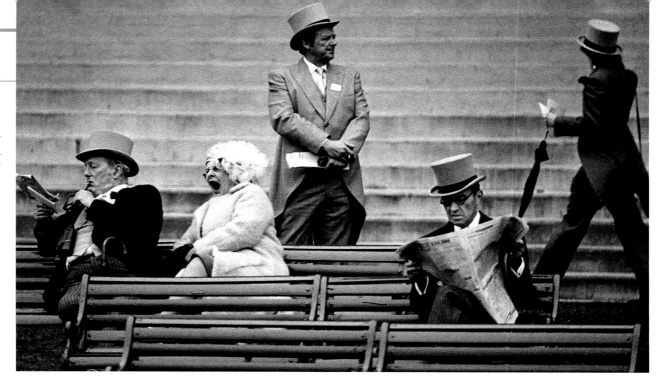

▷ BRITISH RACEGOERS
EAMONN McCABE, 1977

One of the great advantages of the zoom – if not for the people photographed – is that of anonymity. Here, Eamonn McCabe captures some British racegoers unawares.

for other Nikon zooms of the period, it used 15 multi-coated elements in 10 groups.

The importance of the Nikon 80–200mm *f*/4.5 was the change in attitude it stimulated. Other manufacturers raced to imitate it, and then to produce the widest, the longest, the fastest, and the smallest possible zooms. Zooms are now almost a prerequisite for any camera: a standard item on point-and-shoot cameras, and most SLR cameras are sold in a kit with a zoom lens.

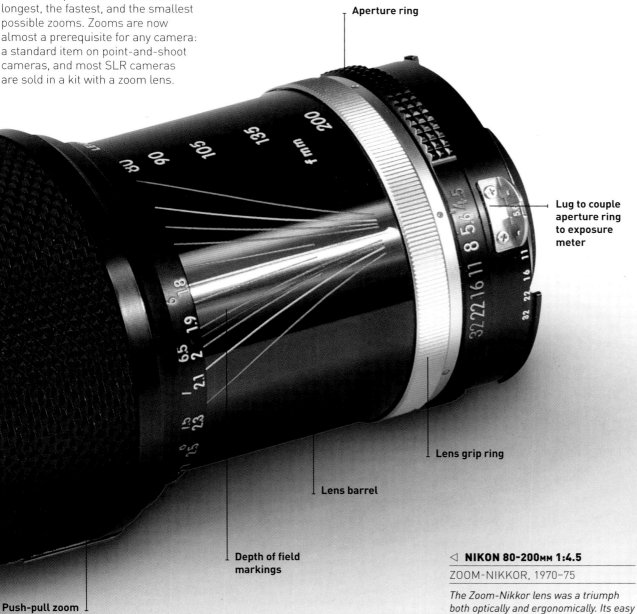

Aperture ring

Lug to couple
aperture ring
to exposure
meter

Lens grip ring

Lens barrel

Depth of field
markings

Push-pull zoom
and focus ring

◁ NIKON 80-200ᴍᴍ 1:4.5
ZOOM-NIKKOR, 1970–75

The Zoom-Nikkor lens was a triumph both optically and ergonomically. Its easy push-pull action for zoom control and twist for focusing made it a joy to use.

IN CONTEXT
Extending zooms

Technically, the zoom range of 80–200mm for 35mm format is the easiest to design. Zooms with shorter focal lengths (e.g. 24mm) or wider ranges (e.g. 50mm–300mm) or greater focal length (e.g. 150mm–300mm) all need special glasses and highly complicated construction. However, the use of small sensors in digital cameras has led to the emergence of zooms with extremely wide ranges (e.g. 28mm–350mm). Compact lenses are also made possible by allowing maximum aperture to vary with zoom range. Today, zoom lenses can even be fitted to smartphones.

SONY QX-10 FOR SMARTPHONES

CANON 16-35mm *f*/2.8

Fly me to the moon

At first, photography in space was regarded by NASA bosses as irrelevant, but it soon became crucial when recording space flight. It is still true that the greatest-ever photography jobs have been given to amateurs.

The first still photographs taken in space were tourist snaps. American astronaut John Glenn was keen to make a record of his space flight but his administrators were more concerned that he came back alive. Glenn returned from three orbits around the planet on 20 February 1962 not only intact, but also having proved that he could fly a spaceship and take photographs at the same time. "When I needed both hands, I just let go of the camera and it floated there in front of me," he said.

NASA engineers gave Glenn a modified Leica 1G equipped with an extra-large viewfinder and a 50mm f/1.5 lens. This was the camera Glenn used during his historic flight to make the first human-controlled, still colour photographs in space (the first film in space had been shot in 1961 by Soviet cosmonaut Gherman Titov).

In the 1960s, the use of non-American cameras caused a furore because the Senate had agreed NASA's multi-billions – over 4 per cent of the Federal budget – on the basis that everything was supplied from the US. This may be the origin of the myth that an American camera – a point-and-shoot Ansco Autoset bought in a local pharmacy – was the first in space. The Ansco was in fact modified by NASA engineers and used to make spectrographic photographs to analyse the wavelengths of star light.

High-quality photographs

In October 1962, Walter Schirra took a Hasselblad 500C into space. The quality of the images was outstanding and secured the place of photography in the space programme.

Astronauts now had to acquire an additional skill – photography. As late as the Skylab missions in 1973, the photography manual was advising astronauts that "the sharpness and contrast of the image is decreased immensely when recorded through dirty, greasy glass... Clean the windows of the Shuttle before you photograph through them".

Modifications

To make cameras suitable for extra-vehicular activity (EVA), they are stripped down to reduce weight. There must not be any sparks, which can be caused by the movement of the film itself, so electrical contacts in motor drives have to be turned into transistor relays to avoid spark discharge. Controls also need to be chunky so that astronauts are still able to operate them when wearing bulky space gloves.

The medium-format cameras used extra-thin 70mm film to squeeze some 100 exposures out of a film load. By 1971, Nikon had supplied a modified Nikon F (see pp.240–41) for the Apollo 15 mission, some using 250-exposure bulk film. Other cameras, such as the Robot and

Zeiss Contarex, have been into space too, but the firm favourites are Nikons and Hasselblads. Space photographs came a long way in a decade – from snapshots to epoch-making visions of our own planet, dominated by blue sea beneath swirls of white cloud.

▽ **BLUE MARBLE**

APOLLO 17 CREW, 1972

The crew took this view of the earth while travelling towards the moon. Almost the whole of the coastline of Africa is visible, and it was the first time the Apollo trajectory made it possible to photograph the Antarctica south polar ice cap, here covered in cloud.

▷ **MOON LANDING**

NEIL ARMSTRONG, 1969

Neil Armstrong took this historic picture of fellow-astronaut Buzz Aldrin, pilot of the first lunar landing mission, with a 70mm Hasselblad (see right). The footprints of the astronauts are visible on the surface of the moon.

◁ **EARTHRISE**

WILLIAM ANDERS, 1968

When Apollo 8 orbited the moon in 1968, the earth appeared to rise above the moon's horizon. The crew made several exposures of the event and called it "Earthrise". These iconic images, together with the portrait of the blue planet (see opposite), changed our vision of the world.

ON TECHNIQUE
Hasselblad on the moon

Hasselblad engineer Gunnar Person modified motorized cameras to NASA specifications to create Hasselblad Electric Data Cameras (HEDCs). They carried a specially designed Zeiss 60mm lens with virtually no distortion, or an 80mm Planar. Loaded with 70mm film magazines, the cameras had a reseau (a glass plate etched with measuring lines) and were used for all the famous photographs of the lunar landing of 20 July 1969. To save weight, only the film magazines were taken on the flight back. There is disagreement over how many HEDCs were left behind – 12 or 13 litter the moon's surface, and one was dropped in space.

HASSELBLAD EDC, 1969

Polaroid SX-70

In 1944, while the world was falling apart, a father was indulging his daughter's demand to see pictures he had taken of her. Asked why she could not see them immediately, Edwin Land asked himself: "Indeed, why not?"

Edwin Land
1909–1991

While still a physics student, Land invented a cheap way of polarizing light, using crystals laid on a thin sheet of material. He called the invention "Polaroid", and founded a company to produce it on an industrial scale. A shrewd businessman, he licensed the technology, but carried on seeking new industrial uses for his invention. Land also worked in a wide range of optical fields, including research into perception that led to changes in our understanding of colour.

EDWIN LAND AND HIS "MAGIC CAMERA"

Land was not only a brilliant scientist and entrepreneur, he was an inveterate inventor for whom all problems were simply solutions waiting to be discovered. He worked on the problem of how to obtain a photograph instantly by exploring the known technique of combining developer and fix in the same solution. His innovation was to separate the development process from the printing process via a thin layer of gel that allowed developed-out silver to migrate from the film layer to a receiving layer – the print. His daughter had to wait three years, but in 1947 Edwin Land showed the world its first self-contained negative-print process, and in he 1948 invented a new category of apparatus – the instant camera – with his Land Model 95.

Colour process
Numerous refinements were made to the process, with colour arriving in 1963, but all involved peeling two sheets apart. Land continued to work on producing the perfect, one-step, self-developing image. Finally, in 1972, he used Polaroid's thin-film expertise to combine a 12-layer complex of developer and dyes into a self-contained, postcard-sized print – and developed an elegant fold-away box the size of a small handbag that was the instant camera: the Polaroid SX-70.

When it was introduced, the camera made the covers of leading magazines and newspapers, but its high cost and initial production problems delayed uptake. It carried a four-element 116mm *f*/8 lens, offered manual focusing (later models used a sophisticated ultrasound sonar autofocus), and automatic exposure control. Housed in its sleek body was an amazingly complicated optical system that sprang into action when the box was unfolded. Unlike any other camera ever invented, the SX-70 used mirrors set at acute angles to minimize its size. Mathematically, it was an extremely complex design – just the sort of challenge that Land enjoyed.

A new visual dialect
The SX-70 was a delight to use: after exposure, the print slid out with a purposeful whirr and click, and photographers could watch as the image developed before their eyes. They soon discovered that manipulating the print while it developed created rewardingly artistic effects. The quality of the image was neither realistic nor unattractive: it appealed to photographers as unlikely as Walker Evans (see pp.174–75) –

who had once snorted, "Colour tends to corrupt photography and absolute colour corrupts it absolutely" – and André Kertesz, who had never been known to use colour until he took up the SX-70. The perfection of its packaging, coupled with a characterful and unique colour palette, created a new visual dialect that enriched photography of the late 20th century.

◁ **ANDY WARHOL WITH POLAROID**

OLIVIERO TOSCANI, 1974

The Polaroid SX-70 was the accessory of choice for pop and avant-garde artists of the time. It became the badge of the fashionable, and umerous artists, including Andy Warhol, were happy to pose with it.

Focus wheel

Shutter button

Picture exit slot

Viewfinder top enclosing mirrors

▷ **DECEMBER 3, 1979**
ANDRÉ KERTÉSZ, 1979

Working from his apartment in New York City, Kertész (see pp.156–57) used the SX-70 to photograph the city skyline. Shot late in his career, these pictures are his only substantial colour work.

Eyepiece

Hinged prop
holds camera open

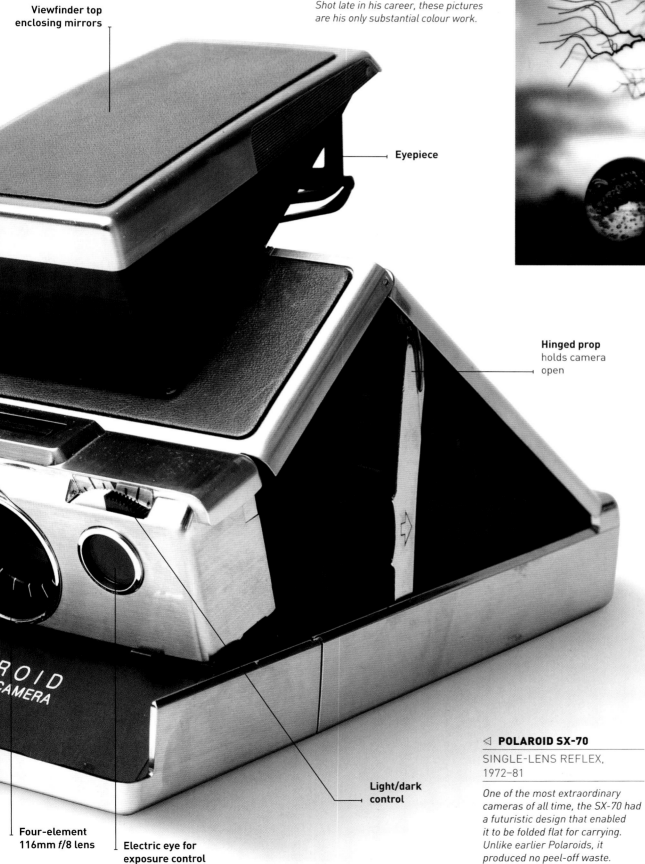

IN CONTEXT
Other polaroids

Land introduced cheaper alternatives to the SX-70. The One Step swapped the folding design for a chunky extra-terrestrial look and cost only $20. At the other extreme, Land courted the art market in 1976 with a cupboard-sized camera that made 20 × 24in prints. In 1976, Kodak tried to muscle in on the market, but lost because it infringed the patent on pinch rollers. Fujifilm were more patient and waited until Polaroid's patents had expired to market their version of the SX-70 – the Instax – which had ingenious improvements.

Light/dark control

◁ **POLAROID SX-70**

SINGLE-LENS REFLEX, 1972–81

One of the most extraordinary cameras of all time, the SX-70 had a futuristic design that enabled it to be folded flat for carrying. Unlike earlier Polaroids, it produced no peel-off waste.

POLAROID 20 × 24IN

Four-element 116mm f/8 lens

Electric eye for exposure control

ROID
CAMERA

The Vietnam War

Long after the dead are buried and bomb craters have grown over, pain and suffering live on in photographs and never more so than after the Vietnam War, the most freely photographed conflict in history.

Horst Faas
1933–2012

Faas was a great photographer who became a great picture editor. He started out as a news photographer in 1951 with the Keystone Press Agency. He joined Associated Press (AP) in 1956, covering wars in Asia and Africa. As AP's chief photographer in Southeast Asia from 1962, he covered the Vietnam War, during which he was wounded and became wheelchair-bound. He then ran AP's picture desk, helping to ensure that two key images of the war were distributed – Eddie Adams's photograph of the summary execution of a Vietcong, and Nick Ut's picture of a girl fleeing a napalm attack (see pp.278–79). He won the Pulitzer Prize twice and received the Robert Capa Gold Medal twice. In 2005, he took the Dr Erich Salomon Award for lifetime achievement.

HORST FAAS, VIETNAM, 1967

Local insurgencies during the 1950s in Vietnam led to foreign intervention and involved regular US troops from around 1963. It was regarded as a just conflict, and photographers were duly welcomed. Philip Jones Griffiths, a Welsh photographer who devoted a large part of his life's work to Vietnam, explained: "The mechanics of the thing was very simple. If you were a bona fide journalist, you were given a card which explained who you were, and with that card you had the ability to travel and see."

Freedom and censorship
At first, American government policy was to encourage their side of the story to be told, so both reporters and photographers operated with unparalleled freedom. Using fast film such as Kodak Tri-X (introduced in 1940) loaded in Leica and Nikon cameras (the Nikon F after 1959), photographers could keep up with troops to catch almost any action. Best of all, their work was uncensored. Because much of the press was in favour of US involvement, some argue that the early coverage encouraged further intervention. Not only were civilian photographers encouraged, the US military fielded their own photographers in the army, navy, and air force, who produced a large body of work between them. Army photographers alone delivered up to 10,000 pictures a month, much of it still unseen.

Unlike the work of civilians, military photographs officially belonged to the relevant force, and were therefore subject to censorship. Sergeant Ronald L. Haberle was a keen amateur photographer who ran the Public Information Office of his unit. On deployment to the hamlet of My Lai 4 in 1968, he was using two cameras. When he returned from the mission, he handed over the official Leica camera with black-and-white films but kept his Nikon with colour film. His colour pictures were crucial in revealing the massacre of up to 500 Vietnamese civilians.

The power of images
By the time casualty figures were rising and military operations failing, it was too late to impose any form of censorship. Adventurers, from college graduates taking a year off to hippies enjoying the Far East, had picked up a camera and press pass, and there were large cohorts of professional photographers. The news agency Associated Press and *Life* magazine set up large operations to feed the appetite of the US public for pictures of the fighting. The war made heroes of widely published photographers, including Larry Burrows, David Douglas Duncan, Gilles Caron, Kyoichi Sawada, Eddie Adams, Horst Faas, and Catherine Leroy.

As more stories came in showing the death, devastation, and civilian misery, and as casualties mounted, opposition to the war grew. In the issue of 27 June 1969, *Life* magazine – formerly pro-war – ran page after page of portraits of men who had been killed in action in earlier that month. The effect was startling; the story starkly horrific. It was one of the most powerful of photographic protests – and it was all made with purely functional images shot at recruitment centres.

> The **moment** you are **dishonest**, you **lose** the **game**... the whole thing.

PHILIP JONES GRIFFITHS

▷ **BATTLE FOR SAIGON**

PHILIP JONES GRIFFITHS, 1968

US carpet-bombing of the Vietnamese countryside drove civilians from their homes. Photographs such as this, showing the anguish and fear of displaced locals, helped turn the tide of public opinion against the Vietnam War.

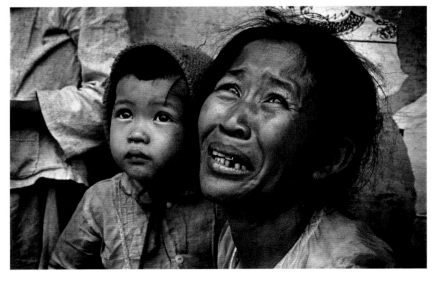

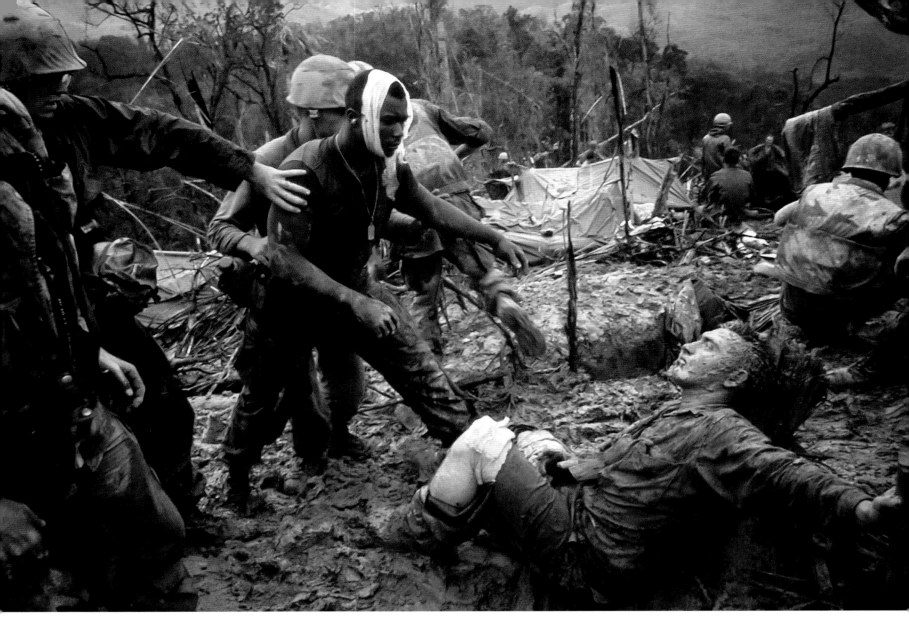

△ WOUNDED MARINES

LARRY BURROWS, 1966

Suffering from a head wound himself, an American sergeant is led past a stricken comrade after a fierce firefight for control of a hill. The Vietnam War was known in Vietnam itself as the American War.

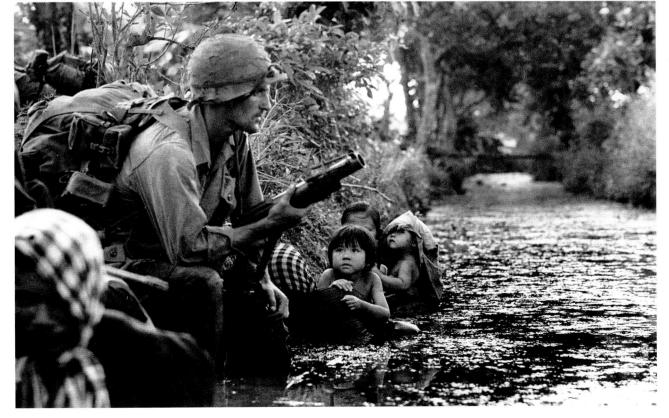

◁ IN THE BATTLE ZONE

HORST FAAS, 1966

Gazing at an American paratrooper holding a grenade launcher, two South Vietnamese children cling to their mothers, huddled against a canal bank for protection from Vietcong sniper fire.

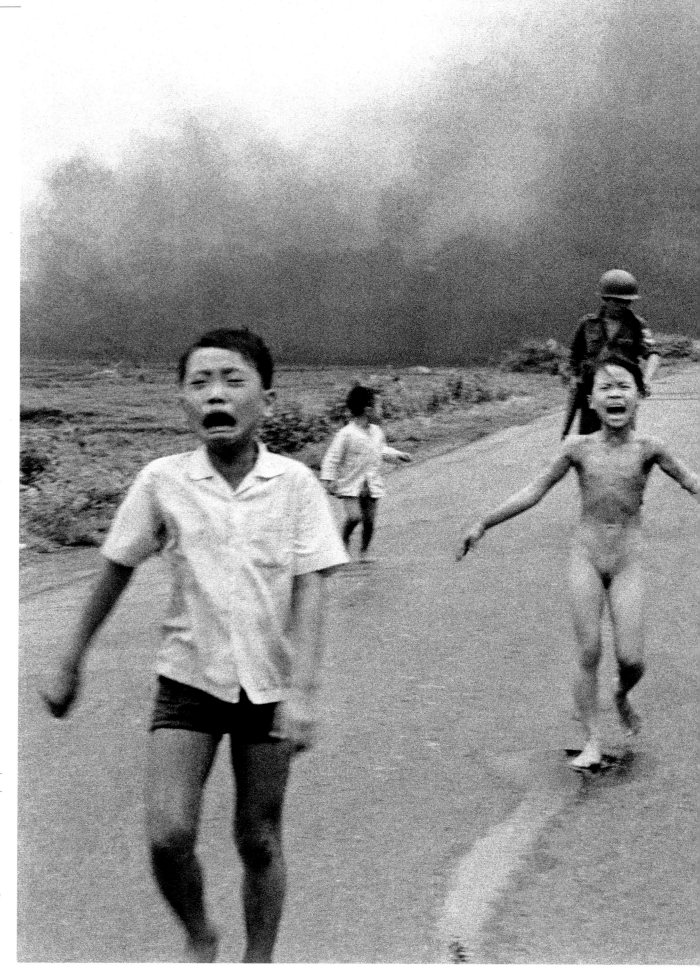

▷ **TRANG BANG**

NICK UT, 1972

A South Vietnamese aircraft accidentally dropped napalm on the hamlet of Trang Bang during the Vietnam War, and the nine-year-old girl ripped off her burning clothes as she fled the blast. Initially rejected because of its depiction of a naked girl, the image was released because of its overriding news value to become one of the defining images of the war. It is usually cropped to remove the three South Vietnamese soldiers on the far right.

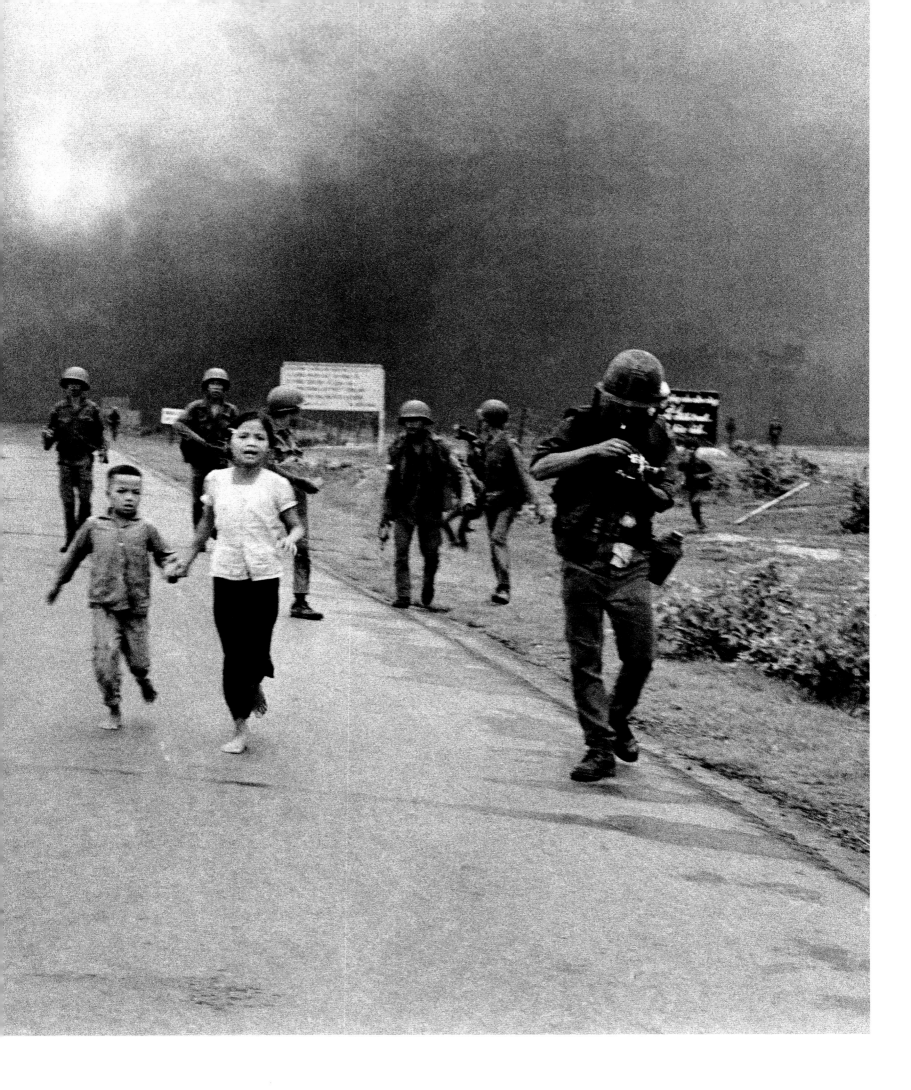

Protest photography

With global channels of distribution, photographs can have extraordinary political power. In the 1960s and '70s, the truths they revealed became a nightmare for politicians – and a weapon for protesters around the world.

David Goldblatt
1930–

Since the early 1960s, David Goldblatt, one of the most thorough chroniclers of South Africa's recent history, has devoted his life to photography and activism. Born in Randfontein, he has photographed people and landscapes throughout South Africa using a variety of formats, including large-format, initially working exclusively in black-and-white. In the 1990s, however, he began to use colour for a story on blue asbestos in Australia, explaining: "You can't make it blue in black-and-white".

In 1989, Goldblatt founded the Market Photography Workshop, to teach photography to people who were disadvantaged by apartheid. Widely exhibited, he was given the Lifetime Achievement Award by the International Center of Photography.

THE MARKET PHOTOGRAPHY WORKSHOP

The period from the late 1950s to the 1970s was marked by numerous civil protests. Citizens were making their voices heard with strikes in Hawaii, resistance to the draft in the US, and passive resistance in Czechoslovakia, – and at every demonstration, march, and protest, photographers were chronicling events.

Emotional distillation
On 21 October 1967, the French photographer Marc Riboud was covering a demonstration against the Vietnam War in Washington, DC. Thousands of people were marching on the capital, where they were met by a line of soldiers. Riboud watched as a girl fearlessly approached the armed men. He recalls: "She was just talking, trying to catch the eye of the soldiers... I had the feeling the soldiers were more afraid of her than she was of the bayonets". For several minutes he captured the scene in both colour and black-and-white.

The girl was Jan Rose Kasmir, who remembers the moment: "All of a sudden, I realised 'them' was that soldier in front of me... A human being

I could just as easily have been going out on a date with. It wasn't a war machine; it was just a bunch of guys with orders. Right then, it went from being a fun, hip trip to a painful reality". Riboud's perfectly composed image (see pp.282–83) distilled the emotion of the entire event.

In the line of fire
On 4 May 1970, during a student protest on campus, John Filo was working in the darkroom at Kent State University, Ohio, when he was startled by the sound of gunfire. Grabbing his Nikon Nikkormat, he rushed outside, thinking the National Guardsmen were shooting blanks. Then he saw

a student – Jeffrey Millar – bleeding to death on the ground. Alhough Filo was nearly shot himself, he followed a girl who was rushing to Millar's aid and took some photographs. Afterwards, he drove to a newspaper where he once worked in Pennsylvania to process his film. He realized that his pictures of the dying man and the girl's distress were important, as inaccurate news reports he had heard suggested that a cover-up was in progress. When his picture was published, it divided the country between those who thought that the protesters "had it coming" and those who were outraged. Four students had been murdered and nine others wounded, and more could have died if the stand-off between the Guardsmen and the students had not been defused by Professor Glenn Frank.

Unarmed unrest
In 1976, another student-led protest led to a tragic photograph that changed attitudes around the world. A group of high school students in South Africa was protesting against being forced to learn Afrikaans. A school strike in Soweto, near Johannesburg, grew into a rally and march on 16 June. At one point, a policeman lobbed a tear-gas canister in front of the crowd while another opened fire. Masana Sam Nzima, who was covering the event for the black daily paper *The World*, said: "I saw a child fall down. Under a shower of bullets I rushed forward and went for the picture".

> A **photo** is never **objective.**
> **If it is,** it is **real boring.**

JOHN FILO / 2000

▷ **KENT STATE SHOOTINGS**

JOHN FILO, 1970

John Filo won the Pulitzer Prize in 1971 for this picture of the Kent State shootings. Soon afterwards, someone unknown airbrushed out the pole behind the girl's head – a version that circulated widely until the alteration was noticed in the 1990s.

His sequence shows Mbusiya Makhubo carrying 12-year-old Hector Pieterson, who had been shot in the head. Nzima made six exposures, then rewound and hid the film in his sock. The picture was published by *The World* the next day, and its proof that police had shot unarmed schoolchildren shocked the world, provoking condemnation of the South African government and its brutality.

Soon afterwards *The World* was closed down, the negatives were destroyed, and the photograph was censured by police – and Nzima's life was ruined by harassment and threats. It was too late for the regime, however. Nzima was followed by other photographers, such as Jan Hamman and Sam Magubane, who covered the spreading unrest, which was to carry on until the following year.

△ **SOWETO RIOTS**

JAN HAMMAN, 1976

Jan Hamman won the Press Photograph of the Year award for this image of two Soweto youths kneeling in front of an armed policeman.

◁ **PRAGUE INVASION**

JOSEF KOUDELKA, 1968

In 1968, Josef Koudelka documented the Soviet invasion of Czechoslovakia. His pictures, which showed ordinary people caught up in the events, were distributed anonymously in the West for his protection.

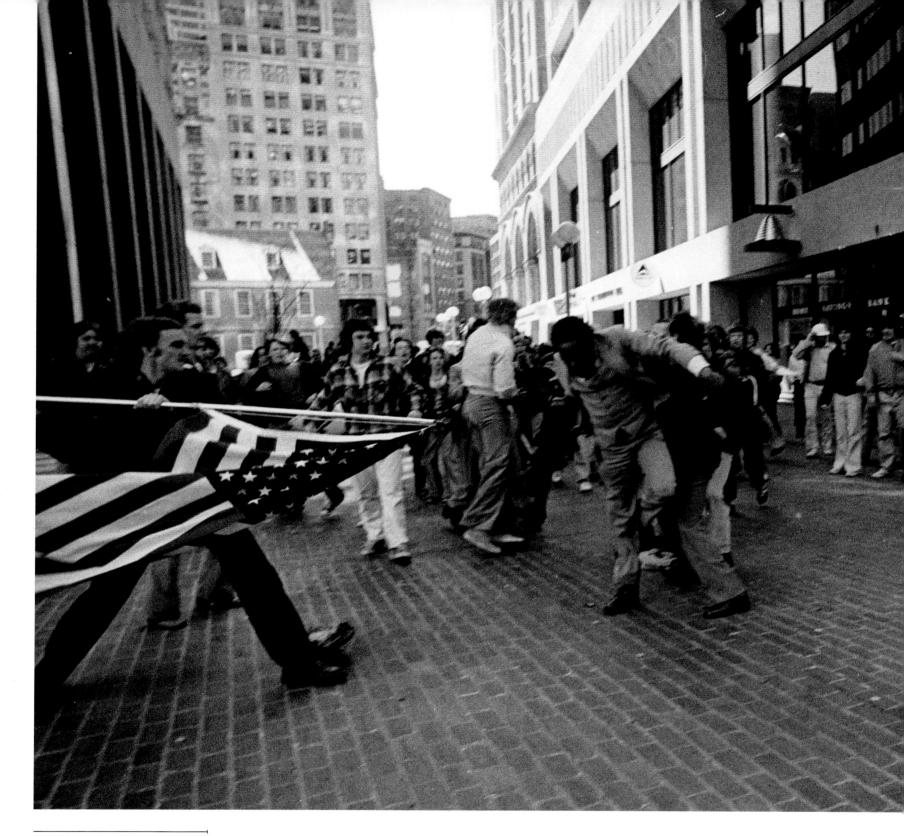

NAVIGATOR

1 **DISTORTED EDGE**
The ultra wide-angle view – about 94 degrees – of Forman's 20mm lens stretches the shapes at the left edge through projection distortion. This emphasizes the vigorous action, which is reinforced by the strong patterns on the American flag.

2 **EXPRESSION**
Forman captures the fierce expression of determination on the face of the alleged assailant. By catching the action at this particular moment, it is not clear whether the man is swinging the flag pole sideways or using it as a spear.

3 **SCUFFLE**
Helped up or pushed over – it is hard to tell, and the ambiguity has led to controversy. Civil rights groups read the image one way and conservatives another. The image can be interpreted either way.

4 **CONVERGING LINES**
Forman's ultra wide-angle view exaggerates the converging parallel lines of the buildings, focusing attention on the action at the centre of the cropped image.

The Soiling of Old Glory

STANLEY FORMAN / 1976

It was such a powerful image that the editors were afraid to publish it above the front-page fold. But overnight it became an icon for the contradictions of American society, showing racial hatred rife not in the South but in Boston, the self-styled Cradle of Liberty. At the same time, it is also a classic case of how a photograph can be misleading.

The story starts with Stanley Forman, a photographer for the *Boston Herald*, turning up late on 5 April 1976 to cover a demonstration against busing – the policy of transporting black students to predominantly white schools to redress racial segregation. As he approached Boston's City Hall Plaza, he saw a scuffle between student groups. He then noticed a black man making his way towards the Plaza. Forman takes up the story: "A bell went off in my head and I thought they were going to get him". Other photographers were also present but were photographing from behind the protesters. Because Forman had been late, the crowd was coming towards him. He continues: "I started taking photographs with the motor drive camera with the 20mm lens on it. I could hear the motor working, but I could also hear the sound of it not transporting the film correctly... I stopped shooting continuous shots and just pressed the button to shoot just one frame at a time". As luck would have it, he was nearing the end of the roll. Had he continued to fire off at a high rate, he might have missed the crucial shot. While several negatives are ruined by overlapping frames, the final image of the roll shows a white protester lunging with the pole carrying Old Glory at a black man being restrained by another white man.

When investigated, however, the story falls apart. The black man, Theodore Landsmark, was not being restrained but helped up – the man holding him, anti-busing protester James Kelly, was trying to protect him. The protester with the flag, Joseph Rakes, was not lunging at Landsmark but swinging the pole (although he was aiming at Landsmark, he missed). The picture won a Pulitzer Prize in 1977.

IN CONTEXT
Slipped film

In the days of film, cameras used motor drives to run film quickly through the camera to expose four or five frames per second. Although generally reliable, if the film stuck in the cassette, the motor drive could rip through its sprockets. Slip clutches helped to avoid such a disaster, but if they became worn and the film stuck, frames would overlap. This is what happened to Forman's camera. By switching over to single shot, he corrected this – cool thinking under pressure ensured that he obtained the shot of a lifetime.

CONTACT SHEET FROM THE EVENT

▷ **ANTI-VIETNAM MARCH**

MARC RIBOUD, 1967

Jan Rose Kasmir, a young American woman, confronts the armed National Guard with a flower, outside the Pentagon in Washington, DC. This march helped to turn public opinion against the US war in Vietnam.

Green Lacewing

STEPHEN DALTON / 1970s

Working almost entirely at home and in nearby woods, Britain's Stephen Dalton has gained a world-class reputation as a nature photographer, taking the pioneering work of Jules-Étienne Marey (see pp.80–81) and Harold Edgerton (see pp.202–03) to the highest level. His photographs of airborne animals are a peerless combination of exquisite detail, delicate lighting, and sensitively conceived habitat.

When he enrolled on a photography course to escape a boring office job, Dalton soon discovered that he was interested in "animals or nothing". Around 1970, he realized that no-one had photographed insects in free flight, and resolving to capture insects in full detail in their natural habitats, he set about creating suitable equipment. Apart from his camera and tripod, he had to make everything himself and painstakingly built set-ups using plants, reflectors, and flash-heads in a home studio. This was not, however, the most difficult part of his task: "Constructing the final picture in my mind's eye is the most taxing part of studio photography, technical problems frequently paling into insignificance", he explains. Patience and effort are also essential. Dalton made more than 900 exposures of the green lacewing, and to get a single shot of a badger crossing a stream, he spent three weeks trudging 67.5km (42 miles) across fields, expending 294 camera hours.

Following a break in the 1990s, Dalton has returned to photographing insects in flight, this time using a high-resolution digital camera and flash with an even shorter duration of 1/60,000 sec to eliminate virtually all traces of motion blur. His work is not just about creating images, however, but also about encouraging conservation: "I just pray that it will convince more of us that the natural world must be protected no matter the cost".

NAVIGATOR

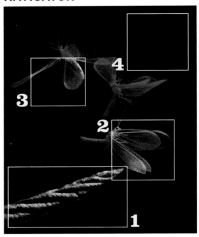

1 TOP-LIT LEAF
The main light comes from above, making the leaf shine. It appears blurred because it moved slightly when the lacewing took off, and the three exposures registering movement are superimposed.

2 WING POSITIONS
From the 900 different exposures made, there are different options for the most attractive wing position. While the first is the most important, the other steps reveal that the four wings flap almost independently of each other.

3 OUT OF RANGE
Within a fraction of a second, the lacewing is falling out of focus. Some elements are sharper than others, which shows the depth of field is only a few millimetres.

4 DARK BACKGROUND
The black background provides a clean backdrop for the translucent insect and is appropriate for this nocturnal insect. It is also necessary for multi-exposure flash images. Without it, the insect would blend into the background after the first exposure.

ON TECHNIQUE
Stop-motion photography

The technical demands of shooting insects in flight using stop-motion photography would drive most photographers to another subject. The flash duration has to be 1/25,000 sec or less and the camera shutter has to respond to being tripped within 1/500 sec or less. The position and delay on the trip – a beam of infrared light that breaks when an animal flies into it – has to be adjusted so that the flash goes off when the animal is in the exact plane of focus. An error of a fraction of a millimetre can ruin the image.

Dalton sets small apertures of around f/16 to ensure adequate depth of field. He originally used Kodachrome 25 film, rated at a mere ASA25. This meant that the flash output had to be extremely high to compensate for both its brief duration and the slow film. To power and control all of this, he assembled electronic components into home-made set ups that weighed more than 10kg (22lbs) and delivered more than 3,000 volts.

Before each shot, Dalton sketched the result he was aiming for, then added plants and background to provide a natural setting. For location work, he set up his equipment one piece at a time to avoid a sudden change to the environment, disguising and hiding items as necessary, including adding soundproofing blimps to muffle the camera's motor drive.

STEPHEN DALTON AT WORK ON A SHOT OF A FLEA

Seeing the invisible

Photography has gone further than its initial remit of drawing with light. Thanks to the invention of the television cathode ray tube, visible light is only a tiny fraction of the radiation that can be used to generate images.

IN CONTEXT
Photographing atoms

In the search for the smallest thing to photograph, few things come smaller than individual atoms. Strictly speaking, we cannot see an atom because it is much smaller than the wavelength of visible light. The scanning tunnelling microscope (STM) can image individual atoms by using a quantum effect called tunnelling, in which electrons flow into a conducting tip held near an atom. As the flow partly depends on how near an atom is to the tip, the changing flow of electrons as the tip moves across a sample will map the position and size of the atoms. Invented in 1981 by Gerd Binnig and Heinrich Rohrer in Zurich, Switzerland, STM has not only imaged structures at an atomic level but has also manipulated those very atoms.

STM OF MANGANESE ATOMS, DRS A. YAZDANI AND D.J. HORNBAKER

In 1907, Russian scientist Boris Rosing used electrical signals to draw shapes visible on a cathode ray tube (CRT). For the first time, variations in electricity could be visualized and turned into images.

A CRT works by applying electrical changes to a beam of electrons in such a way that the beam changes position or intensity. This means that electromagnetic radiation of any wavelength that can be detected can cause a visible effect. With a CRT, changes in magnetic fields, the reflection of electrons, or heat waves – all normally invisible phenomena – can now be converted into images.

Electron scans

One application of the CRT is the Scanning Electron Microscope (SEM), which delivers the most fascinatingly detailed results. Although the images look as if they are created by light, they are in fact produced by electrons that are dislodged from the surface of a sample by a beam of electrons generated by the scanner. To ensure conductivity, the sample is usually coated with a micro-thin layer of metal. One common type of SEM measures the emission of secondary electrons that indicate the angle between the surface and the beam of electronics. By using an extremely narrow electron beam that traverses and scans the sample, the SEM builds an image with extensive depth of field, which gives the characteristic appearance of being in 3D and in focus all over.

First produced in 1965, SEMs magnify up to 500,000 times – 500 times more than conventional microscopes, which use light – and produce astonishingly detailed close-ups of all kinds of specimens, from insects and pollen to diatoms (single-celled algae). The SEM generates a grayscale image on a monitor screen, which can then be photographed. Since the 1980s, photographers such as Lennart

Nilsson (see pp.260–61) have added artificial colours to create even more impressive images.

Imaging the body

Since 1895, when Wilhelm Conrad Röntgen showed how X-rays could look through the body (see p.83), scientists have come up with ever-more sophisticated and non-invasive methods of seeing inside the human body. One of the first photographers to recognize the visual potential of medical imaging as pictures in their own right was veteran American photojournalist Howard Sochurek, who pioneered the digital enhancement of medical images. Rescuing a NASA computer that was on the junk heap in the late 1980s, Sochurek added colours and improved details to create ground-breaking photographs of hearts, cancers, and bone structure obtained from early computed tomography (CT) scans.

Nowadays, methods depending on quantum effects such as positron emission tomography (PET) and magnetic resonance imaging (MRI) can provide high-resolution images of soft tissue structures deep within the bodies, not only of humans but also of other animals. Since its invention in 1972 and the first successful image identifying cancer in 1980, MRI images have entered public awareness through popular TV hospital shows.

Invisible vibrations

Other ways of seeing the invisible emerged when scientists began imaging the structure of air. In the 1890s, Jules Marey studied air flow with the aid of smoke (see pp.80–81), but his methods fell short when it came to fast-flowing air. More productive were developments in schlieren photography – a technique invented in 1864 by German scientist August Toepler. The schlieren scheme is a way of focusing light that makes differences in air density visible. The technique has been crucial to studies

▷ **PANCREATIC CANCER CELL**

STEVE GSCHMEISSNER

This coloured scanning electron micrograph (SEM) image shows a pancreatic cancer cell. The nodules on the cell's surface are typical of cancer cells, so the image supports a diagnosis of the disease.

of air flow over aircraft and cars. Another phenomenon that is usually invisible to the human eye is the coronal discharge emitted by an object such as a hand or foot when it is subjected to a high frequency, high voltage field. In 1939, Russian researchers Semyon and Valentina Kirlian discovered that the discharge could be recorded by holding the charged object on photographic printing paper or film. The resulting image shows the hand or foot in silhouette surrounded by a glow or halo, and has been used for medical diagnosis.

◁ SEM IMAGE OF A MOTH'S HEAD

STEVE GSCHMEISSNER

Typically of SEM images, everything is in focus, from the moth's compound eye (coloured red by the computer) to the scales on its head and its spiral-shaped proboscis (at the right), used to suck up the nectar of flowers and other fluids.

▽ 3D MRI SCAN OF A PIG

THIERRY BERROD

In this coloured 3D magnetic resonance imaging (MRI) scan of a pig, the bones are shown in white. Some of the internal organs, such as the lungs in the chest and the intestines in the abdomen, are also visible. MRI scanning uses powerful magnets and radio waves to generate images of structures inside the body.

Ernst Haas

AUSTRIAN-AMERICAN / 1921–86

Haas mastered the art of colour photography before other photographers realized how much they had to learn. He understood better than anyone else that colour photography had its own visual vocabulary, which was different from that of black-and-white photography, and required new disciplines. He was a wizard with space, light, and colour, and his images are like flashing jewels, perfect in their clarity.

Born into a cultured family in Vienna, Haas was a late starter. At the age of 25, he swapped a block of margarine for a Rolleiflex on the black market. At first, he photographed pictorial subjects, but when he saw Werner Bischof's work (see pp.208–09) he was inspired to pay attention to life going on around him. While on a fashion shoot, he noticed a commotion at Vienna's train station, and found himself photographing homecoming prisoners of war. It was a virtuoso debut – nearly every shot was publishable, and one became a classic. It led to invitations to join Magnum Photos (see pp.206–07) and *Life* magazine. He opted for independence and chose Magnum.

In 1950, Haas went to the US, where he was entranced by the intensity of colours in New Mexico and abandoned black-and-white photography altogether. From then on, he only ever used Kodachrome film. He had an aptitude for exploiting the medium's character rather than working around its shortcomings. He photographed a rodeo show in light deemed hopelessly dim by other photographers, for example. The long exposures caused blur, which all photographers know and avoid, but Haas made a signature virtue of it.

Haas was a pioneer of travel photography – creating images more evocative than documentary. Many of his visual journeys, such as those around Bali and Venice, and his book *The Creation* (1971), remain the benchmark for the genre. A recipient of numerous major honours, Haas proclaimed, "The limitations of photography are in yourself, for what we see is only what we are". His genius is perhaps best defined by his rhetorical question: "If the beautiful were not in us, how would we ever recognize it?"

▷ **TV AND SHADOWS**
CALIFORNIA, c.1975

In this deceptively simple shot, Haas explores the visual possibilities created by a flimsy curtain. It veils the bright sunlight outside, changes the colour of the carpet, casts stripes of shadow, and is reflected in the television screen.

Best **wide-angle lens?**
Two steps backward.
Look for the "Ah ha!"

ERNST HAAS / 1985

◁ **STORMY WEATHER**

COLORADO, 1977

Haas took this shot from a moving car as it passed a motel. He strongly underexposed the image to keep the colours in the sky while suppressing shadow details which support, rather than compete with, the bright spots of colour.

▽ **NIGHT HORSES**

NEVADA, 1957

Wild horses are reflected in water as they gallop across a darkening landscape. Haas makes the most of the beauty of blurred motion, more apparent in the horses themselves than in their reflections.

◁ **CITY ART GALLERY**

NEW YORK CITY, 1962

Like a play within a play, we see the display of paintings on the stuccoed wall through the eyes of the man leaning against a car. As so often in Haas's work, reflections add another layer – here, the pictures are mirrored in the car's bonnet and distorted by the front windscreen, and more paintings are visible through the side window.

Puglia, Italia

FRANCO FONTANA / 1978

The Piet Mondrian of photography, Franco Fontana's images take abstraction as far as visual distillation can go without disconnecting from reality. At their best, his photographs tell you everything there is to know with just two or three elements, like a perfect riff that sets up a key, mood, and tune in a few notes. His views of Italy in particular exude a love and understanding of his home country that no outsider could match. Fontana comments, "I try to isolate in time and space all that is normally mixed up with an infinity of detail. Extracting a few essential elements from the entirety that presents itself to the human eye is one of my inner requirements."

Fontana was born in Modena, northern Italy and initially worked as an interior designer. He did not take up a camera until 1961, when he was 28. Success was not rapid either – his first solo exhibition took place in Modena in 1968. His best-known series, *Landscapes*, was first shown in 1970, celebrating the brilliant colours and sensual forms of the Italian topography. In 1979, a trip to the US exposed him to a different spectrum of experience, which launched his urban studies. These reveal his essentially European sensibility, which abstracts calm significance and intimacy of space from a discordant chaos of urban forms to create a precise composition of harmonious forms, colours, and planes of texture. Up until this time, no figures had appeared in his work, but in the *Presence Absence* series, hints and shadows of people are allowed to impinge upon his carefully articulated surfaces. His style of photography – originally on 35mm colour transparency and now on digital SLR – was made possible thanks to developments in technology. His reliance on precise compositions cut out of a larger view calls for high-quality zoom optics (see pp.270–71), which were only maturing in the 1970s.

Once recognized, Fontana's distinctive style of concisely colourful abstraction chimed well with the sharp, clear corporate values of the time, leading to numerous commercial and advertising commissions, and his diversifying into nudes. Despite a little critical hesitation – some thought his images unfashionably colourful and joyful – his work has been widely exhibited and collected. *Puglia, Italia* is one of several studies he made of this region in the southern "heel" of his homeland.

NAVIGATOR

1 MUSTARD FIELD
A uniformly lit but lightly textured wash of yellow occupies the bottom half of the image. Hints of the land's contours are visible, but the overall evenness soon leads attention to the rest of the image.

2 DARK DIVIDER
While the yellow contrasts with the vivid blue sky, the intriguing black whale-like shape defines the horizon. It interrupts the boundary between the sky and field and draws your eye to the clouds above.

3 PUNCTUATION
The clouds, neatly lined up over the contrasting black hump on the horizon, puncture the vast expanse of blue. A single cloud would not have worked as well, and the shot would have been less effective if the two clouds had not aligned.

4 EVEN BLUE
Zoom lenses tend to leave the corners of the image slightly darker than the centre. For this photograph it is important that illumination across the whole image is uniform, achieved by digitally manipulating the image.

IN CONTEXT
The urban landscape

The selective editing that Fontana applied to American urban views manipulated space in a way that was not possible with his European landscapes. In his city studies, Fontana cuts out clues to spatial relations such as overlaps or shadows, making perspectives ambiguous and hard to decipher. The wall on the left of *Urban Landscape, Los Angeles*, for example, appears to be leading away to the left if you look at the sky, but seems to come forward if you focus on the wall itself. This makes the sky seem strangely like a wall too. Furthermore, by digitally correcting the converging verticals, Fontana has removed an obvious clue as to which direction the camera is pointing (upwards).

URBAN LANDSCAPE, LOS ANGELES, 1979

1989

CHALLENGE AND CHANGE

In terms of media domination, television seemed to have the upper hand in the late 20th century. Photographers kept their heads up because looking at photographs was simple – people could gaze at prints whenever they wished, without needing a machine, or power, or having to press PAUSE for a longer look. By the 1980s, amateur photographers could produce pictures of similar quality to those of professionals, starting a trend that was to dominate 21st-century photography. Indeed, some sections of the profession – such as stock (agency) photography – were already dominated in quantity, if not in outright quality, by amateur photographers with growing access to professional-quality equipment.

Photography became increasingly accepted as a subject for higher education, and colleges turned out considerable numbers of trained, visually literate young photographers. As a result, the profession was squeezed from one side by amateurs keen to make their mark and from the other by articulate

students who considered themselves entitled to a career in photography. As the computing industry developed, photographic methods became an intrinsic part of the manufacture of microprocessors. This brought about a renaissance: capturing images became electronic, and a return to the direct positive – like the daguerreotype – was heralded.

What was not known at the time, was that these electronic images signalled the beginning of the end for film-based photography. Initially, the digital camera seemed like a laboratory curiosity, and the adoption of digital photography was hampered by the same entrenched conservatism and scepticism about technology that had greeted the birth of photography itself. Digital photography was too costly, too clumsy, too unreliable, and of too low a quality ever to supersede the use of film. Within a generation, however, fragile digital images persisted. They increased in such numbers and so quickly that they were to change photography forever.

Controlled compositions

Unable to shake off the legacy of its fine-art precedents, the photographic still life has yet to establish its identity. Torn between focusing on the subject itself or the meanings behind it, photographers have tried many approaches.

Robert Mapplethorpe
1946–89

American Robert Mapplethorpe celebrated the androgynous in a female bodybuilder, objectified the phallus into an art object, and uncovered the erotic in the sinuous curves of plants. Although he disparagingly said, "I played around with the flowers and the lighting, so that was a good way to educate myself", it is clear that he approached the still life with unusually focused intensity. Comparing flowers to phalluses, he commented, "My approach... is not much different. Basically, it's the same thing". His still-life studies, which date from the 1980s, are of flowers in arrangements that are pared down to the essentials. Lit and designed with great care, he worked in black-and-white as well as colour. He photographed statues with the same degree of intensity.

CALLA LILY, ROBERT MAPPLETHORPE, 1986

According to the philosopher Arthur Schopenhauer, one of the reasons why common objects seem transfigured in still life is that we "no longer look at things in the flux of time and in the connection of cause and effect". The thing being celebrated in still life is beauty – more so than in any other genre of photography – and it is brought to the fore by order and composition. Since the very first experimental images of Henry Fox Talbot, still-life studies have been a feature of photography. In the 1860s, Roger Fenton made no attempt to hide his great debt to painting (see pp.62–63) and control has always been an important element of still-life photography. As in painting, the still life is the one genre where the photographer is in complete control, and most photographers have attempted to transcend the ordinary by celebrating the finest detail and most subtle of textures, as is clear in the work of Edward Weston, for example (see pp.160–61).

Layers of meaning

One of the first photographers to realize the significance of arranging objects was Walker Evans (see pp.174–75), who showed in the 1930s that a picture of a dressing table or chair could reveal just as much about their owners' living conditions as a view of the entire room. Common, everyday objects are recorded in a still-life image, but they can also have symbolic meanings. It is a short step to constructing a still life from the start, compiling the components to convey a narrative or mood, then photographing the arrangement.

From the 1980s to the 2000s, the Chilean-born British photographer Mari Mahr produced multilayered still lifes in which everyday objects are combined with images that are often autobiographical in nature. Mahr's quietly dissonant arrangements are photographed with stringent clarity, deliberately leading the viewer beyond the frame to intuitive associations.

American Arthur Tress is as flamboyant as Mahr is diffident, and creates arrangements by placing objects in unexpected environments – pitchforks on a bed littered with leaves, for example. He also constructs fantastical tableaux, painting objects in bright, vigorous colours, and then photographing the assemblages he makes from them.

◁ **UNTITLED NO. 1**

MARI MAHR, 1983

Each picture in the series 13 Clues to a Fictitious Crime *juxtaposes "clues" – spectacles, a book, gloves – with parts of the human face or other human-made objects such as the buildings here.*

Other photographers who have adopted similar strategies include Scottish artist Calum Colvin and Canadian photographer Jeff Wall.

Edible art

Tessa Traegar has turned the relationship between still-life photography and fine art on its head by imitating the eccentric 16th-century Italian painter Giuseppe Arcimboldo. Painting portraits made of fruits and vegetables, Arcimboldo created a humorous, sometimes grotesque, conceit. From the 1980s, Traegar has used fruit, vegetables, nuts, and seeds to create large, two-dimensional compositions. She makes them on the ground floor of her studio, then photographs them overhead from the mezzanine.

◁ **THRONE OF APHRODITE**

ARTHUR TRESS, 1987

In the 1980s, Tress started working in colour, envisaging tableaux and building them himself before photographing them. Aphrodite was the goddess of love in ancient Greek myth.

▽ **FRUIT AND SALAD COLLAGE**

TESSA TRAEGER, 1992

Traeger took this overhead view of fresh fruit and vegetables to feature in an advertisement by the British Heart Foundation promoting healthy eating.

Frans Lanting

DUTCH / 1951–

Combining the heart of a nature lover, the eyes of an artist, and the brains of a scientist, Lanting is one of the most admired and imitated of his generation of nature photographers. A tireless innovator, he will just as readily use a cartload of synchronized flashes and a remote-controlled camera for a picture of elephants at dawn as crouch for weeks in a treetop hide waiting for a family of macaws. More than any other nature photographer, he has brought the public literally nose to nose with animals by working from viewpoints that invite the viewer to share in the creatures' lives.

Lanting was born in Rotterdam and trained in environmental studies. After seeing the beauty of the American West on a trip to the US, he abandoned laboratory work to combine his love of photography with the natural world. Approaching his assignments with scientific thoroughness, he spends weeks planning the shots, getting to know his subjects and letting them get to know him. He has pioneered the wide-angle, close-up view of animals by learning how to approach nearer than anyone else before him. He exploits high-tech trip devices as well as the sheer luck that rewards the meticulously prepared. At best, his work combines a telling portrait of an animal with artistry of light and line. A long-time user of Nikon 35mm SLR cameras, he now uses digital cameras, such as the Nikon D3X, D700, and D7000, paired with a wide range of lenses – which he takes to locations as far afield as the Galapagos Islands, Zambia, Namibia, Hawaii, South Georgia, and Amazonia.

A tireless advocate for conservation through his books, he pioneered a multimedia project with American minimalist composer Philip Glass called *LIFE: A Journey Through Time*, which is touring venues around the world. He explains the concept: "...you can't really understand the present, or project into the future, without an understanding of the past". In between his photographic assignments, he serves on several international conservation bodies. Above all, his photography is for the sake of his beloved wildlife: "What my eyes seek in these encounters is not just the beauty traditionally revered by wildlife photographers. The perfection I seek in my photographic composition is a means to show the strength and dignity of animals in nature".

▷ **WRANGELL-ST ELIAS NATIONAL PARK**

ALASKA, US

Lanting was flown over the park at sunrise to capture this image of the sky reflected in a lake amid acres of forestry. The park, which is larger than Switzerland, is the biggest in the US

◁ **SMALL HERD OF CHITAL**

BANDIPUR NATIONAL PARK, INDIA

Lanting used a long exposure while panning to blur the background and keep the deer relatively sharp. The blur conveys the speed of the animals as they bound over the rolling hills of India's Western Ghats.

△ **AFRICAN ELEPHANTS**

BOTSWANA, AFRICA

Twilight draws a herd of elephants to drink at a watering hole in Chobe National Park. Since the elephants were moving slowly, Lanting could use a long exposure, which enabled him to record colours normally invisible to the naked eye in the moonlight.

◁ **PUMA**

BELIZE, CENTRAL AMERICA

Also called a cougar, panther, mountain lion, or mountain cat, the puma is by nature secretive and solitary. This extraordinarily close-up view is a credit to Lanting's patience and respect for the animal's wellbeing.

Too clever for words

As city dwellers were exposed to rising numbers of publicity and advertising images – hundreds every day – advertisers had to work harder to catch people's attention, cause a stir, and gain media coverage.

UNITED COLORS
OF BENETTON.

▽ **BENSON AND HEDGES**

BRIAN DUFFY, 1977

The regulations regarding tobacco advertising spurred agencies and photographers on to greater originality. Here, the cigarette packet perches like its shadow of a bird in a cage. Other advertisements showed it in a goldfish bowl being eyed by a cat, or hanging as a magnet.

Burgeoning consumerism during the 1980s and '90s in developed countries funded large advertising budgets that, in turn, stimulated increasing levels of creativity and production values to sell consumer products. As companies selling everything from cars to soap powder vied to win their share of the market, photographers jousted to produce the most striking images.

Advertisers wishing to fill 48-sheet billboards – more than 6 x 3m (20 x 10ft) – also pushed up technical requirements. An elite of advertising photographers responded by using 10 x 8in or larger cameras mounted with the finest lenses. It was the heyday of advertising photography, and skilful, inventive photographers were able to make a fortune.

Selling dreams

Creativity and ingenuity were also vital to bypass the increasingly stringent controls on tobacco advertising. In the early 1950s, cigarette manufacturers could claim that smoking was safe. By the early 1960s however, hundreds of studies in favour of the anti-smoking lobby led to requests to restrict tobacco advertising, and cigarette manufacturers found themselves constrained by strict rules about exactly what they could claim, show, or even suggest.

From the late 1970s, the British agency Collet Dickenson Pearce devised bold advertisements free of any copywriting which placed the gold package of the Benson and Hedges brand in incongruous and surreal situations, such as being opened like a can of sardines while floating in an azure pool. Many of the special effects were obtained in-camera through ingenious lighting, use of projectors, and small models.

Simple but effective

In 1983, the agency Saatchi and Saatchi launched their Silk Cut series simply using purple as a brand colour. The images that they created exploit associations and metonymy (using an attribute to suggest the whole entity). A photograph of a purple shower curtain, for example, reminds us of the terrifying murder scene in Alfred Hitchcock's film *Psycho* – and we hold our breath, just waiting for the curtain to be slashed.

In an attempt to compensate for restrictions, cigarette manufacturers spent large sums on advertising, to the considerable benefit of the print media as well as the photographic industry. From a 1999 total in the US of more than US$8 billion, spending peaked in 2003 at over US$15 billion.

Brand ingenuity

Another trend in the 1980s was the awareness of brand value – that consumers could choose a product through loyalty to the brand rather than because of specific features. Advertising – creating brand awareness in effect – was far more difficult than selling specific products. It called for a better understanding of the effect of images on people and the subtle use of indirect stratagems.

One strategy was to provoke a sense of outrage or shock that would stoke controversy and draw attention to the brand. The Benetton Group proved adept at using provocative images created by the Italian photographer Olivero Toscani. He exploited his gift for disquieting images, which seem to suggest one thing at first, but then raise troubling questions.

IN CONTEXT
The language of signs

The visual language of photography attracted the attention of thinkers such as Ferdinand de Saussure and Umberto Eco, whose theories of signs distinguished different levels of meaning in signs, symbols, and images, the subtleties of which art directors and photographers were quick to exploit from the 1980s. The influence of semiotics is visible in long-running campaigns such as the Pirelli Calendar, which gained cult status in the 1990s for its inventive blend of fine art and female glamour.

PIRELLI CALENDAR, 1970s

△ **BENETTON**

OLIVERO TOSCANI, 1991

In 1993, one of clothing chain Benetton's most controversial campaigns showed a newly delivered baby, Giusy, with her umbilicus still intact. The photograph challenged viewers not to be repulsed by the uncompromising view of birth, but it caused a scandal wherever it appeared.

▷ **SMIRNOFF – THE OTHER SIDE (HELLS ANGELS)**

MIKE PARSONS, 1994

Advertisements for alcohol became more and more cryptic towards the end of the century. They aimed to imprint a brand, rather than just a type of drink, in the mind of the increasingly sophisticated consumer.

Steve McCurry

AMERICAN / 1950–

A visual magician, whose props are people, light, and colour, McCurry reached the pinnacle of 20th-century photography. His best work seems supernaturally perfect in execution, brought about by unlikely coincidences that belie the time, trouble, and sheer physical effort he has put in to be ready for the right moment.

Born in Pennsylvania in 1950, McCurry took up photography while he was studying film. Relishing the prospect of travel, he decided to become a professional photographer, and saved up enough money to buy 300 rolls of film. In 1977, he travelled to India where, he recalls, "I stayed at some of the world's worst hotels and wish I had a nickel for every time I was sick". Smuggling himself into Afghanistan in December 1979, he found the borders closing behind him as the Russians invaded. A few months later, with rolls of film sewn into his kameez (traditional tunic), he escaped to Pakistan and published his pictures worldwide. For this, essentially his first assignment, he was awarded the 1980 Robert Capa Gold Medal.

An early injury permanently affected McCurry's right hand. He can use it to hold a camera via a grip, but he has to make exposures using his left hand curved under the lens and over to the shutter button. Photographers looking for what makes his technique unique need search no further. A long-time user of Nikon cameras equipped with prime lenses, in film-using days he shot on Kodachrome, exposing 300–1,000 rolls per shoot. Now an enthusiastic digital photographer, he uses Nikon and Hasselblad cameras. The photojournalist James Nachtwey described McCurry as a dream catcher: "His imagination is a force of nature", he stated.

> Most of my photos are **grounded in people**... the essential soul peeking out, **experience etched on a person's face.**

STEVE McCURRY

▷ **HOLI FESTIVAL**
RAJASTHAN, INDIA, 1996

During Holi, the Hindu spring festival, participants throw coloured powder and water over each other. This overhead shot capitalizes on the vibrant effect produced by the contrast between the red and green.

◁ FRUIT VENDOR

JODHPUR, INDIA, 1996

The blue houses of this walled city in Rajasthan provide a cooling foil to the startling accents of red in the headdresses, fruits, and chillies.

▽ STILT FISHERMEN

WELIGAMA, SRI LANKA, 1995

Perched on poles planted in the seabed, fishermen wait for a bite. McCurry aligned the men with the rock in the background, setting their picturesque but harsh livelihood against the palm-tree-fringed paradise glimpsed on the far right.

◁ AL-AHMADI OIL FIELDS

KUWAIT, 1991

McCurry's pictures of Kuwait told the story of the environmental fallout of the Gulf War, after Iraqi soldiers set the oil wells on fire. The area was dark with acrid smoke and lit by fires as loud as jet engines.

Sharbat Gula

STEVE McCURRY **/** 1984

It is ironic that a Pashtun orphan with no home and no name became one of the best-known faces on the planet. Nominated by *National Geographic* readers in 2001 as the most recognizable photograph in the history of the magazine, Steve McCurry's portrait of Sharbat Gula was almost left in the rejects pile.

Working at the Nasir Bagh refugee camp in Pakistan in 1984, McCurry came across a makeshift school and realized that he had a rare opportunity to photograph Afghan women and children. His quick, sharp eye immediately spotted one girl as the best subject, but his instinct warned him to approach her carefully (see below). Using a Nikon FM2 with 105mm *f*/2.5 – favoured by many photographers for portraits – and Kodachrome, McCurry managed only a few shots before the girl stood up and left. Her pupils appear unnaturally small for the dark conditions because McCurry had a window or door behind him. Her striking green eyes may seem surprising, but in fact blue or green eyes are not uncommon among Pashtun, Pamiri, and other mountain peoples of the region.

After it appeared on the June 1985 cover of *National Geographic*, the portrait was immediately hailed as a modern classic, but no-one knew the girl's name. In 2002, she was finally found, then aged 30. Her identity was confirmed by iris recognition and she was photographed for a second cover.

NAVIGATOR

1 GREEN EYES
Beautiful and haunting, the eyes are the heart and soul of the image. As the girl is facing bright light, her pupils have contracted, maximizing the green iris, which contrasts with her skin colour.

2 TORN SHAWL
The tears in her shawl fortuitously reveal a green top. It anchors the colour scheme to just two principal hues – red and green – giving the image an intense coherence.

3 BLURRED BACKGROUND
Thanks to the use of maximum lens aperture, the background details are blurred but still definable. McCurry's craftsmanship is evident in his care that vertical lines remain vertical, to avoid unwanted distraction.

4 LOOSE FRAMING
McCurry moved around between shots to find a clean, even background and asked Gula to look to her right (compare with the alternative, left). He also framed loosely, to allow flexibility when cropping for a magazine cover.

IN CONTEXT
Behind the image

McCurry tells how he photographed a shy girl who was to be the subject of his most famous picture: "When I walked into the classroom I was kind of convinced that she was really an amazing person but she was very shy. So I started off by photographing the other students, because I thought if I approach her straight away and she says 'No' that would be 'No' for the rest of the day. So I photographed her classmates and got them involved in the process. I wanted her to feel that she was almost excluded so that she'd want to take part in it and, sure enough, it got to the point where she agreed".

One of the shots of another student was a powerful portrait in its own right but it has never been published. Another version of Sharbat Gula has her modestly covering her face, having pulled up her shawl (right). The picture editor preferred this version for the magazine cover as the eye contact is very powerful, with bright catchlights and gentle shading light. The modesty is also appropriate for the culture, but the hands do distract from the face. At the last minute the decision was overruled by the magazine editor in favour of the exposed face with its flatter light and less brilliant eyes but revealing the full beauty of the face. McCurry commented wryly, "We came within an inch of it being on the cutting room floor".

ALTERNATIVE PORTRAIT OF SHARBAT GULA

△ **RHINE II**

ANDREAS GURSKY, 1999

Gursky sees this landscape, his favourite photograph, as an allegory on the alienation of modern life and an example of people's relationship with nature. The size of a mural at 156 x 308cm (61 x 121in), Rhine II is as vast as it is featureless. Gursky digitally removed dog walkers, cyclists, and a factory building to heighten the semi-abstract impact of the horizontal bands.

Cool gaze of objectivity

As poster-sized photographic prints became more widely available, photographers worked on an impressively large scale in an attempt to match the monumentality of their subjects.

Exposure is only the **final act** of making the **image** as a **photograph.**

THOMAS STRUTH

In the late 20th century, the spirit of Group *f/64* (see pp.158–61) was alive and influential in Europe, but the ideal of perfectly formed, fully resolved detail was now directed at the urban environment and instead of richly toned monochromes, the chosen medium was the poster-sized colour print. The chief exponents – most of them graduates of the Staatliche Kunstakademie (State Academy of Art) in Düsseldorf – gazed with admiration at the works of man, such as gorgeous, intricately detailed architectural interiors, and tried to match their glory in large prints resplendent with fine detail.

This group of artists is often called the Düsseldorf School but should not be confused with an earlier artistic movement of the same name. In the 1830s and '40s, the then Düsseldorf Academy championed a style of finely delineated, realistic painting with a subtle, northern European colour palette. The old school was still able to influence modern forms of art.

Becher's legacy

The Staatliche Kunstakademie Düsseldorf was a painting academy until 1976, but it then appointed Bernd Becher (see box opposite) to teach photography. Bernd and his wife Hilla photographed late 20th-century industrial constructions, treating them like an impersonal study of forms.

Reacting against the subjectivity of Otto Steinert (see pp.214–15), the Bechers strove with almost scientific

▽ MUSÉE DU LOUVRE, PARIS

CANDIDA HÖFER, 2005

Light floods through the glass roof into the galleries of France's famous museum. The human touch is in evidence all around, but there are no people to be seen. This is one of an edition of six vast C-prints, 200 x 260cm (78¾ x 102½in).

thoroughness to make "families of objects". Their systematic, objective approach set them apart from the New Topographic photographers of the US, with whom they had exhibited in 1975. (The New Topographics presented critiques of the American urban landscape, rather than the Bechers' celebration of industrial constructions.) It struck a chord with the Düsseldorf aesthetic, however. By the time he retired in 1996, Bernd Becher had passed his vision on to an impressive list of students, leading many of them to international careers. Some followed in Becher's footsteps while others built on his teaching and used it as a springboard to launch their own ideas.

Digital detail

Andreas Gursky, Candida Höfer, Thomas Struth, and Jörg Sasse are the most obvious photographers to follow in the footsteps of the Bechers. Photographing with large-format cameras, they produce high-definition colour images characterized by a cool, seemingly dispassionate objectivity. Their works are a celebration of the

modern world, presented with exquisitely fine detail – often digitally enhanced – that reveal their fascination with buildings and man-made environments. Like the Bechers, they too minimize the human figure. If people are present at all, they are no more important than furniture or architectural elements.

Auction records

The attention to detail and high production values of huge prints, together with a rarity guaranteed by producing small limited editions, have ensured high dividends for the artists. Auction values are among the highest in the market. Andreas Gursky holds the record for the highest price paid for a print – *Rhine II* sold for over US$4 million in 2011, putting it on a par with revered landscape paintings. Thomas Struth shot an exquisitely detailed view of the interior of San Zaccaria, Venice, which sold for more than a million US dollars. His museum interiors full of static figures also command six-figure sums, with Candida Höfer's work close behind.

Bernd and Hilla Becher
1931–2007 and 1934–

Both painting students at the Staatliche Kunstakademie Düsseldorf, Bernd and Hilla met in 1957, and from 1959 they collaborated on photographing the fast-disappearing German industrial landscape. Working with a 10 × 8in camera, they photographed in the flat light of overcast days, seeking an objective black-and-white view of every kind of industrial construction, from giant oil refineries to small water towers. They also shot a general view of every site to locate each component. Their long-term dedication and meticulous documentation have proved widely influential.

STONEWORKS, 1982–1992, BERND AND HILLA BECHER, 2012

Documentary as art

The artistic documentary is a contradiction in terms. By meshing ideological opposites – turning records about life into an art form – it blends humanitarian ideals with aesthetic concerns, undermining its credentials as a documentary.

While there was hope, there were no doubts. As long as photographers believed that documenting wars and famines could bring about change, and that informing public and politicians made a difference to the starving and war-torn, the contradictions of using expensive cameras and rolls of film to photograph poverty could be justified.

The role of photography in making the US withdraw from the Vietnam War was inestimable and made photographers feel that they were doing something really useful. By the 1970s, however, as civil wars tore Africa apart, bringing famine to millions, and the number of armed conflicts doubled, the ineffectiveness of photography to influence policy-makers became only too apparent. To make things worse, the public had became increasingly tolerant of images of starving children, a complacency tagged "famine fatigue".

Hard life at home

While photographers in war zones pondered, others concentrated on subjects closer to home. From the mid-1970s onwards, Chris Killip photographed poor, working class communities in the area around Newcastle-upon-Tyne in northeast England. Using large-format cameras and black-and-white film, Killip was one of the first to blend the bleak subject matter of dispossession, unemployment, and loss of hope with the aesthetics of large fine-art prints.

In 1980, photojournalist Peter Marlow gave up his hard-edged coverage of the conflicts in Lebanon and Northern Ireland for the hard edges of life in Liverpool, northern England. Like many photographers, he used formats larger than 35mm to slow down the photographic process – the contrast with the snatch tactics of photojournalism is one of the defining features of the fine-art approach. Marlow sought out "non-places", the transition zones between apparently significant destinations.

In another project, however, he recorded whatever caught his eye, on the spur of the moment. Shorn of any apparent narrative context, Marlow's documentary became a record of his visual experience.

Colourful tales

Martin Parr was a British pioneer of colour documentary photography. His unflattering, brightly coloured and harshly lit images of holiday-

THE DUNGEON, SUSAN MEISELAS, 1995

▷ **FOOTBALL FANS, LIVERPOOL**

PETER MARLOW, 1986

Instead of focusing on the fans themselves or the action on the football pitch, Marlow makes the staircase to the terraces his ostensible subject matter. The fans are seen from behind, but even in silhouette, their forms show apprehension – Liverpool went on to lose 1-0 to Manchester United.

makers – as in his book *The Last Resort* (1986) – project a jaundiced, mocking sense of post-Thatcherite world-weariness.

British-based Chris Steele-Perkins is well known for his photojournalism for aid agencies, but he also makes more contemplative, measured works. In the late 1990s, inspired by *36 Views of Fujiyama* by the celebrated 19th-century Japanese artist Hokusai,

Steele-Perkins turned to a medium-format 6 x 7cm camera to make a contemporary photographic response to Hokusai's woodblock prints of Mt Fuji. Interweaving images of modern Japan – baseball games, petrol stations, traffic jams – with views of the volcano, Steele-Perkins created a document of Japan that is made elegiac by the presence of the unmistakable snow-capped peak.

Art in the mundane

British-born photographer Paul Graham uses large-format cameras to monumentalize the mundane – from social security waiting rooms to the litter along a main road. He also works in colour. His books, such as *Beyond Caring* (1986), challenge the domination of monochrome in documentary work, combining content with the chaotic colours of urban life.

▽ **FUJI CITY, JAPAN**

CHRIS STEELE-PERKINS, 1999

From a footbridge, Steele-Perkins was able to include the base of Mt Fuji as well as the distinctive pyramidal peak, contrasting its natural majesty with the bustle and trappings of modern city life.

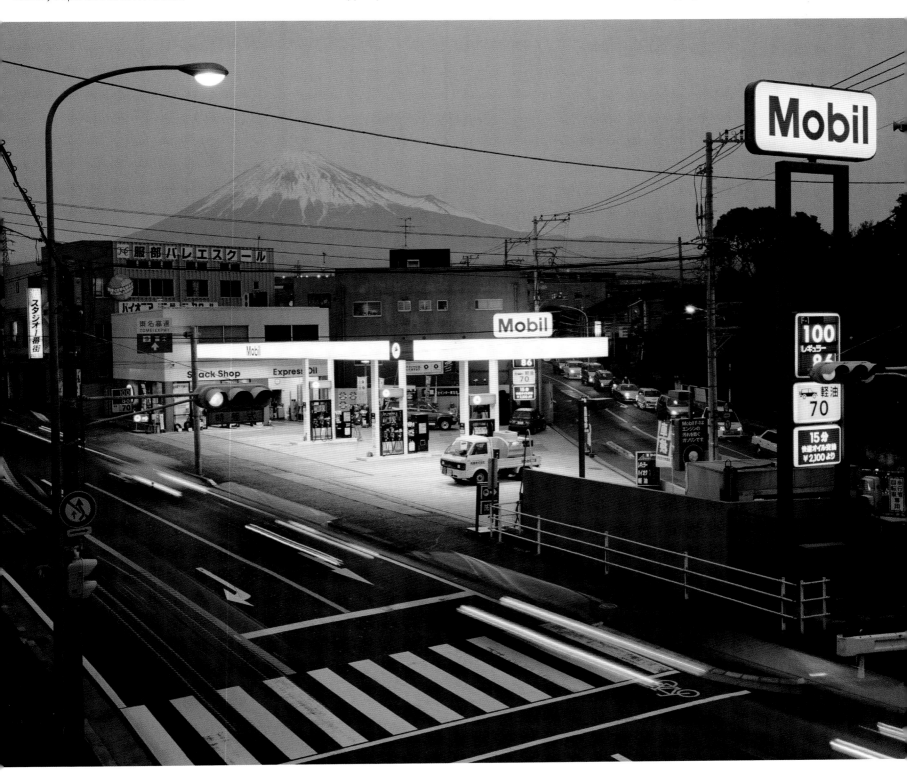

△ **CHRONOTOPIA, AFGHANISTAN**

SIMON NORFOLK, 2002

Norfolk likens the concrete remains of this teahouse in the Afghan capital, Kabul, to the prehistoric monument of Stonehenge in Britain. Balloons were illegal under the Taliban but now balloon-sellers are a common, if incongruous, sight in Kabul.

In the war zones

Nigerian-born Simon Norfolk focused his attention on exploring the concept of the battlefield in every sense of the term. Using large format, he has photographed the aftermath of war in countries such as Afghanistan, Bosnia, and Liberia. He has also photographed the locations of genocides, including Cambodia and Rwanda, and, since the early 2000s, battlefields from the past, such as the Normandy beaches in France, which are both riveting in their beauty and unremittingly depressing. In his work, Norfolk has unflinchingly produced some of the most uncompromising and far-reaching documents of man's inhumanity to man with heroic clarity and vision. By revealing beauty even on a killing field, he is ultimately questioning the value of his work while presenting it as a work of art.

French photographer Luc Delahaye takes the contradictions inherent in treating documentary like fine art to the limit. After a successful career covering news with Sipa Press and Magnum, Delahaye took up large-format cameras in 2001 to photograph conflict in its widest sense, from excavations of mass graves to a dead body in a ditch, or a scene at lunch at an expensive restaurant. By using large-format prints, Delahaye deliberately places death and conflict in the context of fine art, forcing us to confront the contradictions at the very heart of society.

The **denunciation of suffering** by photography has replaced the **religious justification** of suffering in **painting.**

LUC DELAHAYE

△ US BOMBING ON TALIBAN POSITIONS

LUC DELAHAYE, 2001

This was part of a series on war and its aftermath. The grand scale – the dimensions are 112cm × 238cm (3½ × 7½ft) – and beauty of the landscape, still but for the puffs of smoke, strike an uneasy balance with the background of destruction. Using an art format for photojournalistic subject matter also caused controversy.

◁ BEYOND CARING

PAUL GRAHAM, 1986

Graham took a series of pictures under cover in British welfare benefit offices. His matter-of-fact, colour images went against the artistic trend and he said of the book he subsequently published: "A photography tutor described [it] as 'poisonous'. I think [by that] he meant [I didn't use] a Leica and shoot in black-and-white".

Eugene Richards

AMERICAN / 1944–

The most literary of photojournalists, Richards creates photographs whose emotion and complexity call out for words. Celebrated for his commitment to the people he photographs, what is good enough for them – often the homeless and the disenfranchised – is good enough for him. His photographs are neither taken nor made, but emerge from experiences shared at first hand.

A graduate in English, Richards's first taste of journalism as a newspaper intern made him look elsewhere for a career, and needing to do something meaningful, he enrolled on a photography course with the legendary teacher Minor White, who encouraged him to focus on feeling and seeing rather than on the political turmoil of the time.

In 1968, Richards started work as a health advocate in Arkansas, where he helped found a social service organization and community newspaper, *Many Voices*. After five years in the racially divided delta, where he was subjected to a number of assaults, Richards returned to his home town of Dorchester, Massachusetts. There, he made his images from the South into a book, *Few Comforts or Surprises: The Arkansas Delta*, and began to photograph the place where he was born and raised. In 1978, he published his second book, *Dorchester Days*, which led to an invitation to join Magnum Photos (see pp.206–07).

Richards is no subscriber to the notion that pictures speak for themselves. His many books are illuminated by the voices of the people he photographs, interwoven with his own finely tuned observations. The recipient of numerous awards, Richards says of photography, "As soon as I started photographing social issues, I looked at it as a battle". It is not, however, all downbeat: "You are with people who are being tortured or people being shot at and they turn around and give you their food. That's when... I lose it... I can handle it all until the beautiful thing happens".

▷ **SNOW BED**

CORINTH, NORTH DAKOTA, 2006

Richards took this picture in a deserted house in temperatures 30 degrees below zero. He later discovered that the bed had belonged to the parents of one of the last residents in this otherwise abandoned town.

All they want from me is to make sure **their kid's story is told.**

EUGENE RICHARDS

◁ **THE FORAN FAMILY**

CAPE HATTERAS, NORTH
CAROLINA, 1990

*Richards's photographs cover the
lighter moments of life, such as this
family venturing out of the car to
paddle, as well as wider social issues.*

△ **FINAL TREATMENT**

BOSTON, MASSACHUSETTS, 1979

*When Richards's partner discovered that
she had breast cancer, she kept a diary and
he took photographs of her surgery and
chemotherapy. The result was an
unflinching book,* Exploding into Life.

◁ **MARIELLA**

BROOKLYN, NEW YORK, 1992

Taken for the book Cocaine True Cocaine
Blue *reporting on drug abuse, Richards
focuses on the woman's desperate face as
she ties up her arm ready to inject. Mariella
was overcome with anxiety because her
delivery of cocaine was late and she was
unable to find a usable vein.*

Crisis of identity

Photography did not escape the ideological upheavals of the 1970s unscathed. Crtics and photographers alike questioned the validity of the photograph, and its role in society came under scrutiny.

WAYS OF SEEING, JOHN BERGER, 1972

▷ **LAVANDULA ANGUSTIFOLIA**

JOAN FONTCUBERTA, 1984

Fontcuberta arranged various objects to look like the bud of a plant, captioned with the botanical name for a type of lavender. This is from his series Herbarium, *in which his composite, made-up plants look like real species, illustrating the point that a photograph can lie.*

The intellectual changes of the 1970s had a profound effect on photography, which was debated and dissected by essayists such as Susan Sontag and Allan Sekula in the US and John Berger in Britain. Even Berlin-born Walter Benjamin's succinct essay *The Work of Art in the Age of Mechanical Reproduction*, first published in 1936 in French, enjoyed a revival for its critique of photography as an art. French theorist Roland Barthes' book on photography *La Chambre Claire* (translated as *Camera Lucida*) was published in 1980. An inquiry into the nature of photography and its effect on the viewer, it has been widely read.

Deconstructing the image
These critical writings questioned the accepted notions of how photography works and its role in society. Such debates, characterized by scepticism not just about photography and the motives behind it, but also about art and design in general, spawned a movement that is often referred to as postmodernism, which rejected the perceived constraints of modernism and abstraction. Objective

representation in photography was challenged. Purely objective representation, it was claimed, was impossible because photographers could not escape the influence of culture and ideology. Truth could not be found in photographs because all meaning was ultimately multilayered, subjective, and tainted by capitalism.

The American writer Susan Sontag questioned the legitimacy of photography in *On Photography*, a collection of essays published in 1977. "To photograph is to appropriate the thing photographed", she stated. "To photograph people is to violate them, by seeing them as they never see themselves... Just as a camera is a sublimation of the gun, to photograph someone is a subliminal murder..." Many photographers still find the book a dispiriting read.

Books like this made their way onto the reading lists of generations of student photographers in the late 20th century, exerting a powerful and somewhat corrosive influence and shaping students' attitudes not just to photography, but also to their work.

In the 1980s and '90s, following the lead of American Martha Rosler and British Victor Burgin, photographers produced images that were more explicitly political in content and explored issues of cultural, sexual, and social identity. They challenged traditional notions of femininity, for example, by portraying androgynous women in aggressively masculine dress and poses. These portraits were not intended to please, but to challenge viewers by undermining stereotypes. Text was often integrated with the photographs because images alone could not be reliably unequivocal in meaning and context.

Although the critiques swept away old assumptions and ideas about photography, it was not clear what was replacing them. Photographers were so confused by the debates that they either found it hard to work at all or would make photographs simply to clear their heads and try to establish the meaning of their work.

But is it photography?
Meanwhile, in an ironic reversal of the situation in the 19th century, when photographers were influenced by art, photography was appropriated by people who referred to themselves as artists rather than photographers. Cindy Sherman (see pp.354–55) was one of the first and most celebrated to be known as an artist, even though her work was entirely photographic. Spanish Joan Fontcuberta, meanwhile, regards himself as a "conceptual artist using photography"

◁ **OFFICE AT NIGHT**

VICTOR BURGIN, 1986

Basing his photograph on a painting of the same name by American artist Edward Hopper, Burgin changes the boss figure from a man to a woman. The role of women in society is a recurrent theme in his work. The pictograms and coloured area refer to the keen interest in semiotics that was prevalent at the time.

▽ **STUDIO**

THOMAS DEMAND, 1997
C-PRINT/DIASEC, 183.5 x 349.5cm

Demand's picture raises unsettling questions about what is real and what is not. This is a replica of a room, not a real interior, and the treatment is so clinical that it could be a hard-edged painting rather than a photograph.

dedicated to eroding the superficial acceptance of photographic truth. "Every photograph is a fiction with pretensions to truth", he warns. "Despite everything that we have been inculcated... photography always lies; it lies instinctively... because its nature does not allow it to do anything else".

For artists such as Thomas Demand from Germany, photography is essentially utilitarian. "If I'm invited to do a photography show, I tend to say no", he explains. "The medium itself, I find, is a relatively boring context. You would never see a show about acrylic paint". He is best known for creating interior spaces – replicas of existing spaces or imaginary builds – and then photographing them. The resulting images look as if they are of something real, but they actually depict artefacts and thus challenge the reality of the very things they represent.

Public intimacy

Proving that the camera could now go everywhere and show anything, photographers turned their lenses on people's most private moments, shedding light onto once-taboo subjects.

Like many photography students, New Yorker Marc Asnin used family members as a subject for a documentary project while at school in 1982. Unlike almost all others, however, Asnin persisted with his subject, his Uncle Charlie Henschke, for over 30 years. Asnin chronicled the claustrophobic life of a man troubled by schizophrenia with affection and unflinching honesty. Henschke was unable to work or socialize normally and seldom left the house, but he collaborated with Asnin to document every aspect of his life into the book *Uncle Charlie* (2012). Although Henschke's children reacted against the project, Asnin says of Henschke, "He's very happy about his book".

UNCLE CHARLIE AND SON,
MARC ASNIN, 1985

UNCLE CHARLIE AND BIANCA,
MARC ASNIN, c.1985

Long after cameras had been taken to the polar caps, up mountains, and even into space, they were still not welcome to enter bedrooms. Some areas of life were considered private and photographs of intimate subjects were frowned upon. The introduction of the contraceptive pill in 1960 marked the beginning of the sexual revolution that continued into the 1980s. In its wake came a greater acceptance of intimacy, and it was easier for photographers to find their way into their friends' private lives.

On the margins

At the centre of social change, the US was also the place where photography first breached personal boundaries. Larry Clark was an early leader. He started taking photographs for his mother's baby photography business at the age of 13, then began to take his camera to friends' parties in around 1963. Clark recorded drug culture, intimate scenes, and casual nudity, collecting them into ground-breaking books such as *Tulsa* (1971) and *Teenage Lust* (1983).

While Clark's work is almost light-hearted in its depiction of drug-taking and nudity (although violence appears in his films), his younger contemporary Nan Goldin was drawn to the hard edges of the drug and sex culture. She depicted abusive relationships – sometimes her own – and showed friends and lovers in an ambivalent and seldom flattering light. The critical acclaim for her book *The Ballad of Sexual Dependency*, shot between 1979 and 1988, legitimized the snapshot as art object. Images did not have to be accurately focused, well balanced for colour or exposure, or composed with care. The cheap look and the snapshot became chic. Goldin's work – often presented in galleries as slideshows – fluctuated between documentary and pornography on the one hand and reportage and voyeurism on the other.

Goldin's influence is visible in more recent work, such as that of the French photographer Antoine D'Agata and Corinne Day and Richard Billingham, both British. Documenting the life of his dysfunctional family, Billingham made a painfully honest portrayal of deprivation and human weakness in northern England, in which humanity and humour glimmer through the daily grind of poverty.

Family studies

In 1992, a relatively unknown photographer, American Sally Mann, published *Immediate Family*, which propelled her to the front ranks of modern photography, sparking controversy with her intimate portrayal of her children. Mann had photographed them over 10 years to convey a mother's personal view of family life.

Mann's work builds on the intimate, large-format family studies of earlier US photographers Wynn Bullock and Harry Callahan. Because she uses old 10 x 8in and larger-format cameras set on heavy tripods, she is unable to chase events to capture them. Instead, Mann's camera operates like a patient observer, slowing the pace of life down to suit the slow and optically imperfect lenses that she favours.

Mann's children – whether happy, uncertain, pained, dressing up as grown-ups, or naked – seem to have flowed into the photographic plate, and taken over the visual space with quiet, remarkable authority. The lack of self-consciousness and childhood innocence, together with Mann's honest depiction, may have stoked controversy, but the integrity of her work is beyond doubt.

> If it doesn't have **ambiguity,** don't bother to take it. I love... the **mendacity** of **photography**.
>
> **SALLY MANN**

◁ JENNY AND LESLIE, 8 MONTHS PREGNANT

SALLY MANN, 1983–85

This is from Mann's book, At Twelve, about girls on the verge of adolescence. This girl looks straight at the camera while clinging to the heavily pregnant woman, leaving the viewer wondering about their lives.

▽ UNTITLED (RAL 6)

RICHARD BILLINGHAM, 1995

The couple eat their dinner on their laps, with the pet dog and cat bridging the divide between them. The jauntily patterned wallpaper behind strikes a note of incongruity in the somewhat bleak scene.

◁ GREER AND ROBERT ON THE BED

NAN GOLDIN, 1982

The image is partly blurred, indicating that Goldin moved the camera as she released the shutter. The couple seem absorbed in their own trains of thought, and Greer looks tired and emaciated. A toyshop mask hangs over each figure, adding to the sense of disconnection between the two of them.

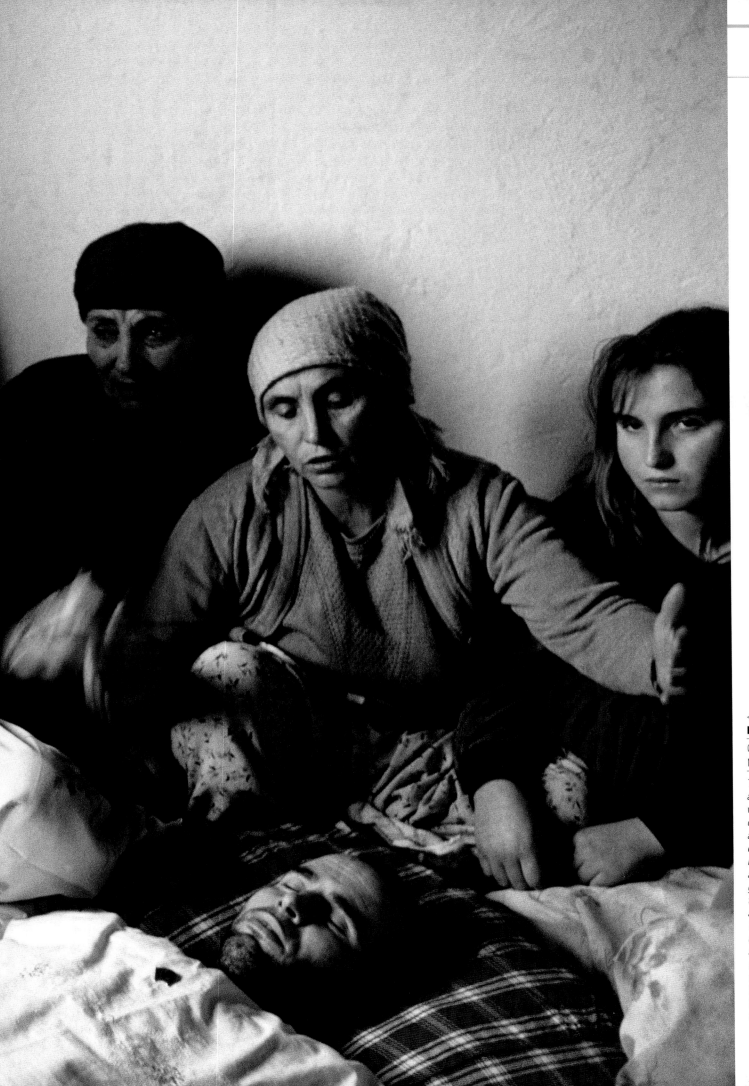

◁ **MOURNING IN KOSOVO**

GEORGES
MÉRILLON, 1990

The mother, sisters, and village neighbours weep over the body of Elshani Nashim, a 27-year-old demonstrator who was killed during a protest against the Yugoslavian government's decision to abolish Kosovo's autonomy. Dubbed the Kosovo Pietà because of its resemblance to an Old Master painting of the Virgin Mary mourning Christ, the photograph won World Press Photo of the Year 1990.

Wolfgang Tillmans

GERMAN / 1968–

Tillmans's oeuvre encompasses a diverse range of genres, from portraiture, still life, and landscape to abstract photography that directly addresses the photographic process and its components. Although they defy easy categorization, his works are motivated by aesthetic and political concerns and an interest in conveying reality, particularly in relation to homosexuality and gender identity. "I'm always interested in the question of when something becomes something, or not, and how do we know?" he explains.

Tillmans first became known for his portraits of friends and their contemporaries in the European club scene of the 1990s. His work ranges from photocopied photocopies of everyday places to colour prints the size of murals and pictures of a solar eclipse. He often blends documentary with staged photography, and social critique with playfulness. Tillmans is also known for his abstract images, and for his experimentation with the printing process. In ongoing series such as *Silver*, he makes images on light-sensitive paper in the darkroom without using a camera at all. For his recent *Neue Welt* (New World) series, made about his travels around the world, however, he used a digital camera. He continually challenges preconceptions about how we view the world, investigating how images are shaped by the photographic process and how these in turn influence the way we see things. Under his acutely observant gaze, the ordinary is elevated; his work is, he says, about "understanding that values are really relative and are very much to be questioned and can be flipped upside down".

Based in Berlin and London, Tillmans is widely exhibited and is represented in numerous major collections. He won the Turner Prize in 2000 – the first non-British artist and first photographer to do so – and in 2009 he was awarded the Cultural Award from the *Deutsche Gesellschaft für Photographie* (German Photographic Association).

> ▷ **SUZANNE & LUTZ, WHITE DRESS, ARMY SKIRT**
>
> 1993
>
> *After the fall of the Berlin Wall in 1989, Tillmans took compelling portraits of his friends, which brought him public acclaim.*

I take pictures in order to see the world.

WOLFGANG TILLMANS

◁ **STILL LIFE, NEW YORK**

2001

The everyday food items and commonplace objects on the windowsill are juxtaposed with the glimpse of New York's distinctive yellow taxis through the window, connecting seemingly disparate elements.

▽ **DAN**

2008

What at first glance seems to be a photograph of a man balancing is in fact an overhead shot in which the figure is standing on the ground on his hidden left leg. Tillmans looks for the combination of fragility and strength in the human figure.

◁ **NEW FAMILY**

2001

The action of the windscreen wiper illustrates how everything is in a state of flux, and the image is best seen in the context of groups of photographs that together build a picture of the ever-changing world.

Colour in the streets

It took photographers a long time to shake off the domination of street photography by black-and-white film. Whether for aesthetic reasons or because of snobbery, black-and-white photography stifled the use of colour for more than 50 years.

Walker Evans, who was highly influential in his day (see pp.174–75), denounced colour photography. "Colour tends to corrupt photography, and absolute colour corrupts it absolutely", he declared, "Colour photography is vulgar!" Henri Cartier-Bresson (see pp.204–05) shared his sentiments: "Photography in colour? It is something indigestible; the negation of all photography's three-dimensional values". Amateur photographers, in the meantime, were busy exposing colour films by the million. In 1950, only 16 per cent of all photographs were in colour, but by the 1980s, more than 90 per cent of all film used was colour, and more than 80 per cent of that was on colour negative film to make colour prints.

Despite the lead of masters of colour, such as Ernst Haas (see pp.290–91) and Paul Outerbridge, colour was seen as commercial and downmarket – useful for weddings but not worthy of artistic attention. Then in 1969, John Swarkowski, the legendary director of photography at MoMA, New York, became captivated by American William Eggleston's bold "drugstore" colour prints. Eggleston acquired stellar status in the following years, which helped to make colour photography acceptable, but it was still not taken seriously, as is clear from the images selected for the *New Topographics: Photographs of a Man-Altered Landscape* exhibition which was held in Rochester, New

△ **NEW YORK CITY STREETS**

JOEL MEYEROWITZ, c.1972

Accents of pure, bright colour, such as the woman's red cardigan, a spot of blue behind a man's shoulder, and the two bunches of flowers, help to distinguish members of the crowd from each other against the dark buildings in the background.

▷ **QUARZAZATE, MOROCCO**

HARRY GRUYAERT, 1986

Blocks of vivid colour defined by strong tonal contrast become the subject under Gruyaert's watchful eye. Gruyaert first became fascinated by the landscapes of Morocco in 1969. Seven years later, he won the Kodak Prize for them.

York, in 1975. More than 80 prints were on show, but only 10 of them – by Stephen Shore – were in colour.

New colour

American Joel Meyerowitz alternated between black-and-white and colour film for his street photography during the 1960s, finally settling on colour in 1972. Inspired by the work of Robert Frank and Eugène Atget (see pp.126–29), Meyerowitz photographed scenes of urban America using a carefully controlled palette, generally limited to complementaries or strong colours against pale or dark backgrounds. He was one of the first photographers to fully understand how colours can be used to shape picture composition.

Meanwhile, Belgian Harry Gruyaert was starting to use colours as pure elements of a scene, basing his work in exotic locations in Morocco and across Europe. Unlike American colour photographers, who favoured large-format cameras, Gruyaert used a Leica (see pp.148–49). Through his use of colour, street photography became less aloof and reliant on the formal composition that marked black-and-white work. More so than with monochrome, colour revealed juxtapositions of shape and form captured in the image that might have passed unnoticed but for the watchful eye of the photographer.

Gruyaert's approach influenced American photographers such as Maggie Steber, Alex Webb, and Constantine Manos, who are known for their command of colour. They combine technical control of exposure with perfect timing to capture fleeting juxtapositions of shape and hue. Above all, they enjoy the exuberant colour that was only made possible by the introduction in the 1980s of films such as Fuji Fujichrome slide film, which delivered high contrast, sharpness, and colour saturation.

△ **DAYTONA BEACH, FLORIDA**
CONSTANTINE MANOS, 1997

Manos is drawn to the beach lifestyle, which attracts colourful personalities, with clothes and cars to match. He has spent 30 years snapping high-spirited bathers and holidaymakers on and around Florida's Daytona Beach.

IN CONTEXT
Robert Herman: New Yorkers

An archetypal street photographer, Robert Herman has tramped New York City's streets and subways – usually in late afternoon light – since the late 1970s with his Nikon and 50mm lens, exposing Kodachrome. He has also used a Polaroid SX-70 and black-and-white film, but after 29 years of using film, he turned to digital cameras. His father ran a cinema, so he grew up watching films, and while studying film-making he discovered the work of André Kertész (see pp.156–59) and Helen Levitt. He was especially inspired by John Berger's book on the art of observation *About Looking* (1980).

STREET SCENE FROM *THE NEW YORKERS*, ROBERT HERMAN, 2013

Pavement Mirror Shop, Howrah, West Bengal

RAGHUBIR SINGH / 1991

Raghubir Singh grafted an Indian sensibility onto photography. Born in Jaipur into an aristocratic family, Singh's approach to his work was influenced by the traditional paintings of his Rajasthani home – richly detailed, formally constructed miniatures full of movement. After dropping out of the tea industry, Singh first photographed Calcutta, then moved to Hong Kong to work for magazines in the mid 1960s. Intellectuals such as the filmmaker Satyajit Ray and the writers V.S. Naipaul and R.K. Narayan were his friends and wrote prefaces for his books, which included projects on the River Ganges and Rajasthan.

Singh met Henri Cartier-Bresson (see pp.204–205) in 1966, and worked with Lee Friedlander, but unlike either of them, he was committed to colour photography. "To see India monochromatically is to miss it altogether", he said. His working methods were minimal: "I have simplified my work into one body and one lens. If that lens can't take the photograph then I don't take it". His technique was classic street photography, as seen in this image of a street stall selling mirrors that create a magical confusion between reality and reflection, conveying a sense of the richness and multiplicity of life.

NAVIGATOR

1 FRAMES WITHIN FRAMES
Not only do the mirrors frame pictures within the overall scene, but the iron beam and bamboo on the left create a secondary frame within the picture. The bright stickers on the mirrors add a characteristically Indian touch.

2 SELF-PORTRAIT
Singh himself can be seen in one mirror, and his shoulder appears in another. By chance, the mirror has moved in the breeze during exposure, blurring his reflection.

3 RED ACCENTS
Bright red items help to punctuate the picture space and form a contrast with the blue shirt in the lower right. Without these accents of vivid colour, the image would be too sombre and dark.

4 AMBIGUOUS DEPTHS
Singh works discreetly, yet manages to fill each mirror with a fleeting sample of street life: "Most of the time... I will have taken a photograph but no one will have realised it. You need to be inside the photograph, not shoot from outside", he stated.

Raghu Rai

NDIAN / 1942–

The extent and richness of Raghu Rai's photography of India expose the glossy superficialities of so many photographs of this most photogenic of countries. Confining his entire photography career to his homeland has neither inhibited the content of his work nor his technical development – he is a master of black-and-white and colour photography, the panorama, and the travel essay, as well as the hard-nosed documentary.

Born in the Punjab in northern India, Rai trained as an engineer before taking up photography. When he was 24, while trailing a photographer, he snapped a picture of a baby donkey. When this photograph was published in *The Times,* he earned enough to last a month. Rai concluded, "I thought it is not a bad idea to take some more pictures". He soon found work at *The Statesman* newspaper, and worked as a picture editor from 1976 for the Kolkata weekly *Sunday,* and 1982–91 for *India Today.*

His work represents the largest, most comprehensive photographic document of 20th century India. His classic portraits of Mother Teresa of Calcutta and Indira Gandhi, and his reportage of the Bhopal industrial disaster, are complemented by lavish picture books that celebrate India's diversity and colour. To capture the country's hectic pace, "the way the life is throbbing in every given space or corner of the street", Rai often uses a panoramic camera as he states, "there are so many different moments living at the same time".

The concept of *darshan* – Sanskrit for "beholding" – is central to Rai's work, as he explains: "*Darshan* is so much more than seeing, witnessing, or glancing. It brings everything together: the energies, vibrations, physicality, and the visual experience. When everything is put together, it makes a whole".

A thoughtful and generous photographer, in 2013, Rai founded the Raghu Rai Centre for Photography to foster a new generation of documentary photographers.

A photograph has picked up a **fact of life**, and that fact will **live forever**.

RAGHU RAI

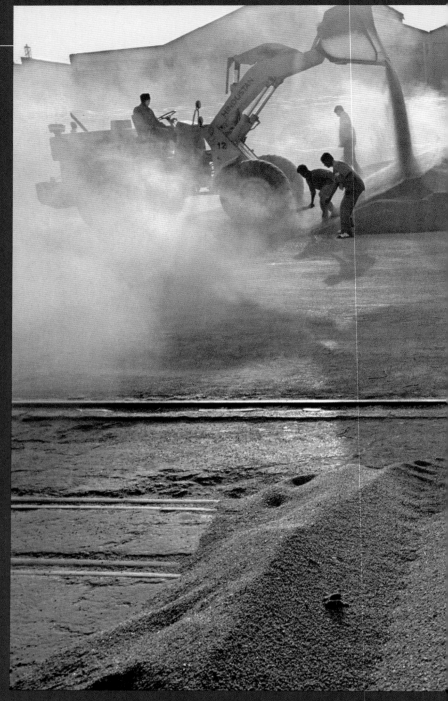

△ **COW EATING WHEAT**

2000

The colour palette of this image made in Kandla Port is restricted to shades of yellow and brown. It relies for impact on contrasts of texture and scale – but above all on the dominant presence of the cow, which is allowed to roam so freely it can wander into busy work areas.

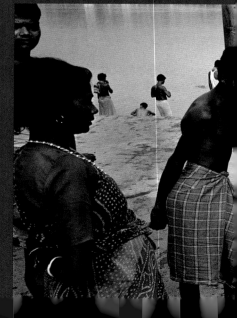

▷ **WOMEN WORSHIPPING GANGA**

2004

Rai uses panorama to capture a "multiplicity of happenings" on the banks of the Ganges. A crowd of figures bathe in the background, while in the foreground a group of women conduct their daily prayers, surrounded by standing men.

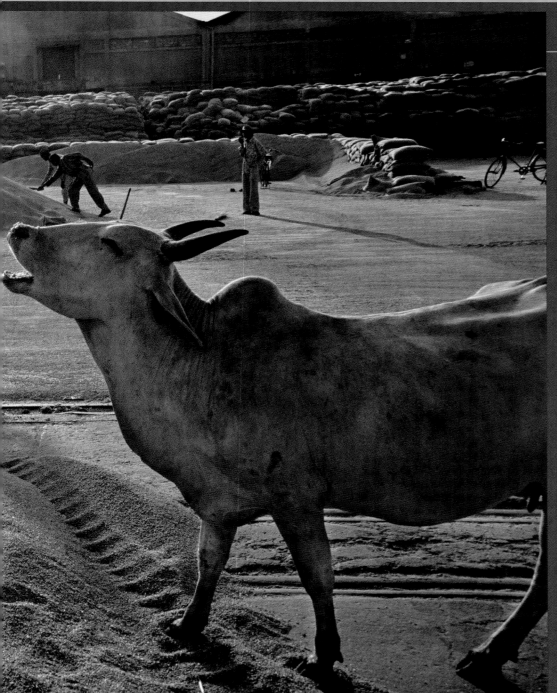

▽ **WRESTLERS THROUGH THE PAINTED GATE**

1989

With perfect timing, Rai captures real life reflected in a painting advertising a wrestling studio. Flat lighting creates smooth flesh tones that harmonize throughout the image.

△ **BHOPAL**

2002

A survivor of the 1984 Bhopal gas disaster returns to the grave of a child victim. The use of monochrome highlights the bleached bones and emphasizes the contrast between the living and the dead.

Multiple exposures

For more than a century, photographers took single perspective – depicting three-dimensional space as if from a single viewpoint – for granted. It was a surprisingly long time before they tried multiple viewpoints.

In Paul Cézanne's late landscapes, produced at the turn of the 20th century, he began to explore multiple viewpoints. He painted a quarry from slightly shifting positions, creating buckled, overlapping planes, and a cliff face as if seen from different angles. This approach was developed by Georges Braque and Pablo Picasso in the early 1900s, and then taken further in the cubist works of Juan Gris, Fernand Léger, and others.

Photographers of the time, such as Hannah Hoch (see pp.142–43), did experiment with collages of images of different sizes and scales, but no photographers took up cubism. Alexandr Rodchenko, for example, was too busy exploring the new viewpoints offered by small cameras.

Multiples
In the early 1970s, artist Reed Estabrook began to break the mould by producing "multiples" – multiple pictures of the same scene arranged in the form of contact sheets – but he still conformed to the idea of a single viewpoint. Then, in 1973, Japanese-American Tetsuaki Okuhara made collages reminiscent of the portraits of Juan Gris, with space folded out

and re-projected to distort figures. In 1981, George Blakely produced installations that were composed of multiple prints, but neither he nor Okuhara really explored multiple viewpoints in their work.

It was David Hockney, the great artistic omnivore, who finally broke single perspective's grip on photography and even so, it took several steps. In the early 1980s, he began to construct scenes using Polaroid prints (see pp.274–75), each of which was taken from a slightly, or sometimes radically, different viewpoint. These were laid out following rigid grids, and viewers had to make their own sense of the finished works, rather as if they were intriguing visual puzzles.

Collage joiners
The strict grid of the Polaroid scenes makes it clear that these are made of composite images, but when the grid lines are removed, you interpret the image as one picture. In the 1980s, Hockney photographed details of a room as reference for a painting, then stuck the prints together to create a wide-angle view of the whole room. The collage provided both an

instantaneous view of the subject as well as the history of its photography: each image from a new position adds a step to the chronicle of its creation. Hockney was so intrigued by the resulting image that he gave up painting for a while to explore these "joiners", as he called them.

▽ **EASTERN STATE PENITENTIARY**
MASUMI HAYASHI, 1993

Hayashi merges a host of images to create a single panorama textured by the angles and exposures of its constituents. The resulting composite shows all four walls of the chapel, including the disintegrating murals painted by an inmate, in the now abandoned prison.

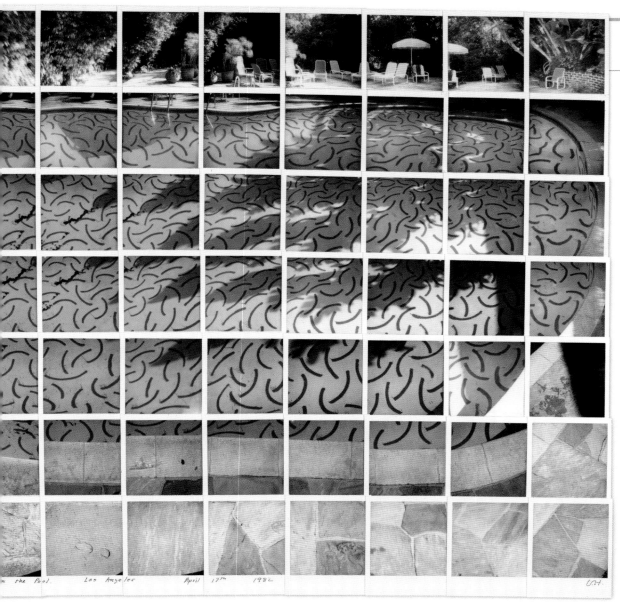

n the Pool. Los Angeles April 17th 1982 D.H.

In the 1990s, Masumi Hayashi constructed large panoramas from collages of multiple prints, in which she exploited different perspectives, colours, and exposures. One of 120,000 Japanese-Americans held in internment camps during the World War II, Hayashi used photography to revive the collective memory of what she called "American Concentration Camps". Going far beyond the painterly dexterity of Hockney's work,

Hayashi's collages attempt to map the space of imprisonment. "The viewer can instantly see a 360-degree panoramic view which would otherwise circle around her", she explained: "From over 100 images, sequential fragments make up one panoramic photo collage, extended and stretched like a warped *shoji* screen... They present the *gestalt* of looking at many fractured images and seeing a unified whole".

△ **SUN ON THE POOL**

DAVID HOCKNEY, 1982

In this early experiment with multiple perspectives, each Polaroid retains its frame and individuality as well as contributing overall. Where the prints do not quite match up, the fractured rim of the pool echoes the shifting play of light on the water.

The Chinese... rejected the idea of the vanishing point... **because it meant the viewer... had no movement,** therefore was not alive.

DAVID HOCKNEY

IN CONTEXT
Ray K. Metzker

Born in Milwaukee, US, in 1931, Metzker is a restless innovator who has experimented with multiple exposures and images, composites, and different forms of processing. His most distinctive works are large composites in which separate images are juxtaposed. Each composite looks like an abstract design, but closer examination reveals a wealth of detail. A master printer in black-and-white, Metzker explores the fractured state of modern life and makes it into a thing of beauty.

NUDE COMPOSITE, RAY K. METZKER, 1966

Pedro Meyer

SPANISH-MEXICAN / 1935–

Voluble and outspoken, Meyer thrives on change: "I have always questioned everything: education, the obligation to memorize, authority. Perhaps that is why I have photographed everything". He is a pioneer in digital photography and multimedia production, merging not only his images but also the soul of the Spanish with those of the Mexicans and Americans, the digital and analogue, the moving and the still.

Meyer's parents fled to Spain from Nazi Germany and he was born in Madrid. The family left for Mexico two years later. Meyer's father gave him his first camera on his 11th birthday. Later, while pursuing a successful business career, Meyer photographed the 1968 student uprisings in Mexico City and covered the rise of the Sandinistas in Nicaragua in the 1970s. In the mid-1980s, he started working with digital techniques. He turned a personal record of his parents' last days into a pioneering CD-ROM presentation, *I Photograph to Remember* (1992), and three years later, he created one of the first curated photography hosting sites, ZoneZero.com. Another CD-ROM in 1995, *Truths and Fictions*, presented popular traditions in the US and Mexico with images in which reality has been manipulated. "The photograph as an objective representation of reality simply does not exist", Meyer explained. "The photograph does not explain to you what is going on to the left or to the right or above or below the frame. Often, it doesn't even explain to you what is going on inside the frame."

Nothing if not ambitious, in 2004 he starting working on *Heresies*, a retrospective of his life's work presented in 60 simultaneous exhibitions in 17 countries around the world. It was premiered in 2008, accompanied by a book and a website. "In the digital era, not a week passes without something new happening. It is important to adapt to these new things... in order to keep up", explained Meyer.

... the human **eye sees**... an accumulation of **moments,** not just one isolated moment **taken out of context.**

PEDRO MEYER

▷ **BIBLICAL TIMES**
NEW YORK, 1987 AND 1993 (PRINTED 2008)

Meyer took this picture of a Bible salesman with "hands like an El Greco figure", but was not happy with the background. He digitally simulated the steam around the man's hands and the Bible, using an earlier picture of the same New York street.

◁ **LIVE BROADCAST**

OAXACA, MEXICO, 1990 AND 1993
(PRINTED 2008)

Meyer combined the image of the man holding a box frame with another photo of the wall covered with religious icons so that "the man became an icon in a television set". The devil showing on the TV adds another twist.

▽ **WINDOW ON WINSLOW METEOR CRATER**

WINSLOW, ARIZONA, 1990

A family gaze at the crater left by a meteor crashing into the Arizona desert. The image comes from Meyer's book Tiempos de América (American Times).

◁ **ON THE TIGHTROPE**

MEXICO CITY, 2000

Meyer used this image of gravity-defying suspension to illustrate a discussion of how the survival of the old guard was hanging in the balance – politically in the face of elections in Mexico and photographically in the digital age of the camera.

Landscape of emotion

The 19th-century response to landscape was essentially descriptive. By the mid-20th century, however, the land had become a mirror for photographers' concepts and emotions.

One of the first photographers to explore emotional response to landscape was Bill Brandt (see pp.220–21). In his landscapes of the late 1940s, he showed greater concern with the feelings evoked by looking at scenery than with an accurate record of the view. While other British photographers such as Fay Godwin, John Blakemore, and Paul Hill felt Brandt's influence, none could fully give up fine-art preoccupations with detail and tone. By the 1980s, some photographers were using landscape as a canvas on which to express their emotions.

Luminous harmony

Hiroshi Sugimoto was born in Japan in 1948 and now divides his time between Tokyo and New York. His early work of artefacts such as museum dioramas and waxworks gave way in 1980 to seascapes. For this series, Sugimoto travelled widely – from Norway and Italy in Europe to the Tasman Sea in Australasia and the Arctic Circle. Pointing the camera straight at the horizon, he cut the view precisely into equal halves of sky and sea. Then he let the light express itself onto his 10 × 8in (25 × 20cm) film, using exposures of as long as three hours. As he explains: "I let the camera capture whatever it captures... whether you believe it or not is up to you; it's not my responsibility, blame my camera, not me". While tongue-in-cheek, Sugimoto's disclaimer is honest in accepting the influence of the camera in the creative process. Making clear the relationship between his thinking and the photographs, he said: "If I already have a vision, my work is almost done. The rest is a technical problem". Ever restless, Sugimoto presents some seascapes with the horizon running vertically, disorienting the viewer.

Cool emotions

For Italian Luigi Ghirri, who died in 1992, photography was a philosophical investigation "... to distinguish the precise identity of man, things, life, from the image of man, things, and life". Inspired by conceptual art, his work aimed to record the "simple and obvious things... under a whole new light". Spending much of his time in the Emilia-Romagna region of Italy, Ghirri created wryly affectionate, insightful images that startled 1970s Italian photographers from their stylistic backwater and subsequently influenced generations of urban photographers around the world.

In 1978, Ghirri published the book *Kodachrome*, and its coolly detached attention to detail became a landmark of the postmodern avant-garde. The US New Topographics photographers were producing similar work in the 1970s, but Ghirri's landscapes offer greater subtlety of vision and less desire for the monumental.

The Czech-French photojournalist Josef Koudelka is famous as the anonymous Prague Photographer who recorded the Russian invasion of Prague in 1968. Since the 1980s, he has used a 6 × 17cm camera to produce "letterbox" views. Aiming it at the land, his concern is with the impact of humans on the landscape, showing how scenes of pollution symbolize the fractures and decay in our relationship with the earth.

△ **BLACK SEA, OZULUCE, TURKEY**

HIROSHI SUGIMOTO, 1991

Sugimoto finds security and calm in the sight of the sea. In every photograph of his Seascapes *series, the horizon falls exactly halfway up the frame. While some images have a sharp dividing line, the sea and sky merge in this misty evocation of water, air, and light – the basic elements of life itself.*

▷ **ABANDONED OIL FIELD, BAKU, AZERBAIJAN**

JOSEF KOUDELKA, 1999

Koudelka renders a scene of environmental wreckage in the capital of Azerbaijan with clinical clarity and the clean aesthetics of New Objectivity. The contradictions in the image mirror Koudelka's own ambivalence to the scene.

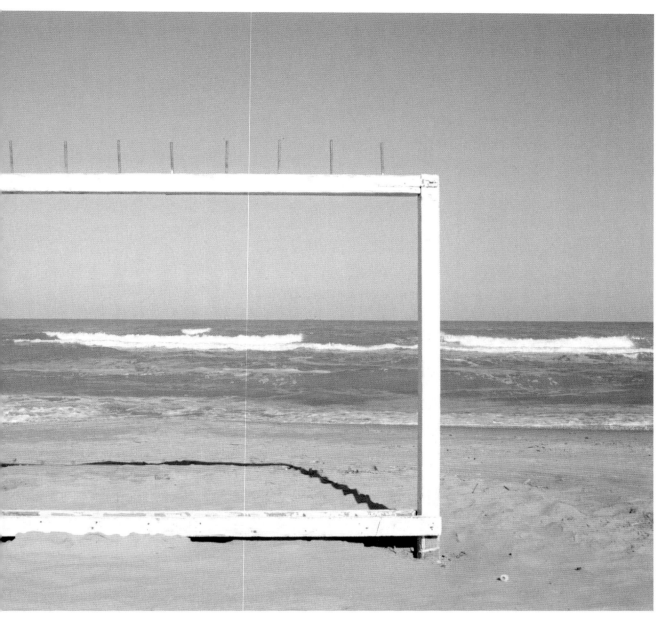

◁ **MARINA DI RAVENNA**
LUIGI GHIRRI, 1986

Rather than taking a typical view of one of Italy's cultural landmarks, Ghirri turns the shell of a beach structure into a frame onto a stretch of sea and sand that expands beyond the real frame of the photograph.

IN CONTEXT
Shoji Ueda

Born in 1913 in Tottori in western Japan, Shoji Ueda was best-known for his work set in the local sand dunes. "Whichever direction one turns", he said, "there is always a subject waiting to be photographed". He used the sands and sky as a minimalist backdrop for situations that blended Magritte-like elements of surrealism with a Zen-inspired economy of expression. He died in 2000, leaving 60,000 prints to the museum of photography founded in his name.

FROM *DUNES* SERIES, SHOJI UEDA, 1949

Aerial abstractions

Photographs have been made from aerial viewpoints since the late 1850s, but it was a long time before affordable aviation and new camera technology made it possible for photographers to create artistic shots of the erth from above.

Nadar was the first to take a camera up in a balloon (see p.39) to capture aerial views. In 1909 – only six years after the first powered flight by the Wright Brothers – a Belgian, Louis Meurisse, was the first to take a camera in an aircraft. By the start of World War II, aerial photography was an integral part of reconnaissance and mapping, but the high cost of flying meant that aerial photography was only used for such purposes.

Bird's-eye view
One of the earliest inklings that photography of the earth from the air could yield artistic images came from American mountaineer Bradford Washburn, who used aerial photography from the 1930s to the 1950s to plan climbing routes for peaks in Alaska. During his flights, he also produced some strikingly abstract images.

Another pioneer was American William Garnett, a photographer who took flying lessons and started to take photographs from his own aircraft in 1949. Working in both colour and black and white and using two 35mm cameras at a time, his work was the first to explore the potential for graphic, abstract-looking images that aerial views offered, and it was widely published in the US.

Unconventional landscapes
In the 1960s, Georg Gerster, a Swiss science journalist turned photographer, transformed aerial photography. When covering a story about archaeology in Egypt, he wanted to fly over the sites to "see the digs as a totality". It was a defining moment, as Gerster explained: "There are very strong graphic images when you look straight down – rather than obliquely... there was a special aesthetic quality that could be achieved".

Gerster would load up to 10 Nikon camera bodies with Kodachrome film to save time reloading. He used mainly 50mm lenses, or occasionally 35mm or 28mm, but no wider. The vibrations of the aircraft made it impossible to use focal lengths longer than 180mm. Before flying, he would lock all the lenses at infinity with tape, cover himself with a silk hood and a cold-weather mask, and put on silk gloves. A screwdriver to undo the window latches was also an essential part of his kit.

After 10 years of aerial flights, Gerster published *Grand Design* in 1976 to great acclaim, changing the public perception of aerial photography. Over a period of 40 years, Gerster has taken photographs all over the world, in the hope that they provide an overview that "facilitates insight, while insight generates consideration".

Environmental tool
The French photographer Yann Arthus-Bertrand has been the most prominent to follow Gerster's lead. Picking up a camera in 1979 to document the life of lions in the Masai Mara of Kenya from hot-air balloons, he was captivated by the landscapes below. By 1991, he had founded an agency that specialized in aerial photography, and in 1994, he won UNESCO sponsorship to picture the planet from above, leading to the publication of *Earth from Above*. The book sold over three million copies, was translated into 24 languages, and the images were widely exhibited. Arthus-Bertrand has since taken on large-scale, planet-wide projects.

A committed environmentalist, Arthus-Bertrand is a prime example of a new breed of humanitarian photographers who know how to generate publicity. He created the Goodplanet Foundation to educate the public about environmental issues and fight deforestation, and has set up non-profit media companies to produce awareness-raising films.

▽ **ROOFS OF A FISHING VILLAGE**

GEORG GERSTER, 1993

Gerster has filled in the frame with the roofs of a village in Manila Bay, Philippines. By aiming straight down, the view is a flat mosaic of colour, which emphasizes how closely packed the dwellings are. Technically, flying low over finely detailed areas is demanding, calling for extremely short exposure times to retain sharpness.

△ **YELLOWSTONE NATIONAL PARK**

YANN ARTHUS-BERTRAND, 1997

IN CONTEXT
Remote sensing

Objects on earth reflect in a wide range of wavelengths in addition to visible light. Sensors used in satellites orbiting the earth can pick up non-visible wavelengths such as infrared and other electromagnetic radiation. Different wavelengths are separated by filters or by the sensitivity of the sensors to create greyscale (monochrome) images. Then colours are assigned to the various wave bands. They may be arbitrarily assigned, for example, red for infrared reflected off leaves to create false-colour composites, or used to imitate natural colours, such as blue for wavelengths reflected off water. Since the launch of the Landsat satellite in 1972, scientists and the public alike have been treated to a endless stream of images of the earth full of information and abstract beauty.

NASA EARTH OBSERVATORY IMAGE OF DUBAI, JESSE ALLEN, 2010

△ **YELLOWSTONE NATIONAL PARK**

YANN ARTHUS-BERTRAND, 1997

This view shows the Grand Prismatic Spring in Yellowstone National Park, Wyoming, US. The striking colours of the hot spring are completely natural. The wavy grey band at the lower left of the image is a boardwalk and it is possible to see tourists making their way along it.

◁ **SUNRISE OVER OWENS VALLEY, CALIFORNIA**

GALEN ROWELL, c.1990

Once described as "a cross between Sir Edmund Hillary and Ansel Adams", Rowell was a climber who allied his love and knowledge of mountains to his skills as a photographer. In 1984, he received the Ansel Adams Award for his contributions to the art of wilderness photography.

THE DIGITAL AGE

The personal computer pushed the film-processing industry aside by turning photographers' sitting rooms or home offices into personal image-processing factories. This gave photographers independence, but it also burdened them with the full responsibility for processing their images. Digital photography developed in line with the increasing power of computers and ever more reliable software, ensuring that image-processing kept pace with photography. Image files multiplied in size, improved in quality and, most astounding of all, the cost per photograph actually dropped, the more images a photographer shot. This reversal of common economic sense alone was a liberating revolution unknown to previous generations of photographers.

While digital photographers revelled in their new-found independence and rejoiced in minimal running costs, they failed to notice that the industry that had once supplied all their material needs was teetering on the verge of bankruptcy.

Mobile-phone and tape-recorder manufacturers were razing the giant and venerable structures of the photographic industry to the ground.

Thanks to its capacity to be super-miniaturized, photography has now become so commonplace and ubiquitous that it has lost its sense of the particular. Photographs stretch in every direction as far as the eye can see – as numerous as the stars in the sky, part of the continuum of life. Personal shots have increased and the number of photographs made by machines has escalated. Surveillance and security cameras, aerial and land surveys, and satellites are now all major producers of photography. As the cost falls, we take as many pictures of the minutiae of our lives as we do to record major milestones. We are now learning, perhaps for the first time, that photography loses significance when it becomes too familiar. The more photography records of life, the less it reveals but it enables millions to see the world more clearly.

Canon D30

During the 1990s, a frenzy of development produced digital cameras in numerous shapes and sizes. These were essentially prototypes of a new technology that finally came of age in 2000 with the production of the Canon D30.

Steve Sasson
1950–

In 1975, Kodak's Steve Sasson was given an early imaging chip to play with and set out to make a camera that had no moving parts. With no budget, he commandeered a forgotten corridor and cannibalized junk equipment. By the end of the year, he had a box weighing 3.6kg (7.9lb), which used an old cine lens that captured 1000 pixels in black and white. "Needs work", said a secretary when she saw her blurry image – one of the first digital captures. Told that three megapixels was needed for a quality image, Sasson realized files had to be compressed, so he invented the first JPEG compression hardware.

THE FIRST DIGITAL CAMERA

The first digital camera, using a data-flow now standard in today's cameras, was built in 1975 (see box, left) in Kodak laboratories. Photographically, its principle was an ancient one: after more than a hundred years of capturing images as negatives and then reversing them, photography had rediscovered the direct positive image – one that looks like the scene it represents. However, there were considerable problems: sensor chips were small and unreliable; recording colour required a whole new field of science and computation; and the large image files needed for adequate quality were unmanageable until compression techniques were perfected.

Rapid progress
By the 1980s, electronic cameras such as the Sony Mavica of 1981 and the Canon RC-701 of 1984 were recording images using electronics, but with analogue technology. The first commercial digital camera was the Kodak CDS-100, which recorded a 1.3 megapixel image by tethering a Nikon SLR body (see pp.240–41) to a very bulky briefcase of electronics. In fact, the first few professional-

quality digital cameras, made by Kodak, were Nikon and Canon SLR bodies with Kodak sensors and signal processors inside them.

In a mere ten years, the digital camera reached a mature form with the Canon D30 of 2000. Based on Canon's line of film-using SLR cameras, the D30 placed a small (APS-C size) chip capturing 3.1 megapixels into what was essentially the body of a film-using Canon EOS. The film cassette and take-up spool were replaced by electronics for the sensor and memory card. At a stroke, the digital camera had a large range of available lenses, albeit with focal lengths effectively increased by the use of the smaller-than-normal sensor.

Meanwhile, improvements in the operating systems of personal computers enabled users to work with the image files without their computers repeatedly crashing. An important parallel improvement was in application software for image manipulation, which became more capable and more stable. In short, the ecosystem of photography was ready for the Canon D30 and the many digital cameras that followed.

Lamp for autofocus assist and red-eye reduction

Shutter button

▷ **MOMENT OF IMPACT**

PETER READ MILLER, 2003

Digital cameras enable photographers to take sharp, well-exposed pictures even in poor lighting conditions – such as those of late-night sporting events.

Front lens mounts for filter and lenshood

▽ CANON D30

DIGITAL SLR, 2000–2002

Canon's first digital SLR camera, the D30 captured a 2160 × 1440 pixel image on a 22.7 × 15.1mm CMOS sensor. Since the sensor was smaller than a frame of 35mm film, the focal length of the lens was 1.6 times greater than its analogue equivalent.

▷ FATHER AND SON IN DETENTION

JEAN-MARC BOUJU, 2003

This photo of an Iraqi man comforting his son at a US holding center in Iraq was voted World Press Photo of the Year in 2003, the first digital image to win the title. Using a satellite link-up, the photographer was able to transmit the picture to his editor a few hours later.

Accessory shoe for flash units

Mode dial for different exposure control modes

Focus mode switch

Lens release button

Cover for computer connector

IN CONTEXT
Smaller, bigger

The search for the perfect marriage of portability and image quality continues in the digital realm. Since the first compact digital cameras and digital SLRs, systems such as Four Thirds and Micro Four Thirds have developed, which combine compact camera bodies with interchangeable lenses and large sensors. The key move was to dispose of the mirror box that is used in all SLR cameras. In 2012, Fujifilm produced the X-S1, a large-sensor superzoom, and in 2013, Sony introduced interchangeable lens cameras with full-frame sensors in bodies half the size and weight of equivalent SLR cameras.

SONY A7R

FUJIFILM X-S1

Twin Towers

THOMAS HÖPKER / 2001

With its textbook composition and perfect arrangement of props and people, Höpker's image is a surprising candidate for virulent debate. But in setting young, beautiful, and seemingly relaxed New Yorkers against the destruction of the World Trade Centre, the photograph forces heaven and hell together into a single frame.

Unlike other photojournalists who rushed to get as close as possible to the World Trade Centre on the morning of 11 September 2001, Höpker – a veteran photojournalist and picture editor – did something they did not. Despite his keenness to get to the scene of the bombings, he saw something in his peripheral vision, stopped to make three exposures, then rushed on.

During edits of hundreds of images for a book on the attacks, this image was rejected. Höpker explains, "The picture… was ambiguous and confusing… This shot didn't 'feel right'". Only five years later did the picture emerge. Höpker comments: "Now, distanced from the actual event, the picture… asked questions but provided no answers… How could this group of cool-looking young people sit there so relaxed and seemingly untouched by the mother of all catastrophes which unfolded in the background? Was this the callousness of a generation, which had seen too much CNN and too many horror movies? Or was it just the devious lie of a snapshot, which ignored the seconds before and after I had clicked the shutter?"

NAVIGATOR

1 COMPOSITIONAL DEVICES
With consummate artistry, Höpker made an image perfectly composed of interlocking triangles. The remains of the jetty lead to the diagonal column of smoke, cut off by the tip of the cypress tree, which itself sits by the foreground wedge of the image.

2 DRIFTING SMOKE
The second tower had collapsed, creating a solid plume of smoke and dust. This divides the sky and frames the activity in the lower two-thirds of the image.

3 PROJECTED GAZE
The strongly lit figure in profile directs our gaze into the image. If the figure had been looking the other way or towards the camera, the line of sight would weaken the coherence of the image.

4 CENTRE OF CONVERSATION
The woman turns to look over her shoulder. This casual pose – attentive to her companion's comment – is central to what looks like a relaxed gathering of friends.

Recomposing truth

The 21st century has finally put an end to the myth that the photograph cannot lie. The general public understand that pictures are processed, and image manipulation has become an accepted fact of life.

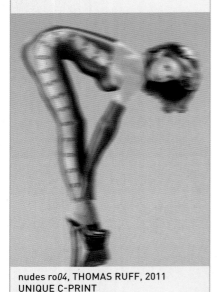

nudes ro*04*, THOMAS RUFF, 2011
UNIQUE C-PRINT
236.2 × 186.1cm (93 × 73¼in)

▷ **BUTTERFLY GIRL**

CHRIS CRISMAN, 2012

Crisman photographed butterflies at different sizes and orientations, and under varying lighting conditions, against a green screen. Working with digital artist Taisya Kuzmenko, he combined the butterflies with a previously shot background of a redwood forest and a model reaching out to catch the fluttering insects.

By the 2000s, the trade name Photoshop, registered to Adobe Systems Inc. for its image manipulation application, had been adopted as a verb meaning to "alter, transform, or fabricate an image". Barely 10 years after it had been introduced in 1989, image manipulation had revolutionized the processing of photographs and the public's perception of photography. Before long, fake images littered the internet – the photoshopped image became a currency of communication.

Digital collage

Some photographers use Photoshop and similar software to create completely new images composed of many separate pictures – they have modernized that flagship of modernism, the collage (see pp.142–43). Taking the concept to its extreme, British photographer Emily Allchurch bases each composite on a classic work of art, such as a print by Italian artist Piranesi or a watercolour by British painter Joseph Gandy. She then photographs scenes in detail to create a library of images, from which she constructs brand-new detailed images that repay close examination.

It is significant that by 2010, the expert in Photoshop was given almost equal standing with the photographer. American advertising photographer Chris Crisman specializes in portraits in an environmental setting, but the key creator for his photograph *Butterfly Girl* was Taisya Kuzmenko, the digital artist who composited dozens of separate exposures of butterflies and a shot of a model into a dreamy Elysium.

Some artists, such as American Sandy Skoglund, make their use of collage techniques obvious. For the *True Fiction* series, begun in 1985 Skoglund started "by photographing people, places, and things... in black-and-white", intending to add colour later. Then she made colour prints and cut out elements and pasted them together to make a true collage, which was rephotographed. In 2004, she decided to enhance these elements digitally to "work on the edges of the subject matter and to blend the cut elements to merge more naturally with the rest of the picture". The result was the follow-up series called *True Fiction Two*.

Deceptive reality

The response to image manipulation has not always been warm, however. Documentary and news photographers were horrified by the idea at first. A front-page picture by Brian Walski for the *Los Angeles Times* in 2003, for example, was found to be made of two images and was widely condemned. Since then, photojournalists have begun to accept some retouching, as apparent in the marked tonal changes visible in the World Press Photo winner of 2013 by the Swedish photographer Paul Hansen.

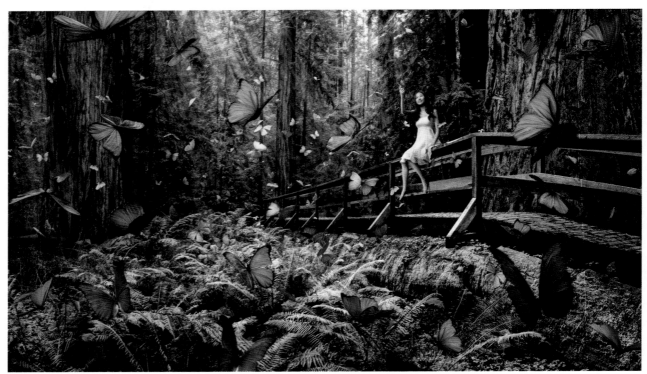

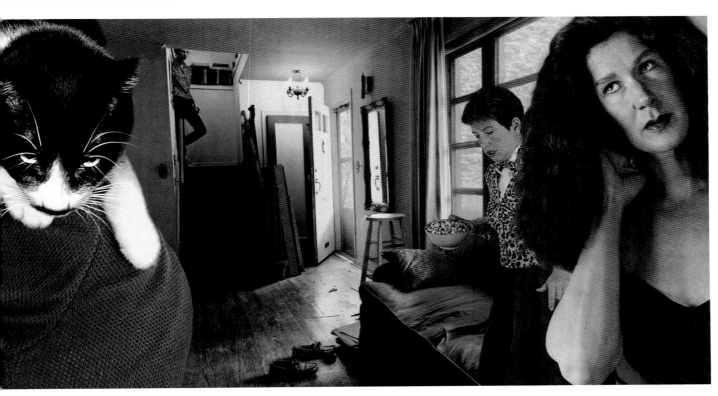

◁ THE SOUND OF FOOD

© SANDY SKOGLUND,
1986–2008

This is part of the series called
True Fiction Two, *in which
Skoglund digitally enhanced
images she had created
almost 20 years earlier, to
create tantalizing glimpses
of domestic life in vividly
coloured interiors.*

▽ GRAND TOUR: IN SEARCH OF SOANE

EMILY ALLCHURCH, 2012

*At first glance, Allchurch's
work is a copy of British
watercolourist Joseph Gandy's
1818* Capriccio, *a homage to
his mentor Sir John Soane,
showing the many buildings
Soane designed. Closer study
reveals intriguing anomalies,
such as a telephone box, in
what is Allchurch's own tour
of Soane's architecture.*

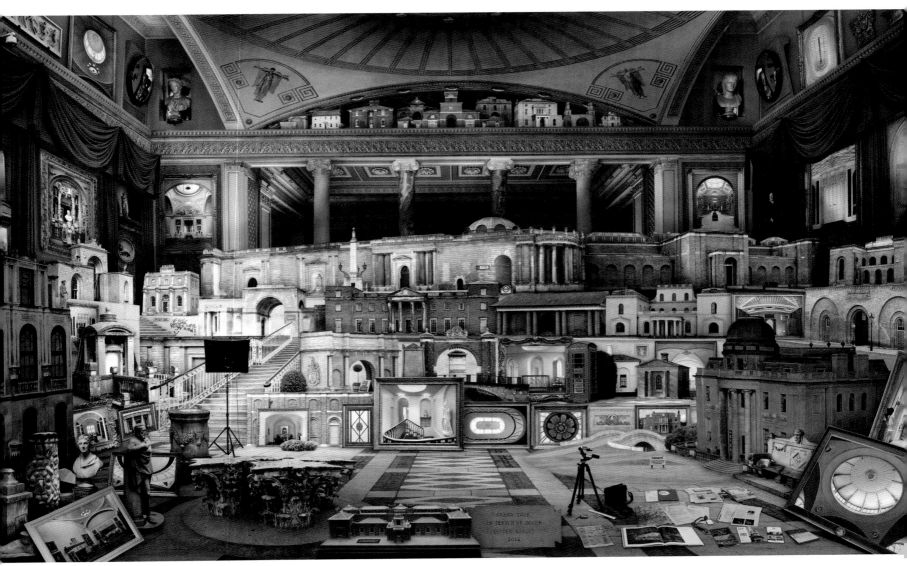

Cindy Sherman

AMERICAN / 1954–

Virtually a one-person art movement, Sherman creates art that is all about her, so no one can trump it. The French photographer Claude Cahun (born Lucy Schwob) made self-portraits transformed by make-up and costume, but she struggled for self-identity. Sherman, on the other hand, has used herself as a model to produce portraits by proxy with unfailing inventiveness for over 30 years, but her sense of self appears to be firmly grounded. Born Cynthia Morris Sherman in New Jersey, she started taking photographs at art school. In 1976, she embarked on a series that defined her methods – *Bus Riders* are portraits of commuters wearing their normal clothes, carrying bags and other accessories. The person in all the pictures, however, is Sherman, who had carefully observed commuters and dressed to imitate them.

The following year she started the *Complete Untitled Film Stills* series, which she finished in 1980 when she "ran out of clichés". Sherman posed in a dizzying array of roles and settings reminiscent of films from the 1940s to 1960s. She used her own props and clothes – for which she must have had a sizeable wardrobe. "To me", she said, "it was a way to make the best out of what I liked to do privately, which was to dress up". As a gauge of the critical reception to *Film Stills*, the Museum of Modern Art (MoMA) in New York bought the entire set of 69 images for a reputed million dollars.

The key to Sherman's success is her ability to transform herself completely into the role, like a method actor: "I think of becoming a different person... By staring into it I try to become that character through the lens... both in the 'acting' and in the editing. Seeing that other person... that's what I want. It's like magic".

> When I look at the pictures,
> I never see myself; they
> aren't **self-portraits**.
> Sometimes **I disappear**.

CINDY SHERMAN

△ **UNTITLED FILM STILL 3**
1977

Here, in a series of photographs that mimic publicity stills, Sherman represents a stereotype of a bored housewife. Her images work as individual scenarios, but together they form a catalogue of female types from black-and-white films.

▷ **UNTITLED 397**
2000

With fake tan, a peroxide blonde wig, a coronet, and a wistful expression, Sherman adopts the persona of an aspiring beauty queen.

△ **UNTITLED FILM STILL 7**

1978

This fictional starlet with her Martini glass is reminiscent of Elizabeth Taylor in one of her films, but the connection is deliberately left ambiguous, making the character a stereotype. Usually, Sherman works in the studio, but for this series of mock publicity stills, she carried around a suitcase of costumes so that she could create the different characters.

◁ **UNTITLED 92**

1981

The camera looks down on Sherman as if she is the heroine in a horror film, caught in a vulnerable crouch on the floor. Her upturned face and frightened expression suggest she has seen something off the frame that scares her.

iPhone 3GS

George Eastman, the founder of Kodak, boosted photography when he created an industrial infrastructure for processing and printing. The Internet and wireless communications offer photography an even greater stimulus by facilitating global distribution.

IN CONTEXT
Connected images

It seems appropriate that the first picture to be wirelessly distributed from a phone was that of a newborn baby. On June 11, 1997, Sophie Kahn was born, and within minutes her picture was on over 2,000 mobile phones, belonging to the family and friends of her father, Philippe. He had used a digital camera connected to his mobile phone to send off pictures in real time using his phone's email facilities. From this, he developed picture messaging products using MMS (Multimedia Messaging Services) that work across different handsets, using different file formats.

MOBILE PHONE IMAGE OF SOPHIE KAHN

By 2000, mobile phone and wireless technologies, together with sensor and a camera miniaturization, had converged sufficiently to produce the first practical cellular mobile phone with a camera (camera phone). It was the J-SH04, made by Sharp and sold by the J-Phone network in Japan. The camera captured a 110,000-pixel image, which could be viewed on a colour display and sent over the cellular network to other phones.

Growing numbers

Although photographers turned their noses up at the quality of camera phone images, the novelty of it seized the public's imagination and by 2003, more camera phones were bought than digital cameras. In 2005, Nokia became the best-selling brand of camera by virtue of being the cellphone market leader.

Photographers' resistance to camera phones weakened gradually. This began with the introduction of the iPhone 3GS in 2009. Under the tiny glass-covered hole that leads to the camera, a major change had taken place. The camera captured 3.2-megapixel images, offered auto-focus and auto white balance, and was able to focus close up.

Thanks to the use of an advanced image processing technique called wavefront coding, the images were surprisingly sharp and detailed.

Better still, the camera had apps – applications that plugged in to the camera's operating system and greatly extended its capabilities. Above all, the camera in the phone was part of a maturing wireless infrastructure that connected it to the rest of the world. With a few taps of the screen, an image could be emailed to friends or shared with thousands of strangers through websites such as Flickr and Facebook. By August 2007, the iPhone was the most popular camera being used to submit pictures to Flickr.

Then, in October 2010, Kevin Systrom and Mike Krieger launched the Instagram app. Once they were past the registration page, users found themselves in a community of like-minded enthusiasts – no fewer than 100 million monthly active users in 2013. Before long, professional photographers were using Instagram to make and post their images. Thus, in 2012, *Time* magazine commissioned five photographers to cover Hurricane Sandy equipped only with iPhones and instructed to report via Instagram. In 2013, the *Chicago Sun-Times* itself made news by laying off all its photographers, equipping journalists with iPhones to collect news images.

The public now have cameras in their smartphones far better than the basic digital cameras at the turn of the century. By late 2013, about one in five people in the world owned a smartphone – so over 1.4 billion people carry an internationally connected camera at all times.

◁ **SEA OF CAMERA PHONES**

JIM DYSON, 2012

By 2012, cameras had become a standard feature of mobile phones. In this image taken at a Nicki Minaj concert, almost everyone is holding up a camera phone to capture the rapper as she appears on stage.

Forward-facing camera records HD still images and video

▽ iPHONE 3GS

SMARTPHONE, 2009

Apple Inc's third-generation iPhone, the 3GS had a 3.2-megapixel camera made by OmniVision. With its unprecedented picture quality, it was the first camera phone to find favour with professional photographers.

Photo app for storing and organizing images

Camera app for accessing camera function

Touch screen provides high-quality view of images

▷ HURRICANE SANDY

BRYAN WALSH, 2012

In October 2012, Bryan Walsh was one of five photographers Time magazine commissioned to document Hurricane Sandy via Instagram. One of his pictures, taken on an iPhone 3GS, took pride of place on the magazine's front cover.

ON TECHNIQUE
Nostalgic processes

Much as photographers delight in space-age technology, they are now rediscovering old photographic styles, thanks to camera phone technology. From the uneven edges of platinum or Polaroid prints and the faded colours of early colour photographs to the dappled tones of tintype and sepia, filters that simulate old printing processes have become so common that a "vintage look" is now a badge of honour. Thus, even though camera phones offer higher resolutions, and some designs, such as the Sony QX-10, supplement phone features with camera-grade optics, images that mimic the soft, faded tones of those of the 19th-century have proved to be extremely popular.

A DIGITAL IMAGE TREATED WITH A KODACHROME-STYLE FILTER

Citizen journalists

Widely equipped with camera phones and vastly outnumbering news photographers, the general public is now in a far better position to capture on-the-spot news events than the biggest press corps.

Camera phones overtook plain mobile phones in 2004, accounting for two thirds of the mobile phone market at the end of the year. By 2009, their photographic features included eight-megapixel sensors, auto-focus, and built-in flash (see pp.352–53), meaning that many were capable of taking publication-quality images. By 2011, quality had continued to improve and ownership had topped a billion in just ten years – the most rapid growth in camera ownership in history, and all thanks to cellular telephony.

All photographers

With camera phones now ubiquitous, ordinary people are better placed than journalists or news reporters to capture breaking news. Not only are they more numerous, they do not have to rush to a scene – they are already there. In 2001, for example, much of the 9/11 attack on New York was recorded by amateurs, although

it is significant that the professional coverage was markedly superior. It was the coverage of the Indian Ocean earthquake and tsunami of 26 December 2004 that first showed that amateur photographs could be better than those of professionals. The disaster was brought vividly to life for horrified people all around the world, thanks to the many terrified but brave tourists who photographed and filmed the waves crashing into their hotels. The coverage of the disaster by professionals was mainly restricted to the aftermath, sometimes several weeks after the event – a situation that was repeated on the occasion of the Fukushima tsunami in 2011.

Citizen reporting

In the middle of London's crowded rush hour on the morning of 7 July 2005, three bombs went off on underground trains, and another blew apart the upper deck of a bus. In all, 52 people were murdered, more than 770 were injured, and central London spiralled into chaos. As TV and press caught up with events, most of the content came in the form of images caught by the survivors, showing them staggering through train carriages and escaping along dark tunnels.

The event marked an epochal shift in the balance between the news professional and news consumer: it was the birth of the citizen reporter. In emergencies, cellular networks are often blocked by a surge in traffic or to give priority to emergency services, but immediately afterwards, ordinary people's broadcasts – to friends and social networks – appear much faster than those of the best news networks. Attempts to control press coverage of the Gaza War of 2009–10 was partially neutralized by local people photographing the carnage and posting images to websites such as demotix.com. On the other hand, professionals have Internet access too: images of the earthquake in Haiti

in 2010 were on Twitpic only hours after the disaster, posted by the Haitian photographer Daniel Morel.

One consequence of amateur coverage is that many news photographers and videographers are losing work. According to one report, the numbers of visual news professionals in the US fell by 43 per cent between 2000 and 2012. At the same time, there has also been a growth in false reporting – creating sensational but false news, or setting up shots or embellishing real news to improve the impact and saleability of images.

Undercover photographer

The camera phone has also transformed the photography of conflicts. A photographer using a camera phone is indistinguishable from hundreds of ordinary citizens on the streets who are themselves hastily posting images to their social

▽ **LONDON BOMBINGS**

ALEXANDER CHADWICK, 2005

London Underground commuter Alexander Chadwick took this image of his fellow passengers making their way along a tunnel near King's Cross station in 2005. Only minutes earlier a bomb had exploded on their train, killing many.

media networks or picture-sharing sites such as Instagram to inform friends and supporters.

The ousting of Tunisia's president during mass demonstrations in 2011 inspired activists throughout the Middle East. The smartphone became a key weapon in the ensuing pro-democracy uprisings in Egypt, Ukraine, Libya, Turkey, Syria, and elsewhere by providing supporters and the world with virtually hour-by-hour coverage from the heart of the action.

In 2014, the Venezuelan government slowed down its Internet services and blocked social media sites in an attempt to prevent protesters from spreading images of their dissent, but activists soon found ways to circumvent the censorship, demonstrating again the power of the connected image.

△ **TASMANIAN BUSHFIRE**

TIM HOLMES, 2013

Tammy Holmes and her five grandchildren huddle under a jetty at Dunalley, Tasmania, as a bushfire rages around them. The picture is one of several taken by Tammy's husband, Tim, who posted them on the Internet.

◁ **MALAYSIAN TSUNAMI**

ERIC SKITZI, 2004

Tourist Eric Skitzi captured the moment when a tsunami crashed onto Penang Island in Malaysia in 2004. The wave killed over 230,000 people in 14 countries.

Live action

Sports photography has come a long way from Muybridge's early analyses of galloping horses. Now the most advanced photographic technology available is used to capture live action and to freeze the beauty of athletes in motion.

Long-focus lenses free from colour aberrations first appeared in 1969 with Canon's FL-F 300mm *f*/5.6, which was followed in 1974 by the epochal Canon FL 300mm *f*/2.8. This 1974 lens caused a diplomatic stir as it made confidential documents clearly legible in photographs of Henry Kissinger (then the US Secretary of State) at the 1975 Helsinki Accords. Sports photographers queued up for these lenses as they made indoor and night-time photography feasible.

Picture transmission

As sport became more newsworthy, greater technical resources were needed to speed up image delivery to newspapers. The Nikon NT-1000 – designed by Kenji Toyoda and introduced in 1983 – was essentially a film scanner which sent a positive image over telephone lines. One of the first times it was used, images of a cricket Test Match taking place in Australia were published the same day in Britain with a quality far superior to that of wire pictures. By the 2010s, photographers could use

their cameras to send files wirelessly to editors, who could select images to transmit to agency headquarters and clients. At the 2014 Sochi Winter Olympics, each major news agency handled more than 60,000 images daily, selecting and filing about 2,000 images per day within an average time of just 180 seconds from capture to worldwide distribution.

Robots at work

In the search for new angles, sports photographers in the 21st century can follow athletes with remotely released cameras either mounted in a static pod or on a remotely controlled vehicle. These cameras can go where photographers cannot – following runners round an athletics track or underwater looking up at swimmers.

Now, with High Definition Multimedia Interface (HDMI) since 2003, and cameras equipped with WiFi and other network technologies since around 2010, photographers can watch what is passing in front of their cameras from their laptops. The previous hit-or-miss approach to remotely released cameras has gone, improving the quality of images.

Tracking events

The first modern autofocus SLR was the Minolta 7000, which was introduced in 1985. It became the template for all subsequent autofocus systems. Allied with high-performing lenses such as 300mm *f*/2.8, modern systems can hold in focus an object travelling at more than 300kph (186mph) towards the camera. Motorized exposure rates of 15 frames per second also lower the technical hurdles, enabling photographers to capture views of sports that were never possible before.

△ **GOING FOR GOLD**

ADRIAN DENNIS, 2012

A remotely controlled camera equipped with a fish-eye lens captures a worm's-eye view of a long jump in the stadium at the London Olympics. Being able to view the scene remotely removes the possibility of error in timing the shot.

▷ **EXTREME SKIING**

LUCAS JACKSON, 2014

As every angle of every shot has become accessible to photographers, the pressure is on to find new creative interpretations, such as this imaginative picture of a ski jump at the 2014 Sochi Winter Olympics.

▽ **BREAKING THE SURFACE**

ADAM PRETTY, 2011

Sports photographers have been quick to take advantage of improvements in camera technology. Here, an extremely high-sensitivity camera has allowed a very brief exposure, capturing the glassy flow of water over a swimmer just before it breaks into turbulence.

ON TECHNIQUE
Point of view

Compact cameras no larger than a small box of matches, yet capable of capturing high-quality stills and high-definition videos, can be mounted on sky-diving helmets, the handlebars of a bicycle, or an athlete's body. Set to run continuously or controlled by a cable, they can capture point-of-view shots that bring the viewer right into the middle of the action and convey a sense of speed and movement. Because they are compact and lightweight, they pose minimal hazard to the athlete.

SKY DIVERS JUMP FROM AEROPLANE

Cristina García Rodero

SPANISH / 1949–

With her abiding interest in religious celebrations and cult practices, Cristina García Rodero's subject could be defined as the timelessness of ritual. Her subjects appear to be out of time in a world that has moved on. Re-enactments of ancient histories and occult ceremonies repeated down the centuries – all are brought startlingly to life in García Rodero's empathetic images. Working at first with 35mm black-and-white film, then digitally, she observes unobtrusively. "I photograph what thrills me, what gives me a blow to the heart, what captivates me", she explains.

Born in Puertollano, Spain, García Rodero's first love was painting, but she took up photography and went on to teach it at the Complutense University in Madrid. Quietly, assiduously, she photographed traditional festivals throughout Spain for 16 years. Her direct, affectionate coverage of Catholic rituals burst onto the photography world in 1989 with the publication of *España Oculta* (Hidden Spain). She said of the book: "I tried to photograph the mysterious, true, and magical soul of popular Spain in all its passion, love, humour, tenderness, rage, pain; in all its truth…" The toast of the 1989 Rencontres Arles photography festival, García Rodero was propelled from locally known professor to one of the world's leading documentary photographers, a standing sealed by winning the W. Eugene Smith Foundation prize the same year. Following these successes, she has photographed rituals around the Mediterranean and in the Americas. In 1996, she received the premier Spanish award, the Premio Nacional de Fotografía, and she joined Magnum Photos in 2005 after 15 years with Agence Vu. Her coverage of rituals in Haiti in the 2001 Venice Biennale confirmed her place in fine-art circles.

▷ **MARÍA LIONZA CULT**

YARACUY, VENEZUELA, 2007

Every October, thousands of Venezuelans congregate on a mountain permeated by the spirit of goddess María Lionza. Glowing embers emphasize the theatricality of the event.

◁ **FILM SET**

ALMERIA, SPAIN, 1991

Originally a film studio used as a set for American Westerns, the mocked-up town is now a theme park and also used for advertising shoots.

△ **THE CONFESSION**

GALICIA, SPAIN, 1970s–80s

In a time-honoured Catholic tradition, a woman makes her confession to a priest. This rite took place outdoors as part of the pilgrimage of Our Lady of Miracles of Saavedra.

◁ **MARÍA LIONZA CULT**

YARACUY, VENEZUELA, 2006

A medium hands a young woman's body over to the spirit of María Lionza in a dramatic ritual of healing on the sacred mountain of El Sorte, now a national park

Hell from Heaven

AKINTUNDE AKINLEYE / 2006

Living proof that having oil does not necessarily make a country rich, Nigeria is a major oil exporter but most of its 160 million people live in abject poverty. A petroleum pipeline running through the poor and densely populated district of Abule-Egba, on the outskirts of Nigeria's commercial capital, Lagos, had been illegally tapped by gangs for months. One night they did not fully seal a conduit, which prompted locals to rush in to collect the pools of petrol pouring out. One can of petrol sold on the black market can earn two weeks' wages for a poor Nigerian, according to *The New York Times*. Police tried to control the crowds, but could not arrest anyone for lack of vehicles.

At about 8am on 26 December 2006, the petrol burst into flames. The Red Cross, in its final assessment, said the fire killed at least 269 people and injured dozens more. The photographer Akintunde Akinleye, working for Reuters, took only 30 minutes to reach the scene after the blast. The fire would rage for another four hours. Moving through the devastation, Akinleye spotted a man trying to pick up whatever was left of his valuables. He says: "... he poured out a little water left in his blue bucket. He used the rest to brush off soot from his face – that was the moment I anticipated... When I took this shot... I felt it might be too artistic for a news story and I thought maybe my editors wouldn't accept it. In the end, I sent it in anyway and then I got a text saying 'You've just taken a world class picture'". The image won First Prize for Spot News in World Press Photo 2007.

NAVIGATOR

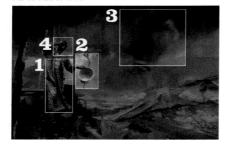

1 BRIGHT KAFTAN
The colours of the kaftan, coupled with the man's striking pose, stand out against the dark and dull colours of the burnt wreckage around him. The red in the fabric is also a reminder of the fire still burning.

3 BLACK SMOKE
The thick smoke dramatically darkens the sky – visually such an effect is always striking but here it also tells us that the fire is still raging elsewhere. Only the wind direction allowed Akinleye to take the picture at all.

2 BLUE BUCKET
By good fortune, the bucket is almost exactly the same hue as the blue on the man's kaftan, and a contrast to the pallor of other colours in the scene.

4 ANTICIPATED MOMENT
Waiting for the moment when the man would cool himself with some water, Akinleye timed his shot perfectly, catching the droplets of water falling from the man's face.

Portraying nature

Only a lucky minority are able to see wild animals in their habitat, so nature photography provides an indispensable, if imperfect, substitute. Thanks to technology, it is possible to see animals better in photographs than in the wild.

More than any other genre, nature photography owes its evolution to advances in technology. During the first half of the 20th century, the shortcomings of both the speed of film and the quality of long-focus lenses forced photographers to move up close to their wildlife subjects, sometimes risking their own safety. British photographer Eric Hosking, for example, constructed hides as near as possible to bird nests, while taking great pains not to disturb his subjects. In 1937, he went too close and was attacked by a barn owl, which blinded him in one eye.

Telephoto revolution

In 1969, the Canon FL 300mm f/5.6 lens was the first to use artificial fluorite crystals to provide high-contrast, highly corrected images at long focal length. For the first time, subjects taken from far away were captured as sharply as when photographed at normal distances, with rich colours. Steadily improving technology meant photographers could use lenses of 600mm and greater focal length, which bridged considerable distances to provide close-up views of large mammals and full-length portraits of smaller animals and birds. Large maximum apertures of up to f/2.8 in combination with faster colour film also meant that nature photographers could work in a wider range of environments.

> Every time a **special** wildlife photo is shared... **love** for **wildlife** grows.
>
> **GREG DU TOIT**

All in all, the image quality of nature photography took a dramatic leap forwards in in the 1970s. Before long, a mere portrait of a wild animal was not enough. The photographer treated nature like a painter and the animal completed the composition. Fine-art ideals had infiltrated the wildlife safari. Dutch photographer Hugo van Lawick, who worked with British chimpanzee expert Jane Goodall for some 20 years, was one of the first to realize that the atmosphere of the wildlife image – light, composition, and timing – was taking precedence over accurate depictions of animals themselves. Other photographers, such as Japan's Mitsuaki Iwago, American Jim Brandenburg, and Norway's Pål Hermansen, also tend to place more emphasis on artistry than on portrayal.

Extra lights

As long ago as 1906, American George Shiras used flash powder to illuminate deer grazing and drinking at a water hole at night. Eric Hosking used flash to light his bird pictures in the 1950s – he was one of the first to use sensor trips to trigger the flash units automatically.

By the end of the 20th century, compact and powerful flash units could be synchronized by arranging one flash to set the others off. In 2003, Nikon introduced systems that automatically control exposure with multiple synchronized flash units. The units were originally designed for fashion and editorial portraiture, but

▽ **JUMP OF LIFE**

BONNIE CHEUNG, 2014

Hong Kong's Bonnie Cheung captured the climax of the wildebeests' annual summer migration in Kenya. Her photograph was shortlisted for the Sony World Photography Awards 2014.

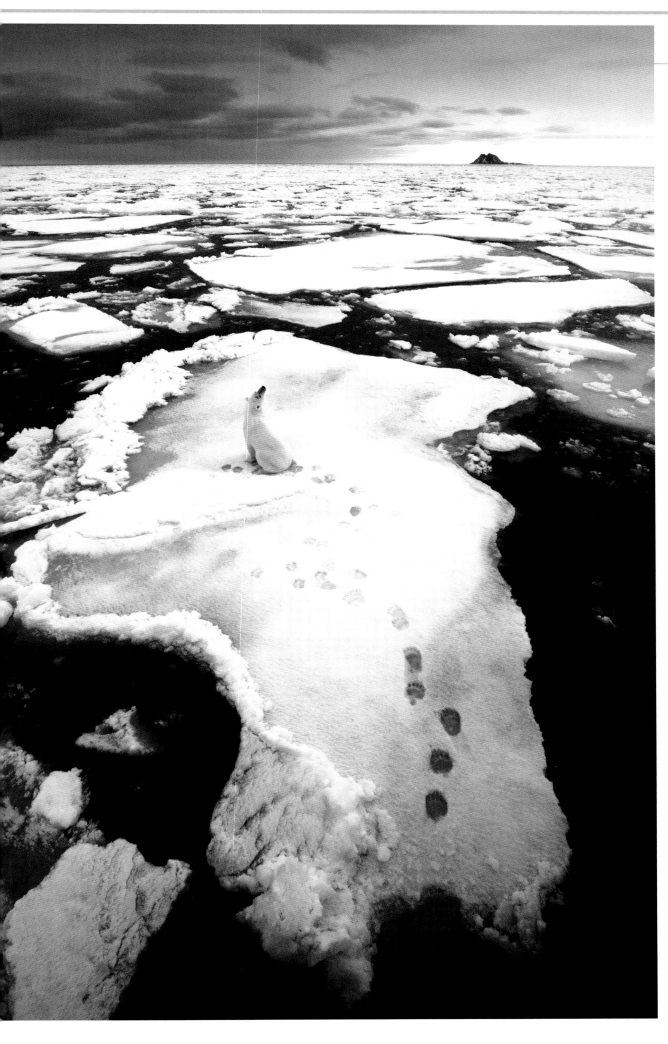

ON TECHNIQUE
Dark light

As flash units shrank in size without diminishing their output and camera batteries improved, photographers were able to venture onto mountain tops or into jungles to take pictures automatically tripped by infrared devices. Setups may need an initial trip that charges up the flash units as the animal approaches the camera position, followed by a separate trip for the flashlit exposure itself. For all the technology, expert knowledge of animal behaviour is essential because the camera must be set up where the subject is likely to go.

Using multiple flash units set to balance available light, American Steve Winter has extensively photographed tigers, jaguars, and snow leopards on their home ground.

SNOW LEOPARD, STEVE WINTER, 2008

◁ **LIVING ON THIN ICE**

OLE JØRGEN LIODDEN, 2012

The Norwegian photographer has photographed polar bears more than 100 times around the islands of Svalbard in northern Norway. While drifting ice is usual here in summer, it melted much earlier than normal in 2012, leaving this polar bear stranded on a diminishing raft.

▽ **ESSENCE OF ELEPHANTS**

GREG DU TOIT, 2012

This shot was taken from a sunken hide close to a waterhole in Botswana. South African photographer Greg du Toit wanted to capture a unique elephant portrait, so he set up a camera with a wide-angle lens and waited patiently. Suddenly, a young elephant calf raced right past the camera. The slow shutter speed and a polarizing filter gave the resulting image a mysterious quality.

photographers such as Michael Nichols and Steve Winter, and Frans Lanting (see pp.300–01) pioneered their use to create studio-like lighting effects in the field.

By using remote controlled and automatic trip devices, photographers no longer have to wait for an animal to obtain their pictures. Extremely wary creatures, such as tigers and snow leopards, can be photographed at close hand in the wild only with hidden cameras that make an exposure when the animal breaks an invisible light beam. Ironically, just as it is becoming easier to take pictures of wildlife, the numbers of animals and habitats left to photograph are rapidly declining.

Animal ethics

As the interest in wildlife photography grew, the temptation to take short cuts increased. Baiting animals by leaving out dead prey, or training them by leaving out food increases people's chances of obtaining photographs, but also infringes the rights of animals to lead a normal life. Institutions that give out awards, such as Wildlife Photographer of the Year, founded in 1964, have not just shaped styles, but have held the torch for maintaining high ethical standards.

▷ **ORANGE AGARICS**

THOMAS MARENT, c.2000

Swiss photographer Thomas Marent specializes in photographing the life of the rainforests. He found these delicate, orange-capped fungi in Peru.

▽ **ESSENCE OF ELEPHANTS**

GREG DU TOIT, 2012

△ A MARVEL OF ANTS

BENCE MÁTÉ, 2010

Hungarian photographer Bence Máté put a flash behind the leaf to capture leafcutter ants in Costa Rica cutting and carrying a leaf, something they only do at night. Máté won Wildlife Photographer of the Year prize for this image.

ON TECHNIQUE
Hello, robot

Nowadays, machines capable of carrying an SLR camera enable wildlife enthusiasts to approach wild animals as never before. In 2012, New Zealand photographer Chris McLennan and engineer Carl Hansen developed a remotely controlled four-wheel drive buggy. On it, he mounted a Nikon D800E enclosed in the protective padding of a sound blimp. With a zoom lens set to 18mm, the camera could capture an ultra wide-angle view. On its third outing in Botswana, the buggy trundled past a pride of eight lions who were fascinated by it. The resulting shots were viewed more than two million times within three days.

CURIOUS LIONS PAW THE BUGGY, CHRIS MCLENNAN, 2013

Baby Green Sea Turtle

DAVID DOUBILET **/** 2009

American marine-life specialist David Doubilet has spent more time working under the water than most photographers do on dry land. Snorkelling from the age of eight, he took his first underwater photographs in 1958 when he was 12. He used a Brownie Hawkeye camera protected by an adapted anaesthesia bag filled with air – not a legendary success. By 1971, he had improved both his diving and photography skills and began work on the first of more than 70 stories for *National Geographic* magazine. On assignments – from interior Africa to Australian coral reefs – Doubilet dives with several cameras because no one has yet invented a way of changing lenses underwater. He combines underwater flash with ambient lighting in innovative ways that have inspired a generation of divers.

Doubilet is a leading exponent of the split-lens technique, in which the top half of the image (usually above water) is focused on the distance while the bottom half, underwater, is focused on a much nearer subject. This is the technique he used for *Baby Green Sea Turtle*, which he shot in French Polynesia in the South Pacific. Doubilet has also photographed turtles in Israel, Florida, and Malaysia. He is a passionate conservationist and a founding member of the International League of Conservation Photographers. His personal challenge is "to create a visual voice for the world's oceans and to connect people to the... invisible world below".

NAVIGATOR

1 WATER DROPLETS
Splashes of water remain on the surface of the lens. Doubilet could have removed them by image manipulation but then the photo would have been digitally altered.

2 DEEP FOCUS
The upper half of the image field is focused on the background, but not too far back. If the apparent depth of field had been too great, the distant palm trees would have appeared too sharp and competed with the turtle.

3 UNDER LIGHTING
The white sand on the seabed reflects the sunlight entering the sea and illuminates the underside of the turtle, giving perfect fill-in light.

4 WATERY REFLECTIONS
The smooth surface of the water acts as a mirror that reflects the little turtle's face, as well as light from the sandy sea bottom, adding a further dimension to the image.

Oriental perspectives

The fusion of classical Chinese fine art with photography was not achieved until the 1940s. It resulted in a distinctive approach to landscape by combining classical forms with a challenge to the Western representation of space.

Don Hong Oai
1929–2004

Born in Canton, Don Hong Oai was apprenticed to a portrait studio in Saigon, Vietnam, at the age of seven. In 1979, he emigrated to the US, but regularly returned to China both to photograph and to study with Long Chin-San, who taught him how to layer images with multiple negatives. Extending Long's technique, Don used negatives of varying contrasts as well as masking techniques to create ethereal landscapes which blend modern continuous tone with traditional black-and-white gestures like the spring blossoms below. His images revel in nostalgia for the old China and completely ignore its modernization. He received no critical attention until the 1990s, when a series of shows propelled him to international fame.

SPRING SCENERY, c.1986

Photography had reached China and Japan by the 1840s, but long remained an imported art form used primarily by foreigners. Fundamentally, it was alien to the aesthetics of Oriental fine art. The fine detail of a photograph was at odds with the eastern tradition of depicting a scene with just a few brushstrokes. And whereas Eastern art dealt with symbols – mountains representing wisdom, water standing for the flux of life and so on – photography seemed unremittingly literal and heavy-handed to the Oriental eye. Eastern art was also fixedly monochrome: black was Heaven's hue, and too much colour was considered bad for the eyes.

Three dimensions in two
A further element foreign to Oriental minds was the handling of perspective – how three-dimensional space was represented on the flat surface of a print or painting. In Europe, 15th-century thinkers, such as the architect Filippo Brunelleschi, showed that a geometrically accurate way to represent objects in space was to depict parallel sides as if they converged towards a vanishing point on the horizon. Early photography reinforced the dominance of this linear perspective in Western art.

Classical Oriental art was based on different models of space. It showed space with receding planes, in which a nearer object overlaps and covers

part of a further object. This was joined to aerial perspective, which exploits how contrast and clarity naturally diminish the further away things are to express receding space.

Asian pictorialism
By the 20th century, even artists in the West were rebelling against geometrical perspective, most visibly in the Cubist movement, which spilled over to montage effects in modernist photography (see pp.142–43 and pp.330–31). Finally, in the 1940s, Long Chin-San (also transliterated Lang Jingshan) in Hong Kong marked the first successful fusion of Oriental with European modes. Trained in photography by a brush-and-ink artist, Long considered a traditional painting "as a composite image of fragmentary visual memories".

From this, Long derived composite photographs using subtle toning and multiple printing techniques to place traditional elements such as calligraphically expressive bamboo shoots, leafless branches, and craggy rocks against a plain ground, suspending his subjects in an indeterminate space. Relationships between elements were defined by aerial perspective and overlapping receding planes. Minimal and calligraphic expressions also came naturally to photographers such as Jiang Peng, but Long's best-known student was Don Hong Oai (see left).

Modern interpretation
China's Huangshan (Yellow Mountains) is a glaciated mountain range much venerated for its exquisite scenery of 72 steep peaks, often shrouded in mist. The Huangshan inspired its own school of painting, which made extensive use of aerial perspective. Wang Wusheng is a leading modern exponent of the style.

Wang was working as a news photographer when he turned his attention to the Huangshan in 1974. In his photographs, he exploited the ultrafine grain of Kodak Technical Pan film to create a modern interpretation of ink-and-wash paintings, adding directional light to classically conceived compositions Receding planes of inky-black silhouettes are grouped against the smoothly shifting swathes of mist, their softening tones deftly defining distance.

The art of the East essentially expresses the artist's mind.

WANG WUSHENG

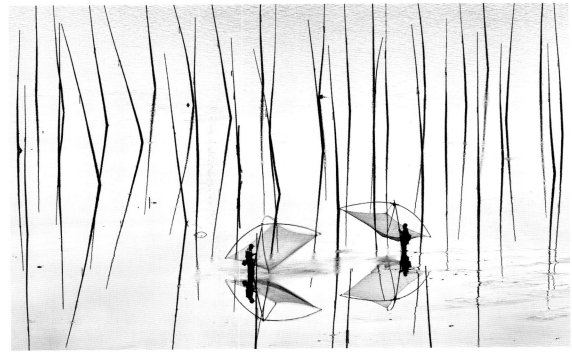

△ NORTH SEA GUEST HOUSE, LION PEAK, HUANGSHAN

WANG WUSHENG, 1984

This image is part of the Celestial Realm *series, published in book form in 2005. In Wang's contemporary interpretation of traditional Chinese black-ink painted landscapes, mist separates the deep velvety darkness of the sharply silhouetted rocks and trees in the foreground from the progressively fuzzier bands of trees and rocks.*

◁ TWO FISHERMEN, XIAPU

JIANG PENG, 2012

In Chinese calligraphy, bamboo is one of the plants that a painter must learn to portray with deft, perfectly placed brushstrokes. Here, the overlapping bamboo poles and their reflections punctuate this stretch of coast like brushstrokes, defining the space and framing the figures.

China's New Wave

Innovations in photography have grown as rapidly as China's economy since the 1980s, when Chinese artists and photographers began reinventing their own culture.

During the Cultural Revolution of the 1960s and '70s, China was not only cut off from the rest of the world but also forced to renounce its own culture. Photography under Chairman Mao's regime was strictly controlled – all professional photographers were government employees. Individual creativity was discouraged, and the concept of the freelance, independent photographer was incomprehensible.

However, in 1978, two years after Mao's death, one of the first unofficial photography clubs emerged – the April Photographic Society in Beijing. Its name reflected the Chinese liking for nature symbolism, suggesting a new spring in photography, and it drew large attendances from people eager to see non-state-sponsored imagery.

Individuality

The chief catalyst for change was the Zhejiang Art Academy (now the China Academy for Art) in Hangzhou, near Shanghai. The 1985 show by graduate students of the Academy took direct aim at the orthodox. Provocative and challenging, the show unleashed long pent-up frustrations. It was dubbed *Sheying Xinchao* (New Wave) by the critic Gao Minglu, and within two years, 79 avant-garde groups emerged. They put on 149 exhibitions throughout China's 29 provinces, although most activity took place on the prosperous East Coast and in the central cities.

The variety, daring, and freely experimental nature of the art and photography showed that within a decade, Chinese artists had cast off years of official, conformist art and assimilated half a century of modernist and postmodern experimentation from the West to forge their own avant-garde.

New generation

While some work was clearly derivative of Western models and other images were based on Chinese folk art, artists soon found their own way. Leading conceptual artist Ai Weiwei expressed his view: "I don't think it's worth discussing new directions in the context of Chinese art – there were no old directions, either". When China emerged as an economic superpower towards the end of the 20th century, the status of art and photography kept pace, and Chinese works of art are now widely exhibited and collected.

The Chinese century

Much recent and contemporary Chinese photography is conceptually driven and constructed. Wang Qingsong left his oil-painting training behind to construct vast tableaux – with dozens of models placed around film sets or warehouse shelving – in satirical comment on the changes in Chinese culture. Based in Beijing, his works comment on China's rapid growth by replicating the vastness beyond number of modern China

If my art has nothing to do with people's pain and sorrow, what is "art" for?

AI WEIWEI

in his images crammed with models and props. He says: "I think it would be absurd for an artist to ignore what's going on in society".

Comment also motivates the Gao Brothers, Zhen and Qiang. In one series, they contrast the fragility of nudity with the sharp edges of the decaying dreams of the modern. They explain: "Naturally, the general masses of China may still view nudity with certain traditional ideals, but we believe that [certain] political issues, and not nudity, are what should be viewed as unacceptable in society".

Yang Zhengzhong was born in Xiaoshan and studied oil painting locally in Hangzhou. Now based in Shanghai, his work – video and photographic prints – reveals playfulness and humour, elements that are rare among the 21st-century generation challenging the state, cultural taboos, and social norms.

△ **LONELY SUMMER**

GAO BROTHERS, 2012

The figure partially covered with broken paving material lies on a building abandoned before completion. Far from flaunting nudity, the Gao brothers aim to show the vulnerability of people in the face of unfinished urban development.

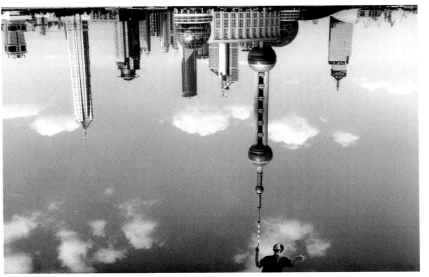

◁ **SHANGHAI**

YANG ZHENGZHONG, 2002

The upside-down Oriental Pearl Tower looks light enough to balance on one finger. It is part of a photo and video series about buildings losing historical significance in cities such as Shanghai, thereby making memory as light as air.

Sebastião Salgado

BRAZILIAN / 1944–

Salgado has turned the picture essay into a monumental *pièce de résistance* on a grandiose theme. Dignified and compassionate, his series include *Workers*, on labourers across the world; *The End of Polio*, in countries where the disease is endemic; and *Migrations*, tracking population movement through war, poverty, or repression.
The intelligence of Salgado's picture-making is evident in the phenomenal craftsmanship of every image – from virtuoso composition in well chosen locations and control of light and shade to the giclée printing. Salgado used to work exclusively with 35mm black-and-white film, but he has developed a unique digital workflow. Refusing to review images digitally, he fills memory cards with images captured in raw format from his Canon or Hasselblad cameras. Back at base (he lives in Paris), the raw files are turned into black-and-white images using custom presets and printed out. Only then does Salgado review his shoot and make his selections.
The sheer beauty of Salgado's photography is set against a background of pessimism about capitalism and environmental vandalism, always presented with sensitivity to how humans are affected by often devastating socio-economic conditions. Of the relation between his work and visitors to his exhibitions, he says: "I believe that the average person can help a lot, not by giving material goods but by participating, by being part of the discussion, by being truly concerned". His latest ventures, following the creation of his press agency Amazonas Images in 1994, channel earnings from his photography directly to humanitarian and environmental projects.

> I don't want anyone to appreciate **the light or the palette of tones**. I want my pictures to **inform**, to provoke **discussion** – and to raise money.
>
> **SEBASTIÃO SALGADO**

▷ **GOLD MINE**

BRAZIL, 1986

In scenes reminiscent of 19th-century gold rushes, every day some 50,000 people clambered down the treacherous slopes of this mine in the Serra Pelada to shovel up sackloads of mud.

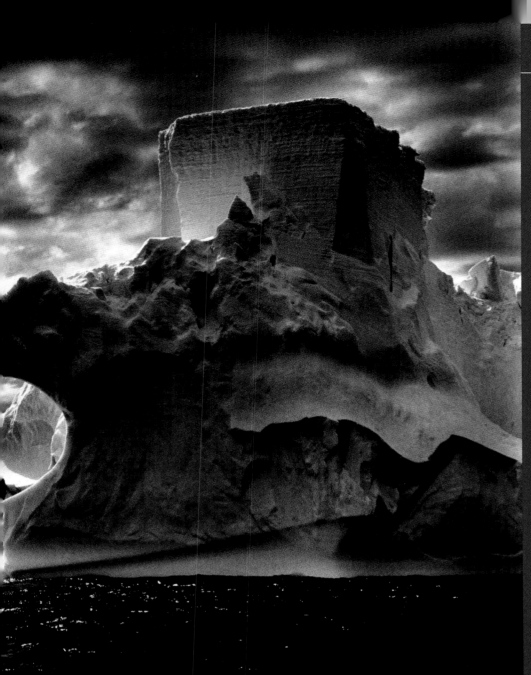

◁ **"THE CASTLE" ICEBERG**

ANTARCTICA, 2005

Part of the Genesis series, an eight-year expedition to rediscover the landscapes, animals, and peoples that have so far escaped the imprint of modern society, this shot shows how the forces of nature shape icebergs into extraordinary forms.

▽ **BRAZIL**

1981

Salgado spent seven years, from 1977 to 1984, living with ordinary peoples of Central and South America to portray culture and politics expressed through their daily life. The work was published as Other Americas in 1986.

Group of Zo'é, Pará, Brazil

SEBASTIÃO SALGADO **/** 2009

This photograph of the Zo'é tribe comes from *Genesis*, one of the long-term projects undertaken by Sebastião Salgado on monumental themes such as workers and migrations. The project has an unlimited field – planet Earth. As Salgado explains: *"Genesis* is an attempt to portray the beauty and the majesty of regions that are still in a pristine condition, areas where landscapes and wildlife are still unspoiled, places where human communities continue to live according to their ancient culture and traditions". He wants to open people's eyes to the wonder of the Earth, still there despite destructive human activity. By helping people to understand the fragility of the environment, he hopes to inspire them to take action to preserve it. Started in 2004, the project was completed in 2012 and toured widely; it was also published as a photobook.

The subject of this image, the Zo'é, live in the rainforest on the Cuminapanema River basin and speak a language belonging to the Tupi-Guarani group, a sub-family of about 50 languages in South America. The Fundação Nacional do Índio (known as Funai) first made contact with them in 1989, although there is evidence of non-Indian contact going back 80 years. The Zo'é are also known as *poturu*, which is the name of the wood used by both men and women to make labret (bottom lip) piercings. The tribe numbered only 256 in 2010, and the Brazilian government gives them special assistance to preserve their way of life. Officially an isolated tribe, they are a prime example of the indigenous exoticism of the Amazon Indian and so this is not the first time they have been photographed.

NAVIGATOR

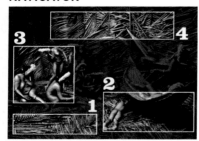

1 TEXTURED BACKDROP
The palm fronds create a regular but casually arranged pattern of diagonal hatchings like a pencil drawing, against which the lithe bodies stand out clearly.

2 LEADING SHADOW
The lighting is extremely soft and even. The only area of deep shadow is under this hammock; together with the prone body to the left, it leads your eye towards the main group of women.

3 LIVELY GROUP
The women in this Zo'é village use the red fruit of a small shrub, the *ucurum*, as a body paint. The women on the left, with echoing body positions, are rubbing the colour onto themselves.

4 PERFECT SPACING
Through his choice of viewpoint – slightly elevated – and perhaps by waiting for the swings of the hammock, Salgado has spaced out all the elements of the image. The strongly rhythmic vertical lines in the back help to anchor the image.

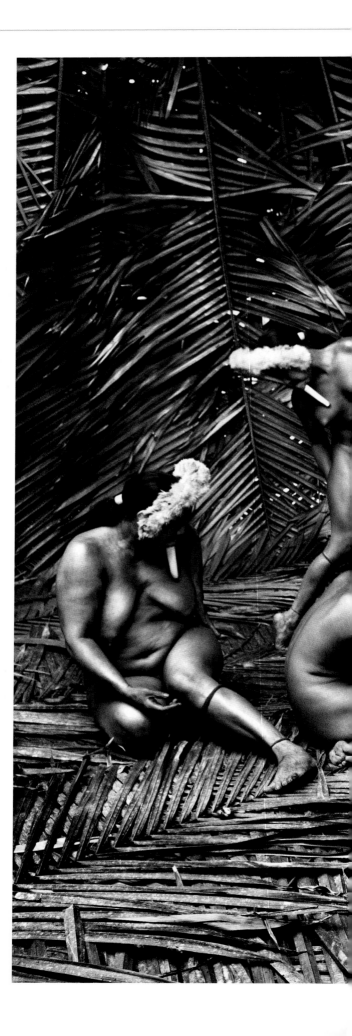

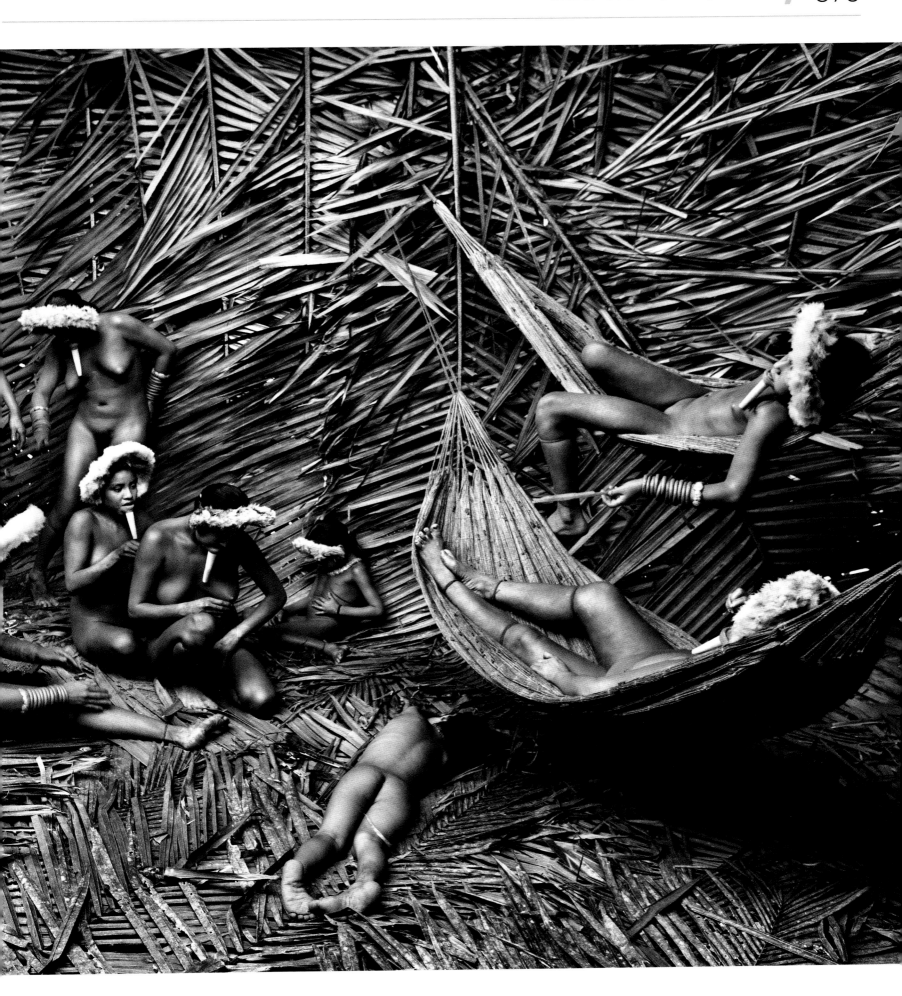

Evidence of damage

While many concerned photographers of the 20th century bore witness to man's inhumanity to man, their 21st-century counterparts also focus on maltreatment of the planet itself and take an active role in preserving the natural world.

One small picture helped mankind make a giant leap forward in global awareness. *Blue Marble* (see p.272), made in 1972 as the Apollo 17 spacecraft flew towards the moon, became the symbol around which conservation campaigns would rally. Already, protection of the environment was moving up the political agenda. The same year, use of the pesticide DDT was banned in the US because it was poisoning bird life.

North American landscape
In the 1960s, photographers such as Philip Hyde and Ansel Adams (see pp.162–65) used images of natural beauty to campaign for protection of the landscape, but environmental motivations were becoming more explicit by the 1980s. Fellow American Richard Misrach aimed his large-format camera at urban sprawl and industrialization, turning despoilation of the environment into fine art. Canadian Edward Burtynsky explicitly documents humanity's impact on the environment in order to reveal the horrific scale of damage. Typically working from high vantage points to gain large-scale, almost abstract views, he has photographed mining worldwide, recycling, and oil and water pollution. He has also used medium-format digital cameras mounted on drones (radio-controlled aircraft) to obtain vantage points otherwise impossible to reach.

Environmental proof
In the 21st century, photographers began to appreciate that they would have to play a role in preserving the wildlife and natural beauty they loved to photograph. In 2005, at the World Wilderness Congress in Alaska, Mexican Christina Mittermeir and others founded the International League of Conservation Photographers (ILCP) with the "goal of enlisting the skills and expertise of some of the best photographers in the world to advance conservation efforts around the globe".

The membership of ILCP is a rollcall of many of the greatest wildlife and environment photographers. From Frans Lanting to David Doubilet and Daniel Beltrá (see pp.300–01; 366–67; and 378–79), their combined ability to communicate visually drives the conservation activities of non-governmental organizations such as the World Wide Fund for Nature (WWF) and Greenpeace.

Photography has progressed from salons and art galleries to debating chambers and international conferences. Photojournalists such as Briton Marcus Bleasdale and New York-based Brent Stirton use mass media to reveal injustices ranging from poaching big apes and large cats to the struggle of people to make a living from hazardous small-scale mining. Others, such as Hungarian Balazs Gardi and American Ed Kashi, pursue monumental themes such as water shortage and the impact of the oil industry to lay bare the damage caused by nations' insatiable desire for economic growth.

▽ **OXFORD TYRE PILE**

EDWARD BURTYNSKY, 1999

Shortly after Burtynsky photographed this "Grand Canyon made from 30 million tyres", it caught fire and "burned for two years with flames more than 2,000ft high". The aerial view makes the scene semi-abstract, creating beauty from a dumping ground.

◁ **MOUNTAIN GORILLA**

BRENT STIRTON, 2007

Mourning villagers carry the body of Senkwekwe, a 240kg (530lb) silverback, from Virunga Park, Eastern Congo. The motivation for the killing was not known but was thought to be connected with clashes between the illegal charcoal industry and conservation efforts. The gorilla's murder, and that of half his family, sparked worldwide outrage.

▽ **PANNING FOR GOLD**

MARCUS BLEASDALE, 2013

In the Congo, gold is the most lucrative of so-called conflict minerals, which fund brutal struggles between rebel groups and government troops. Little of the money goes to the people, often children, who do the panning. Since 2010, international efforts to stem the scramble for spoils and reduce the violence it spawns have helped.

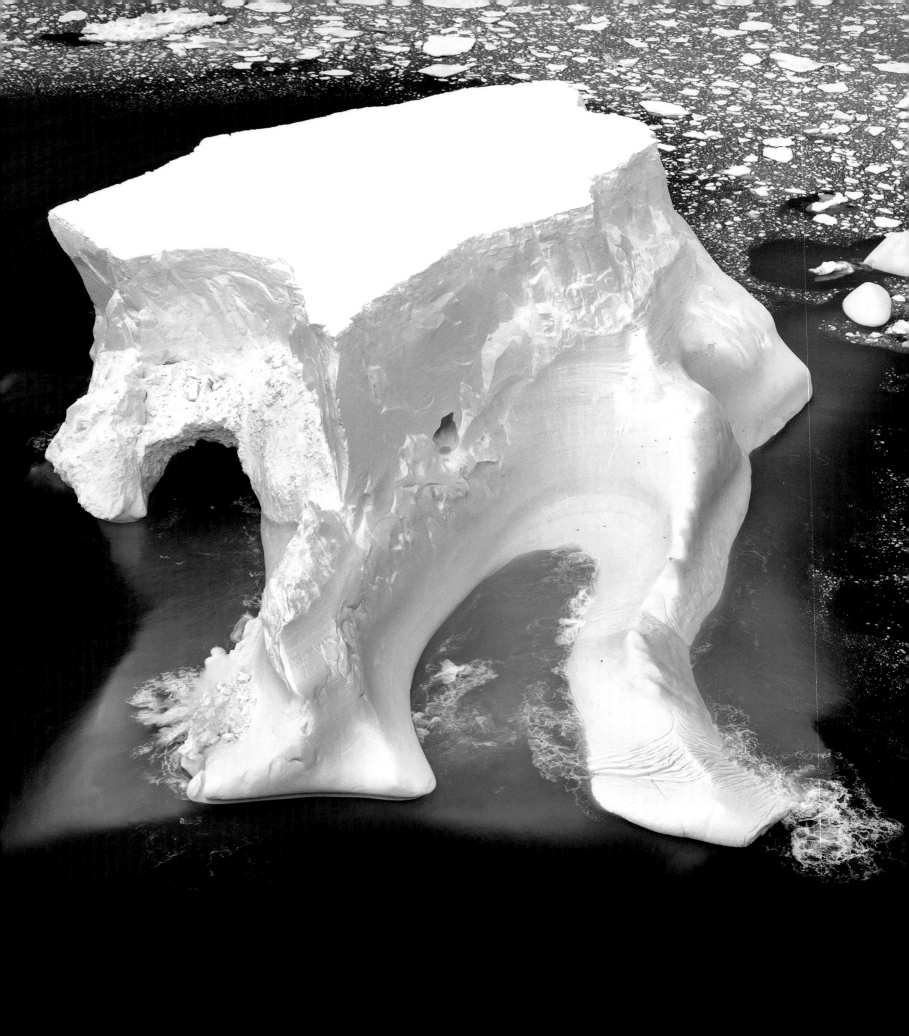

◁ **ICE**

DANIEL BELTRÁ, 2007

*Spanish-born photographer
Daniel Beltrá is passionate
about conservation and finds
the fragility of the planet's
ecosystems easier to see
from the air. Based in
Seattle, Washington, he
travelled to the Antarctic
with Greenpeace and
photographed icebergs
from a helicopter.*

Ends of the universe

Early digital imaging was driven by astronomy, which studies the distant past by studying distant objects. Some of the first digital pictures, made by light that took millions of years to reach earth, were of stars.

The very first image of the moon was probably made as early as 1840, by John William Draper, from New York. Five years later, French physicists Louis Fizeau and Léon Foucault made the first photograph of the sun. Using an exposure of 1/60th of a second, their daguerreotype was some 12cm (8in) in diameter and showed several sunspots. The light for the image took around eight minutes to cross the 150,000,000km (93,000,000 miles) between the sun and the earth. Just over a century later, images were being captured with light that had taken billions of years to reach us.

Single photons
In 1969, Willard Boyle and George E. Smith invented the charge-coupled device (CCD) that could transfer electrical charge across its surface. Being light-sensitive, it could be used as an imaging device, and by 1975 Steve Sasson had implemented a simple CCD in the first digital camera (see pp.344–45). In 1976, James Janesick used a CCD to obtain images of planets. Thanks to their ability to register individual photons, CCD devices are valued by astronomers for detecting extremely dim and distant objects.

Earth-based astro-photography reached its limits with refinements in sensors, optics, and observatory collaboration. Precision control of deformable mirrors – whose shape can be minutely adjusted – reduces sparkling (a form of distortion) caused by atmospheric disturbances, delivering sharp pictures of the stars. Images from different earth-bound telescopes can be combined to enhance detail and cover a wide range of wavelengths. As a result, we have been treated to a stream of astonishing images since the 1990s – more magnificent than anything produced by science fiction artists.

The amateur astronomer has also benefitted from advances. Affordable but high-quality reflector telescopes comfortably outperform the professional telescopes of the past. When attached to sensitive cameras exploiting digital processing techniques (to enhance the capture), amateur astronomers can produce images that are invaluable to professionals, and regularly spot new celestial bodies. Even without telescopes, photographers can combine the high sensitivity and resolution of modern SLRs mounted on equatorial mounts so that the camera tracks the sky and the stars appear as spots instead of streaks.

Hubble Space Telescope
The launch of the Hubble Space Telescope into orbit in 1990 was a major advance for astronomy (see right) – even if the gala was marred by the main mirror being too flat by two thousandths of a millimetre. For three years, astronomers used Hubble to image relatively nearby objects, but in 1993, astronauts installed a corrector plate that greatly extended its range. Subsequent improvements to the telescope have enabled astronomers to see back almost to the birth of the universe. The deepest view of space was obtained in 2012 by accumulating data over a ten-year period. Amounting to an exposure time of 2 million seconds (23 days), Hubble picked up dim light emitted from galaxies 13.2 billion years ago – just half a billion years after the birth of the universe.

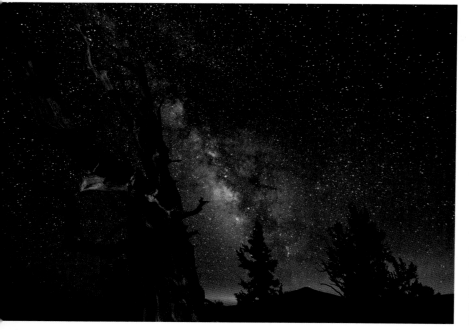

▷ **CURIOSITY SELF-PORTRAIT**

CURIOSITY ROVER, 2013

This self-portrait of NASA's Mars rover Curiosity is a mosaic of dozens of pictures taken by the rover's Mars Hand Lens Imager. The robotic arm that held the camera was kept out of each of the images.

ON TECHNIQUE
Hubble Space Telescope

At US$2.5 billion, the Hubble Space Telescope is the most expensive camera ever made. About the size of a school bus, it mounts a 2.4-m (7.8-ft) main mirror, and originally used eight CCD chips, just 0.64 megapixels each. Cost-cutting led to some errors in its optics, but analysis of the defects made it possible to make a corrector plate, which astronauts fitted with amazing skill. The Wide Field Camera, added in 2009, captures ultraviolet to visible red light on a 16-megapixel sensor. Colour is added to the composite images during processing.

THE HUBBLE TELESCOPE, TAKEN FROM THE SPACE SHUTTLE, 2009

△ **WHIRLPOOL GALAXY**

ANDRÉ VAN DER HOEVEN, 2013

Astro-photographer André van der Hoeven combined images from two telescopes – the Hubble and the Spitzer – to create this extraordinary picture of M15, the Whirlpool Galaxy. The Hubble shot was taken in visible light, and had an exposure time of nine hours. The Spitzer image was taken in infrared and uses false colour.

Photography trends

In a world with few certainties, it is sure that people will photograph for as long as they can, that more and more will have access to cameras, and that the numbers of images captured will increase dramatically.

The actual numbers of photographs being taken are not only hard to judge, but hard to comprehend. In 2012, Fujifilm estimated that the number of images captured each year had reached 1.5 trillion (not including the millions of pictures taken by robotic devices such as surveillance and speed cameras). In 2013, users uploaded over 350 million images onto Facebook every day, piling up more than 250 billion images on the site. By contrast, the major news agencies churned out a mere three million images during their 16-day coverage of the Winter Olympics at Sochi, Russia, in 2014.

There is a world of difference between images snapped by the typical Facebook user and those obtained by photographers working for Getty Images, Associated Press, and Reuters. It is the old divide created in the 1900s by the invention of the Kodak Brownie (see pp.92–93), the gulf that separates leisure photography from the professional's high-pressure enterprise.

Although the photographic profession took a jolt at the turn of the millennium, when new digital technology gave people affordable access to high-quality equipment, the technology was unable to bestow users with vision and artistry. Despite the claims of camera promotions, technology does not improve people's ability to make pictures, but just facilitates existing skills. However, as more and more amateurs take up photography – by 2014, they numbered over a quarter of a billion worldwide – the standard of photography continues to rise. Year on year, the improvement in amateur talent is evident in the quality of tens of thousands of entries submitted to the major international competitions such as the Sony World Photography Awards, the Wildlife Photographer of the Year, and the Hamdan International Photography Award.

Familiar themes

Stills photography evolved into cinema and video, but has yet to evolve into radically new forms itself. Despite technical advances, what and how people photograph has scarcely changed and photographers regularly return to techniques from the past. Resurgences in low-tech approaches, exemplified by the Lomo camera, occur from time to time, and users of the latest camera phones and digital cameras often use filters that simulate 19th-century processes. Artists such as Linda Oppenheim and Walead Beshty take this approach further, appropriating camera-less techniques such as the photogram, and using chemicals to explore "obsolete" darkroom processes.

By contrast, Irish photographer Richard Mosse uses large-format film in a camera, but loads a false-colour infrared film, Kodak Aerochrome, to record conflict in war zones such as the Congo. Mosse's striking work shows that film-based photography retains the capacity to surprise. Others, such as Gilbert Garcin, rebel against manipulating images digitally and make a point of creating their composites in the darkroom.

The omnipresent camera

Just as photography has been shaped by technology in the past, so it will be in the future. The greatest influence on photography has not in fact been the digital camera itself, but its reincarnation in the form of the smartphone (see pp.352–53). The emergence of such a readily available

(see pp.92–93)
(see pp.352–53)

▽ **SELF-PORTRAIT**

KLAUDIA CECHINI, 2012

Polish photographer Klaudia Cechini uses her smartphone to explore forms of self-portraiture. Here, reflections mask her face with a blur of spots while backlighting turns her form into a silhouette. Both effects subvert the normal function of the self-portrait.

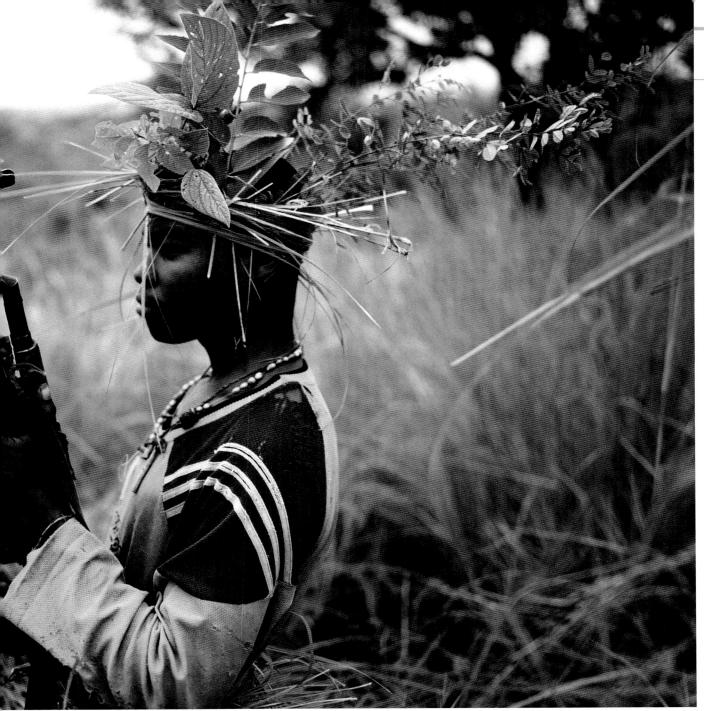

◁ SAFE FROM HARM
RICHARD MOSSE, 2012

Mosse has used infrared film like that once employed by the military to detect enemy installations from the air to portray a Congolese soldier in a camouflage headdress in a burst of psychedelic colour. The resulting unreality of the image highlights Mosse's concern that documentary photography fails to show the true horror of war.

▽ RIGHT-WING CANDIDATE
GILBERT GARCIN, 2012

With its partnering flipped image, Left-wing Candidate, this photograph is a visual pun on political suicide. Garcin assembles photographs to make composites in the darkroom in the time-honoured way, pairing photographs much as people used to hang matching Old Master paintings on either side of a fireplace.

camera has broadened the scope of photography. It has made everyone a potential reporter and photography part of the fabric of life, because anything – from people themselves to daily trivia and world news – can be photographed. Furthermore, the camera phone has given birth to a genuinely new phenomenon – the connected image – one that you can share the minute it has been created.

GLOSSARY

INDEX

ACKNOWLEDGMENTS

PICTURE
CREDITS

Glossary

A

Aberration A defect in an image, typically caused by the camera lens. Chromatic and spherical aberrations are common. Respectively, these are caused by different wavelengths of light focusing at different distances from the lens, and by the spherical form of the lens.

Achromatic lens / Achromat A lens designed to correct some chromatic aberration caused by the dispersion of light as it refracts through the camera lens.

Additive colour Combining two or more coloured beams of light to simulate or give the sensation of another colour.

Additive primaries The three colours – red, green, and blue – that can produce any other colour when added together. In optics, their combined light is called "white light".

Albumen print An early photographic printing technique in which a sheet of paper was coated in egg white and dipped in light-sensitive silver nitrate. The albumen in the egg white gave the prints a smooth, glossy sheen and warm tones.

Ambrotype An early photographic process that was essentially a thinly exposed collodion negative. When it was placed against a dark background, its light, creamy image tones were visible as bright parts of the scene.

Ambient light The available light that is not under the control of the photographer.

Anaglyph A picture composed of two differently coloured images (usually red and green), which, when viewed through correspondingly coloured filters, produce a 3D effect.

Aperture An opening of different sizes used to control the amount of light passing through the lens into a camera. A narrow aperture admits a smaller amount of light, resulting in a greater depth of field.

Artefact A defect in a digital image that usually occurs as a result of image processing.

Autochrome The first commercially available colour photography process. It used coloured particles of starch and a gelatin silver-bromide emulsion to capture coloured images.

Autofocus A system that uses sensors to assess the subject and focus the camera automatically.

B

Bayonet mount A method of mounting lenses to cameras that uses tabs at the rear of the lens to grip behind corresponding tabs in the camera's lens throat.

Brightness Subjective impression of the amount of light emitted or reflected.

Burning in Increasing the exposure of specific areas of a photographic print to make them darker. The opposite of burning in is called dodging.

C

Calotype An early photographic process that used paper made sensitive to light with silver iodide to produce a photographic negative. It could be used to create multiple positive prints of a single image.

Camera obscura Latin for "dark chamber", the camera obscura was a lightproof box or room with a hole on one side that projected the image of its external surroundings onto an internal screen or wall.

Candid A photograph captured without artificially posing the subject.

Carbon transfer An early process for contact printing using pigment such as carbon ink in sensitized gelatin to transfer a positive image onto paper to produce a richly black image in low relief.

Cartes de visite Small photographic portraits that were used as calling cards in the mid-19th century, when they were highly fashionable and collectable. They were usually albumen prints mounted on cards measuring 64 x 100mm (2½ x 4in).

Celluloid An early thermoplastic, composed primarily of nitrocellulose and camphor.

Claude glass A convex, blackened mirror, used in the late 18th and early 19th century, that gave objects or landscapes reflected on its surface the quality of paintings.

Clipping The loss of detail in either the highlight or shadow of an image.

Collodion process An early photographic process that captured great detail but was extremely difficult to use. The glass plate on which the exposure was made had to be prepared with various chemicals (including collodion and potassium iodide) and had to be used within minutes, while it was still wet. The exposure produced a negative image, which had to be processed immediately.

Colour transparency A positive colour image produced on a transparent film or glass and viewed via projected light. Modern transparencies offer high contrast and colour saturation in comparison to images captured on colour negative films.

Combination printing The use of two or more negatives to create a single positive print.

Contact print A print created by exposing a sheet of light-sensitive photographic paper through a negative placed in direct contact with the paper.

Contrast The range between the brightest and darkest parts of an image.

CMYK The primary inks used in desktop and commercial printing to simulate a range of colours: cyan, magenta, yellow, key black.

Crop To remove unwanted areas from an image, by enclosing in a frame, cutting the print, or using image manipulation software.

Cyanotype An early photographic process in which potassium ferrocyanide and ammonium ferric citrate were used to create a cyan-blue print on paper.

D

Daguerreotype The first widely used photographic process. A copper plate was polished, then coated with silver, which was treated with a layer of light-sensitive iodide. The plate was carried to the camera in a lightproof holder, where it was exposed to the image projected inside the camera by the lens. This created an invisible, latent image on the plate, developed by exposure to mercury vapour.

Darkroom A lightproof room in which light-sensitive photographic materials can be handled and processed.

Depth of field The distance between the closest and furthest parts of a scene that appear acceptably sharp.

Diaphragm The part of the lens that adjusts the size of the aperture.

Diffusion The scattering of light particles, resulting in a softening of light and shade.

Dodging Decreasing the exposure of a specific area of a photographic print to make the area lighter. The opposite of dodging is called burning in.

Dpi (dots per inch) A measure of print resolution. The greater the number of dots (of ink) per linear inch in a print, the higher the resolution of the image.

E

Emulsion A micro-thin layer of gelatin in which light-sensitive silver salts are suspended. Light triggers a chemical reaction in the salts, creating a photographic image.

Exposure The process of allowing a specific amount of light to reach a camera's film or sensor for a specific amount of time to create an image.

F

f/number (f/stop) The term used to refer to the size of the aperture in a lens. Expressed as a fraction of the focal length: f/4, f/11, f/22 etc.

Fast film Film that is highly sensitive to light and so requires less light to produce a properly exposed image.

Film processing The chemical transformation of a latent image on a light-sensitive film into a permanent, visible image.

Filter (1) A piece of glass or resin, often coloured, which is put in front of a lens to modify the light entering the camera. (2) A software feature that modifies an image, often to emulate a lens feature.

Fixed focal length Descriptive of a camera lens that cannot be zoomed.

Flare Unwanted, extra light in an image.

Flash gun A device that produces a short, bright flash to enable exposures to be made under low light conditions.

Flash synchronizer A device that synchronizes the timing of the flash with the opening and closing of the camera's shutter.

Focal length The distance between the optical centre of a lens and a sharp image of an object projected by it at infinity.

Focus The point at which light rays are brought together to produce the sharpest image.

G

Gelatin A nearly transparent substance produced by boiling animal tissue in water. It is used as a medium for suspending light-sensitive crystals, which make images on photographic film.

Gelatin-silver print Introduced in 1882, the standard black-and-white print in which paper is coated with silver halides suspended in gelatin.

Giclée A word coined in 1991 for fine-art digital prints made on inkjet printers.

Greyscale A measure of the number of distinct steps between black and white in an image.

Gum bichromate print In use from the 1890s to the 1920s, a print made from coloured pigment suspended in gum arabic and sensitized with potassium or ammonium bichromate. Such prints resemble charcoal drawings, with broad tonal areas and little detail.

H

Halation A blurring of an image caused by light that has passed through the film but reflected back, usually off the camera back.

Headshot A photograph of a person's head and shoulders, usually made for promotional purposes.

Highlight The brightest part of an image.

I

Incident light The light that falls onto a surface, as opposed to the light that is reflected off it.

Infinity The lens setting at which, for all practical purposes, the light rays enter the lens parallel to each other.

Instant return mirror A component of an SLR camera. A mirror is used to reflect light from the lens to the viewfinder. When the shutter is pressed, the mirror flips out of the way of the exposure, and returns when the exposure is complete.

ISO An international standard film rating, denoting a film's sensitivity to light. In digital cameras, changing the ISO boosts signal amplification.

L

Large format An image format greater than 60 × 90mm (2¼ × 3½in), for example, 5 x 4in.

Latent image An image recorded on a film or plate that is only made visible by the process of development.

Lens A single piece of curved glass used to change the path of light rays. In photography, a lens is a device containing several such lenses, which receive light from an object and form an image of the object on the focal plane.

Light meter An instrument that measures light to produce an exposure reading.

M

Medium format An image format of 60 × 60mm (2¼ × 2 ¼in) or 60 × 90mm (2¼ × 3½in).

Megapixel One million pixels. The measurement is used to describe digital cameras in terms of sensor resolution.

Micro Four thirds A digital standard developed jointly by Panasonic and Olympus and popularized by their G-series and PEN compact system cameras respectively. It is based around a sensor size of 17.3mm x 13mm, giving a focal length magnification of 2x.

Monochrome A photographic image composed of black, white, and greys, and which may or may not be tinted.

Montage (1) The process of combining elements of different images to create a new image. (2) An image created using this technique.

Multiple exposure The creation of more than one exposure on a single frame.

N

Negative A photographic image in which colours and areas of light and dark are reversed. Projecting light through a negative onto light-sensitive paper creates a positive photographic print after processing.

P

Paget process An early colour photography process that used two glass plates – a standard black-and-white negative plate and a colour screen plate that had red, green, and blue filters. The filters were exposed together to create a single coloured image.

Panning Moving a camera horizontally, usually to follow an action.

Panorama A photographic view that takes in a single image the whole of a vista seen by looking from one side to the other.

Paparazzo A photographer who shoots surprise pictures of celebrities, usually for publication in tabloid newspapers or magazines.

Parallax In photography, the difference between what is seen through the viewfinder lens and the taking lens.

Petzval lens A lens arrangement featuring two sets of achromat pairs with an aperture stop between them. The lens greatly increased the focus and exposure times of 19th-century portrait photography.

Photogram A lensless photographic process. Solid objects left on light-sensitive paper create masked areas, like shadows, when the paper is exposed to light.

Photomicrography A photographic image taken through a microscope.

Pictorialism A late-19th- to early-20th-century photographic style. Subjects were given artistic arrangements and often represented in soft focus rather than documented realistically.

Picture essay / Photo essay A series of photographs intended to show a narrative, the passage of time, or to promote a sequence of emotions in the viewer.

Pixel The smallest unit of digital imaging; short for "picture element".

Plate A plate of glass or metal with a light-sensitive chemical coating. Such plates were used in early photography.

Platinotype Also known as platinum printing. A printing process that uses paper sensitized to light with potassium-platinum chloride salt to produce high-quality prints.

Positive A photographic print in which colours and areas of light and dark match the scene, object, or figure they represent. It is the opposite of a photographic negative.

Prime lens A lens that has a fixed focal length.

R

Rangefinder A focusing system that merges two images of the same scene, viewed from slightly different viewpoints, in the viewfinder. The focusing ring on the lens is turned to move the images together: when the images overlap each other, the scene is in focus.

Resolution (1) The measure of detail captured by a camera. (2) The measure of the number of pixels on a sensor or in an image.

Rotogravure A printing press that uses a metal cylinder chemically etched with the text or image to be reproduced. It was widely used to mass-produce early illustrated magazines and newspapers.

S

Scanning The process of turning an original image into a digital facsimile, creating a digital file of a specified size.

Scrim A woven, net-like material that can be used as a screen to diffuse direct light, softening the features of photographic subjects.

Sensor The light-sensitive imaging chip inside a digital camera.

Sepia toning Chemically altering black-and-white positive prints to soften their tones and to increase their stability – typically to give them a vintage or nostalgic look.

Shutter The mechanism inside a camera that determines for how long the film or sensor is exposed to light.

SLR (Single-lens reflex) A camera with a viewfinder that shows an image seen through the same lens that will project an image to the film or sensor.

Solarization Reversal of tones when a developing print is exposed to light during development. Photographers exploit partial reversal, known as the Sabattier effect.

Stereo cards Pairs of photographs that together create a single 3D scene when viewed through a stereoscope.

Stereoscope A device that creates the illusion of seeing in three dimensions. Two photographs of the same scene representing left- and right-eye views are observed through the stereoscope, which fuses them into a single image that appears three-dimensional.

Subtractive filters Lens filters used in early colour photography. Each filter lets through only one of the three primary colours of light. When the three images are overlaid they synthesize into a single, full-colour photograph.

Subtractive primaries The three colours (cyan, magenta, yellow) that are used to create all other colours in photographic printing. They do so by absorbing (or subtracting) each other to various different degrees.

T

Tableaux Photographs of carefully posed or arranged scenes, often of costumed models. They were particularly associated with the pictorialist style.

Taking lens The lens that admits the light that forms the image, as opposed to the viewfinder lens, which is for compositional purposes only.

Telephoto A focal length with a narrow viewing angle, typically 35 degrees or smaller.

Tint An overall, usually light, colouring that tends to affect the denser areas of the image.

Tintype An early photographic process in which a direct positive image was created on a sensitized iron plate.

Tripod A three-legged stand that is used to support a camera.

Twin-lens reflex A camera with two lenses of the same focal length. One lens takes the photograph; the other projects to the viewfinder system.

V

Vignetting Darkening the corners of an image by obstructing light rays.

Vivex process An early colour photography process that used three simultaneously exposed negative plates (cyan, magenta, and yellow). When printed on top of each other, the three images created a colour print.

W

Wet-plate photography See Collodion process.

White balance A shade of white (warm, cool, neutral) used as standard white.

Wide-angle A focal length giving a wide angle of view, usually at least 50 degrees.

Z

Zone system A system developed by photographers Ansel Adams and Fred Archer for determining optimum film exposure and development.

Zoom lens Lens whose focal length (and with it the field of view) can be varied without change of focus.

Index

QR

Acknowledgments

The concept and scope of this book had been developed over several years by Nicky Munro, who I had the privilege to have as my editor on nearly 20 books. Tragically, and to our profound loss, Nicky died before she could start work on this book – her most keenly anticipated project. But it still bears the hallmarks of her genius for making fine books and her love of photography. I dedicate this work to her memory, in the hope that it meets her high and exacting standards.

My first and last thanks go to my wife, partner, and work-support system, Wendy: thank you so much for creating the home that made it possible for me to research and write this book. My warm thanks to the team at Dorling Kindersley, led by Angela Wilkes and Joanne Clark – Saffron Stocker, Anna Fischel, Andy Szudek, Satu Fox, Stuart Neilson, Jenny Faithfull, Sarah Smithies, and Sarah Hopper – for their considerable hard work and professionalism and ever-reliable and perceptive design work. I would like to thank the following for their help with information, leads, and advice: Professor Larry Shaaf (http://foxtalbot.dmu.ac.uk/letters/letters.html); Akintunde Akinleye, Nigeria (www.akintunde1.com/); Robert Elsie, author of *Writing in light: early photography of Albania and the southwestern Balkans*; Qerim Vrioni, Albania, photographer; Wesemann Michael (www.sumotalk.com); Nancy Matsumoto (www.nancymatsumoto.com); Saskia Asser, Online Archive Coordinator, World Press Photo; Gary Knight, Founder of the VII Photo Agency and Director, Program for Narrative & Documentary Practice, Institute for Global Leadership, Tufts University; Jenny Altschuler, Director, South African Centre for Photography. Big thanks to everyone who puts their scholarship, research, and knowledge freely onto the Web. I wish I could mention individually each of the hundreds of sources of insight, information, and back story that have contributed to this book.

Any errors or omissions are mine and mine alone. I have done my best to use only facts I could corroborate from the best sources, but there will be many points on which the knowledgeable can call on different facts or offer alternative interpretations. If so, I'd love to hear from you. Please contact me at info@tomang.com with any comments, corrections, or information that could help to improve future editions of this book. The team and I give special thanks to Cindy Sherman for her support.

Tom Ang, Auckland 2014

Dorling Kindersley would like to thank the following people for their help with this book: Reg Grant, Iain Zaczek, and Ian Chilvers for compiling biography entries; Diana Le Core for compiling the index; Carrie Mangan for editorial assistance; DK Delhi for design and editorial assistance; Sophia Brothers of SSPL, Valentina Bandelloni of Scala, Barbara Galasso of George Eastman House, and Sarah Hopper for their assistance with picture research; and finally, the many photographers and galleries who have checked the text and suggested improvements.

Picture Credits

The publisher would like to thank the following for their kind permission to reproduce their photographs:

(Key: a-above; b-below/bottom; c-centre; f-far; l-left; r-right; t-top)

The Advertising Archives: 302-303, 303tr, 303b; **akg-images:** 401, Africa Media Online / David G Photos 280, Hervé Champollion 81br, André Held 86bl, The British Library Board 50tr, ullstein bild 52-53t, 136-137, 190bl, 205br, ullstein bild / Teutopress 121t, 182l, ullstein bild / ullstein - Leica 148tl, Voller Ernst / Chaldej 197tr; **Alamy Images:** Aflo Foto Agency 270bl, Archive Farms. Inc 31tr, 51, 56l, Julian Eales 247bc, ES Tech Archive 275br, imageBROKER 241cr, Interfoto 72-73, Oliver Leedham 352-353, Oleksiy Maksymenko 353, Mary Evans Picture Library 95br, Mixpix 59r, Jeremy Pembrey 274-275, Pictorial Press Ltd 118l, 231tr, RIA Novosti 140tl, Universal Art Archive 353br, Martyn Williams 247br, Maksym Yemelyanov 177br; **Emily Allchurch:** 349b; © **Aperture Foundation Inc., Paul Strand Archive:** 159r; **Art+Commerce:** © Copyright The Robert Mapplethorpe Foundation. Courtesy Art + Commerce 298, © Estate of Guy Bourdin. Reproduced by permission of Art + Commerce 266, 266-267t, 266-267b, 267b; **Marc Asnin:** 318tl, 318bl; **Australian War Memorial:** 135b; **Jocelyn Bain Hogg/VII:** 314l; **Barbara Wolff, Linhof Präzisions-Systemtechnik GmbH München:** 104tl, 105br; © **Daniel Beltra:** 378-379; **Ben Brown Fine Arts:** © Candida Höfer, Köln / VG Bild-Kunst, Bonn and DACS, London. 2014 / DACS (Design And Artists Copyright Society) 309t; **(c) Bill Brandt / Bill Brandt Archive Ltd:** 220bl, 221; **Boston Public Library:** 47tl; **The Bridgeman Art Library:** Art Gallery of New South Wales, Sydney, Australia 139r, Bibliothèque de la Faculté de Médecine, Paris, France / Archives Charmet 83bl, Cincinnati Art Museum, Ohio, USA / © The Harold & Esther Edgerton Foundation, 2008, courtesy of / Palm Press, Inc 203t, Private Collection / © Charles Plante Fine Arts 17br, Private Collection / © Christie's Images / © Albert Renger-Patzsch Archiv / Ann und Jürgen Wilde / DACS, London 2014 146l, 151r, 213t, Private Collection / © Look and Learn 16-17b, Private Collection / Photo © Bonhams, London, UK 63br, Private Collection / Photo © Christie's Images 58b, 227t, Private Collection / Prismatic Pictures 190l, The Israel Museum, Jerusalem, Israel / Vera & Arturo Schwarz Collection of Dada and Surrealist Art / © DACS 2014 142r; **British Architectural Library, RIBA, London:** RIBA Library Photographs Collection 43b; **Victor Burgin:** 316-317; **Image copyright Edward Burtynsky, courtesy Flowers East Gallery, London / Nicholas Metivier Gallery, Toronto:** 376; © **Canon:** 271br; © **Carl Zeiss AG:** 212-213; © **Collezione Cavazza:** 97t; © **Klaudia Cechini:** 382l; © **Bonnie Cheung:** 362l; © **Chris Crisman:** 348r; **Cinémathèque française:** 81tr; **Copyright Conway Link. Image courtesy of The O. Winston Link Museum:** 228-229; **Corbis:** © Ansel Adams Publishing Rights Trust 162br, 162-163t, 163b, adoc-photos 126l, Akintunde Akinleye / Reuters 386, Akintunde Akinleye / X02000 / Reuters 360-361, Pablo Alfaro 186tl, Yann Arthus-Bertrand 336-337, 388, Bettmann 20tl, 39cr, 88b, 178-179, 203cr, 226t, 270tl, Bettmann / © 2014 The Estate of Edward Steichen / ARS, NY and DACS ,London 226tr, © Marcus Bleasdale 377b, Christie's Images / © Georgia O'Keeffe Museum / DACS, 2014 107, 109, Dev Gogoi / Demotix / Demotix 328tl, Philip Gould 230, 231cr, 248tl, Hulton-Deutsch Collection 24-25, 24-25, 26tl, 27r, © Yevgeny Khaldei 427, Frans Lanting 300br, 300-301t, Abilio Lope 358tl, Lawrence Manning 167cr, Bence Máté / Nature Picture Library 365tr, © Condé Nast Archive / © 2014 The Estate of Edward Steichen / ARS, NY and DACS, London 117t, 117bl, 117br, 182br, 183, 231l, 232-233, Alain Nogues / Sygma 200-201, 204tl, Galen Rowell 338-339, Seattle Fine Art Museum 50l, Shepard Sherbell 159l, Stapleton Collection 26br, Peter Turnley 135t, 156bl; **Courtesy the Estate of Don Hong-Oai:** 368l; **Courtesy Foto Colectania Foundation, Barcelona:** © Joan Colom 222bc; **Courtesy Gagosian Gallery, London:** © Thomas Ruff / © DACS 2014 / DACS (Design And Artists Copyright Society) 348l; **Courtesy Howard Greenberg Gallery, New York:** © Estate of Martin Munkácsi 234; **Courtesy Laurence Miller Gallery, New York:** Copyright Ray K Metzker 331r; **Courtesy Maureen Paley, London:** 322br, 323bl, 323r, 322-323t, / Image Carmen Brunner 322tl; **Courtesy NASA Johnson Space Center:** 272bl; **Courtesy of Fraenkel Gallery, San Francisco:** © Hiroshi Sugimoto 223b, 334bl; **Courtesy of Hua Gallery:** Copyright Gao Brothers 371; **Courtesy of ShangART Gallery and the artist:** 371b; **Courtesy of Stephen Bulger Gallery:** © Estate of André Kertész 275tr; **Courtesy of the artist and Jack Shainman Gallery, New York:** © Richard E Mosse 382-383t; **Courtesy Sprüth Magers Berlin London:** © Thomas Demand, VG Bild-Kunst / © 2014 DACS 317b, Andreas Gursky / © DACS 2014 308-309; **Luc Delahaye & Galerie Nathalie Obadia:** 313t; **Donation Lartigue:** © Ministère de la Culture - France / AAJHL: Photograph by Jacques Henri Lartigue 79t, 96-97, 97r; © **Die Photographische Sammlung/SK Stiftung Kultur - August**

Sander Archiv, Cologne, DACS, London 2014: © Die Photographische Sammlung / SK Stiftung Kultur - August Sander Archiv, Köln / VG Bild-Kunst, Bonn and DACS, London 2014 152tl, 152-153, 153br; **Dorling Kindersley:** 149bc, Steve Gorton 148-149; © **Greg du Toit:** 364-365b; © **George Eastman House, International Museum of Photography and Film:** 22-23, 23br, 31tl, 38-39t, 42br, 42br, 43tr, 44b, 45t, 45br, 47br, 56r, 57bl, 72br, 93tr, 93cr, 93br, 105l, 110-111, 120l, 160l, 167tr, 167br, 176-177, 213tr, 240-241, 241crb, 246-247, 251br, 393, 439; **Robert Elsie:** ÖNB/Wien, VUES IV 41060 50b; © **Estate of Masumi Hayashi (Dean A Keesey):** 330; **Fahey Klein Gallery.com:** 224-225; **FLPA:** Frans Lanting 300tl, 301b, Thomas Marent / Minden Pictures 365tl; © **Franco Fontana:** 292bl, 293; **Joan Fontcuberta:** 316bc; **Stanley Forman:** 282-283, 283; © **FUJIFILM Europe GmbH:** 345br; **Gagosian Gallery, New York:** © Sally Mann.Courtesy Gagosian Gallery 318-319t; © **Gilbert Garcin:** 383b; **Getty Images:** Adrian Dennis / AFP 222l, 281t, 355, 356-357t, Alinari Archives / Alinari via Getty Images 391, Andreas Feininger / Premium Archive 218-219, 254-255t, Brad Elterman / BuzzFoto / FilmMagic 255br, British Library / Robana via Getty Images 32-33, Jim Dyson / Redferns via Getty Images 352bl, Édouard Boubat / Gamma Legends / Gamma-Rapho via Getty Images 210-211, 247tr, Galerie Bilderwelt 199br, Sean Gallup / Getty Images Entertainment 258r, 372tl, Walter Hahn / AFP 198-199t, Hulton Archive 54-55tl, 66l, 80-81t, 83t, 88tl, 99t, Cavan Images / Stone 356bl, 357t, Neil Leifer / Neil Leifer Collection / Sports Illustrated via Getty Images 262tl, 268-269, Peter Read Miller / Sports Illustrated 148bl, 177tr, 212tl, 271tl, 344b, Michael S Yamashita / National Geographic 155tl, 162, 184l, 184-185, 185tr, 185br, 202bl, 463, Rebecca Sapp / WireImage 290tl, 290br, 290-291t, 291bl, 291r, 304tl, 350tl, Scott Polar Research Institute, University of Cambridge / Hulton Archive 94bl, 118r, 119r, Sovfoto / UIG via Getty Images 123tc, SSPL via Getty Images 21b, 39b, George Strock / The LIFE Picture Collection / Time Life Pictures 198tl, Anthony Suau / The Denver Post via Getty Images 457, Succession Willy RONIS / Diffusion Agence Rapho / Gamma-Legends / Gamma-Rapho via Getty Images 154l, William Vandivert / The LIFE Picture Collection / Time & Life Pictures 104tr, 104bl, 134, 181tr, 202-203b, 206l, 226b, 238tl, 238b, 238-239, 239tc, 239bc, 239r, 240bl, 241tr, 274, 276-277t, Walker Evans / The LIFE Picture Collection / Time Life Pictures / © Walker Evans Archive, The Metropolitan Museum of Art 175r, Weegee(Arthur Fellig) / International Center of Photography 62l, 90-91, 377t; **Glasgow University Library:** 30c; **Glaz Gallery:** 196-197t; © **F. C. Gundlach Foundation;** ; © **F.C. Gundlach Foundation:** 214l; © **HARMAN technology Limited:** 73br; **Harvard Theatre Collection:** 236br; © **Hasselblad:** 273br; © **Heritage Cameras (www.heritagecameras.co.uk):** 344-345; © **1981, 2013 Photo by Robert Herman:** 325br; **Higher Pictures:** 154-155, 156br, 157; © **David Hockney:** Photo by Richard Schmidt 330-331t; **International Center of Photography:** Collection International Center of Photography 180, © International Center of Photography 181b, © The Lisette Model Foundation, Inc (1983). Used by permission / ICP / © The Lisette Model Foundation 259, © Mara Vishniac Kohn, courtesy International Center of Photography 188-189; **Taka Ishii Gallery:** © Daido Moriyama / Courtesy of Taka Ishii Gallery, Tokyo and Daido Moriyama Photo Foundation, Tokyo 251tr; **Jiang Peng:** 369b; © **Philippe Kahn / Fullpower Technologies, Inc:** 352tl; **The Kobal Collection:** Riama-Pathe 255bl; **Least wanted:** 85; © **Leica Camera AG:** 149tr, 149br; **Lily Et Ses Livres:** 68bl; © **Kodak Limited:** 344l; © **Tom Lowe:** 380l; Magnum Photos: © Eve Arnold 256-257, © Werner Bischof 208tl, 208br, 208-209tl, 209bl, 209r, © Henri Cartier-Bresson 204br, 204-205tl, 205tr, 205bl, 206b, © Robert Capa © International Center of Photography 188b, 197br, 198bl, 207tr, © Elliott Erwitt 262-263tl, 262-263b, 263tr, 263br, © Philip Jones Griffiths 276br, © Harry Gruyaert 324-325, © Philippe Halsman 237, © Thomas Höpker 346-347, © Josef Koudelka 281b, 335br, © Sergio Larrain 223t, © Constantine Manos 325t, © Peter Marlow 310r, © Steve McCurry 304br, 304-305t, 305bl, 305r, 306, 307, © Susan Meiselas 310l, © Raghu Rai 328-329t, 328-329b, 329t, 329b, © Marc Riboud 284-285, © Cristina García Rodero 358b, 358-359t, 359r, 359b, © George Rodger 207l, © Ferdinando Scianna 452, © David Seymour 189br, 207br, © W Eugene Smith 248br, 248-249, 249bl, 249r, © Chris Steele-Perkins 311, 455; © **Vivian Maier / Maloof Collection:** 246bl; **Jan Manuel / flickr: jmtosses:** 270-271; **Mari Mahr:** 298br; **Mary Evans Picture Library:** Iberfoto 188l; **Courtesy Matthew Marks Gallery:** © Luigi Ghirri 334-335; © **Chris McLennan:** 365br; **Georges Mérillon:** 320-321; **Courtesy of the Artist and Metro Pictures:** 350br, 350-351t, 351tr, 351b; © **Pedro Meyer:** 332tl, 332-333t, 332-333b, 333tr, 333br; **Copyright Joel Meyerowitz:** 324l; © **Peter Miller/Disfarmer:** 258; **Museum Folkwang Essen:** 214-215, 215; **Museum of Decorative Arts, Prague:** 216, 216br, 216-217t, 216-217b, 217r; **NASA:** 272-273t, 273bl, 381br, JPL Caltech MSSS 381bl, NASA, ESA, S Beckwith (STScI), and The Hubble Heritage Team STSc / AURA 272-273t, 273bl, 380-381t; **NASA's Earth Observatory:** NASA Earth Observatory image created by Jesse Allen, using data provided courtesy of the